A Time of Gathering

Thomas Burke Memorial Washington State Museum Monograph 7

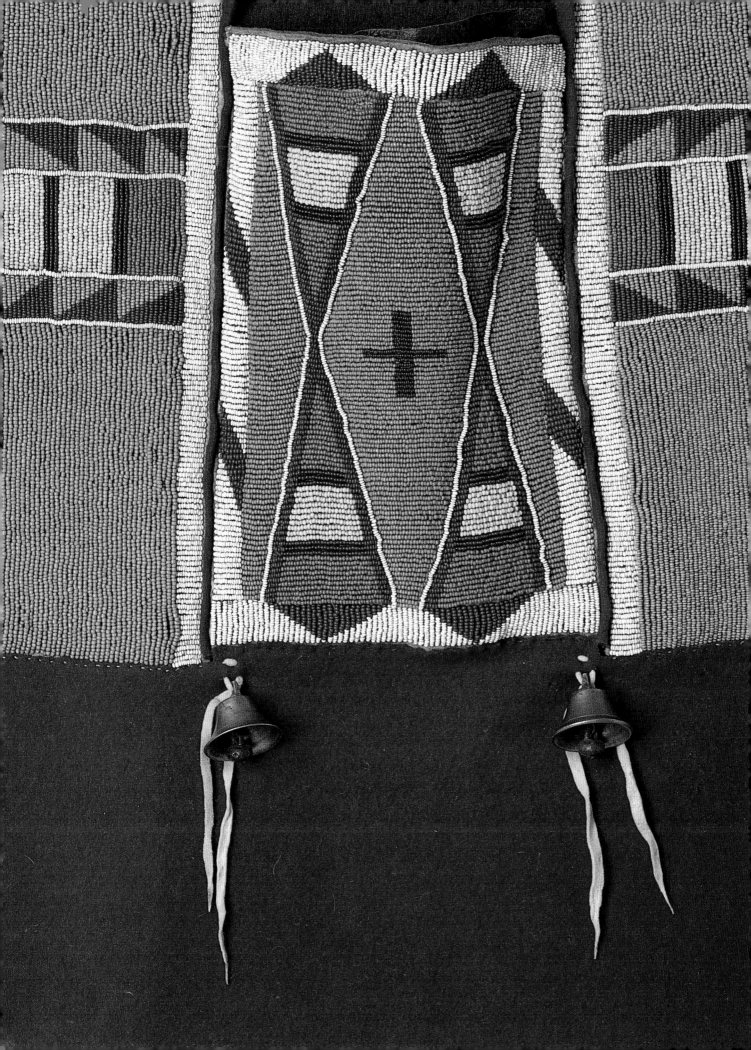

A Time of Gathering

Native Heritage in Washington State

Robin K. Wright, editor

Burke Museum *Seattle*
University of Washington Press *Seattle and London*

Composition by Continental Typographics, Inc., Chatsworth, CA
Printed and bound in Singapore by Times Publishing Group
Designed by Dana Levy, Perpetua Press

This work was prepared to document the exhibit *A Time of Gathering* (April 1–October 1, 1989), a
project initiated and partially funded by the 1989 Washington Centennial Commission.

Publication of this work was made possible by the assistance of the National Endowment for the
Humanities and of the Getty Grant Program.

Library of Congress Cataloging-in-Publication Data

A Time of gathering : native heritage in Washington State/Robin K.
 Wright, editor.
 p. cm. — (Monograph/Thomas Burke Memorial Washington State
Museum ; 7)
 Includes bibliographical references.
 ISBN 0-295-96819-2. — ISBN 0-295-96820-6 (pbk.)
 1. Indians of North America—Washington (State)—Exhibitions.
2. Indians of North America—Washington (State)—Art—Exhibitions.
I. Wright, Robin Kathleen. II. Thomas Burke Memorial Washington
State Museum. III. Series: Monograph (Thomas Burke Memorial
Washington State Museum) ; 7.
E78.W3T56 1990
979.7′00497074797—dc20 90-1341
 CIP

Burke Museum Publications Program

Dr. Sievert Rohwer, Acting Director
Dr. Susan D. Libonati-Barnes, Editor
Jenifer Young, Editorial Associate

Thomas Burke Memorial Washington State Museum Monographs

1. *Northwest Coast Indian Art: An Analysis of Form*, by Bill Holm
2. *Edward S. Curtis in the Land of the War Canoes: A Pioneer Cinematographer in the Pacific Northwest*,
 by Bill Holm and George Irving Quimby
3. *Smoky-Top: The Art and Times of Willie Seaweed*, by Bill Holm
4. *Spirit and Ancestor: A Century of Northwest Coast Indian Art at the Burke Museum*, by Bill Holm
5. *Niuatoputapu: The Prehistory of a Polynesian Chiefdom*, by Patrick V. Kirch
6. *gyaehlingaay: Traditions, Tales, and Images of the Kaigani Haida*, by Carol Eastman and Elizabeth
 Edwards
7. *A Time of Gathering: Native Heritage in Washington State*, by Robin K. Wright

Eastern and western Washington graphic designs based on
Columbia River mountain sheep horn bowl (pl. 48) and
Klallam whale bone club (pl. 67), respectively.
Drawings by Robin K. Wright.

COVER: Female Figure. Makah, made by Allabush; late 19th century. Field Museum of Natural
History. (See plate 80.) Photograph by Ron Testa.

BACK COVER: Beaded Bag. Yakima; early 20th century. (See plate 24). Photograph by Ray Fowler.

PAGE 2: Bandoleer Bag (detail). Transmontane style. Honnen collection. (See page 198.)
Photograph by Paul Macapia and Ray Fowler.

PAGES 6–7: Robe (detail). Coast Salish; early 19th century. National Museum of Natural History,
Smithsonian Institution. (See plate 1.) Photography courtesy of the Smithsonian Institution.

TABLE OF CONTENTS

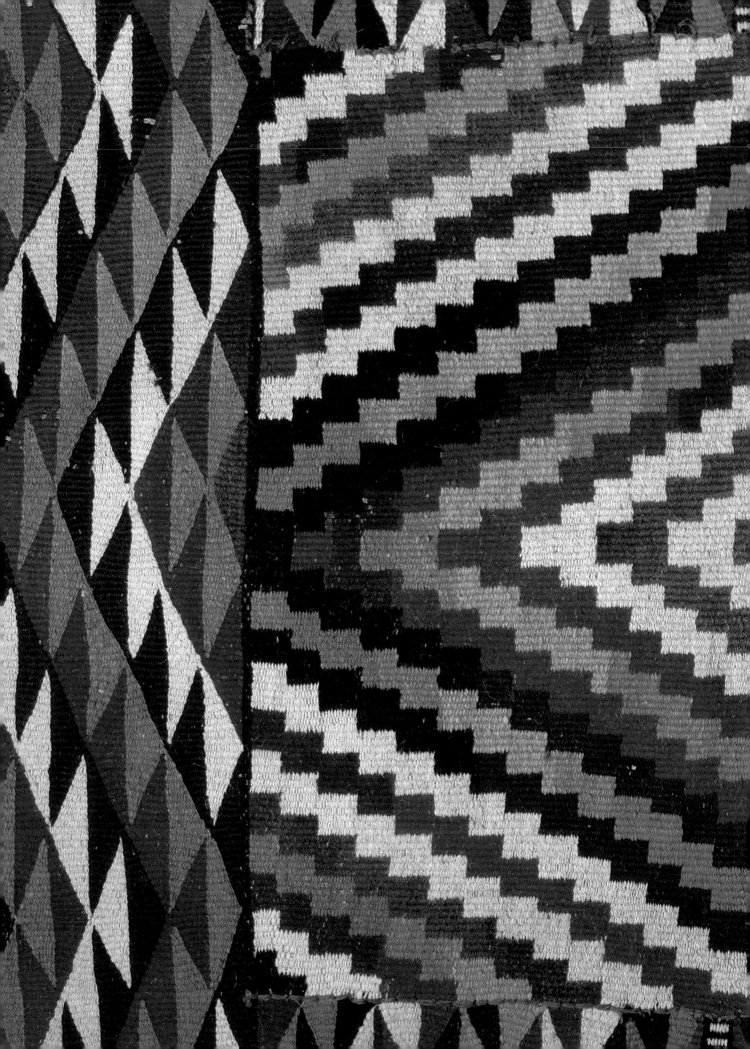

ACKNOWLEDGMENTS

To the Native People in Washington

The task of thanking all those who contributed to or assisted with this book is enormous. It is necessary to thank not only those involved directly with the catalogue, but all those who participated in the production of the exhibition, whose work was crucial to the success of this publication. The exhibit would not have been possible without the direction of the 1989 Washington Centennial Commission and the Lasting Legacy Committee who conceived and partially funded the exhibit. These organizations were led by Ralph Munro and Jean Gardner, Co-Chairs of the Washington Centennial Commission; Putnam Barber, Executive Secretary of the Washington Centennial Commission; and Senator Al Williams, the Chair of the Lasting Legacy Committee. Patricia Cosgrove developed the exhibit prospectus for the Lasting Legacy Committee before the Burke Museum was selected to host the exhibit. She continued her work as Exhibit Manager, a member of the Burke Museum staff, to coordinate the efforts of the staff and find the additional financial support needed to implement the exhibit. We would also like to thank the National Endowment for the Humanities and the Getty Grant Program for their financial support of the publication of this catalogue.

Equally deserving of thanks are all of the Native people in the state who contributed their time and talent to the planning, building, and staffing of the exhibit. Hundreds of people participated in our outreach trips and shared their knowledge and insight so that this exhibit would better reflect the heritage of Washington Native people. In the initial planning stages of the exhibit, Barbara Lawrence (Suquamish) and Joseph Waterhouse (Jamestown Klallam) were instrumental in seeing that the Centennial Commission, the Lasting Legacy Committee, and the Burke

Museum were responsive to the concerns of the Native people in the state, and kept to the commitment of involving Native people at all stages of the exhibit. Also crucial to the success of this exhibit were the commitment and dedication of the nine members of the Native Advisory Board: Vivian Adams (Yakima), Greig Arnold (Makah), Linda Day (Samish), Leonard Forsman (Suquamish), Kaye Hale (Spokane), Vi Hilbert (Upper Skagit), Charlie Sigo (Suquamish), Agnes Tulee (Yakima), and Nile Thompson (representing the Steilacoom Tribal Museum), who spent long hours traveling to and participating in monthly meetings over a two-year period. Thanks also to the many other Native people who attended and participated in these meetings or helped us with the many issues raised during these meetings: Bill Cagey, Rodney Cawston, Laura Eduards, Pauline Flett, Adeline Fredin, Delores George, Margaret Greene, Hildred Ides, Martin Louie, Sr., Oliver Mason, Bruce Miller, Kenneth Moses, Shirley Palmer, Salena Pascal, Helen Peterson, Charlie Pierce, Charles Quintasket, Jeannette Smartlowit, Leona Smartlowit, and Helma Ward, to name only a few.

A special thanks is owed to Roberta Haines (Moses Band of the Wenatchee Tribe, Colville Confederated Tribes), Co-Curator of the exhibit, and to Cecile Maxwell (Duwamish), Protocol Officer, for their dedication and hard work. Roberta shared with me the curatorial responsibility for the content of the exhibit, and had particular responsibility for the coordination of the many outreach trips to Native communities, the development of the thirty-five tribal panels, the search for contemporary artists, and the coordination of the jury selection process. As well, she was an editorial reader and contributing

author to the exhibit catalogue. As the liaison between the Museum and the tribal governments in the state, Cecile Maxwell's contribution was also pivotal in assuring the participation of Native people in this exhibit.

I would like to thank the fifteen contributing authors for their participation in this publication: Vivian Adams, Kate Duncan, Leonard Forsman, Linda Goodman, Roberta Haines, Vi Hilbert, Bill Holm, Eugene Hunn, Barbara Loeb, Martin Louie, Sr., Lynette Miller, Emmett Oliver, Amelia Sohappy Sampson, Wayne Suttles, and Helma Ward. The high quality of their contributions and their patience with the extensive editorial process are greatly appreciated. I am grateful for the thoughtful comments provided by the editorial readers Roberta Haines, Bill Holm, and Victoria Wyatt, as well as the several anonymous readers. Assistance with the inclusion of Native terms in both the book and the label copy was provided by Ann Renker, Hildred Ides, Helen Peterson, John Thomas, and Helma Ward of the Makah Cultural and Research Center; Agnes Tulee of the Yakima Museum; Randy Bouchard of the British Columbia Indian Language Project; and Eugene Hunn of the University of Washington. Additional thanks must go to Patricia Cosgrove, Linda Goodman, Roberta Haines, and Lynette Miller, who facilitated the articles authored by Emmett Oliver, Helma Ward, Martin Louie, Sr., and Amelia Sohappy Sampson, respectively.

Susan Libonati-Barnes, Burke Museum Editor, deserves credit for her work on this volume. Her role involved not only the compilation of the readers' comments and the technical editing of the text, but also the coordination with the University of Washington and Perpetua presses, and grantwriting to help fund the catalogue. Thanks should also go to her staff, Kirsten Aanerud, Jayson Jarmon, Christine Kleinke, and Jenifer Young. We are grateful to our co-publishers, the University of Washington Press, particularly to Naomi Pascal, Editor-in-Chief, for her advice and assistance with fundraising; Don Ellegood, Director; Richard P. Barden, Assistant Director; Julidta Tarver, Managing Editor; and Veronica Seyd, Production Manager. Thanks also to Dana Levy and Letitia Burns O'Connor, Perpetua Press, for their work on the design and production of this book.

Many other Burke Museum staff were critical to the production of the exhibit and the exhibit catalogue. Patrick Kirch, Director of the Burke Museum during the time that this exhibit was being planned and implemented, was instrumental in the selection of the Burke Museum as the host of this exhibit and the support that the staff received in order to produce the exhibit. After Dr. Kirch left the Museum, Sievert Rohwer, Acting Director, saw us through the chal-

lenging stages of the final installation, opening, and the six-month run of the exhibit. We were assisted by other key Museum staff in the administration, curation, and installation of the exhibit: Roxana Augusztiny, Assistant Director; Arn Slettebak, Chair and Curator of Education; Kathy Kuba, Associate Curator of Education; Gary Wingert, Curator of Exhibits; Margaret Davidson, Graphic Designer/ Illustrator; Meg Ross, Graphic Illustrator; Janine Ipsen and Owen Smith, Preparators; and Greg Watson, Exhibit Associate. Promotion Products, Inc., led by Tony Baby and Craig Kerger, contributed significantly to the exhibit design and its evolution through the various stages of planning and installation.

I would also like to thank the private collectors and the staff of the many institutions who graciously received me during the time I was doing the initial research for this project, and those who generously agreed to loan objects to this exhibit: Jonathan C. H. King, Assistant Keeper, Museum of Mankind, British Museum; Larry Schoonover, Curator of History, Cheney Cowles Museum; Fred Harnisch, District Ranger, Darrington Ranger Station; Richard Conn, Curator of Native Arts, Denver Art Museum; Christine Gross, Collections Manager, Field Museum of Natural History; Nancy Blomberg, Assistant Curator, Natural History Museum of Los Angeles County; Ann Renker, Director, and Debbie Cooke, Conservator, Makah Cultural and Research Center; Linda Mountain, Director, and Betty Long, Registrar, Maryhill Museum of Art; Mary Jane Lenz, Curator, Museum of the American Indian, Heye Foundation; Jim Barmore, Curator of Collections, Museum of History and Industry; Jeff Mauger, Curator, Museum of Native American Cultures; Berete Due, Curator, National Museum of Denmark; Felicia Pickering, Museum Technician, Susan Crawford, Loan Coordinator, and Jane Walsh, Department of Anthropology, National Museum of Natural History, Smithsonian Institution; Susan Buchel, Museum Curator, Nez Perce National Historic Park; Bradley Baker, Collection Manager, Ohio Historical Society; Don Dumond, Director, Oregon State Museum of Anthropology; Ian Brown, Curator, and Richard Beauchamp, Conservator, Peabody Museum of Archaeology and Ethnology, Harvard University; Susan Payne, Keeper of Human History, Perth Museum and Art Gallery; Linda Stouch, Curatorial Coordinator, Portland Art Museum; Daryl Thiel, Curator, Washington State Historical Society; George Pierre Castile, Professor of Anthropology and Curator, Whitman College; Alan and Jeanette Backstrom; Wayne Badovinus; Patricia Cosgrove; Sylvia Duryee; Douglas Ewing; Roberta Haines; Vi Hilbert; Bill and Marty Holm; Steven and Patricia Honnen; Scott Kingdon, President, Ivar's Restaurants; Dr. and Mrs. Allan Lobb; Jean Mills; John and Grace Putnam;

Jerrie and Anne Vander Houwen; Greg Watson; and the anonymous donors to the exhibit. None of these loans could have been accomplished without the help of Debra Miller, Assistant Registrar, who worked tirelessly to coordinate the endless details concerning the loan agreements, insurance, condition reports, shipping, customs, and couriers' arrangements.

I would like to thank the five members of the jury who selected the contemporary artists to be commissioned for this exhibition: Margery Aronson, Greig Arnold, Harry Fonseca, Agnes Tulee, and Victoria Wyatt. I would also like to thank the artists who were selected and whose works are included in the catalogue: Greg Colfax, Ron Hilbert Coy, Bill James, Fran James, Nettie Kuneki, Steve Noyes, Marvin Oliver, Caroline Orr, Norma Pendleton, Lillian Pitt, and Maynard Lavadour White Owl, as well as the forty other artists who submitted their work for consideration. Bill and Fran James, Steve Noyes, and Marvin Oliver also made a number of objects for us that were used to furnish the two houses. Thanks also to Lance Wilkie, who built the cedar plank house; James Selam, Delsie Selam, and Sarah Quaempts, who built the tule mat winter lodge for the exhibit; and Martin Louie, Sr., who built the sweat lodge for the exhibit. The cedar plank house and tule mat lodge with their furnishings, as well as the ten contemporary art commissions, have enriched the Burke Museum's permanent collections.

Special thanks go to Paul Macapia and Ray Fowler for their professional work in photographing the objects from the Burke Museum's and other local collections. Thanks as well to Eduardo Calderón for supplying us with additional photographs. I would like to thank Barbara Bridges, Ethnology Division Collection Manager, for her patience with the lengthy process of photography that was conducted in the Ethnology Division. I would also like to thank the many other institutions and individuals who supplied photographs for this publication.

To these and all whom we have been unable to name, but who participated in the process of this project, we gratefully share the lasting legacy of that process with you.

ROBIN K. WRIGHT

WELCOME STATEMENT

Vivian M. Adams

W elcome to *A Time of Gathering: Native Heritage in Washington State*, the catalogue of the Washington State Centennial exhibit (April 1–October 1, 1989). In 1985, Governor Booth Gardner appointed Jean Gardner to co-chair the 1989 Washington Centennial Commission with Secretary of State Ralph Munro. Governor Gardner proposed that the commission develop recommendations concerning the protection and preservation of our state heritage, thus providing a lasting legacy of the centennial celebrations.

The Centennial Commission appointed a citizens' committee, the Lasting Legacy Committee, chaired by Senator Al Williams. The goals of this committee included developing a comprehensive heritage policy, developing legislation to protect archaeological resources, promoting historic preservation, and providing education on Native American heritage. I was appointed a member of the Lasting Legacy Committee.

The Governor and the Lasting Legacy Committee marked as a priority an exhibit focusing on the first inhabitants of the region now known as Washington State. In 1986, the Lasting Legacy Committee chose the Thomas Burke Memorial Washington State Museum on the University of Washington campus as the host institution for this exhibit. "A Time of Gathering" was designed and implemented in close coordination with the Native American community. The Indians of Washington had a hand in telling our story!

My participation in this exhibit was a task of love and provided a wonderful opportunity to help present the art and lifestyles of Washington's Native people. I had been curator for the Yakima Nation Museum in Toppenish and had worked with Plateau-area heritage. Based on this experience, I also served as an advisor to the Burke Museum's exhibit staff.

Members of the Tribal Museum Association of Washington, which consists of the Suquamish, Makah, Yakima, Samish, and Steilacoom tribes, made up the Burke's standing Native Advisory Board. This board worked extensively with the Burke exhibit staff to ensure the accurate portrayal of the words, artifacts, ceremonies, and lifestyles of our people so that you might gain a better understanding of who we are. The Native Advisory Board intended to accomplish two tasks: to enlighten the public to the true lifestyle of our people, and to instill pride in the heritage of the Native people in Washington.

Members of the Advisory Board met with the Burke exhibit staff throughout the state, and through our conversations and brainstorming we came face to face with the title "A Time of Gathering." Through our talks we recognized that many important activities come about through gathering of our people. Native people gather to eat, to play, to work, to pray and give thanks, to settle questions and solve problems, to celebrate and to say farewell. This was indeed a simple, straightforward title describing the events that shape lives and futures, and we felt it described what would happen during the exhibit while we met to celebrate our histories and heritage.

The exhibit told the story of Native cultures in Washington, focusing primarily on the time from shortly after contact with Euro-Americans until statehood (1775–1889). Traditonal arts, dwellings, games, music, and dance illustrated this story. These, together with contemporary art objects and tribal dis-

Vivian M. Adams, Yakima Indian Nation, former Curator of the Yakima Nation Museum, Toppenish, Washington.

plays, showed the varied Native cultures and the continuing vitality of those cultures.

Through this exhibit we sought to dispel the stereotyped images of Native people that may have been learned from stories of early settlers, from incomplete history books, or from movies and television. This stereotyped image is one of the Plains people—warriors in splendid feather and buckskin finery. In reality, all of Washington's bands and tribes have characteristics unique to their environments, and most are considered especially peaceful societies.

Our arts and crafts, clothing, style of homes, family hierarchy, religion, songs, and dances can all differ and yet be similar because of the materials available for use and the ways in which we use them. We also share a belief that every living thing, be it plant, animal, fish, bird, or insect, has a life of its own and must be offered thanks for giving that life for our survival. We hoped that in viewing the beautiful utility items used by our ancestors, you would realize our respect for the spirit in all things.

Tribes throughout Washington share an interest in the basic activities of life: hunting, fishing, food gathering, the building of shelters, methods of transportation, music-making, ceremonial dance, and the crafting of beautifully decorated utilitarian objects. In our history of contact with Euro-Americans we also share losses: the loss of life from introduced disease, the loss of tradition and ceremonialism from foreign religions, the loss of land through treaties and settlement, and the loss of language through forced education. Since treaty time, we have had to learn a new way of living. We have had to regain a grasp of our past in order to revive and revitalize our traditions from generation to generation.

Let me tell you about my people, the Yakima Nation, and their times of gathering In the older days our tribes and bands came under many names, not under one as we are known today: Yakimas. We all followed essentially the same seasonal round of gathering from our separate areas.

The food-gathering cycle began in spring, the season of new growth, with the digging of roots. From late spring through summer, salmon-fishing took place along the rivers. We had several creeks and rivers and this task was performed simultaneously across hundreds of miles by the different tribes and bands. In late summer and early fall when the leaves turned colors, berries in the high mountains were picked and prepared for winter consumption. Mid-fall and early winter were for hunting animals for their meat, fur, and hides.

Trade areas were important for those who wanted to exchange roots for berries, fish for deer meat, or perhaps to obtain a favorite food prepared in a different manner by another tribe. It was at trades

like this that families became reunited, betrothals and marriages were performed, food and clothing exchanges were made, and memorials and other ceremonies were held; these were also favorite times for races, games, dancing, and singing.

At the beginning of each season a special group of people was selected for the first gathering of that season's offerings. Upon return of the group, a feast was held: for the first digging, the first catch, the first picking, and the first kill. Only after this feast of thanks would the rest of the people be allowed to begin their family's gathering. At these feast gatherings water was the most important resource, the main source of life. Without water there would be no plants, no animals, no fish, and no human beings. During the feast, prayer songs were sung before and after eating. Water was used as a sacrament after each set of prayer songs. Today, these feasts are still given after the first gathering. Water is still our sacrament before and after the meal. Traditions continue.

My people also gathered to work, as in the making of tule mats. The tule is a slender reed found with cattails in swampy, wet areas. Mats made from tules were used for a variety of purposes. Certain women proficient in working with tules were selected to do the gathering, then a ceremony of thanks was given before the young people did the cutting. Various sizes of tules were cut, separated into widths, and packed into bushels. Peeled willow bark or strands from the Indian hemp plant were spun into string with which the tules were woven and knotted together into large, beautiful mats. In the past, each tule mat had a specific use: as a floor rug, a sleeping mat, a mat for a couple to stand upon during the marriage ceremony, a mat for someone to stand upon during a name giving, a mat in which to wrap a deceased person, or a mat to make a lodge. Today mats are made for general use and can be purchased for particular ceremonies, though sometimes the family approaches a specific weaver to request her time and ability for a special ceremonial mat.

In ancient times, we Yakima people did not have names for each month because we did not recognize time as months, but as seasons. Each day was marked by the rising of a new sun, and until Christianity was introduced we did not name each day. Our way of experiencing time grew out of our environment.

Because we depended so much on what nature or the season had to offer, we always gave thanks and practiced conservation so that there would be offerings for the next season. Daily life consisted mainly of the search for food to see us through the harsh winter, and the hunting to acquire hides and furs for clothing and utility items. In good times when food was plentiful and the gathering easy, there was time to devote to decorating the objects used for everyday work and for making special ceremonial objects for

family, for gifts, or for trade.

In good times or harsh times the people always gave thanks, remembering that seasons would not always be mild, food gathering plentiful, fishing and hunting easy, or daily life comfortable. We would all do well to continue that practice today!

In summary, I believe that "A Time of Gathering" is a fitting title. We gathered together to celebrate one hundred years of change and growth for all the people of Washington State. Through these words and the objects you see here, we reach out our hand to you in friendship. We want to create an understanding and a mutual respect between our cultures. We hope that through the exhibit and this catalogue we have accomplished that. May there be an enlightened, cooperative future beneficial to all residents of our unique and bountiful state!

INTRODUCTION

Robin K. Wright

I. A TIME OF GATHERING: THE BOOK

This book is a unique and lasting legacy of the work that began in 1986 and culminated in the exhibit, "A Time of Gathering: Native Heritage in Washington State," but it is more than an exhibit catalogue. It brings together in one volume a record of this unprecedented exhibit amplified by essays written from a variety of viewpoints, intended to present the diversity and vitality of Native heritage in Washington. A printed volume cannot recreate the experience of walking into the cedar plank house and smelling the pungent yellow cedar, sweet red cedar, and hard-smoked salmon hanging from the rafters. Nor can a book bring to the reader the feeling of stepping into the expansive interior of a tule mat lodge, smelling the grassy fragrance of the tule rushes, and looking up through the open lodge poles. But a book can record in permanent form the beautiful images of the one hundred works of Washington Native art, never before assembled, that were brought together for a too-brief six-month period, and then dispersed. It can also present information on Washington Native heritage in far greater detail than is possible in the form of exhibit label copy.

One hundred masterworks of Washington Native art were gathered for the exhibit's Masterpiece Gallery, some from the Burke Museum's own collection, others from museums and private collections around the world. These rare pieces, some taken from the area nearly two hundred years ago, were selected for their excellence. They represent more than two thousand years of artistry—from prehistoric stone and bone sculpture to contemporary works of art commissioned specifically for this exhibition. The selection of these one hundred objects was a complicated process that began with research in museum collections and involved consultations with Native advisors and scholars throughout the state. Since the objects preserved in museum and private collections reflect the biases of collectors and the circumstances that surrounded their collection, this catalogue of the Masterpiece Gallery is coupled with a chapter on the history of the collection of Native art in Washington.

It was decided early in the planning process that Native authorities should be sought for a significant number of essays in the catalogue. Articles by Native and non-Native scholars in the fields of art history, anthropology, linguistics, and ethnomusicology also are included. Following the illustrated masterworks, essays by fourteen of the contributing authors are grouped in two sections for eastern and western Washington. The authors present information in a variety of styles, ranging from scholarly to personal and poetic impressions, from analytical treatises to reminiscences and storytelling.

Published sources that focus on Washington Native heritage treated as a whole were practically nonexistent at the time of this publication. The interested reader had to gather information from ethnographies or histories of specific tribal groups, articles on specific objects, or from catalogues of Native art that combined information from a broader geographical area. The need for a publication on Washington Native art and culture was apparent. While we do not expect this to be the definitive book on Washington Native heritage, ethnology, or history, we do hope that this publication will provide a much needed contribution to the literature in the field.

Robin K. Wright is Curator of Native American Art at the Burke Museum, Assistant Professor of Art History at the University of Washington, and curator of "A Time of Gathering."

Women's Dress (detail). See plate 6

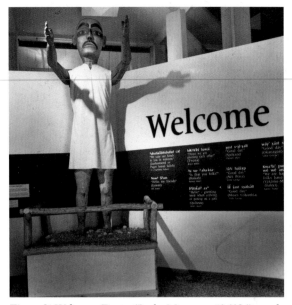

Figure 1. Welcome Figure (Burke Museum #1-1124), made by Charley Williams, Tla-o-qui-aht (Clayoquot), ca. 1930. Welcome Figure Head (replica, Burke Museum #R-198), made by Steve Brown, 1969. Photo by Mary Levin, neg. #8908568-17.

One hundred years ago they named our land. Washington State was what they named it. In the coming days this will be celebrated. Our honored ancestors will be remembered. Their ways and the way they lived will be remembered. The treasures they made with their hands will be borrowed from all over. And then everyone will see them when they come here to this place. The advisory board carefully selected a name for this exhibit. This is what they have named it. A Time of Gathering. This is very good. Because our honored people will gather along with their treasures. Then we may observe the ways of our ancestors. Possibly it will be the first time for individuals to observe this. We shall all celebrate this TIME OF GATHERING!

— Vi Hilbert (ṭaqʷšəblu), Upper Skagit elder

Figure 2. Vi Hilbert presented this speech on the occasion of the naming ceremony for the exhibit "A Time of Gathering" in November 1987.

II. A TIME OF GATHERING: THE PROCESS

To introduce "A Time of Gathering," a history of the development of the exhibit is coupled with a discussion of the exhibit itself. Both the exhibit and the book are the result of a lengthy process in which information about Native heritage in Washington was gathered from throughout the state, across the nation, and around the world. Though the goal of this process was the production of an exhibit held at the Burke Museum on the University of Washington campus during the state's centennial year, 1989, the benefits of the exhibit rest as much in the process undertaken to prepare the exhibit as in the final products, the exhibit and this exhibition catalogue.

"A Time of Gathering" was the largest and most complex exhibit the Burke Museum had undertaken. The process of bringing the exhibit to completion was a learning experience for all who were involved, and provided an unprecedented opportunity for cooperation between museums, tribal and state governmental agencies, and Native people throughout the state.

Conceived and partially funded by the Lasting Legacy Committee of the 1989 Washington Centennial Commission (see Adams, this volume), the exhibit grew in scope and content from its initial prospectus. When the Burke Museum was selected by the Lasting Legacy Committee in July of 1986 to host the centennial exhibit celebrating Washington Native heritage, an initial planning year began. Patricia Cosgrove, who developed the exhibit prospectus for the Lasting Legacy Committee, was hired as the exhibit manager. As the Curator of Native American Art at the Burke Museum, I became the exhibit curator.

In order to generate Native participation in the planning and implementation of the exhibit, we contacted people who could serve as Native advisors. Drawing from the University of Washington faculty, we consulted with Vi Hilbert, Upper Skagit elder, Lushootseed linguist, and instructor in the American Indian Studies Center. Knowing that the tribally run museums in the state were far better equipped than the Burke Museum to facilitate Native involvement, we looked to them for advice and assistance, meeting with several Native advisors on an individual basis during this first year. In April of 1987 several Native advisors, elders, and linguists were invited to the museum for a preliminary discussion of the exhibit content. This was the first of a series of such meetings. During this period the Washington Tribal Museums Association was formed, composed of many of the same museum professionals with whom we had been meeting on an individual basis. In June of 1987, a formal Native Advisory Board was formed of members of the Washington Tribal Museums Association and additional Native Advisors: Vivian

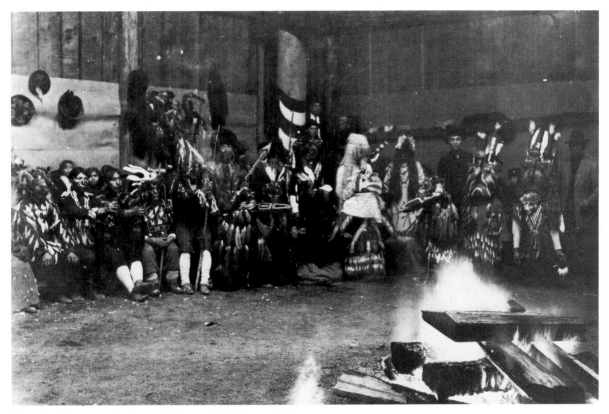

Figure 3. Dancers inside the smokehouse at Tulalip, ca. 1915.
Photo by H. C. Katterle, Sultan, Washington, courtesy of Vi Hilbert.

Adams, Greig Arnold, Linda Day, Leonard Forsman, Kaye Hale, Vi Hilbert, Charles Sigo, Nile Thompson (representing the Steilacoom Tribal Museum), and Agnes Tulee. We met on a monthly basis from June 1987 through the opening of the exhibit in April of 1989. These meetings were open to the public and, depending on the subjects to be discussed, included specific additional Native consultants. There were usually several additional observers and participants at these meetings.

During the initial planning year I conducted research in over thirty museums in the United States, Canada, and Europe in an effort to locate, study, and photograph objects from Washington that might be borrowed for the exhibit. Several thousand objects were photographed, and their collection histories investigated. This process generated a slide collection that allowed us to share information with our advisors, as decisions concerning the content of the exhibit were made. Also during the first year, the outline for the exhibit catalogue was developed, and contributing authors were contacted.

After the year of planning, the Lasting Legacy Committee provided the funds necessary to continue the project into the second and third years; substantial additional funding from federal and private sources was acquired for the implementation of the exhibit and publication of the exhibit catalogue. This

Your religion was written on tablets of stone by the iron finger of an angry God....Our religion is the tradition of our ancestors, the dreams of our old men given to them in the solemn hours of night by the Great Spirit...and it is written in the hearts of our people.

—Chief Seattle, Suquamish/Duwamish, 1854

In the 1880s, the federal government outlawed the practice of traditional Indian religions. Indian children were taken away from their elders and taught Christianity. To practice the traditional religions became a punishable crime, and old people were put in jail for teaching their children the ancestors' beliefs. But the dreams remained in their hearts. The elders spoke of the old ways in hushed tones behind closed doors, high up in the mountains or deep in the forests.

The traditional religions are expressed through song and dance and through direct communication with the Great Spirit. The traditional religions teach a respect for all things provided in the world by the Great Spirit. The traditional religions are the very life in all aspects of Indian people. In 1974 the American Indian Religious Freedom Act was passed by Congress. The Great Spirit and the traditional religions of the Indian people survived and continue to be taught by the elders to the youth, as was done by the ancestors.

The traditional religion of the Puget Sound tribes, Sqálalitute (Lushootseed language) or Seowyn (Halkomelem language), is practiced in a longhouse lit and heated by open fires. These gatherings are private, by invitation only. The Seowyn dancers will share only this glimpse of their spiritual world with you (fig. 3).

Figure 4.

17

funding allowed us to hire additional staff in the fall of 1987: Roberta Haines, a member of the Moses Band of the Wenatchee Tribe of the Colville Confederated Tribes, as Co-Curator; Cecile Maxwell, Chairwoman of the Duwamish Tribe, as Protocol Officer; and Greg Watson as Exhibit Associate.

At this stage, the exhibit still had no name, and had not yet taken on a distinctive personality. In October of 1987 we met with the Native Advisory Board to discuss the several names that had been suggested for the exhibit. The initial exhibit prospectus developed by the Lasting Legacy Committee had the working title of "Invisible Treasures." Another possible title, "To a Different Canoe," was found in a quoted message from Susie Sampson Peter, Skagit elder, to Ruth Shelton, Tulalip elder (see Hilbert, "To a Different Canoe," this volume). While I was particularly fond of this name, it proved difficult to explain. Several other names were discussed, but none seemed to be quite right. It was pointed out that some Native people in Washington might not wish to celebrate the state's centennial year, and that the name of the exhibit should describe what the exhibit would mean to Native people. The ensuing discussion, led by Greig Arnold and Vivian Adams, produced a name. The exhibit would be an occasion for the bringing together of objects that had been gone from the state for many years, and the coming together of people to see them and to see each other. In this way it would be like many gatherings attended by Native people in the state throughout the years—it would be "A Time of Gathering." The name had a spontaneous and instantaneous acceptance. To acknowledge this transition, an official naming ceremony was held in November of 1987. On that occasion Vi Hilbert offered an explanation of the name "A Time of Gathering" (fig. 2). From that point, the exhibit acquired a distinctive personality and took on a life of its own.

The next phase in the process of assembling "A Time of Gathering" involved reaching out to the Native people in the state to share information on the exhibit and invite their involvement. Cecile Maxwell, Protocol Officer, contacted the tribal governments in the state, provided them with information on the exhibit, and developed lines of communication with cultural contacts within each tribe. Roberta Haines, Co-curator, arranged for and accompanied me on a series of twenty-three outreach trips, giving slide shows at Native gatherings throughout the state. These presentations generally occurred at regularly scheduled elders' luncheons, although basketry classes, tribal council meetings, and specially arranged gatherings also were effective forums. These events, featuring slides of Washington State objects in museum collections, were designed to share information and to elicit suggestions on the

exhibit content. We sought advice on which objects should be exhibited and which, if any, would be inappropriate for exhibition, either for reasons of aesthetics or religious or spiritual privacy. Comments from many of the people who participated in these slide sessions and reacted to specific objects have been incorporated in the object labels and in the exhibition catalogue.

The sharing of slides and information at grass-roots gatherings resulted in the alteration and improvement of the content of the exhibit in response to the feelings of Native people in the state. Perhaps the most striking realization that I gained from this experience is the extent to which there has been a wide gap between the academic/museum/institutional world and the experience of Native people living both on reservations and in urban settings. At the time I began working on this project, most of my professional training had occurred within a traditional academic setting, and my research had been conducted in museums and libraries. Consequently, I had at my disposal a vast quantity of information of the type that has been recorded in museum archives and stored in museum vaults: what objects are in museum collections, when they arrived there, from whom they were acquired, and how they had been described by collectors or museum curators. However, this information does not reveal the meaning that these objects had for the original makers and still have for their descendants. The heart and soul of the objects remained with the original makers, the owners of the pieces, and their descendants. Many Native people in the state have never had the opportunity to see the objects that their ancestors made, yet they retain a deep feeling about them, and an understanding passed down to them from their grandparents. Through the slide show process we were able to begin to bridge this gap, and both archival and direct personal information was shared. In order to allow this process to happen, a great deal of time, patience, and persistence was required on the part of both the organizers and the Native participants. Opening up the curatorial decision-making process also required a willingness to relinquish preconceived ideas and predetermined plans in favor of new ones. Extensive outreach trips and flexibility in planning are luxuries not often possible in the preparation of museum exhibits, either for lack of time or funding, or for lack of motivation. We have been fortunate that the circumstances governing the preparation of this exhibit allowed us to devote an unprecedented amount of time to this process of consultation and revision.

A few examples of how the content of the exhibit was altered as a result of information obtained through outreach trips and input from the Native Advisory Board will reveal something of how this

Figure 5. Cedar Plank Shed-Roof House made by Lance Wilkie. Photo by Robin K. Wright.

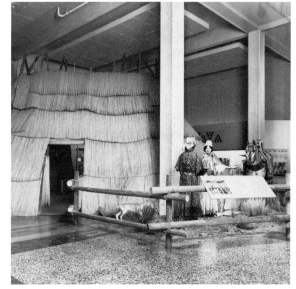

Figure 6. Tule Mat Winter Lodge made by James Selam with Delsie Selam and Sarah Quaempts. Photo by Mary Levin, neg. #8904569-4.

process worked. At the first meeting of Native advisors at the Burke Museum in April 1987, Martin Louie, a Colville elder, asked if we intended to include a sweat lodge in the exhibit. When we told him that we had not yet considered that possiblity, he rose and spoke very eloquently about the importance of Sweatlodge to the Plateau people and why it should be included in the exhibit (see Louie, this volume). He ended by offering to make a sweat lodge as a gift to the exhibit, and we accepted his offer. Nearly a year later, we learned that some Colville people opposed the inclusion of the sweat lodge on the grounds that it was a private and personal religious experience, and not appropriate for public display. The Native Advisory Board recommended that the decision be left to the Colville Cultural Resources Board. Rodney Cawston, Archivist for the Colville Confederated Tribes, facilitated a discussion of this issue among Colville tribal members and the Colville Cultural Resources Board, chaired by Mathew Dick, Jr. The board concluded that they would not oppose the right of Martin Louie to make a gift of this sweat lodge to the exhibit, and asked that they be allowed to approve any accompanying label copy. With the agreement that this would be done, the Native Advisory Board recommended that the sweat lodge be included in the exhibit.

In a similar fashion, a number of objects that we had originally thought to include in the exhibit were eventually excluded. We wanted to include as many objects as possible that were known to have belonged to specific individuals. Housed in the Otago Museum in Dunedin, New Zealand, are a man's coat, a pair of gauntlets, a woman's dress, and pair of moccasins,

said to have belonged to Chief Moses and his family (Harsant 1988: figs. 1, 3, 4, 7; Duncan, fig. 3, this volume). We were aware that Chief Moses' grave had been robbed in 1904, five years after his death, and were concerned about the possibility that the Otago Museum's Moses objects may have come from this grave (Ruby and Brown 1987). The objects came to the museum in 1939 from the collection of Sir Percy P. R. Sargood, who had acquired them in Portland after their display at the Lewis and Clark Centennial Exposition in 1905. This date, only a year after the theft, supports the likelihood that the pieces were from the grave. However, the gauntlets are said to have been sold by Chief Moses to Chris Miller, a north Yakima storekeeper, in 1898, shortly before Moses' death. Ruby and Brown concluded that an eagle feather fan in the collection, in relatively poor condition, may have come from the grave, but that the coat shows no sign of the mildew that would have appeared if it had been buried for five years. They also point out that this coat is small in size, and would not have fit Moses at the time of his death.

During an outreach trip to Nespelem, Adeline Fredin, Director of the History/Archaeology Department of the Colville Confederated Tribes, assisted us in contacting direct descendants of Chief Moses. We were able to show slides of the Moses pieces and discuss the circumstances of the robbery of the grave, and the evidence, or lack of it, that could document the exact circumstances of the acquisition of the Moses objects in the Otago Museum. We also discussed this issue with a larger group at an elders' luncheon. While some expressed the wish to see the objects brought back, one member of the family

expressed the opinion that because the desecration of the grave was so offensive, the mere possibility that any of these objects might have been from the grave meant that none of them should be included in the exhibit. The Native Advisory Board concluded that, out of respect for Chief Moses and his family, these objects should not be included in the exhibit.

In a similar manner, many other controversial issues were discussed during the outreach sessions and later with the Native Advisory Board. It was concluded that objects used in ongoing Coast Salish religious practices (Sqálalitute/Seowyn) as well as some historical religious objects, such as Spirit Canoe figures, should be excluded, while historical photographs of dancers posed in their ceremonial costumes (fig. 3), taken with their consent, and presented along with information about this religion written by a participant, would be incorporated in the exhibit (fig. 4).

Though contemporary art and culture were not included in the initial exhibit prospectus, from the very first discussions with Native advisors it was clear that these should be an essential component of the exhibit. Contemporary art would be exhibited alongside historical pieces in the Masterpiece Gallery, and information on the contemporary tribal governments in the state would be presented in an introductory zone. The Native Advisory Board was also particularly forceful in urging the incorporation of historical information from the late nineteenth and early twentieth centuries. They asked that we include explanations of the devastating impact of introduced diseases, Euro-American religions, government, forced education in boarding schools, and economic factors that have changed the lives of Native people in Washington.

Both the process of consulting with Native advisors and the final content of the exhibit represent a sharing of information. This catalogue is intended to continue that process. We aspire to combine here, in a single source, images of the works of art that have been loaned from museums and private collections, information on their collection history, contributions by Native and non-Native scholars on a variety of issues that represent the diversity of Native heritage, and some of the heart and soul that has been shared with us from the Native people in Washington.

III. A TIME OF GATHERING: THE EXHIBIT

The purpose of the exhibit "A Time of Gathering: Native Heritage in Washington State" was to present an accurate picture of both the traditional nineteenth-century lifestyles in eastern and western Washington and the vitality and diversity of the living cultures. To accomplish this, the exhibit was divided into four sections that utilized three different exhibit styles. An Intertribal Welcome area greeted the visitor with panels presenting information from thirty-five tribes in the state. This area featured the tribal names and logos on banners positioned above text panels with historical photographs and maps.

Beyond the welcome area, eastern and western Washington areas used another exhibit style that recreated historical environments. In these two areas there were historical houses, furnished in the 1889 style, which could be entered and experienced. The western Washington cedar plank house was built by Makah carver Lance Wilkie (fig. 5). The eastern Washington tule mat lodge was constructed by James Selam, Delsie Selam, Sarah Quaempts, and their family, members of the Yakima Confederated Tribes (fig. 6). Also in these two areas were scenes that used mannequins in historical dress positioned in naturalistic settings, some with projected historical photographs as backdrops. The western Washington area included a beach scene with a 24-foot Quileute sealing canoe being loaded by a family in preparation for attending a potlatch, and a 24-foot Sauk-Suiattle shovel nose canoe, made by Jackson Harvey in the 1920s for use in the cedar shake-bolt industry. The eastern Washington area had a scene of a dip-net fisherman on a platform above Celilo Falls, a scene with two women loading a horse in preparation for attending a wedding celebration, and a morning scene with a sweat lodge made by Martin Louie, Sr. of the Colville Confederated tribes (see Louie, this volume). In addition, objects displayed in cases in the eastern and western Washington areas presented information on basketry, skin and beadwork technologies, hunting, fishing and trade. Information on both the individual objects and a variety of historical issues such as First Foods ceremonies, changing economies, and forced attendance at boarding schools, was presented in the form of labels and historical photographs incorporated on the text panels.

A Masterpiece Gallery, designed in the style of a fine art gallery, separated the two historical environments at the back of the museum and displayed one hundred works of art ranging from prehistoric stone and bone sculpture to specially commissioned contemporary pieces. Each work of art was accompanied by a full label with collection information, an object description and, in some cases, interpretive comments by Native people (see Wright, Masterworks of Washington Native Art, this volume). The following sections will discuss from a curator's point of view some of the information the visitor encountered in the Welcome and the eastern and western Washington areas.

THE WELCOME

A monumental human figure, with outstretched arms, gestured welcome to arriving visitors (fig. 1).

Such large, standing human figures were erected by high-ranking families on the coasts of Washington and Vancouver Island. They were often placed in front of the village, facing the beach, to welcome arriving guests. The figure that welcomed guests to "A Time of Gathering," however, was always displayed inside a house at Neah Bay. It, along with several other carvings, was given by Annie Williams, the daughter of Atliyu (ʔeˑɫyuˑ), a Tla-o-qui-aht (Clayoquot) chief, to Charlie Swan, a Makah chief from Neah Bay, at a potlatch held at Clayoquot in December of 1930, when he was made her heir. The mechanical arms could be raised and lowered. The figure's feet were attached to a wheel that could be turned, and the figure could be made to pivot counterclockwise, the same ceremonial turn made by Makah dancers as they enter and exit a house. Based on the recollections of Helma Ward, Charlie Swan's daughter, this figure once wore a tunic, perhaps of cedar bark or cattail leaves (Helma Ward, pers. comm., 1989). This is supported by the evidence that the figure is painted on the head, neck, and lower legs; the upper thighs and torso are unpainted and more roughly carved. To simulate its original appearance, a cloth tunic was made for the figure that approximates the cut and shape of a cedar bark or cattail tunic. The welcome figure was flanked by words of welcome in ten Native languages (fig. 7).

Central to the goal of the exhibit was the importance of presenting an accurate account of the contemporary tribes. Each tribe was invited to develop its own display panel. Thirty-five tribes were included: twenty-five federally recognized tribes and ten tribes that are currently seeking federal recognition (see fig. 11 and Appendix I). All of the tribes that cooperated in this effort supplied us with text copy as well as the photographs that were included on the panels (Haines and Wright 1990). Each tribe focused on different issues, ranging from historical accounts of important tribal members, through current economic enterprises, fisheries, museums, and tourism, to the struggle for federal recognition. Located to either side of the Welcome Figure at the entrance to the exhibit, the tribal panels communicated immediately to the visitor the diversity and vitality of the tribes in the state, and complemented the portions of the exhibit that focused on historical issues (fig. 8).

TRIBAL LOCATIONS AND LANGUAGES

After leaving the Welcome area, the visitor encountered a large map featuring the names and approximate locations of many of the tribes that inhabited in the early nineteenth century what is now Washington State (fig. 9). Because Native people lived along waterways—freshwater rivers and lakes, saltwater sounds and shores—they gave directions in

WELCOME

These ten Native language greetings and their English translations were gathered by Greg Watson from several Native language speakers throughout the state. The greetings are rendered in a linguistic alphabet (see Hunn, note 2; and Hilbert, note 1, this volume), with a phonetic spelling in parentheses to suggest their approximate pronunciations.

Nowʔ Siʔam (now- see-ahm)
"Hello, my friends."
Lummi, Bill James

ʔubutlačibitubuɫəd cəɫ (-oo-boot-lah-chee-too-boo-thluhd chethl)
"We raise our hands to you in welcome."
Lushootseed, Vi Hilbert (taqʷšəblu)

ʔu xuˑʔaƛaˑksaˑ (-oo qhooo-ah-tklah-ksah)
"Is that you folks?"
Makah, Helma Ward

t'íl' x̱ə'st sx̱əlx̱ə'lt (til- qhuhst sqhuhl-qhuhlt)
"Good Day."
Moses Columbia, Tillie George

táʔc haláx̱p (ta-ts hahl-aqhp)
"Good Day."
Nez Perce, Tillie George

wáy' x̱ást sx̱əlx̱áʔlt (way-qhahst sqhuhl-qhalt)
"Good day."
Okanagan, Tillie George

liʔátskalʔ ax̱ʷ (lee-aht-skal- axwh)
"Hello."—greeting used when arriving or passing on a path
Quileute, James Jaime

x̱est sʔx̱lʔx̱alt (qhuhst s-qhl-qhahlt)
"Good Day."
Spokane, Pauline Flett

biKWihi tuwəl (bee-kwee-hee too-wuhl)
"(Now) we are praising each other."
Twana, Bruce Miller

Kwa'ɫa' pum íche wé wé anáuwe (kwah-thlah puhm ee-chay way way an-now-way)
"We are happy you folks have come."
Yakima, Mamachet dialect, Agnes Tulee

Figure 7.

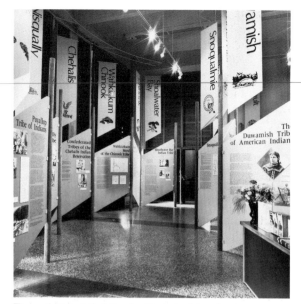

Figure 8. Intertribal Panels. Photo by Mary Levin, neg. #8908567-4.

relation to the flow of water: up is upstream or inland, and down is downstream or away from the land. Native people and early settlers probably viewed this vast land as divided along natural boundaries rather than political borders.

While many of the waterways in Washington still bear the names of their original inhabitants, the names of other people who lived here have been lost, as entire families, villages, and tribes perished in the late eighteenth- and nineteenth centuries from diseases introduced by Europeans and Euro-Americans. The names on this map represent only a portion of the peoples who originally lived here.

Traditionally, Native people named and identified themselves as part of their family or household and of the village or band with whom they lived. It is only in later times that anthropologists and linguists have identified Native people according to their languages. Languages are forms of speech so different that speakers of one cannot understand speakers of another. Dialects are slightly different forms of a given language. Related languages, those that have a common origin, form language families (Suttles 1985). Twenty-four Native languages were spoken here (fig. 10), but differences in language were not seen as a barrier to social relationships and cultural sharing. Many Native people spoke more than one language, and neighboring people intermarried despite language differences. During the late nineteenth- and early twentieth centuries, Native people were not allowed to speak their own languages in the schools that they were forced to attend. This resulted in the loss of many languages and dialects. Today, Native people treasure the few remaining native language speakers who now teach their children.

The eastern and western environments were located at opposite sides of the exhibit, separated by a clerestory opening in the middle, and connected by the Masterpiece Gallery at the back and the Intertribal Welcome Panels at the front. This arrangement simulated the geography of Washington, divided by mountains, but connected by river valleys.

While the two major language families in Washington, Salishan and Sahaptian, divide the Native peoples of the state into northern and southern groups, the natural environment is dominated by the Cascade Mountains, a range that divides the state into environmentally different eastern and western regions. Ethnographically, the western coastal tribes generally are lumped with the more northern Northwest Coast tribes due to their common cultural features: economic dependence on marine resources, travel by canoe, permanent winter villages, cedar plank architecture, hierarchical social structure based on the accumulation and control of wealth, and the development of elaborate ceremonial and religious systems that reinforce this social system. In a similar manner, the Native peoples of eastern Washington are usually included in the greater Plateau or Intermontane culture area bordered by the Plains to the east, the Great Basin to the south, and the Western Subarctic cultural area to the north. Their cultural similarities include a nomadic hunting, fishing, and gathering lifestyle; mat-covered pole-frame and semi-subterranean architecture; a pacifistic and egalitarian social structure organized by bands or small village clusters; and a religious system centered around personal spirit helpers and the celebration of First Foods ceremonies. The horse, after its arrival on the Plateau in the early eighteenth century, was important in similar ways for the Plateau, Great Basin, and Plains tribes.

This east/west cultural division, however, is an oversimplification of a complex cultural situation. Linguistic evidence linking eastern and western Washington tribes is only one of the many elements that draw the two halves of the state together. The two major river drainages—the Columbia River in the south, and the Fraser River in the north—as well as several overland mountain passes, were routes of trade and travel that linked the peoples on two sides of the mountains. Similarities in cultural traits shared between east and west include the importance of salmon-fishing and root-gathering as major sources of food; the importance of gift-giving at ceremonial times, First Foods ceremonies; a relatively egalitarian social ranking compared with more northern or eastern systems; leisure activities, particularly gambling games; shamanism and the acquisition of personal spirit helpers; a winter ceremonial season during

which extended families lived together in larger structures; and seasonal rounds to utilize spring, summer, and fall fishing, hunting, and gathering sites.

The works of art produced by Native peoples in the state reflect this complex interrelationship of similarities and differences between east and west. Different environments result in the use of different raw materials. Cedar bark and mountain goat wool clothing and textiles, carved wooden house posts and cedar plank houses all characterize the art of western Washington. They are directly related to the availability of their component materials and to the environments in which they were made. Likewise, buckskin clothing and tule mat architecture are the products of available materials and the environment in eastern Washington. Despite the differences of materials and environments, remarkable similarities in artistic traditions exist between the east and west, particularly in basketry techniques. Coiled cedar root baskets, decorated with beargrass and cedar bark imbrication in zigzag patterns, are found on both sides of the mountains. Only the subtle differences in shape and detail separate the flaring cylindrical coiled baskets made by Yakima, Klickitat, Cowlitz, Nisqually, and Puyallup basketmakers (pls. 30–34). The rectangular coiled baskets produced by Fraser River, Thompson River, and Okanogan basketmakers of the north show more similarities in form and design to each other than to their southern neighbors on either side of the mountains (see Miller, this volume). Similar twined basketry techniques are also found on both sides of the mountains (pls. 28, 29, 35–37).

These similarities reflect the extensive contacts made through trade and travel between Native people in eastern and western Washington. Certainly, the movement of treasured objects among different tribes can be well documented. Dentalium shells, harvested off the west coast of Vancouver Island, were used as a form of currency and as decoration on clothing and jewelry in both eastern and western Washington. They were traded extensively beyond this region. The elaborately carved mountain sheep horn bowls and spoons produced in an area centered on Celilo Falls and The Dalles were traded throughout the state and treasured as family heirlooms by many tribal groups (pls. 48, 49, 56, 57). Chief Seattle owned a Plateau cornhusk bag (Burke Museum #2–1448), and Jerry Kanim, a Snoqualmie leader, owned a Yakima beaded bag (pl. 24). Native people in the state also treasured works of art made by Native people from outside the area. Red pipestone (catlinite) pipes and beaded pipe bags (Burke Museum #2–453a, b, c) made by Sioux artists in the Plains were valued ceremonial possessions of Native leaders in Washington.

The arrival of Euro-American explorers, traders, missionaries, and settlers in the nineteenth century brought an additional link between east and west in the cultural experience of Native people in the state. Introduced wealth in the form of trade goods had an initial positive impact. Metal, glass beads, and trade cloth were incorporated into the art, tools, clothing, and economy in both the east and west. Cultural sharing with non-Euro-American foreigners was also experienced during this period. Polynesian people who worked for fur-trading companies settled in the state in the nineteenth century and brought their material goods with them (Ivory 1985). Simultaneously, however, devastating epidemics of small pox and measles swept through and depleted Native populations, often even before there was direct contact with the Euro-Americans who brought them. Native people in both eastern and western areas had to deal with the subsequent arrival of missionaries who sought to suppress Native religions and convert people to Christianity, as well as government agents who imposed treaties on Native tribes, reducing or removing their homelands, and forcing their removal to foreign locations.

TRIBAL GOVERNMENTS AND THE UNITED STATES GOVERNMENT

Upon exiting the eastern Washington historical area, visitors could view the slide show "Waterborne" (see Oliver, this volume), or continue on to the eastern Washington Intertribal Welcome Panels in the foyer. These tribal panels concluded with information on the history of reservations in Washington and relations between tribal governments and the federal government (figs. 11, 12).

In 1854 and 1855, tribal leaders throughout the state were forced to cede 64 million acres in a series of six treaties. On the surface the treaties provided a compromise. Tribal peoples were to be safe from encroachment and attack on the lands reserved to them. They secured their rights to education, health care, fishing, and hunting. However, the treaties signed in 1855 did not become law for four years and many assurances to the tribes were ignored.

Some of the reservations were established by Executive Order (fig. 11). After the series of treaties in 1854–55, Congress made a decision to stop treaty negotiations with the tribes. There remained several tribes occupying lands not addressed by the treaties. Their leaders negotiated land exchange and reserved areas through United States government representatives, and the succeeding presidents issued orders to legally seal the exchanges. The Colville and Moses reservations are examples of reservations created by Executive Order. They were soon reduced in size, however. The originally designated Colville Reservation was relocated the same year it was established, and then reduced by half twenty years later.

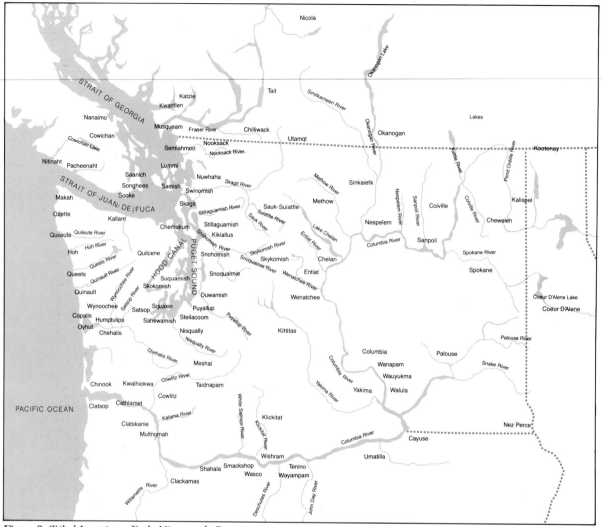

Figure 9. Tribal Locations, Early Nineteenth Century.
Derived from Suttles' language map (Suttles 1985).

The Dawes Act of 1887, commonly known as the Allotment Act, required that reservation lands be divided, and that each tribal member be assigned or allotted a parcel. The remaining land could then be claimed by the United States government and be made available for homestead to settlers. The Colville Reservation reduction in 1892 is a result of the Dawes Act. The adjacent Moses Reservation did not survive even seven years. The people living in these "terminated" areas were forced to move to progressively smaller areas and to adjust to cultures and people that were very different from their own. Many questions of land ownership and related rights, some guaranteed by treaty, continue to arise today.

In the decades following the signing of treaties in 1855, the United States government discouraged the traditional lifestyles of Native people and tried to replace them with those of Euro-American society by encouraging farming and ownership of private land. Education for Native children became obligatory in 1893. From the 1880s through the 1920s many young people in Washington were separated from their families and sent to boarding schools near Everett and Tacoma or as far away as Pennsylvania and California. Traditional languages, hairstyles, and clothing were forbidden, and students took up the task of learning to read and write in the foreign English language.

Despite governmental efforts to promote farming on reservations, many Native people maintained their hunting and fishing lifestyles into the twentieth century. Native men and women also played a significant role in the local labor force by marketing fish and shellfish; by working in logging camps, sawmills, hopfields, and shipyards; and by participating in the war effort during the two world wars. The developing urban centers drew many Native people away from reservations. These people needed to supplement their incomes as fisheries and forest resources became increasingly depleted. Endangered species today,

LANGUAGES WITH NO RECOGNIZED PHYLUM

Chimakuan Language Family

Chemakum language
Chemakum
Quileute language
Quileute
Hoh

Salishan Language Family

Coeur D'Alene language
Coeur D'Alene
Columbian language
Chelan
Columbia
Entiat
Methow
Wenatchee
Cowlitz language
Cowlitz
Halkomelem language
Chilliwack
Cowichan
Katzie
Kwantlen
Musqueam
Nanaimo
Tait
Kalispel language
Cheweleh
Kalispel
Spokane
Lower Chehalis language
Chehalis
Humptulips
Wynoochee
Lushootseed language
Duwamish
Kikiallus
Muckleshoot
Nisqually
Nuwhaha
Puyallup
Sahehwamish
Sauk-Suiattle
Skagit
Skykomish
Snohomish
Snoqualmie
Squaxin
Steilacoom
Stillaguamish
Suquamish
Swinomish
Nooksak language
Nooksack
Okanagan language
Colville
Lakes
Nespelem
Okanagan
Sanpoil
Sinkaietk
Quinault language
Copalis
Oyhut
Queets
Quinault
Straits language
Klallam
Lummi
Saanich
Samish
Semiahmoo
Songhees
Sooke
Thompson language
Utamqt
Twana language
Quilcene
Skokomish
Twana
Upper Chehalis language
Satsop

Wakashan Language Family

Makah language
Makah
Ozette

PENUTIAN LANGUAGES
Chinookian Language Family

Cathlamet language
Cathlamet
Kiksht language
Clackamas
Multnomah
Shahala
Smacksop
Wasco
Wishram
Lower Chinook language
Chinook
Clatsop

Maidu Language Family

Cayuse language
Cayuse

Sahaptian Family

Nez Perce language
Nez Perce
Sahaptin language
Kittitas
Klickitat
Meshal
Palouse
Taidnapam
Tenino
Umatilla
Walula
Wanapam
Wauyukma
Wayampam
Yakima

NĀ-DENE LANGUAGES
Athapaskan Language Family

Lower Columbia Athapaskan language
Clatskanie
Kwalhiokwa
Nicola language
Nicola

Figure 10.

TRIBAL LANDS AND RESERVATIONS IN WASHINGTON

Abbreviated Tribal Name	Size of Tribal Land or Reservation	Treaty or Instrument
Chehalis	4,215 acres	Executive Order, 1886
Colville	1.4 million acres	Executive Order, 1872
Elwha Klallam	443 acres	Indian Reorganization Act, 1934
Hoh	443 acres	Executive Order, 1893; based on Treaty of Quinault, 1855
Jamestown Klallam	210 acres	Trust land, purchased 1874
Kalispel	4,600 acres	Executive Order, 1914
Lummi	13,500 acres	Executive Order, 1855
Makah	44 square miles	Makah Treaty, 1855; after 1974 includes administration of Ozette Reservation (one acre)
Moses Columbia	Terminated	Executive Order, 1879; terminated 1886
Muckleshoot	3,600 acres	Executive Order, 1874, based on Treaty of Point Elliott, 1855
Nisqually	5,000 acres	Executive Order, 1857
Nooksack	2,062 acres	Federally recognized, 1973
Port Gamble Klallam	1,301 acres	Federal land trust, 1935
Puyallup	18,061.5 acres	Treaty of Medicine Creek, 1855
Quileute	one square mile	Executive Order, 1889
Quinault	196,645 acres	Executive Order, 1873, based on Quinault Treaty, 1855
Sauk-Suiattle	23 acres	Purchase, 1982
Shoalwater Bay	one sq. mile + tidelands	Executive Order, 1886
Skokomish	4,987 acres	Treaty of Point-No-Point, 1855
Spokane	155,000 acres	Executive Order, 1881
Squaxin Island	2,175 acres	Treaty of Medicine Creek, 1854
Stillaguamish	60 acres	Actual acreage of "reserved" status is pending
Suquamish	7,800 acres	Treaty of Point Elliott, 1855; enlarged by Executive Order, 1864
Swinomish	10 square miles	Treaty of Point Elliott, 1855
Tulalip	22,000 acres	Treaty of Point Elliott, 1855
Upper Skagit	130 acres	Executive Order, 1974
Yakima	1.4 million acres	Yakima Treaty, 1855

Treaties

Makah Treaty, 1855
Treaty of Medicine Creek, 1854
Treaty of Olympia, also known as the Treaty of Quinault, 1855
Treaty of Point Elliott, 1855
Treaty of Point-No-Point, 1855
Yakima Treaty, 1855

Landless Tribes Seeking Federal Recognition

Chinook
Cowlitz
Duwamish
Marietta Nooksack
Mitchell Bay
Samish
Snohomish
Snoqualmie
Steilacoom
Wahkiakum Chinook

Figure 11.

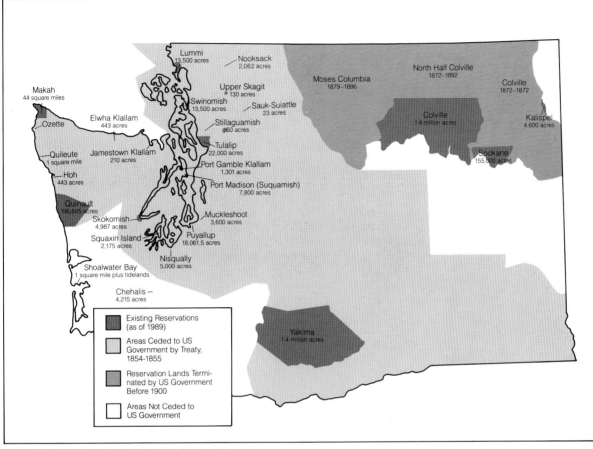

Within the map:

Makah
44 square miles

Ozette

Elwha Klallam
443 acres

Quileute
1 square mile

Jamestown Klallam
210 acres

Hoh
443 acres

Quinault
196,645 acres

Skokomish
4,987 acres

Squaxin Island
2,175 acres

Shoalwater Bay
1 square mile plus tidelands

Chehalis —
4,215 acres

Lummi
13,500 acres

Nooksack
2,062 acres

Upper Skagit
130 acres

Swinomish
13,500 acres

Sauk-Suiattle
23 acres

Stillaguamish
60 acres

Tulalip
22,000 acres

Port Gamble Klallam
1,301 acres

Port Madison (Suquamish)
7,800 acres

Muckleshoot
3,600 acres

Puyallup
18,061.5 acres

Nisqually
5,000 acres

Moses Columbia
1879–1886

North Half Colville
1872–1892

Colville
1872–1872

Colville
1.4 million acres

Kalispel
4,600 acres

Spokane
155,000 acres

Yakima
1.4 million acres

Legend:

Existing Reservations
(as of 1989)

Areas Ceded to US
Government by Treaty,
1854-1855

Reservation Lands Terminated by US Government
Before 1900

Areas Not Ceded to
US Government

Figure 12. Tribal Lands and the United States Government.
Derived from map prepared by Judy Stanley for the Seattle Times.

whales and other sea mammals are no longer hunted by Native people in Washington. Stringent regulations have limited other kinds of fishing activity, as well, and permanent fishing agreements are still being negotiated. Significant numbers of Native people in Washington still earn their living through the management of fisheries and other marine resources.

Subjected to similar circumstances related to contact with Euro-American government, economy, and culture, Native people in Washington share a cultural bond with each other as well as with other Native communities throughout North America. The strong forces of acculturation, however, have not succeeded in erasing all elements of cultural diversity among Native people in the state. On the contrary, much of the cultural heritage that has come to them from their ancestors has been retained and maintained. Bonded by their common experience, yet separated by their history, environment, and ancestry, Native Americans in the state of Washington are proud of their diversity.

REFERENCES

Haines, Roberta, and Robin K. Wright. 1990. *A Time of Gathering—An Intertribal Welcome: Statements from 36 Washington Tribes.* Seattle: Burke Museum Publications, University of Washington.

Harsant, Wendy J. 1988. The Otago Museum, Dunedin, New Zealand: The North American Indian Collection. *American Indian Art Magazine* 13(2): 38–45.

Ivory, Carol S. 1985. Northwest Coast Uses of Polynesian Art. *American Indian Culture and Research Journal* 9(4): 49–66.

Ruby, Robert H., and John A. Brown. 1987. In Search of Chief Moses's Lost Possessions. *Columbia: The Magazine of Northwest History* 1(3): 21–28.

Suttles, Wayne. 1985. *Native Languages of the Northwest Coast* (map). Portland: Western Imprints, the press of the Oregon Historical Society.

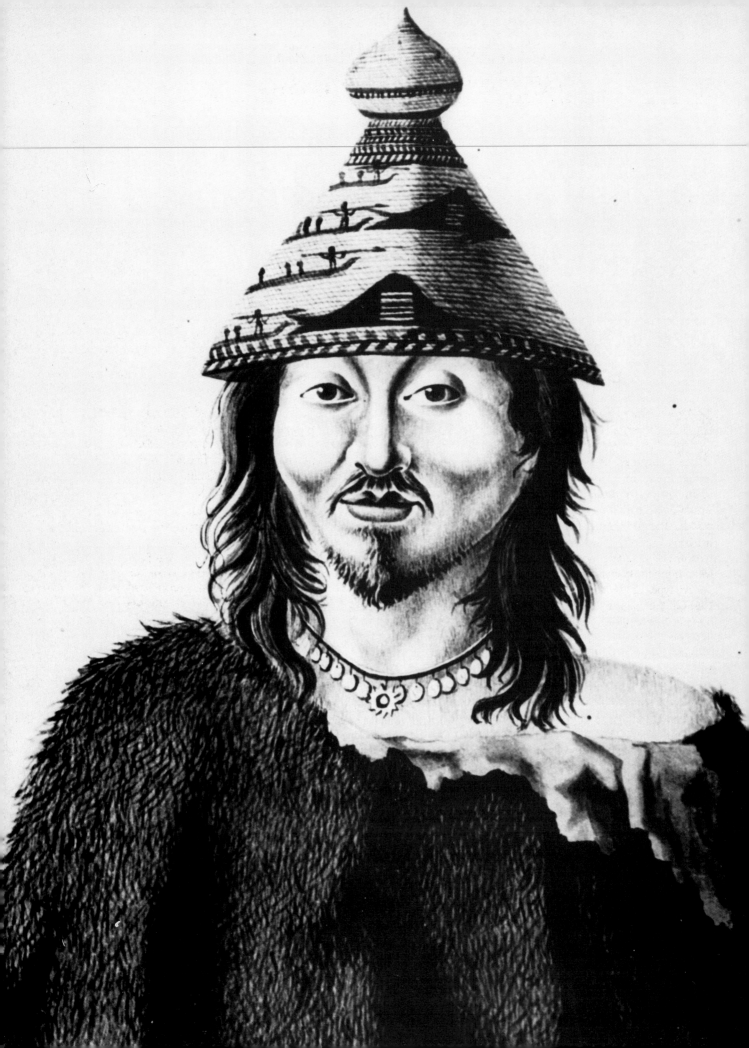

A COLLECTION HISTORY: WASHINGTON NATIVE ART

Robin K. Wright

Since the earliest years of Native contact with Europeans and Euro-Americans, the art and other material objects of the Native people in what is now Washington State have been dispersed around the globe. These artifacts are housed in museums and private collections across North America, in Europe, and throughout the rest of the world. Much of the story of this dispersal of materials has been lost forever due to missing or incomplete records of the transactions through which the objects were acquired. Because of the limited availability of certain types of objects, the personal interests or biases of the collectors, and the accidents of fate that preserved certain collections while others were lost or destroyed, the surviving collections present a skewed record of the cultures that produced them. Nevertheless, much can be learned from the documentation associated with objects that survive in museums. Understanding the circumstances that led to their preservation can help us to know the extent to which the existing collections may or may not accurately represent the Native cultures in Washington.

The earliest European expedition to make contact with the Native people in Washington was that of Capt. Bruno Heceta sailing on the Spanish exploring ship *Santiago* in July of 1775. The frigate *Santiago* had sailed to the Northwest Coast the previous year under Juan Perez. Perez made contact with Native people on only the Queen Charlotte Islands and the west coast of Vancouver Island, and did not land at either of those places (Sierra 1930: 5).

Heceta was accompanied on part of his voyage by Juan Francisco de la Bodega y Quadra on the schooner *Sonora*. On July 14, 1775, Heceta entered a small inlet which he named Rada de Bucareli (now Point Grenville). According to Fra. Benito de la Sierra, a Franciscan chaplain on board:

At six in the morning a canoe with nine Indians approached the Frigate, making gestures of friendship, and inviting us to go to their settlement, but although we invited them to come on board and threw them ropes for the purpose they refused to do so. They carried no bows or arrows and all we saw in the canoe was a large almost new machete. They gave us some fish and exchanged some otter skins with the sailors. At the same hour, more or less, the Commandant, I, the pilot and the surgeon and twenty armed men went in the launch to take possession of the land, which was done without opposition but with the greatest possible haste and without mass being said, because the weather and the position of the Frigate did not admit of any delay. We did not come across any people, with the exception of six grown boys on the beach who were looking for shellfish and eating, unarmed, and who invited us to go where they were roasting the fish, but the Commandant would not allow any of our people to join them, and when they came over to us offering to share the fish they had caught, to avoid delay he declined their offer. About seven we returned on board. At noon an observation was taken which showed the position of the roadstead to be 47° 25' N. The name of "Rada de Bucareli" was given to it (Sierra 1930: 29).

Later, the schooner *Sonora*, anchored off Point Grenville near the mouth of the Quinault River, had a less peaceful encounter with the Native people. Initially the crew members traded peacefully with the Indians, who brought fish and whale meat to the schooner to exchange for "trifles." But when the Spanish sent seven men ashore in a longboat to get

Figure 1. Portrait of Chief Tetacus (Tatoosh), drawn by José Cardero in 1792. Photograph by John Fraser Henry, courtesy of the Oregon Historical Society and the Museo de America.

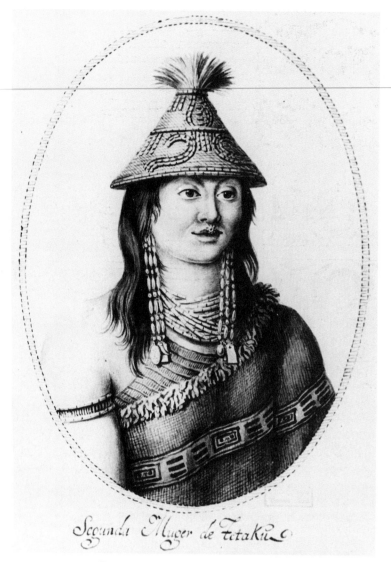

Segunda Muger de Tetakiu̱

Figure 2. Portrait of Chief Tetacus' second wife, drawn by José Cardero in 1792. Photograph by John Fraser Henry, courtesy of the Oregon Historical Society and the Museo de America.

water and cut a topmast, the party was attacked. Five were killed, and the other two drowned while trying to swim to the ship. The longboat was dismantled by the Indians, and all of the iron fittings were salvaged. Nine canoes then approached the ship. While their passengers appeared to be friendly, they were observed to be stringing their bows and putting on their armor. The crew of the schooner enticed the canoes within range of their guns by holding up glass beads. When the canoes came close enough, the Spaniards opened fire and killed seven of the nine aboard the nearest one. Shortly afterward, the two Spanish ships separated, the *Sonora* continuing north and the *Santiago* turning south to the mouth of the Columbia River, which Heceta named Rio San Roque (Sierra 1930: 29).

The record of this unfortunate encounter provides us with interesting descriptions of the clothing and equipment used by the Quinault people at this time. The details of the women's skirts and men's fur robes are consistent with those of garments described and collected in later years. Leather armor is also described in some detail:

They use in fighting some skins as well tanned and as white as those worn by our soldiers, shaped like cloaks which cover them down to their feet, on which they paint reproductions of the skulls of their victims as emblems of their prowess (Sierra 1930: 30).

Heavy skin armor such as this has been collected from areas further north on the coast, but none collected in Washington is now known.[1]

The first canoe encountered by Heceta, as noted above, had a "large almost new machete," and the women were described as wearing copper rings in their pierced noses (Sierra 1930: 30). Since this was the first direct contact between Europeans and Native people of this area, the copper and the machete must have been acquired indirectly, either through the salvage of Japanese junks that had drifted with the Pacific currents or by means of Native trade routes (Quimby 1985). This supports other evidence that iron and other metals had been in use on the Northwest Coast since well before direct contact with European sources.

The entrance to the Strait of Juan de Fuca was not discovered by European explorers until twelve years after this first contact. In 1778, Capt. James Cook sailed past and named Cape Flattery at the northwest tip of Washington State. However, due to the bad weather, he failed to notice the opening of the Strait of Juan de Fuca and continued north to Nootka Sound. In 1787, Capt. Charles Barkley of the British fur-trading ship *Imperial Eagle* observed and named the Strait of Juan de Fuca, contradicting Captain Cook's denial that such a body of water existed (Wagner 1933: 3).

Figure 3. Front and back designs, wooden comb collected by Hewitt, Museum of Mankind, British Museum VAN219, collected by George Hewitt at Restoration Point, 1792. Drawings by Robin K. Wright.

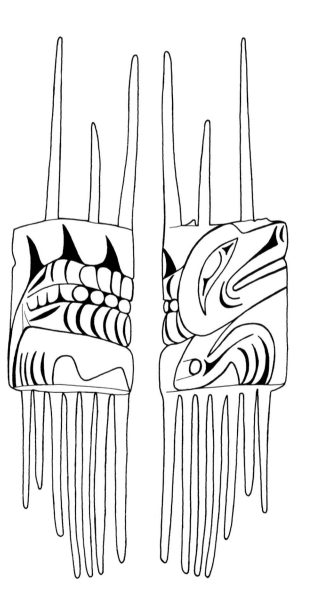

Figure 4. Front and back designs, wooden comb, Ozette Village, Makah Cultural and Research Center. Drawings by Robin K. Wright.

British and American fur-trading vessels worked these coastal waters during the next few years, including those of Meares, Duncan, Gray, and Kendrick; several Spanish vessels continued their explorations. Although we believe that the early Spanish explorers and Boston fur traders must have collected artifacts from the people of western Washington in the late eighteenth century, none of these objects has yet been identified in museum collections. Research on collections in Spanish museums is currently being conducted, and it is possible that some pieces from Washington may eventually be identified among the early Spanish collections (Cabello 1989).

In 1790, Manuel Quimper, a Spanish sub-lieutenant in command of a captured British ship, *Princesa Real*, sailed into the Strait of Juan de Fuca to the San Juan Islands and the area around New Dungeness on the southern shore of the strait. Quimper's journal for July 5 records that many Indian canoes came out to trade a variety of fish and shellfish for cask hoops. He presented the principal chiefs with some pieces of copper as a sign of friendship, and reports that the Indians also traded reed mats, "white painted woolen blankets," and others mixed with duck feathers (Wagner 1933: 110). This statement is interesting, since no mountain goat wool blankets are known that have been painted, though the wool was mixed with white clay or diatomaceous earth to clean it and remove some of the oils before it was spun. The clay was removed before spinning by means of long sword-like wool beaters.

For a brief period in 1792, a Spanish settlement was occupied at Neah Bay. The Spanish ship *Sutil*, under the command of Captain Galiano, visited this village. José Cardero, the artist on board, painted portraits of Chief Tetacus (Tatoosh) and his two wives (Gunther 1972: 67). Cardero's paintings provide our first glimpse of the dress and jewelry of the Makah people in the late eighteenth century (figs. 1, 2). Tetacus wears a knob-topped whaler's hat and a fur robe; his second wife wears what appears to be a cedar bark cape edged with mountain goat wool. She also wears necklaces, earrings, and an arm band, all made of shells; a circular nose ornament, perhaps of metal; and a basketry hat with tassels at the top. This hat is decorated with curvilinear designs either painted or made with attached shells.

The earliest collection of objects known to be from what is now western Washington is that from Capt. George Vancouver's voyage. In April 1792, Vancouver arrived at the Strait of Juan de Fuca. In June, Vancouver "took possession of" the area that is now Washington State, and named it "New Georgia" in honor of the King of England, George III (Meany 1915: 167). Several artifacts collected there by George Hewitt, the surgeon's first mate on Vancouver's ship the *Discovery* (Meany 1907: 338), are now housed in

the British Museum. As with most early collections made on the Northwest Coast, little or no mention is made in Vancouver's journals of the acquisition of specific objects. Hewitt's collection was acquired by A. W. Franks for the British Museum around 1890. It was accompanied at that time by Hewitt's list of objects, arranged by the location of their collection (Hewitt n.d.).

At Port Discovery (Discovery Bay), Hewitt collected a number of utilitarian objects from the Klallam people living there. Included was a mountain sheep horn spoon with a broad bowl and short square handle, very similar to one that would be collected from the Nisqually in the early twentieth century (pl. 58). Also collected by Hewitt at Discovery Bay were a sheep horn rattle (Wright 1989: fig 37) and a whale bone club in the form of a serpent (pl. 67). Both objects are carved with curvilinear two-dimensional patterns formed by incised T- and crescent-shaped reliefs, closely related in style to the art produced by the Halkomelem-speaking people further north. Mountain sheep horn rattles of this type are very important ritual objects; some are still in use among Coast Salish people (Feder 1983; Suttles 1983).

Hewitt lists that a wooden comb and eight horn bracelets were collected at a village at Restoration Point on Bainbridge Island. They are carved in the same curvilinear two-dimensional style found on the rattle and club from Discovery Bay. The animal design on the wooden comb (fig. 3, pl. 66) is similar to the design on a comb—excavated at Ozette Village near Neah Bay—which dates to approximately 450 years ago (fig. 4; Kirk and Daugherty 1978: 4; Carlson 1983: 193, fig. 10.10). Though slightly different in style, the similarity in the position of the profile animal heads, their clawed paws, and their pointed eyelids testify to the stability of the art style over several hundred years. On the Ozette comb, four back spines may identify this animal as a sea monster. The head and front paw of the animal are represented on one side, while the body and hind leg are wrapped around to the other side. The treatment of the reverse side of the Hewitt comb is much more abstract: circular and H-shaped designs are defined by crescent- and T-shaped reliefs (fig. 3). The wrapping of the body on the Ozette comb suggests that the circular designs on the Restoration Point comb may represent the hip joints of the animal. Though the circular designs on the horn bracelets (pls. 46, 47) are equally abstract, they may also represent animal forms.

At Restoration Point, Hewitt collected two human-form objects: a beautifully carved grease dish representing a reclining figure (Gunther 1972: fig. 29), and a standing figure wearing a hat (pl. 79). The standing figure is inlaid with bits of glass, copper,

shell, leather, and human hair. A small inlaid piece of copper below the mouth is described in the British Museum's records as a labret, a lip plug of the type worn by northern Northwest Coast women. However, the inlaid piece of copper is square, not oval like a labret, and may merely be a decoration on the chin projection of the figure similar to those seen on the hat and body.

It is instructive to compare this figure with the portrait of Tetacus' second wife (fig. 2), painted by Cardero in the same year that this figure was collected. The same type of basketry hat with tassels is seen on both. Erna Gunther believed that this figure came from elsewhere, saying that it "in style does not belong there" [Restoration Point] (Gunther 1972: 82). She speculated that this figure was used as an invitation, associating the glass inlaid in the abdomen with the crystals, representing spirits, which were sent as invitations to guests by the Kwakiutl and Nuu-chah-nulth people of Vancouver Island (Gunther 1972: 83). The position of the hands is similar to that on five prehistoric bone figures from the San Juan Islands and Skagit River areas, as well as to that on one found further north on the central British Columbia coast (fig. 5; pl. 78; see also Carlson 1983: 124; Kirk and Daugherty 1978: 87, pl. 78; Holm 1987: 52). The similarity between the hat on the Hewitt figure and the one worn by Tetacus' second wife, combined with the related postures of the prehistoric San Juan Island bone figures, suggests that the Hewitt figure could well have been carved near where it was collected.

The Columbia River, a major arterial connecting the coast with the interior Plateau, had been navigated by Native people for thousands of years. The earliest Plateau object collected by a European from present-day Washington is a woman's hat (pl. 41). It was probably acquired by George Hewitt while he was taking part in a survey trip headed by Lieutenant Broughton, Vancouver's second-in-command on the ship *Chatham*. The survey party traveled only about one hundred miles up the Columbia River in a smaller launch and visited several Chinook villages. Thirteen years after Hewitt traveled up the river to the area of The Dalles, Meriwether Lewis and William Clark paddled down the Columbia in the other direction. The Lewis and Clark expedition, thirty years after the first European contact on the coast, marked Euro-Americans' first well-documented contact with the people of the interior Columbia Plateau.[2]

The Lewis and Clark expedition made its way to the mouth of the Columbia River in 1805, and spent that winter at a camp on the southern side. Some of the materials collected by Lewis and Clark during their stay on the Columbia were given to President Thomas Jefferson, who in turn gave the collection to Charles Willson Peale's museum in Philadelphia. In

Figure 5. Antler figure excavated at Conway, Washington. Burke Museum #1983–1.3. Photograph by Robin K. Wright.

1850, the Peale collection was sold. Half of it went to P.T. Barnum and was eventually destroyed by fire, and the other half went to the Boston Museum. In 1899, the Boston Museum material was acquired by the Peabody Museum of Archaeology and Ethnology at Harvard. Three of the objects Lewis and Clark collected on the Columbia River survive in this collection: a twined Wasco/Wishram–style basket (pl. 28), a woman's skirt (pl. 5), and a knob-topped whalers' hat (pl. 38).

We know from the Lewis and Clark journals that hats were commissioned from Clatsop women at the mouth of the Columbia River and worn as protection from the winter rains:

We were visited today by two Clatsop women and two boys who brought a parsel of excellent hats made of cedar bark and ornamented with beargrass. Two of these hats had been made by measures which Capt. Clark and myself had given one of the women some time since with a request to make each of us a hat; they fit us very well, and are in the form we desired them. We purchased all their hats and distributed them among the party (Thwaites 1904–05, vol. 4: 94).

The whalers' hat collected by Lewis and Clark and now in the Peabody Museum at Harvard is of the type worn by Chief Tetacus in Cardero's drawing (fig. 1). Though this style of hat is usually associated with the Makah or the Niu-chah-nulth (Nootka) people of Vancouver Island, it is described in Lewis and Clark's journals as having been worn by the local people at the mouth of the Columbia River:

In the evening a young Chief 4 men and 2 womin of the War-ci-a-cum tribe came in a large canoe with Wapto roots, Dressed Elk skins etc. to sell, the Chief made me a present of about a half a bushel of those roots we gave him a medal of a small size and a piece of red ribin to tie around the top of his Hat which was made with a double cone, the diameter of the upper about 3 Inches the lower about 1 foot (Thwaites 1904–05, vol. 3: 293).

They wear a hat of a conic figure without a brim confined on the head by means of a string which passes under the chin and is attatched to the two opsite sides of a secondary rim within the hat. The hat at top terminates in a pointed knob of a connic form also, or in this shape. These hats are made of the bark of cedar and beargrass wrought with the fingers so closely that it casts the rain most effectually in the shape which they give them for their own uce or that just discribed. On these hats they work various figures of different colours, but most commonly only black and white are employed. These figures are faint representations of whales and canoes and the harpoonneers striking them. Sometimes squares dimonds triangles etc. (Thwaites 1904–05, vol. 4: 24).

The phrase, "…in the shape which they give them for their own uce or that just discribed," implies that the Clatsop made hats of a shape differ-

ent from the whalers' hats. A simpler domed hat with no knob on the top was common throughout western Washington (pl. 40). Whaling hats were probably acquired by the Clatsop from further north on the coast either through trade or through marriage connections. A painted black-rimmed hat, obtained in 1899 by the Peabody Museum in the same accession as the Lewis and Clark material, is probably the earliest hat of its type known (pl. 39; Vaughan and Holm 1982: 34). Though its origin is a mystery, it is similar to other painted black-rimmed hats made by the peoples who lived on the Washington coast and on the west coast of Vancouver Island.

A woman's skirt from the Lewis and Clark collection was probably made by the Chinook or Clatsop people living on the Columbia River (pl. 5). Although this skirt is described in the Peabody Museum's catalogue as being made of cedar bark, the fibers from this skirt are now known to be cattail leaves.[3] This material is twisted into fine two-ply cord. Cedar bark skirts were worn by women throughout western Washington and were mentioned by Fra. Sierra in 1775 (Sierra 1930: 30). However, there are only four examples of skirts made using this two-ply technique, and all appear to be of the same cattail material. Three from the George Catlin collection are in the National Museum of Natural History, Smithsonian Institution (#73306, 73291, 386547).

Catlin is known to have acquired some of his collection of Native artifacts directly from William Clark in the late 1830s. After Clark returned from his expedition to the West Coast, he was made governor of Missouri Territory and Superintendent of Indian Affairs. In 1816 he founded a museum in St. Louis to house his personal collection of Indian artifacts which he maintained until his death in 1838. The majority of objects in Clark's museum were obtained by him in later years; only a few came from the 1805–1806 expedition (Ewers 1967: 55). There is no way to determine whether Catlin acquired his three skirts from Clark, but it is intriguing that their materials and construction are identical to those of the Peabody Harvard skirt. Although Clark's collection was dispersed and lost after his death, a catalog of 201 of the objects survives in the Missouri Historical Society. It lists, among other things, "two squaw's petticoats" (Ewers 1967: 64), which could possibly be two of Catlin's three skirts. These three skirts differ from the Peabody Harvard skirt only in having red and white paint applied in a band at the top. Also in the Catlin collection at the Smithsonian is a beautiful whale bone bark shredder (pl. 61). While neither it nor the skirts can be connected with the Lewis and Clark material, we know that they were probably acquired by Catlin before 1840, since they were part of a collection he took to Europe that year. After Cat-

lin became financially destitute, in 1852, he sold this collection to Joseph Harrison in Europe (Halpin 1965: 21). This collection came to the Smithsonian from Mrs. Sarah Harrison in 1884.

The first land-based fur-trading post in the Pacific Northwest was Astoria at the mouth of the Columbia River, named for John Jacob Astor, who had organized and financed the American Fur Company a few years earlier. Astor's fur traders quickly expanded operations from their base at Astoria and built forts up the Columbia, Okanogan, and Willamette rivers. The War of 1812 between Britain and the United States prevented Astor from resupplying Astoria by sea, and his holdings on the West Coast were sold to the Northwest Company in 1813, at which time Astoria was renamed Fort George. In 1821, the Northwest Company merged with the Hudson's Bay Company under the name of the latter; in 1825, Fort Vancouver was built one hundred miles upriver from Fort George.

Since the crossing of the bar at the mouth of the Columbia was a notoriously dangerous undertaking in which many ships had been lost, the Hudson's Bay Company planned to establish its major depot at the mouth of the Fraser River. Fort Langley was built there for this purpose in 1827. It was soon discovered, however, that the Fraser River was not suitable for navigation or for communication with the interior. Thus, the Columbia River remained the major route to the interior, and Fort Vancouver became the major depot for the receipt and dispersal of the company's supplies, both by land and by sea. It remained the major Hudson's Bay Company post on the Northwest Coast until the headquarters were transferred to Fort Victoria, in Victoria, British Columbia, in 1849 (Wright 1977: 44).

The fur-trading posts of the Hudson's Bay Company were important centers for the acquisition of the nineteenth-century Native art that is now preserved in museum collections. Paul Kane, who painted some of the earliest depictions of the scenery and people of the area, traveled as a guest of the Hudson's Bay Company during 1846 and 1847 (see Holm, fig. 2, and Suttles, fig. 6, this volume; and Kane 1925). His sketches and paintings provide us with a glimpse of the house interiors and activities of Native people, which cannot be reconstructed from objects in museum collections.

A major early collection of Coast Salish art came to the Perth Museum in Scotland from Fort Langley in 1833. Though known as the Colin Robertson collection, this material was probably acquired at Fort Langley between 1829 and 1831 by James M. Yale, an employee of the Hudson's Bay Company during those years (Idiens 1987: 51). Included in this collection are three model Salish canoes, each with two figures carved in one piece

with the canoes. All three canoes have a paddler at the stern; the figures at the bow all once held separate sturgeon spears in their hands. The canoes are accompanied by a lengthy written description of sturgeon-fishing techniques. One of the bow figures still retains this spear (pl. 84). Seven mountain goat horn bracelets similar to those collected by Hewitt at Restoration Point are also part of this collection; only twenty-one bracelets of this type are known.

In 1839 Captain Edward Belcher of the British exploring ship *Sulphur* visited the Hudson's Bay Company's fur-trading post at Fort Vancouver (Belcher 1843, vol. 1: 288). Several objects collected along the Columbia River on the Belcher expedition are preserved in the British Museum. These include a mountain sheep horn bowl, an elegant wooden ladle with two small birds carved on the handle (pl. 55), a cedar bark skirt, several Chinook/Clatsop style baskets, and an oblong Klickitat basket displaying a row of human figures on one side (pl. 30).

In his journal, Belcher mentions that a severe smallpox epidemic had swept through the area in 1836 (Belcher 1843, vol. 1: 293). As early as 1792, Vancouver's journal describes people with pockmarked faces and notes the prevalence of abandoned villages and hastily buried bodies (Vancouver 1798, vol. 1: 254, 256). Thus the impact of Euro-American contact had been felt in western Washington for over sixty years by the time of Belcher's arrival in 1839.

The first Christian missionaries to settle in "Oregon country" were Jason and Daniel Lee, who settled in the Willamette Valley after arriving at Fort Vancouver in 1834. The second group included the Whitmans and the Spaldings, who arrived in 1836. While the Whitmans settled near present-day Walla Walla, Reverend Spalding and his wife went on to Lapwai in present-day Idaho. They stayed at Lapwai until the Whitmans were killed in Walla Walla in 1847, after which they relocated to Calapooya, Oregon, until 1859. Spalding returned again to Lapwai in later years (Downs 1941: 11). A large collection of Nez Perce material collected by Spalding was sent to Dr. Dudley Allen in 1846, and in 1893 was given to the Allen Memorial Art Museum at Oberlin College, Ohio. This collection includes a beautiful woman's dress with dentalium shells, elk teeth, glass beads, and thimbles (pl. 6); and a cradleboard also decorated with dentalium shells, elk teeth, and beads (pl. 7). Aside from the Plateau woman's hat acquired by Hewitt in 1792, the Spalding collection is the earliest documented assemblage of Plateau clothing, and as such provides an important record of the early nineteenth-century styles of clothing and beadwork on the Plateau.

The Spalding collection was sent by ship to the Hawaiian Islands and around the Horn to Boston, and then on to Ohio. A letter from Henry Spalding

to Dr. Allen, dated April 27, 1846, contains an interesting description of the objects:

Two womens Dresses worn by the rich, often the value of 3 horses. The Aquois [dentalia] a row of which is on one, are very costly shells, found in a small lake between this and Pugets Sound, obtained by diving, contain a small insect. The Aquois from a single dress were once taken to the mountains by a man who lives near, & sold in small parcels for $1600.00 sixteen hundred dollars. A young lady...in one of these dresses, upon a firey horse well equiped with saddle & crouper, makes a fine appearance. The Elk teeth upon one dress as also upon the cradle are obtained only from the Buck Elk, two from an animal, after & before certain ages, like the horse. ...Cradle made for the occasion & rather short often much larger in this the young infant is lashed tight, face only out, often a heavy bandage over the forehead which flattens it, lower Indians much. This cradle with its victim is hung upon the horn of the saddle when camp moves, hangs upon the mothers back when she goes for roots of wood, sits in the sun against a rock through the day while she digs her two or three bags of roots, going now and then to nurse it, or against the root of a tree while she cuts & binds up a bundle of wood weighing from 150 to 200 lbs, to warm a gambling son or husband who may be at home asleep. When the great pile is swung upon the back the belt coming over the head, the cradle with the child is laid upon the top. The woman's dress would sell I learn in the southern states for $50.00 or $60.00 apiece (Fletcher 1930).

Spalding goes on to list the prices he paid for the items: 2 Dresses Woman $27.00, 1 Child's Cradle $3.00.

In 1841 the first United States Exploring Expedition, under the command of Lt. Charles Wilkes, arrived at the coast of what is now western Washington in order to survey the coastal waters and explore the interior regions. The collection made by the Wilkes Expedition was first catalogued in 1867, and is preserved in the National Museum of Natural History. However, several pieces were traded to the National Museum of Denmark in Copenhagen, and other pieces have made their way into private collections. A very fine bird-down robe, made of thin strips of bird skin, which is now in the National Museum of Denmark (pl. 3), may have been collected by the Wilkes Expedition (Jane Walsh, pers. comm., 1989). The material from western Washington was collected throughout Puget Sound and along the Columbia River, but the exact localities are not recorded (Marr 1984).

A number of baskets and black-rimmed basketry hats, similar to that in plate 39, were collected by the Wilkes Expedition, but perhaps the most interesting objects acquired by this expedition from the people of Washington are several textiles that display the range of weaving styles produced by Coast Salish people. These include a colorful geometric blanket finely twined in the central Salish style (pl. 1), and a blan-

ket made of a combination of mountain goat wool and bird down (pl. 2), a type first described at Discovery Bay by Manuel Quimper in 1790. One of these blankets (pl. 1) was mistakenly given catalogue numbers associated with the G. K. Warren collection. Lieutenant Warren was never on the Northwest Coast, and Smithsonian officials now believe this blanket was almost assuredly collected by the Wilkes Expedition. The other blanket (pl. 2) may also have been collected by the Wilkes Expedition (Jane Walsh, pers. comm., 1989). The expedition also acquired two wooden combs carved in the Puget Sound style. Of particular interest is the one that shows a figure wearing a Euro-American-style hat (pl. 65). A painted rawhide case of the type made on the Columbia Plateau (pl. 17) has, inscribed on the back, the names of R. R. Waldron and J. L. Fox, purser and surgeon, respectively, of the Wilkes Expedition.

In the first half of the nineteenth century, the collection of Washington Native art was dominated by maritime exploring and fur-trading expeditions; during the second half, a number of large and important collections were made by government officials, agents of newly formed anthropological museums, ethnographers, missionaries, military personnel, and entrepreneurs.

George Gibbs—who served as an assistant to Territorial Governor Isaac Stevens during the 1850s, the important period when several treaties were negotiated with Native people—collected a number of western Washington objects now housed at the National Museum of Natural History. These include a sheep horn ladle (pl. 56) and a sheep horn bowl (pl. 48). In addition, at Shoalwater Bay on the southern Washington coast, Gibbs collected a wooden bowl (#692) very similar to one in the Burke Museum's collection (pl. 52). Similar bowls, with rows of small animal heads on the raised ends, have been excavated at Ozette Village and collected throughout western Washington.

In 1849 and 1850, Dr. William F. Edgar served with two companies of the regiment of Mounted Rifles in Oregon and on the Snake River, five miles east of the Hudson's Bay Company station of Fort Hall. It was probably during that time that he collected a beaded panel bag, the earliest documented example of woven beadwork from the Columbia River (pl. 27; see Duncan, this volume).

After Fort Simcoe was abandoned by the military in 1859, it became the home of the Yakima Indian Agency. James Harvey Wilbur, a Methodist missionary, was appointed agent in 1862, and remained in that position for 20 years (Kimmel 1954). During his tenure at Fort Simcoe he acquired a beaded bag (pl. 21) that still bears the inscription, "Indian Woman's Saddle Pouch, Ft. Simcoe, W. T., James H. Wilbur, Agent, July 10, 1876." This pouch

Figure 6. Photograph of "Lifting the Daylight," a staged demonstration of the recovery rite of the Coast Salish Spirit Canoe ceremony. Pictured are Jerry Kanim, Tommy Josh, Ed Davis, and Gus James (Miller 1988: 20). Photographed on July 12, 1920, by J. D. Leechman at Tolt (now Carnation), Washington. Burke Museum #L3911/3.

was acquired by the Smithsonian Institution in 1876.

James G. Swan came to the Pacific Northwest in 1852, and ran the gamut of careers from oysterman to judge. Having been a teacher at Neah Bay, Swan developed close associations with Native people on the Olympic Peninsula, and collected there for the Smithsonian Institution as early as 1860. Swan's collections of Makah, Klallam, and other western Washington material made during the last half of the nineteenth century are now housed in the Burke Museum, the National Museum of Natural History (Smithsonian Institution), the Field Museum of Natural History, and a number of other museums around the world. An exquisite Makah bird-down robe (pl. 4) was sent to the Smithsonian in 1865, and an elaborate model of a Makah whaling canoe, complete with crew and equipment (pl. 85), was sent in 1884.

The Rev. Myron Eells was the son of Mr. and Mrs. Cushing Eells, who had come as missionaries to "Oregon country" in 1838. They built a mission at Tshimakain, about twenty-five miles northwest of Spokane. Myron Eells became a Congregationalist

missionary and worked in the Puget Sound region from 1874 until his death in 1907. A grease dish (pl. 54), collected by Eells from the Quinault, is now housed at Whitman College in Walla Walla. Together with Swan, Eells provided much of the material for the Washington State Pavilion at the World's Columbian Exposition in Chicago in 1893. The many objects assembled by Eells for the pavilion included a stone club (pl. 68), several delicate blanket pins (pl. 45), and a Quinault shaman's staff representing the personal spirit helper of the owner (Burke Museum #72).

Charles Willoughby and Livingston Farrand also collected objects from the Quinault in the 1880s and 1890s as part of museum-sponsored expeditions—Willoughby for the Smithsonian Institution, and Farrand for the American Museum of Natural History as part of the Jesup North Pacific Expedition. It was during this period that the first significant collections of shamans' objects were made. Willoughby collected a power figure from the Quinault in the early 1880s that is similar to the one acquired later by Eells.

Figure 7. Clovis points excavated near Wenatchee, 1988.
Photograph by G. Leonhardy, courtesy of P. J. Mehringer,
Anthropology Department, Washington State University,
Pullman.

These objects still were in active use during this
period. The 1886 report on the Indians of Quinault
Agency explains:

In order to give or sell one of these images to a white man,
the Indian doctor must make a new image like the one to
be disposed of, and must place it for awhile beside the old
one to absorb its spirit (Willoughby 1889: 278).

By the time Livingston Farrand arrived on the
coast of Washington in 1898, he found that many of
the Quinault had converted to Shakerism[4] (Jonaitis
1988: 191). In 1900, Farrand was able to acquire a set
of six Spirit Canoe boards from a Coast Salish village
near Seattle. Part of an elaborate shamanic voyage to
the land of the dead to recover lost souls, the boards
were made for a single ceremony, after which they
were left in the woods. For this reason, the boards
were probably more easily obtained than their accom-
panying "little earths," humanoid figures that were
considered to be alive and were retained and main-
tained by their associated shamans.

The earliest documented Spirit Canoe figure
may have been among the objects presented to the
University of Washington by its president, A. J.
Anderson, in the 1870s (Holm 1987: 48). The figure
came to the Burke Museum in 1890. By 1920, the
Spirit Canoe ceremony was no longer being per-
formed (Miller 1988: 51), but several photographs of a
staged performance were taken by J. D. Leechman at
Tolt (now Carnation, Washington) when Thomas
Waterman bought a set of two-thirds-size boards
from Jerry Kanim (fig. 6). This set of Spirit Canoe
figures and boards is now in the Museum of the
American Indian, Heye Foundation, New York.

Objects of supreme artistry produced by Wash-
ington people in much earlier periods continued to
be collected well into the twentieth century. Grace
Nicholson, a dealer who operated a shop in Pas-
adena, California, collected many fine objects in the
first decade of the twentieth century; part of her col-
lection is now found in the Peabody Museum at
Harvard. It includes the Quinault D-adze that
belonged to Captain Mason, a Quinault leader and
carver (pl. 60), and a wooden mortar from the
Columbia River (pl. 51). A mountain sheep horn
spoon from the Nicholson collection (pl. 58), identi-
fied as Nisqually, is nearly identical to the spoon
collected by Hewitt on Vancouver's voyage in 1792. It
brings us full circle, linking objects acquired in the
early twentieth century to those available in the same
area over one hundred years earlier.

By the mid-nineteenth century, however, many
of the traditional utilitarian and ornamental
objects—especially those made of shell, mountain
sheep horn, and mountain goat horn—had been
replaced by commercial metal spoons and bowls, and
jewelry made of metal and trade beads. In western

Washington, traditional clothing of furs, cedar bark, dog and mountain goat wool, and bird down was replaced by commercial blankets and tailored Euro-American clothing. By the late nineteenth century in eastern Washington, traditional buckskin clothing was used only on special occasions; clothing made of commercial trade cloth was the daily garb. While some items of older clothing were retained within families as treasured heirlooms, many by this time had been traded away. The combination of social and economic factors which weighed on Native people in Washington in the late nineteenth century (see Haines, Forsman, this volume), coupled with the ready market provided by avid collectors, led to the loss to Native people of many of these objects (Cole 1985).

The objects preserved in museum collections, then, offer us a valuable record of the material culture of Native people in the Pacific Northwest during the late eighteenth and nineteenth centuries. Late eighteenth- and early nineteenth-century collections of Native art, however, reflect both the types of objects Native people were willing to part with, and the tastes of explorers, who were interested in acquiring curios or souvenirs of their travels. These collections often survived or disappeared only because of quirks of fate or accidents. Systematically acquired late nineteenth- and early twentieth-century collections reflect the missions of ethnographers and anthropological museums to preserve "traditional objects" from what they perceived to be "dying cultures." These collectors frequently overlooked the contemporary art of the times that incorporated new materials and was produced for new or different reasons, and they totally missed the point that Native cultures were surviving and evolving into something new.

Though a number of traditional art forms were discontinued in the nineteenth century, many of the artistic traditions of the Native people of Washington have been continued throughout the twentieth century, evolving in style in response to the changing social and economic atmosphere. Beadwork and basketry have continued to serve economic and social functions within the society (see Miller, Sampson, Duncan, Loeb, this volume). Despite the suppression of Native religions by the United States government and the discontinuation of some traditional religious practices, such as the Spirit Canoe ceremony and other shamanic traditions, traditional religions continue to be active throughout the state, inspiring the production of personal, and private, ritual objects and costumes (Amoss 1978).

Many twentieth-century Washington Native artists have pursued careers in mainstream Euro-American or contemporary art traditions. Many of these artists, as do their colleagues who work in more traditional styles, express their Native identity in their work. "A Time of Gathering" has provided an opportunity to focus on the work of contemporary Native artists in Washington State. It was decided that the Burke Museum would commission several artists to produce pieces for inclusion in "A Time of Gathering" to become part of the Museum's permanent collection (see Wright, Introduction, this volume). On the advice of the Native Advisory Board, only artists from tribes indigenous to Washington were included in the competition. Over fifty artists from throughout the state submitted their work for selection by a five-member jury. In order to provide a balanced representation, the jury selected five artists from eastern Washington tribes, and six artists from western Washington tribes (two of whom worked as a team), and included artists from a broad range of styles (see pls. 91–100). The juried selection of contemporary Native American art for inclusion in museum collections is a twentieth-century phenomenon, one which will shape the history of art and the careers of artists for years to come.

The twentieth century has also seen the rise of a new source of information on the prehistoric arts and material culture of the Native people of the state: the science of archaeology. Excavations at Ozette Village (pl. 70) have revealed a wealth of 500-year-old material objects (Kirk and Daugherty 1978); new excavations near Wenatchee have revealed beautifully chipped Clovis points (fig. 7)—larger than any others found in North America—dating to 11,000 years old (Mehringer 1988, 1989). In the late twentieth century, museum collections are growing with the addition of the oldest along with the very newest of Native arts.

One hundred years ago, Myron Eells and James G. Swan set out to collect a sample of Native material culture from Washington State for the Washington State Pavilion at the 1893 World's Columbian Exposition in Chicago. Because of their own biases and the circumstances that prevented the incorporation of inland materials, this exhibition was heavily weighted toward western Washington, to the virtual exclusion of eastern Washington material (Castile 1988). As with other expositions held in the late nineteenth and early twentieth centuries, it presented a historical or nostalgic view, with little or no information on the 1890s lives of Native people in the state.

Washington's 1989 centennial exhibition at the Burke Museum, "A Time of Gathering: Native Heritage in Washington State," presented a more balanced view. It, too, was the product of a variety of quirks of fate, and of personal, political, and institutional agendas. Yet it achieved its goal: to draw attention to the historic and artistic significance of Native art and culture, as well as to the ongoing and vital heritage of Native people in Washington State.

NOTES

1. Recently it has been speculated that a skin armor tunic catalogued as Tsimshian (Field Museum of Natural History #18166) may have been made on the lower Columbia River, due to the similarity between the painted human faces and sculpture from that area (Henrikson 1989).

2. Two French-Canadian voyageurs, Le Blanc and La Gasse, probably contacted Native people in northeastern Washington a few years earlier (Ruby and Brown 1970: 34).

3. A sample of fibers from this skirt was recently analyzed by Mary Lou Florian at the Royal British Columbia Museum and determined to be cattail leaves, *Typha latifolia* (Richard Beauchamp, pers. comm., 1989).

4. The Native Shaker religion of the Pacific Northwest should not be confused with the Euro-American Shaker religion of the eastern United States. Native Shakerism combines certain aspects of traditional Native religious beliefs with Christianity. It began in 1881 when John Slocum, of the Squaxin band, is said to have died and come back to life, telling of his mission to return to earth and lead others to the Christian way of life. He nearly died again a year later, but recovered when his wife began praying and trembling uncontrollably, giving rise to the name of the Shaker religion (Barnett 1957: 6).

REFERENCES

Amoss, Pamela. 1978. *Coast Salish Spirit Dancing: The Survival of an Ancestral Religion.* Seattle and London: University of Washington Press.

Barnett, H. G. 1957. *Indian Shakers: A Messianic Cult of the Pacific Northwest.* Carbondale and Edwardsville: Southern Illinois University Press.

Belcher, Capt. Sir Edward. 1843. *Narrative of a Voyage Round the World. Performed in Her Majesty's Ship Sulphur, During the Years 1836–1842, Including Detail of the Naval Operations in China from Dec. 1840–Nov. 1841.* 2 vols. London: Henry Colburn, Publ.

Cabello, Paz. 1989. Materiales etnográficos de la Costa Noroeste recogidos en el siglo XVIII por viajeros espanoles. In José Luis Peset, ed., *Culturas de la Costa Noroeste de América.* Madrid: Sociedad Estatal Quinto Centenario.

Carlson, Roy L. 1983. *Indian Art Traditions of the Northwest Coast.* Burnaby, B.C.: Archaeology Press, Simon Fraser University.

Castile, George Pierre. 1988. Washington State in the World's Columbian Exposition of 1893: The "Ethnographic" Section. Unpublished paper, Department of Anthropology, Whitman College, Walla Walla, Washington.

Cole, Douglas. 1985. *Captured Heritage.* Seattle and London: University of Washington Press.

Downs, Winfield Scott. 1941. *Encyclopedia of Northwest Biography.* New York: The American Historical Co., Inc.

Ewers, John C. 1967. William Clark's Indian Museum in St. Louis, 1816–1838. In Walter Whitehill, ed., *A Cabinet of Curiosities.* Charlottesville: University of Virginia Press.

Feder, Norman. 1983. Incised Relief Carving of the Halkomelem and Straits Salish. *American Indian Art Magazine* 8(2): 46–55.

Fletcher, Robert S. 1930. The Spalding-Allen Indian Collection. *The Oberlin Alumni Magazine,* February 1930.

Gunther, Erna. 1960. Vancouver and the Indians of Puget Sound. *Pacific Northwest Quarterly* 51(1): 1–12.

———. 1972. *Indian Life on the Northwest Coast of North America: As Seen by the Early Explorers and Fur Traders during the Last Decades of the Eighteenth Century.* Chicago and London: University of Chicago Press.

Halpin, Marjorie. 1965. *Catlin's Indian Gallery: The George Catlin Paintings in the U.S. National Museum.* Washington, D.C.: Smithsonian Institution Press.

Henrikson, Steve. 1989. Art of the Lower Columbia River, unpublished paper presented at the 7th Native American Art Studies Association Conference, University of British Columbia, Vancouver, British Columbia.

Hewitt, George. n.d. Ms Catalogue of the Vancouver Collection from the List of George Goodman Hewitt, Surgeon's Mate on the *Discovery.* British Museum Ethnological Document 1126.

Holm, Bill. 1987. *Spirit and Ancestor: A Century of Northwest Coast Indian Art at the Burke Museum.* Seattle: The Burke Museum and University of Washington Press.

Idiens, Dale. 1987. Northwest Coast Artifacts in the Perth Museum and Art Gallery: The Colin Robertson Collection. *American Indian Art Magazine* 13(1): 46–53.

Jonaitis, Aldona. 1988. *From the Land of the Totem Poles: The Northwest Coast Indian Art Collection at the American Museum of Natural History.* New York: American Museum of Natural History; Seattle and London: University of Washington Press.

Kane, Paul. 1925. *Wanderings of an Artist Among the Indians of North America, from Canada to Vancouver's Island and Oregon through the Hudson's Bay Company's territory and back again.* Toronto: Radisson Society of Canada Ltd.

Kimmel, Thelma. 1954. *The Fort Simcoe Story.* Toppenish, Washington: The Toppenish Review.

Kirk, Ruth, and Richard Daugherty. 1978. *Exploring Washington Archaeology.* Seattle and London: University of Washington Press.

Marr, Carolyn. 1984. Salish Baskets from the Wilkes Expedition. *American Indian Art Magazine* 9(3): 44–51, 71.

Meany, Edmond S. 1907. *Vancouver's Discovery of Puget Sound: Portraits and Biographies of the Men Honored in the Naming of Geographic Features of Northwestern America.* New York and London: The Macmillan Company.

Mehringer, Peter J., Jr. 1988. Clovis Cache Found: Weapons of Ancient Americans. *National Geographic,* October: 500–503.

———. 1989. Of Apples and Archaeology. *Universe* 1(2): 2–8.

Miller, Jay. 1988. *Shamanic Odyssey: The Lushootseed Salish Journey to the Land of the Dead.* Menlo Park, California: Ballena Press.

Quimby, George I. 1985. Japanese Wrecks, Iron Tools, and Prehistoric Indians of the Northwest Coast. *Arctic Anthropology* 22(2): 7–15.

Ruby, Robert H., and John A. Brown. 1970. *The Spokane Indians: Children of the Sun.* Norman: University of Oklahoma Press.

Sierra, Fray Benito de la. 1930. An account of the Heceta expedition to the Northwest Coast in 1775. Trans., ed. A. J. Baker. *California Historical Society Quarterly* 9(3).

Suttles, Wayne. 1983. Productivity and Its Constraints: A Coast Salish Case. In Roy Carlson, ed., *Indian Art Traditions of the Northwest Coast*, pp. 67–87. Burnaby, British Columbia: Archaeology Press, Simon Fraser University.

Thwaites, Reuben G. 1904–05. *The Original Journals of the Lewis and Clark Expedition*. 8 vols. New York: Dodd, Mead Co.

Vancouver, George. 1798. A *Voyage of Discovery to the North Pacific and Round the World...performed 1790–1795 with the "Discovery" and the "Chatham" under Captain George Vancouver*. 3 vols. London.

Vaughan, Thomas, and Bill Holm. 1982. *Soft Gold: The Fur Trade and Cultural Exchange on the Northwest Coast of America*. Portland: Oregon Historical Society.

Wagner, Henry R. 1933. *Spanish Explorations of the Strait of Juan De Fuca*. Santa Ana, California: Fine Arts Press.

Willoughby, Charles. 1889. Natives of the Quinaielt Agency, Washington Territory. *Annual Report of the Board of Regents of the Smithsonian Institution for the year ending June 30, 1886:* 267–82.

Wright, Robin K. 1977. *Haida Argillite Pipes*. Master's thesis, Division of Art History, School of Art, University of Washington, Seattle.

_____ . 1989. "Western Washington Native Art: A Collection History." In José Luis Peset (ed.), *Culturas de la Costa Noroeste de America:* 163-71. Madrid: Sociedad Estatal Quinto Centenario.

MASTERWORKS OF WASHINGTON NATIVE ART

Robin K. Wright

1. **Robe** Coast Salish; early 19th century
 Mountain goat wool; 152 cm x 154 cm
 National Museum of Natural History, Smithsonian Institution
 #1891; collected by the Wilkes Expedition (?), 1841
 Photograph courtesy of the Smithsonian Institution

Southern and central Coast Salish people, who live in present-day western Washington and southern British Columbia, produced a variety of textiles woven of mountain goat wool. This white wool was and is very highly prized, and continues to be an important ritual material used in traditional religious practices. Plain, twill-woven blankets with simple colored stripes were produced on the southern Northwest Coast from prehistoric times until the early twentieth century. Recently, Salish weavers have revived this weaving tradition (pl. 96).

Twined blankets such as this one are much rarer than plain twill-woven blankets. First collected in the early nineteenth century, the earliest documented blankets of this type (Perth Museum and Art Gallery #1978.522 and National Museum of Finland #VK-1) have narrow horizontal bands with colorful zigzag, diamond, and triangular patterns, as well as checkerboard borders. Slightly later blankets, dating from the 1840s through the 1860s, display floating central rectangular or square panels. This blanket, incorrectly cataloged by the Smithsonian as part of Lt. G. K. Warren's 1860s collection, has recently been associated with the Wilkes Expedition of 1841. Though it has been speculated that this style of blanket is derived from imported patchwork quilt designs (Gustafson 1980: 48), the early Wilkes collection dates for weavings in this style suggest that it developed independently, directly from the earlier Salish weaving tradition.

Similarities have also been noted between this type of Salish blanket and Navajo "eyedazzler" blankets. While the colorful, overall geometric designs with floating diamond patterns are similar, this style of Salish blanket predates the development of the Navajo eyedazzler by at least twenty years. Eyedazzler blankets, characterized by a central floating diamond pattern with serrated edges, were influenced by blankets woven during the nineteenth century at Saltillo in northern Mexico. The influence of Saltillo design on Navajo blankets dates to between 1860 and 1885 (Kent 1985: 63–64). Though there is a superficial resemblance to Salish blankets, no direct connection between these two weaving styles can be made.

2. **Robe** Coast Salish (?); early 19th century
 Mountain goat wool, bird down, vegetable fiber; 128 cm x
 100 cm
 National Museum of Natural History, Smithsonian Institution
 #1894; collected by the Wilkes Expedition (?), 1841
 Photograph courtesy of the Smithsonian Institution

Textiles woven of mountain goat wool mixed with the downy feathers of ducks and geese were described in the journals of the earliest European visitors to the area of the Strait of Juan de Fuca and Puget Sound. Though these blankets ceased to be made in the nineteenth century, in the 1920s Klallam people remembered the process. The down of geese, ducks, and gulls was separated from the quills and mixed in varying proportions with mountain goat wool, dog wool, or fireweed cotton; sometimes one material was used alone with warps of nettle fiber (Gunther 1927: 221).

Several members of Vancouver's 1792 expedition to the Strait of Juan de Fuca and Puget Sound mentioned the presence of a small dog raised specifically to be sheared for its wool (Vancouver 1798, 1: 266; Newcombe 1923: 58). While these accounts have become legendary, of the Salish blankets said to be made of dog wool in museum records, only one may in fact contain that material (Field Museum of Natural History #19773; Gustafson 1980: 79). After commercial blankets and domestic sheep wools became available in the nineteenth century, the breeding of this dog was abandoned and it disappeared. It is likely that domesticated dog wool was mixed with other fibers such as mountain goat wool when it was used, further complicating its identification today. Much more scientific testing of blanket fibers needs to be conducted before the exact fiber content of Salish blankets is known.

The central portion of this blanket consists of warps, made of mountain goat wool mixed with bird down, loosely twined with vegetable fiber wefts. Tightly twined narrow strips of mountain goat wool with green, red, and brownish black rectangular patterns decorate the borders. The long wool fringes would hang at either side as the blanket was worn.

Only certain women could make those blankets. The knowledge was passed from one woman to the next, generation to generation. You could tell them by their names: Dogwool Woman, Swan Down Woman, Bird Down Woman....

—Margaret Green, Samish

3. **Robe** Coast Salish; early 19th century
 Mountain goat wool, bird skin with down, cedar bark,
 vegetable fiber, leather; 114 cm x 100 cm
 National Museum of Denmark Hd38; collected by the Wilkes
 Expedition (?), 1841; acquired in 1868 in an exchange
 from the Smithsonian Institution (Smithsonian #1841)
 Photograph courtesy of the National Museum of Denmark

The rarest of all weavings from the southern Northwest Coast are those made of strips of bird skin. The larger feathers were plucked out leaving only the down. The skin was then cut into one long continuous strip; the cut started at the edge and proceeded inward in an ever-tightening spiral. The strip would automatically twist, producing a "cord" feathered on all sides (Gunther 1972: 262). This material was then twisted with cedar bark to create warps, which were twined together with two-ply nettle or other vegetable fiber wefts. Subtle color differences in the down of the warps create narrow brown and white horizontal stripes; the wefts disappear in the down.

Constructed similarly to the previous robe (pl. 2), this rare blanket has mountain goat wool attached at the ends of the bird skin/cedar bark warps. These wool warp ends, twined with mountain goat wool wefts to form white borders at the robe edges, continue as fringes. Leather ties remain where the robe was tied around the neck of the wearer.

This robe, sent to Copenhagen, Denmark, in 1868 as part of an exchange with the Smithsonian Institution, may have been collected by the Wilkes Expedition in 1841 (Jane Walsh, pers. comm. 1987). Though firm documentation on this robe is lacking, its method of manufacture and the materials used link it with other textiles collected by the Wilkes Expedition, produced in the early nineteenth century on the southern Northwest Coast.

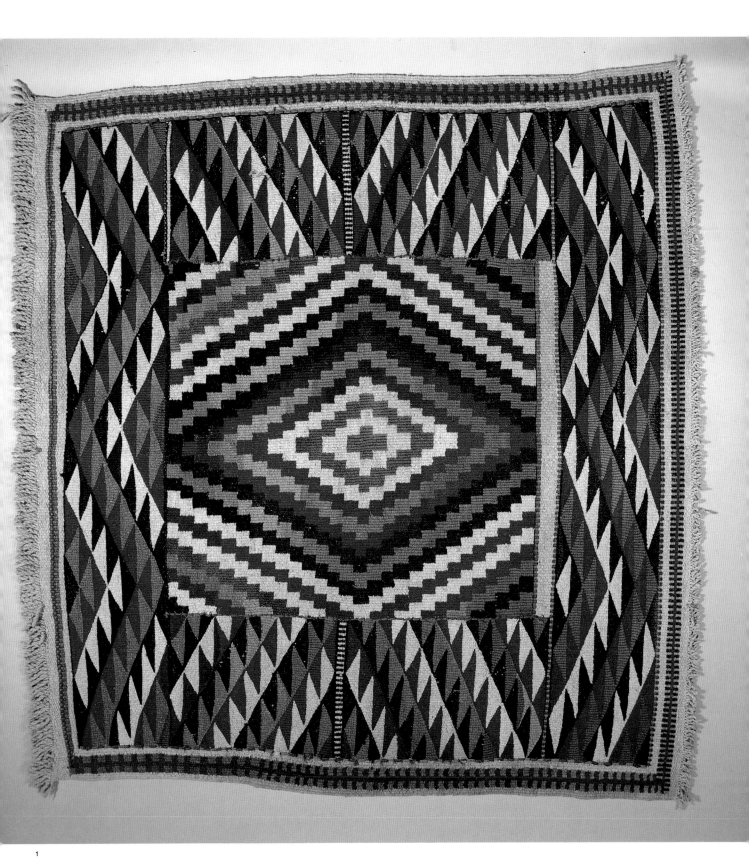

2

3

4. **Robe** Makah; early to mid-19th century
Bird skin with down, vegetable fiber, cotton string; 136 cm x
70 cm
National Museum of Natural History, Smithsonian Institution
#1296A; collected by James G. Swan; received 1865
Photograph courtesy of the Smithsonian Institution

This robe is made entirely of strips of downy bird skin,
twisted on cotton string, twined together with vegetable
fiber (nettle?) cord. The natural white and brown colors of
the down alternate to produce a soft variegated pattern.
This robe was collected by James G. Swan at Neah Bay.
Though looms were not necessary for this type of twining,
archaeological excavations at nearby Ozette Village have
revealed a number of weaving tools, including roller looms,
spindles and their whorls, combs, and wool beaters,
thought to be about 450 years old. A twill-woven mountain
goat wool blanket, very similar to those made and used by

the Makah's Coast Salish neighbors, as well as a bird down
robe similar to this one, were also found (Gustafson 1980:
97).

This technique of twining together long narrow strips
of skin (more often furred animal skin) was widespread not
only on the Northwest Coast but on the Plateau (Gunther
1972: 261–62). A fur robe collected by the Wilkes Expedi-
tion (Smithsonian Institution #1895), made by a similar
technique, has been identified as being made of fur resem-
bling most closely that of a coyote (Gustafson 1980: 83).

This type of down robe is described in the Makah lan-
guage as *p'u·quk x̌tid hiti·d ; p'u·quk* means bird down; *-x̌tid*
means made of; *hiti·d* means blanket.

*I remember my mother said she had seen one of those. You
wear it around your shoulders. Oh, it's beautiful.*

—Helen Peterson, Makah

5. **Woman's Skirt** Chinook/Clatsop (?); late 18th to early 19th century
 Cattail leaves; 54 cm x 70 cm
 Peabody Museum of Archaeology and Ethnology, Harvard University #5299; collected by the Lewis and Clark Expedition, 1805–1806; acquired in 1899 from the Boston Museum, gift of the heirs of David Kimball
 Photograph by Hillel Burger

Acquired by Lewis and Clark, who wintered at the mouth of the Columbia River in 1805–1806, this is the earliest skirt collected from the Northwest Coast. Probably made by a Chinook or Clatsop woman, it is one of only four known skirts made with finely twisted two-ply cattail leaf cord (see Wright, "Collection History," this volume). The Lewis and Clark journals describe skirts made by the Wahkiacum as being made of "the bruised bark of white cedar," "strings of silk-grass," or "flags and rushes" (Biddle 1962: 326, 368).

This skirt is also interesting for the fineness of its twined cording and the technique used to make it. The cords are plied in both S-twists (to the right) and Z-twists (to the left), alternating throughout the skirt. The cords are looped around the waist band cord; each ends in a knot at the bottom of the skirt. A single cord looped around a waist band retains either its S- or Z-twist no matter which end you look at. The maker of this skirt had to produce equal numbers of cords, individually twisted to the right or the left. This virtuosity might not be apparent to the casual observer, but it was no doubt important to the woman who produced and wore this skirt.

6. **Woman's Dress** Nez Perce; early 19th century
 Deer skin, dentalium shells, elk teeth, glass beads, brass thimbles, porcupine quills, sinew; 135 cm x 138 cm
 Ohio Historical Society #1994/22B (on loan to the Nez Perce National Historic Park); collected by Rev. Henry H. Spalding and sent to Dr. Dudley Allen in Kinsman, Ohio, in 1846; received from the Allen Memorial Art Museum, Oberlin College
 Photograph by Eduardo Calderón, courtesy of the National Park Service

The construction of women's hide dresses was similar throughout the Plateau and the Plains. Two full, untrimmed hides—usually deer, elk, or mountain sheep—were sewn together with the tail ends up to form the front and back of the dress. The tail ends were folded out and over, allowing the tails to hang down below the neck line. The yoke thus acquired the graceful undulating line of the hind legs and tail, which was emphasized by the addition of shells and beadwork.

This dress is constructed of two deer skins. The head sections with ears have been left on the skins and hang with the forelegs at the bottom of the dress; eight skin inserts add length and fullness to the hemline. This dress was well used before it was collected; wrinkles indicate it was worn with a belt at the waist. This is one of two dresses collected by Spalding in the early nineteenth century, the earliest documented Plateau women's dresses known.

The yoke of this dress is decorated with dentalium shells that were used for money and obtained in trade from the west coast of Vancouver Island where they were harvested. Spalding states that dentalium shells were known as "aquois" (Fletcher 1930). The shells were known throughout the fur trade as "Iroquois" shells, apparently from the Nootkan name *hai-kwa*, which is probably the source of this word (Andrews 1989: 301) . The Sahaptin word for dentalia is *áxš-áxš*. Spalding notes that the shells from one such dress were once sold for $1600. He bought both this and another Nez Perce dress for $27 (Fletcher 1930). In addition to the dentalium shells, the dress is decorated with elk teeth (also extremely valuable since each male adult elk has only two), glass trade beads, and brass thimbles; the fringes are wrapped with flattened porcupine quills.

The Nez Perce words for woman's hide dress are *a-yat wespole sumphkh*.

7. **Cradleboard** Nez Perce; early 19th century
 Buckskin, dentalium shells, glass beads, elk teeth; 76 cm x 23 cm
 Ohio Historical Society #1994/16; collected by Rev. Henry H. Spalding and sent to Dr. Dudley Allen in Kinsman, Ohio, in 1846; received from the Allen Memorial Art Museum, Oberlin College
 Photograph courtesy of the Ohio Historical Center

This small cradleboard is infant-sized. Larger ones were made for the baby as it grew. Plateau cradleboards were constructed of soft tanned buckskin stretched over a flat wooden frame that flares at the top and tapers at the bottom. The baby was laced snugly inside the buckskin pouch with a protective hood above its head.

The geometric patterns, sewn with large glass "pony beads" and dentalium shells, are characteristic of early nineteenth-century Plateau beadwork. Black, white, and red triangles surround a corona of dentalium shells above the hood. The shells are sewn with the wide ends up and out, which enhances the flare of the corona. A similar technique was used on the associated dress (pl. 6); the dentalium shells are sewn with the wide ends down, enhancing the flare of the undulating yoke line. This cradle is so similar in style to the dress that it would seem it was made by the same woman. Similar pendants strung with elk teeth and large, faceted beads—blue, clear, and opalescent—hang as a fringe at the top of the cradle. A second row of beaded elk teeth pendants hangs with a buckskin fringe from the back of the cradle. The beads, dentalium shells, and elk teeth lavished on this small cradleboard indicate that the user was a very cherished child.

My great-grandmother, Susie Williams, told me that the fully beaded cradleboards were for baby girls. Cradleboards for boys were only beaded around the edge.

—Maynard Lavadour White Owl, Nez Perce/Cayuse

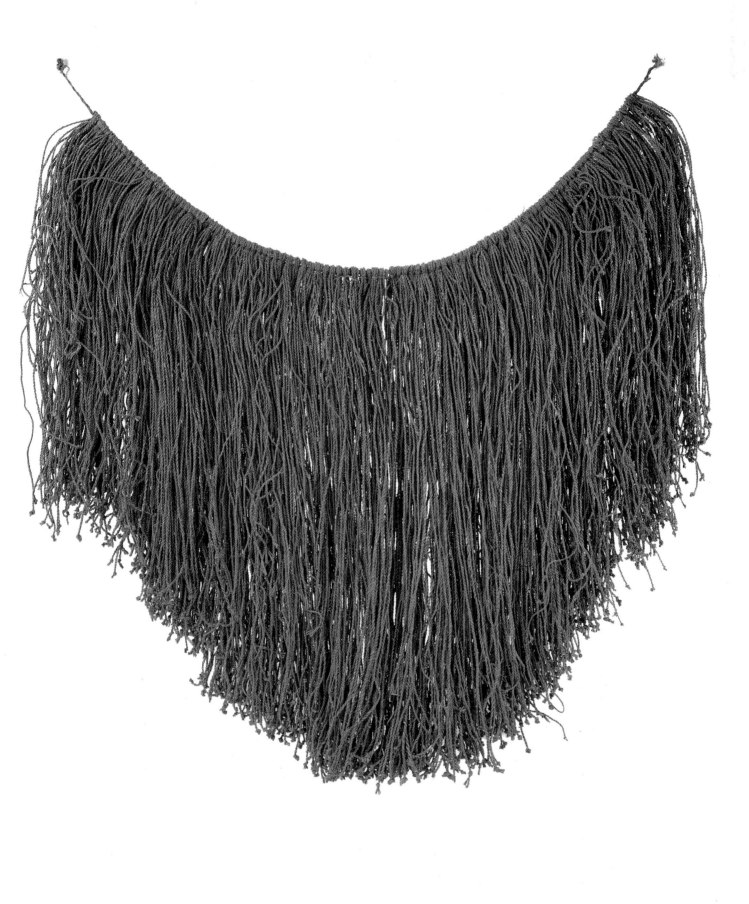

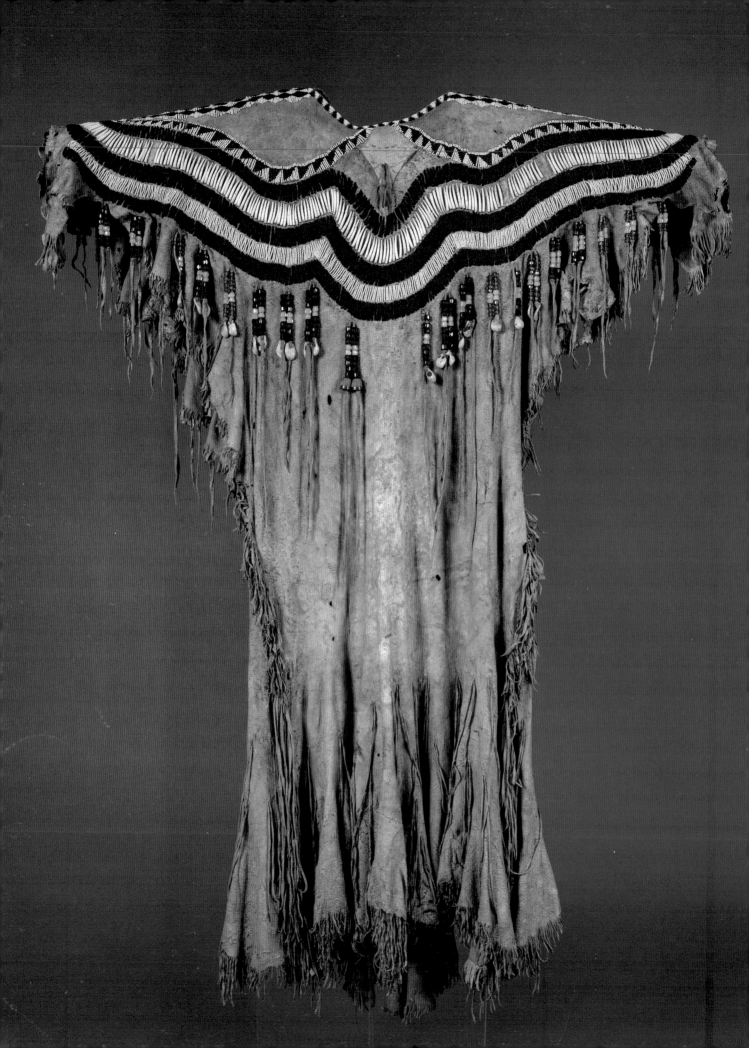

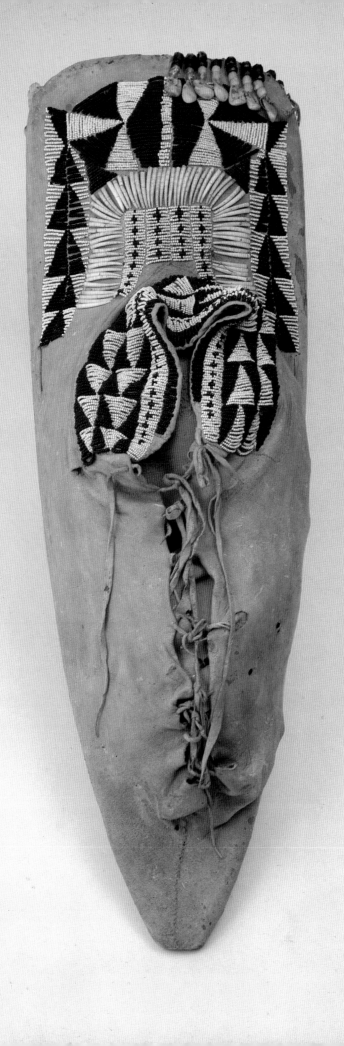

8. **Man's Shirt** Transmontane style; mid-19th century

Buckskin, glass beads, porcupine quills, horsehair, wool yarn, red and blue trade cloth, sinew; 94 cm x 111.8 cm

Honnen Collection

Photograph by Paul Macapia and Ray Fowler

Decorated with panels of quill-wrapped horsehair, this type of shirt, produced in the Transmontane region, is very rare. Its manufacture and use are generally attributed to the Nez Perce, Cayuse, and Crow, spanning the boundaries of the eastern Plateau and northern Plains. Porcupine quills are wrapped around paired bundles of horsehair and sewn down between the bundles to form long, rectangular strips. Red-, yellow- and blue-dyed quills are used to wrap the horsehair in central rectangular panels between panels of naturally white quills. These dyed quill panels are bordered by black and white beads, sewn in triangular patterns, and bands of pink beads. The undyed quill areas have plain blue beaded borders. Triangular flaps, here decorated with red and blue trade cloth bordered with white beads, are sewn on both the front and back at the neck. Long buckskin fringes, decorated with wrappings that emphasize the

patterns on the adjacent strips, hang on the back edges of the sleeve strips and the outer edges of the shoulder strips. Undyed quills are wrapped on the fringes near the undyed part of the strips, while wool yarn in red and blue is used to wrap the fringe near the dyed quill panels. Below the wrapping, the fringe is linked together with spacers of blue beads. Along the unfringed edge of the quilled panels, thin strands of red wool yarn are sewn down with sinew.

Men's shirts, like other skin clothing from the Plateau and Plains, retain the shape of the hides from which they are made. This shirt is made of two skins, both cut in two below the front legs. The hind parts form the front and back of the body, sewn together at the shoulders, hind legs hanging at the sides. The "sleeves" are made of the front halves of the two hides, folded so the necks form the cuffs and the front legs hang below. On this shirt the open areas of skin have been decorated with spots of red ochre pigment as an additional embellishment.

This is perhaps the best preserved example of this type of quill-wrapped horsehair shirt. It was photographed with the back forward to better show the fringe decoration which hangs from the back of the sleeve and shoulder strips.

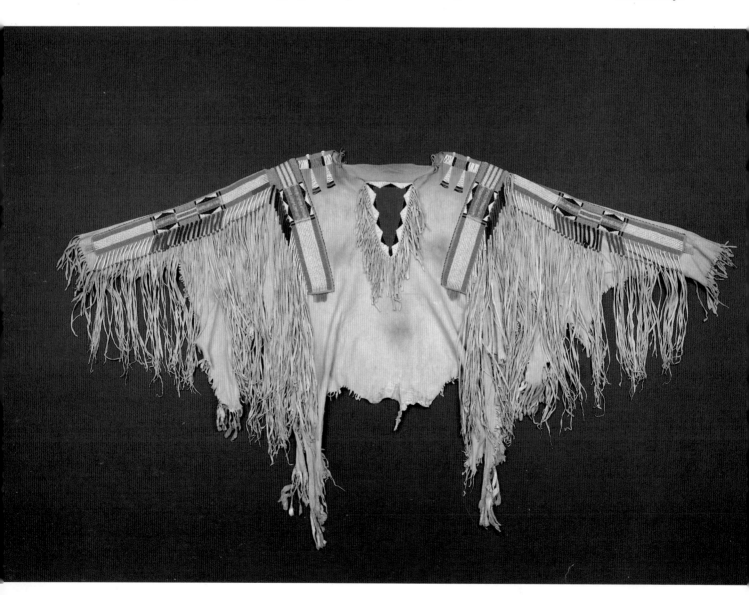

9. **Man's Leggings** Transmontane style; mid-19th
century
Buckskin, glass beads, red trade cloth; 70 cm x 25.4 cm each,
without fringe
Honnen Collection
Photograph by Paul Macapia and Ray Fowler

These leggings are displayed from the front to show their
decorative beaded strips. The geometric Transmontane style
of beadwork, produced on the Plateau and northern Plains
in the mid-nineteenth century, unites these leggings with
the previous shirt (pl. 8). The leggings are constructed of
one hide each. The hide's hind legs form the extensions
that attach to a belt at the waist, while the forelegs are cut
to form long fringes. These fringes would have dragged on
the ground if the wearer were afoot, but they hung down
freely when the wearer rode a horse.

A broad panel of red trade cloth bordered by white
pony beads decorates the fringed cuffs. Wide beaded strips
decorate the outer face of the leggings along the seamed
edge. As with the quill-wrapped horsehair panels, these
beaded strips have colorful rectangular panels inserted
between larger white rectangles. Narrow beaded borders

switch from blue against the white to white and red adja-
cent to, and emphasizing, these colorful panels. In
addition, the wrapping on the adjacent fringes switches
from yellow-dyed quills next to the white part of the beaded
panels to red and blue wool yarn next to the colored panels.
This technique of emphasizing the colored panels with
beaded borders and colorful wrappings on the adjacent
fringe is testimony to the aesthetic sophistication of the
Transmontane beaders.

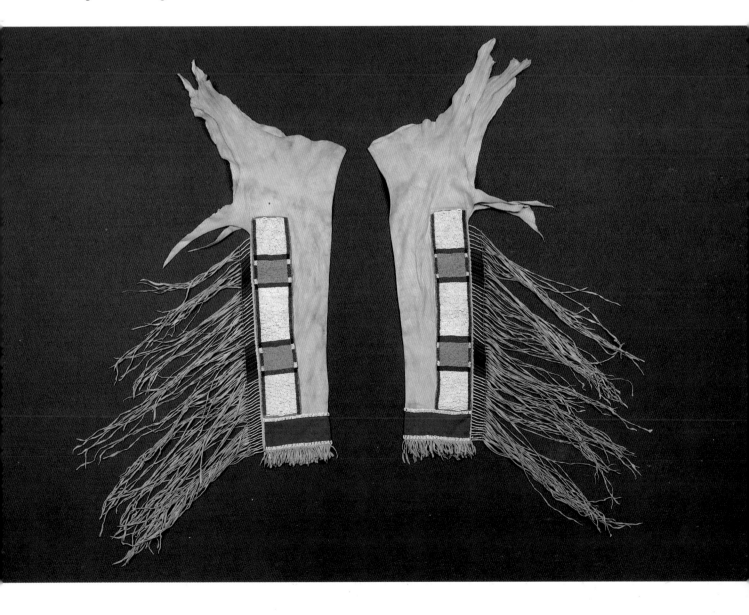

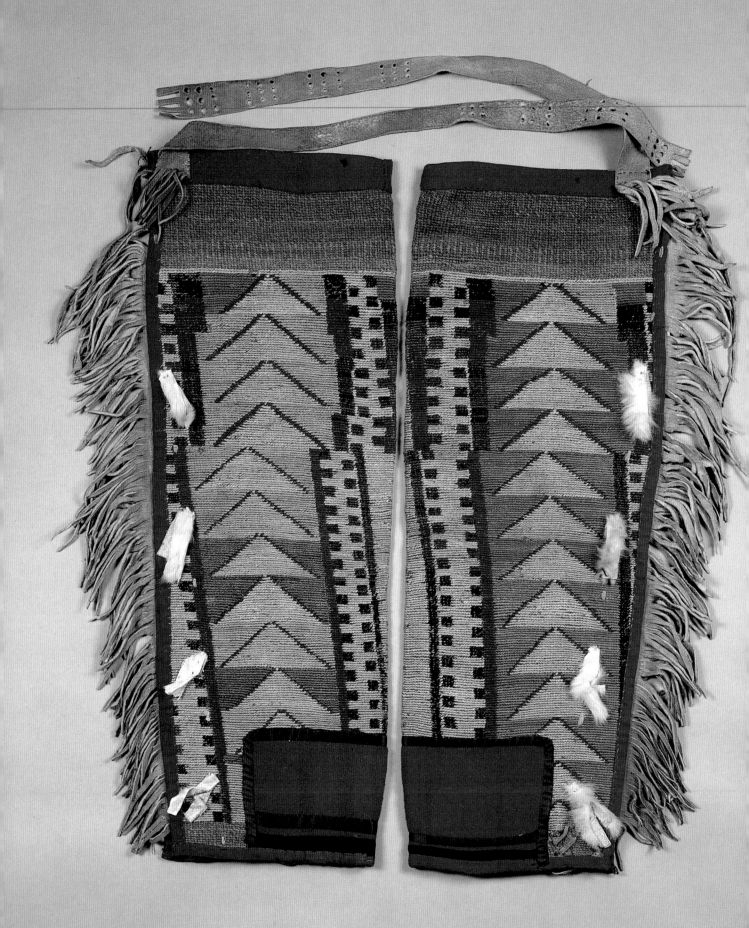

10. **Man's Leggings** Walla Walla; late 19th century
Hemp twine, cornhusk, buckskin, wool yarn, blue ribbon,
rabbit skin, trade cloth; 67 cm x 25 cm each
Museum of the American Indian, Heye Foundation
#10/8091
Photograph by David Heald, courtesy of the Museum of the
American Indian

This very unusual pair of man's leggings is made of a
twined hemp and cornhusk root bag that has been cut in
half. Constructed like the more traditional beaded buckskin
leggings (pl. 9), these reflect the ingenuity of the maker
who was able to improvise a beautiful pair of leggings from
materials normally put to a different use. Red trade cloth
has been sewn along the cut edges and used as a border at
the tops and cuffs. Blue ribbon borders the cuff panels.
White rabbit skin strips are tied on at intervals along the
sides on the front, and a buckskin fringe has been attached
at the seamed edge. The buckskin ties at the top fastened
the leggings to the belt.

 As with the original bag, the designs on the fronts and
backs of the leggings are different. Stacked triangles with
zipper-like designs at the edges are on the fronts, and dia-
mond designs decorate the backs, making these leggings
richer than buckskin leggings, which are generally plain on
the backs. (See pls. 13 and 14 for examples of cornhusk bags
made into horse gear.)

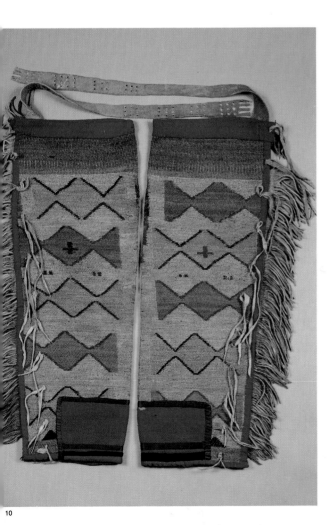

11. **Flat Twined Bag** Plateau; late 19th century
Hemp twine, leather, cornhusk; 61 cm x 47 cm
Burke Museum #2-1974; collected by Caroline McGilvra
Burke (Mrs. Thomas Burke); received 1932
Photograph by Paul Macapia and Ray Fowler

Subtly beautiful, flat twined bags made of hemp fiber were
produced as functional root storage containers on the
Plateau (see Miller, this volume). They were probably first
decorated with beargrass. In the nineteenth century, when
cultivated corn was introduced to the area, weavers began
to decorate twined hemp bags with dyed cornhusk using a
false embroidery technique. These bags have come to be
commonly known as cornhusk bags. The earliest were large
and had a leather thong or hemp cording cinch at the top.
The cornhusk decoration was limited, allowing the hemp
twine that formed the body of the bag to show extensively.

 This bag is an example of this early style of decora-
tion. Here some of the cornhusk has been dyed green to
contrast with the brown hemp and natural buff color of the
undyed cornhusk. Triangular cornhusk designs alternate
with the natural hemp background to form an interlocking
grid of positive and negative triangles. Plateau twined bags
very rarely have identical designs on both sides. In this
case, the opposite side is composed of a solid cornhusk pat-
tern of alternating green and yellow diamonds.

 A small leather patch has been sewn on the right side
of this bag, indicating that it was well used before it was
collected.

12. **Flat Twined Bag** Plateau; early 20th century
Hemp twine, cornhusk, buckskin, wool yarn; 42 cm x 32 cm
Collection of Wayne Badovinus
Photograph by Paul Macapia and Ray Fowler

This bag shows the evolution of twined bag styles that
occured in the late nineteenth and early twentieth centu-
ries. Bags began to be made in smaller sizes, and were
carried by women as purses. At the same time, the corn-
husk decoration became more extensive, covering nearly
the entire surface. Wool yarn was combined with the corn-
husk for false-embroidered designs. The top rim of this bag
is reinforced with leather, and the hemp twine only shows
at the very bottom edge and on the inside.

 On this bag, undyed buff cornhusk is combined with
red, black, and blue wool yarn to form a pattern that com-
pletely covers the surface. On one side two delicate trees,
one blue and one red, have tapering trunks and diagonal
branches with small diamond leaves. They are flanked by
vertical black bands with projecting triangles. This "Tree of
Life" motif is found on other twined and beaded bags from
the Plateau (Cheney Cowles Memorial Museum 1974: 9).
On the reverse, a large bold hourglass and flanking trian-
gles in red and blue are bordered by stepped black squares.
The hourglass pattern is closely related to Plateau painted
rawhide and beadwork designs.

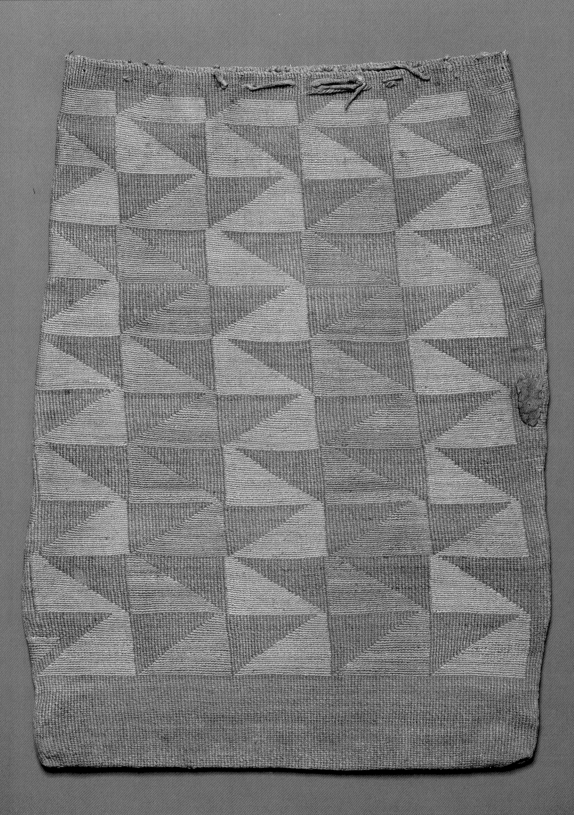

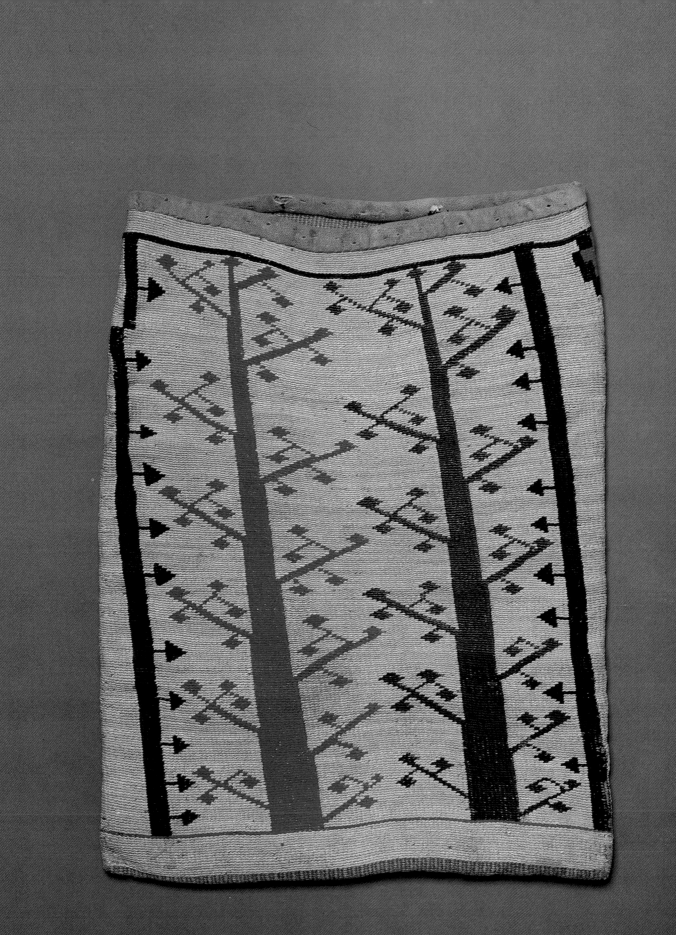

13. **Horse Drape** Nez Perce(?); early 20th century
Cornhusk, cotton string, wool yarn, glass beads, metal bells, canvas, muslin, leather; 141 cm x 31.8 cm without fringe

14. **Horse Collar** Nez Perce(?); early 20th century
Cornhusk, cotton string, wool yarn, canvas, cotton, silver thread, silk cloth, tin tinklers, German silver sequins; 64.8 cm x 94 cm
Museum of Native American Cultures
Photograph courtesy of the Museum of Native American Cultures

This unusual horse collar and drape—a matched set—are constructed of pieces of twined cornhusk bags. The horse drape (sometimes called an epishamore) is made in the form of a double saddle bag, so named because it usually has pockets at either end that can be stuffed with goods. It is hung across the rump of the horse behind the saddle (see Loeb, fig. 3, this volume). No pockets are sewn on this piece which should more properly be called a horse drape or throw. The horse collar (sometimes called a martingale) derives its shape from the form of decorative shoulder bags (bandoleer bags) that began to be used on the Plateau in the late nineteenth century. Plateau people hang them around the necks of parade horses, primarily those of women. As the horse moves, the long buckskin fringes sway gently and the bells and tin tinklers jingle.

Horses, introduced into North America by the Spanish in the sixteenth century, were traded through Native networks into the Plateau sometime during the eighteenth century, well before Plateau people had any direct contact with Euro-Americans. Horses soon became important in Plateau culture as both a form of wealth and a means of increased mobility. On special occasions, horses were dressed in elaborately decorated horse gear, including beaded horse collars, bridle ornaments, saddles, cruppers, saddle blankets, and saddle bags or horse drapes or throws.

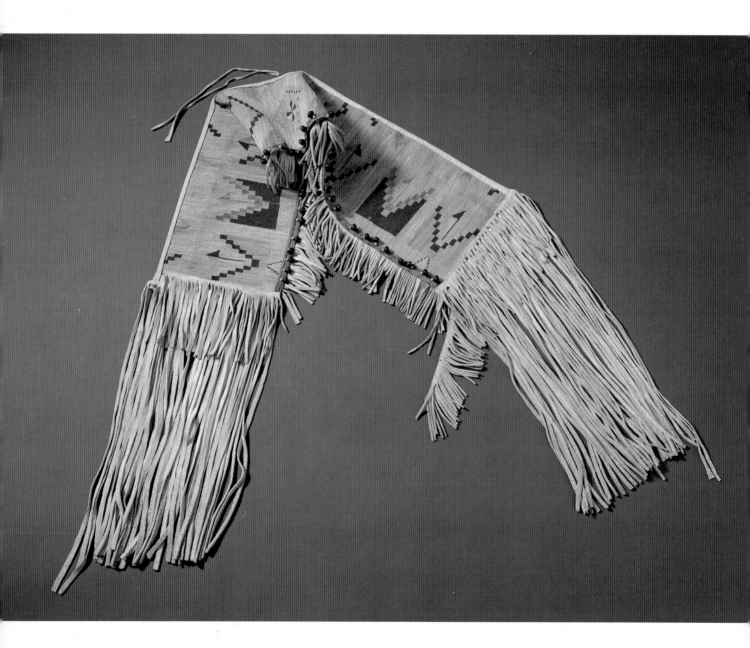

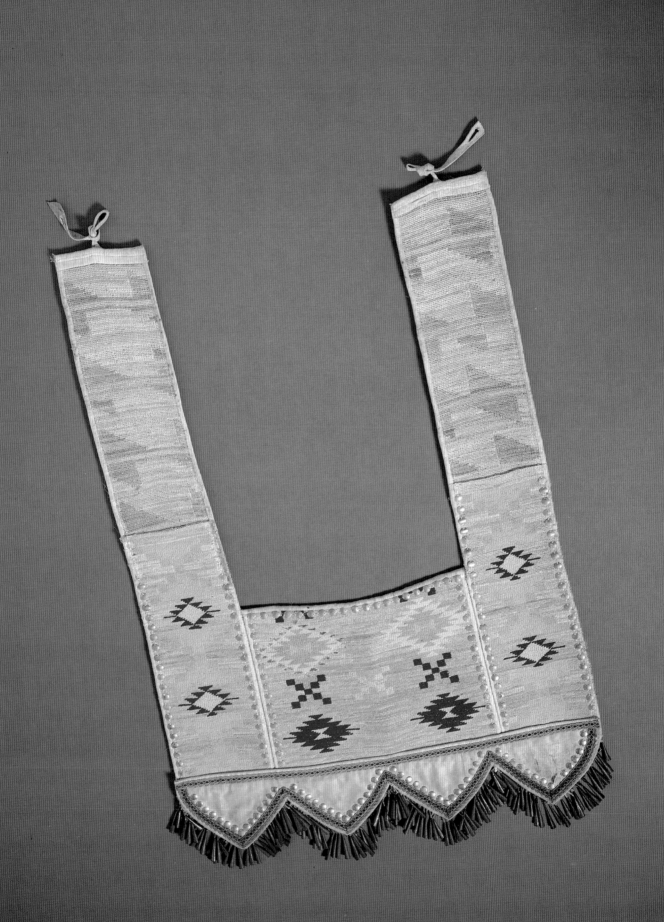

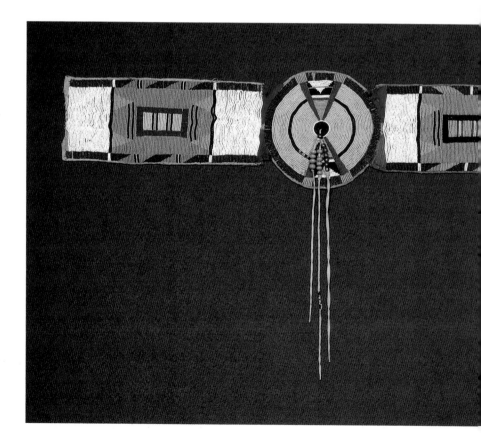

15. **Robe** Transmontane style; late 19th century
Elk skin, porcupine quills, horsehair, glass beads; 217.5 cm x 160 cm
Honnen Collection
Photograph by Paul Macapia and Ray Fowler

This robe is decorated with a rare strip of quill-wrapped horsehair "rosettes" combined with beadwork. On the Plateau and Plains, a distinctive way of decorating animal skin robes was developed. When skinning out a large animal, women sometimes split the hide down the backbone, then sewed the halves back together. The seam was covered with a long, narrow decorative strip of quillwork, and later, beadwork. When worn, the robe was wrapped around the body with the decorative strip running horizontally.

This unusual blanket strip combines beadwork and quill-wrapped horsehair. The five circular "rosettes" are each made of a spiraling bundle of horsehair with natural white, red, and yellow-dyed porcupine quills sewn down over it. This forms a pattern of broken concentric circles with triangular wedges of red, yellow, blue, and white at the top and bottom. Long quill-wrapped buckskin tassels hang from the center of each rosette. The long rectangular beaded panels between the rosettes display the geometric diamond patterns with a light blue beaded background, typical of the Transmontane style (see Loeb, this volume). This blanket strip is sewn onto a separate pieced-together strip of buckskin. Usually, as in this case, decorative strips are reattached to new robes as the old robes wear out.

16. **Blanket Strip** Walla Walla; late 19th century
Buckskin, glass beads, brass beads, red trade cloth; 150 cm x 16.4 cm
Burke Museum #2-11569; collected by H. E. Holmes between 1872 and 1880; gift of the H. E. Holmes estate, received 1928
Photograph by Paul Macapia and Ray Fowler

This blanket strip is a classic example of the Transmontane style of beadwork made in the eastern Plateau. Composed of triangles, rectangles, and hourglass shapes, this geometric style of beadwork is closely related to designs painted on rawhide containers (pl. 17). The circular rosettes separated by rectangular panels are derived directly from the form of porcupine-quill rosettes (pl. 15).

This blanket strip is made entirely of glass trade beads sewn on pieces of buckskin; red trade cloth inserts fill in around the rosettes. Large blue and brass trade beads hang on the tassels at the centers of the three rosettes. The rosettes consist of concentric circles of yellow and blue, with wedges of red, blue, and white intruding at the top and bottom. The beaded panels between the rosettes have solid white areas bordered by either red or blue beads. The colorful rectangular panels have pink background areas with diagonally striped blue borders. Light blue triangles connected at their apexes by thin blue lines flank long rectangular central designs.

The Sahaptin word for blanket strip is *čálšt'xi*.

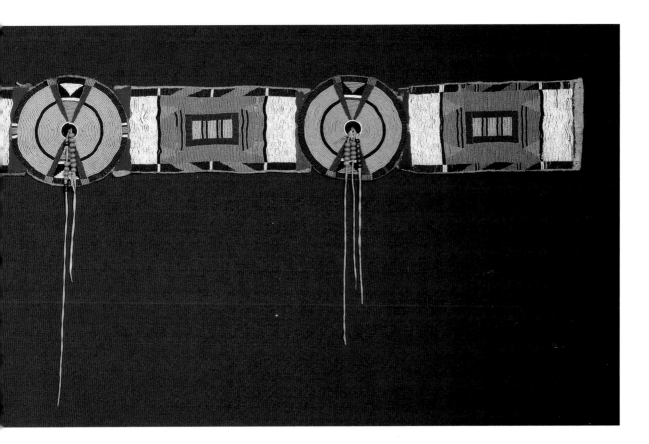

17. **Flat Case** Plateau; early 19th century

Rawhide, paint; 38 cm x 27 cm without fringe
National Museum of Natural History, Smithsonian Institution #2618; collected by the Wilkes Expedition, 1841
Photograph courtesy of the Smithsonian Institution

The bold design on this rawhide case is a prime example of Columbia Plateau artistry. This old style of painted design probably predates the introduction of glass beads to the Plateau and may have directly influenced the development of the Transmontane style of beadwork, as well as the geometric patterns used on Plateau twined basketry bags.

Painted rawhide containers were made in several shapes on the Plateau. Folded rectangular cases known as "parfleches" were used to store clothing and preserved foods. Cylindrical cases were used as quivers and bonnet cases. These often have long buckskin fringes and were hung from saddles along with other decorative horse gear. In addition, a smaller, envelope-shaped rawhide case with long fringes was often used as a type of saddle bag or for the storage of smaller objects.

Though the records of the Wilkes Expedition do not indicate where the case was acquired, an inscription on its back names two individuals, Waldron and Fox, who were members of this expedition.

18. **Bowcase-Quiver** Transmontane style; mid-19th century

Otter skin, trade cloth, glass beads; 127 cm x 83.8 cm
Honnen Collection
Photograph by Paul Macapia and Ray Fowler

Bowcase-quivers are perhaps the most elaborate objects decorated in the Transmontane style of beading. Though a practical container for a bow and arrows, the heavily beaded flaps and tabs combined with the richness of the otter fur and trade cloth make these objects true works of art. Worn on dress occasions, such a quiver displayed the wealth and prestige of the owner and the skill of the beadworker. These quivers were made primarily by the Nez Perce people and their neighbors on the Plateau. This is one of only six unaltered and complete otter skin bowcase-quivers known.

Made of three otter skins, this bowcase-quiver is constructed in the classic fashion (Holm 1981). Two otter skins are each sewn into a tube and used for the bowcase and quiver. The tails of the otter skins form the solidly beaded flaps. A third otter skin is split in half lengthwise and the halves sewn end-to-end to form the strap (bandoleer). Where the bowcase and quiver are attached to the strap, decorative beaded tabs are added. The fur trimmed from the edges of the otter skins is cut into strips and used for fringe at the bottoms of the quiver and bowcase and at the ends of the tabs on the strap.

As with many of the Transmontane-style beaded objects, otter skin quivers have often been associated with the Crow people of Montana. However, most documentary evidence indicates that these quivers were used extensively by the Nez Perce people and their Plateau neighbors. Interestingly, an otter skin quiver flap (Burke Museum #70) was collected by Rev. Myron Eells from Joseph Kapomen at Quinault, further evidence of the active Native trade networks within what is now Washington State.

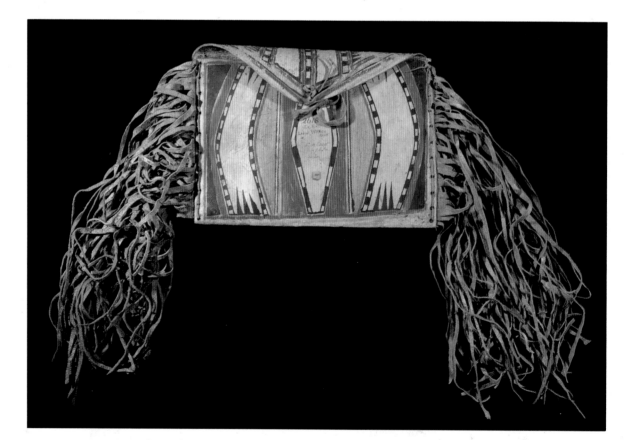

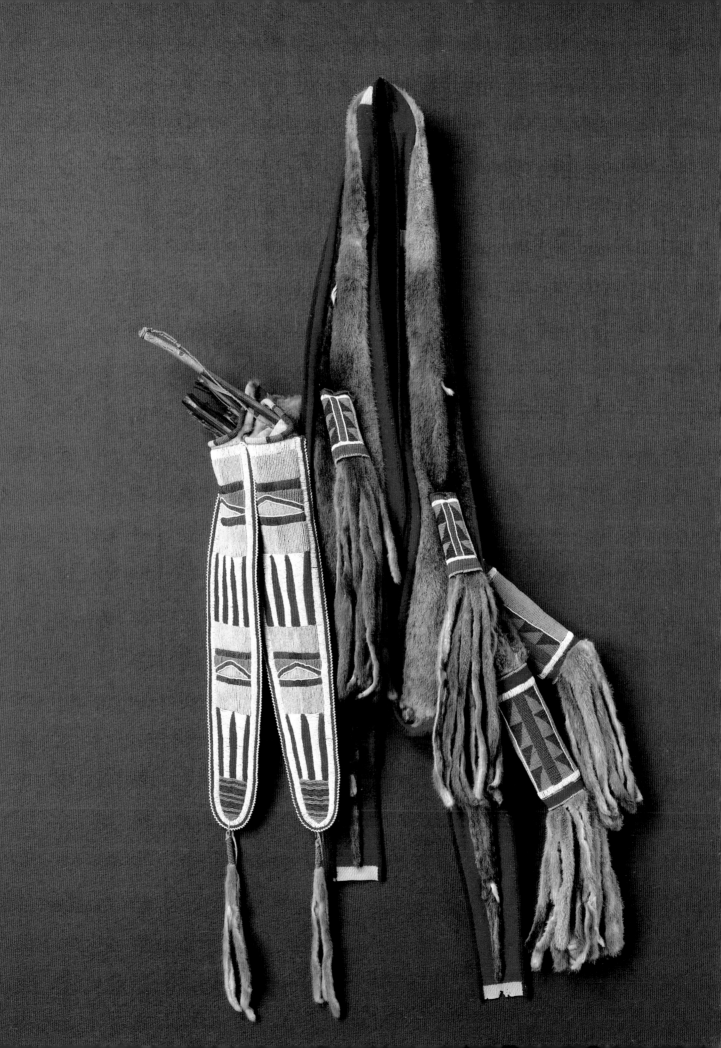

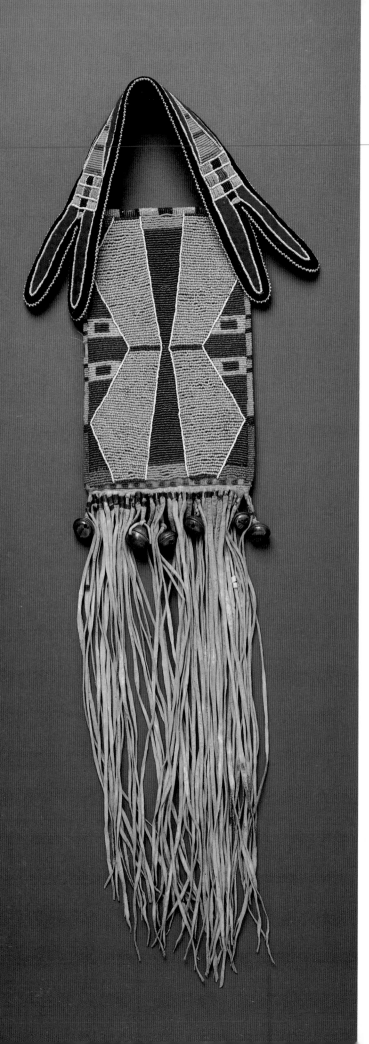

19. **Mirror Bag** Transmontane style (collected from the Yakima); late 19th century

Trade cloth, buckskin, brass bells, glass beads; 22 cm x 14 cm (bag only)

Collection of Bill and Marty Holm

Photograph by Paul Macapia and Ray Fowler

In the nineteenth century, small flat beaded bags with a handle and long fringe were used by men to hold mirrors used in applying their facial paint. These continue to be an important part of many well-dressed dancers' outfits today.

This mirror bag displays all of the classic features of the Transmontane style of beadwork: the hourglass, triangular, and rectangular shapes constitute the design; light blue beads form a background that vies with the other shapes for attention; single white bead rows border design areas. As with all mirror bags and most cornhusk bags, the designs of the two sides differ, offering subtle variations on the geometric forms. This mirror bag is beaded with extremely fine, faceted beads. The handle was added recently to replace the missing original handle.

20. **Beaded Bag** Yakima; mid- to late 19th century

Buckskin, trade cloth, glass beads, brass buttons; 29 cm x 30 cm

Museum of the American Indian, Heye Foundation #11/6672

Photograph by Nancy Morningstar, courtesy of the Museum of the American Indian

Floral beading styles may have been brought to the Plateau by Cree and Ojibwa people who worked for the fur-trading companies in the early nineteenth century (see Duncan, this volume). This Yakima beaded bag shows the influence of these more northern and eastern styles of beadwork. Parallel rows of beads that outline the floral elements and fill the inner spaces in contoured rows are characteristic of Plateau floral beadwork.

Just as the early Plateau twined bags have a minimum of cornhusk false embroidery, allowing large areas of hemp twine to show on the surface, mid-nineteenth-century beaded buckskin bags from the Plateau often show open areas of buckskin, which may reflect the scarcity of glass trade beads at this early period.

Beads were applied with the overlay, or couching, technique in which strings of beads are stitched down at intervals with a second thread. This technique allows for curvilinear patterns of beads laid out in parallel rows along the contour of the patterns. As with most Plateau beaded bags, this bag is beaded on only one side with plain red trade cloth on the back.

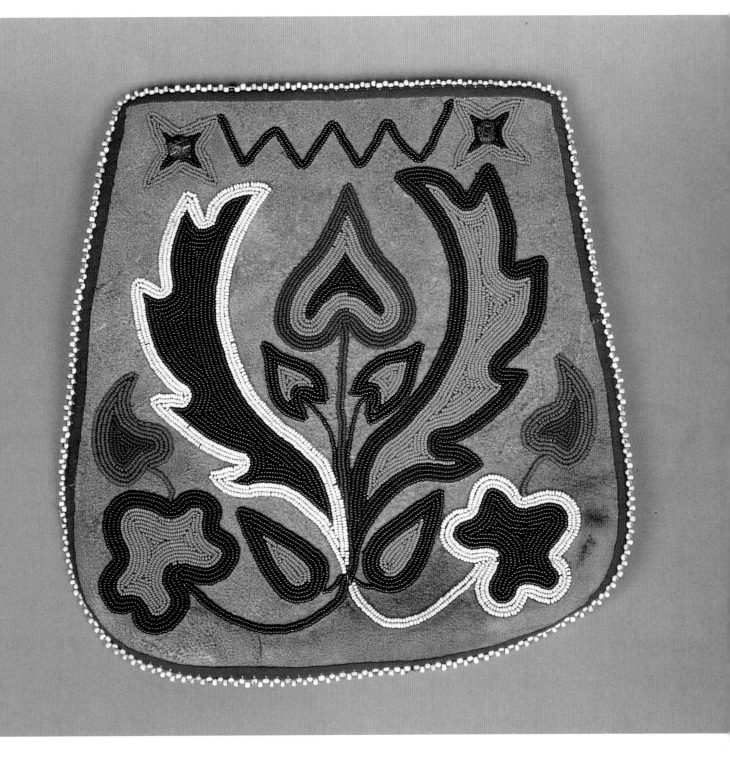

21. **Double Beaded Bag** Yakima; late 19th century

Trade cloth, buckskin, glass beads, brass buttons, commercial fringe; 28.5 cm x 31 cm

National Museum of Natural History, Smithsonian Institution #23873; collected by Rev. James Harvey Wilbur; received in 1875

Photograph courtesy of the Smithsonian Institution

This vibrant woman's saddle pouch displays the contoured style of Plateau appliquéd beadwork. The floral patterns are outlined in beads, and the background is filled in completely with rows of beads that follow the contour of the floral designs. Actually a double pouch, the two complete bags are attached at the top. The piece probably would have been placed over the saddle horn with the two bags hanging at opposite sides.

One bag shows a three-part floral design with a white and blue background; the other, strikingly different, has a bold, central, eight-petaled flower outlined in yellow, with lobes of red, blue, black, and yellow around it .

This double bag was collected by Rev. James Harvey Wilbur, a Methodist missionary who served as the Indian Agent for the Yakima Agency at Ft. Simcoe from 1862 until 1882.

The Sahaptin word for beaded bag is *supk'uk't kàpi̇t*.

22. **Woman's Leggings** Umatilla; late 19th century

Trade cloth, glass and metal beads; 40 cm x 36 cm each

Collection of Bill and Marty Holm

Photograph by Paul Macapia and Ray Fowler

Symmetrical floral designs in contoured beading wrap around the lower leg to form an elegant display of curves and color that would be visible just above a woman's moccasins and below the hem of her dress. These leggings show the white undyed selvedge of the red woolen trade cloth, called stroud, because it was made in Stroud, England.

Highlighted by a flare of yellow beads and the glimmer of a few faceted metal beads, the tiny faceted blue glass trade beads on these leggings define a row of abstract flowers growing along an undulating baseline. A few green beads pick up the color of a narrow strip of green trade cloth sewn on the bottom edge and up one side.

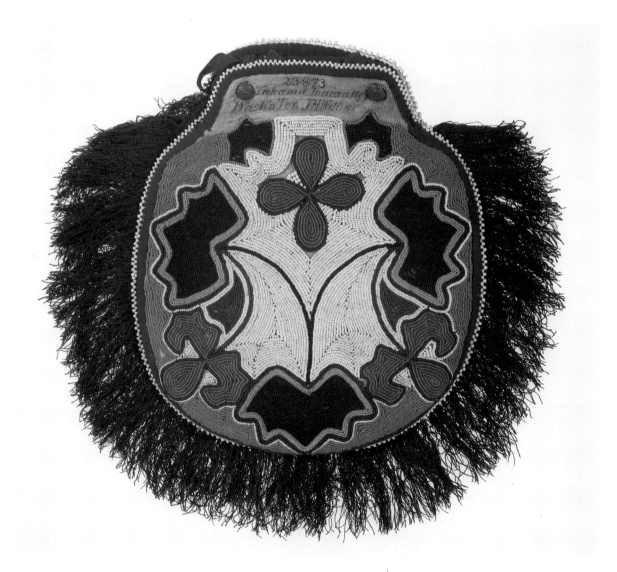

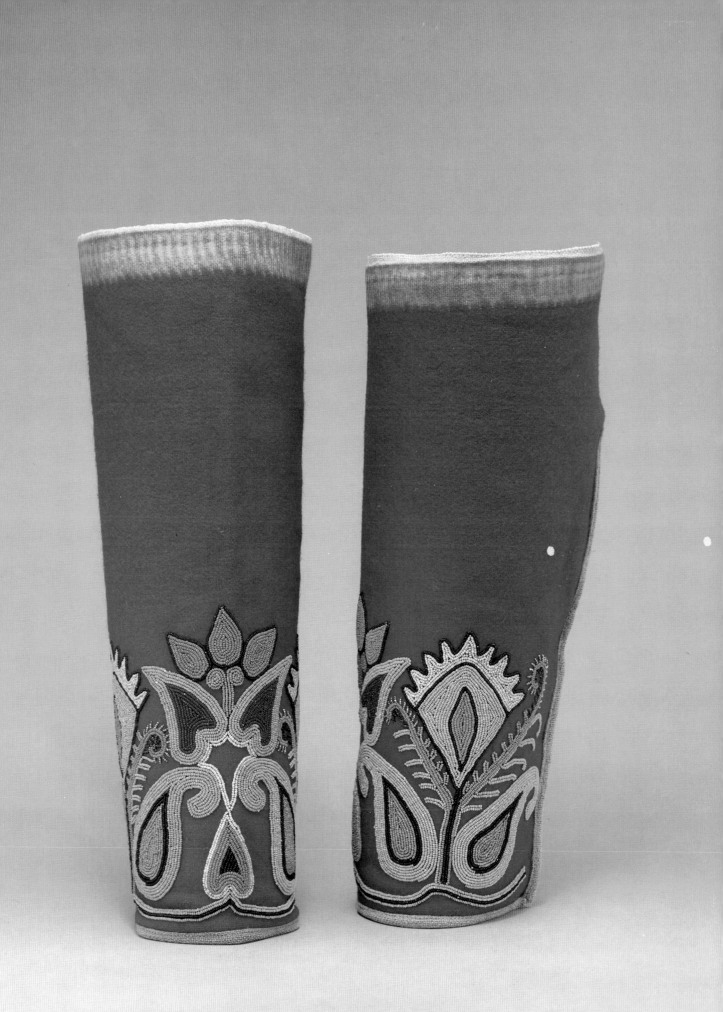

23. **Man's Vest** Yakima Reservation; late 19th century

Black velvet, cotton trade cloth, glass beads; 58.5 cm x 46 cm

Burke Museum #2-482; collected by Mrs. L. J. Goodrich, 1904; purchased from the estate of Mrs. Goodrich through Mrs. Paul D. Moran; received 1932

Photograph by Paul Macapia and Ray Fowler

This vest represents a new type of clothing, decorated in the classic late nineteenth-century style. By this time, traditional clothing made of buckskin had already become heirlooms worn only on special occasions, and the new styles of Euro-American clothing had been adopted. Tailored vests, shirts, and pants were worn by Plateau men on a daily basis, and beaded vests such as this one became an important new type of dress clothing.

Here, contoured beadwork outlines and fills in the floral designs. Leaves and various forms of buds and flowers, including one pansy-like, grow from a central stem on each side of the vest; two butterflies alight on these flowers. Rather than continuing the curvilinear patterns in the background, as was done on the double beaded bag (pl. 21), this beader has filled in with nearly horizontal rows of white beads. The back of the vest is black cotton; the striped cotton lining has a tiny fleur-de-lis pattern. Black velvet strips are sewn on as a border, and a small floral beaded design decorates the back of the vest.

The Sahaptin word for beaded vest is *wáqalpii*.

24. **Beaded Bag** Yakima (collected from the Snoqualmie); early 20th century

Brown velvet, cotton and wool trade cloth, buckskin, glass beads; 33.5 cm x 29 cm

Burke Museum #2-1537; purchased from Mrs. Jerry Kanim and Mrs. Evelyn Ennick (daughter); received 1944

Photograph by Ray Fowler

This beaded bag is a masterful example of the pictorial style of Plateau beadwork. Two types of horses are readily recognizable, an Appaloosa in the back and a smaller pinto in the foreground. During the late nineteenth century, Plateau beaders began to produce complex pictorial designs. These could combine human figures, animals, buildings, lettering, and floral motifs. Using a double row of beads for the contour of the horses, this beader has filled in the horses with straight vertical rows of beads and the background with straight horizontal rows. This bag belonged to Jerry Kanim, a Snoqualmie leader, who won it gambling and used it to carry his gambling equipment.

Gambling is an intertribal activity carried on between groups of Native people from both eastern and western Washington. The guessing game known as *slahal*, the bone game or the stick game, is played with two sets of bones. One of each pair is marked, and two teams compete to guess in which hand the unmarked bone is hidden. Score is kept with long wooden sticks used as counters. Today, as in earlier times, this type of gambling is a popular recreation. Singing and drumming accompany the action, to help each team to win. It is said that this game was also played to test the spiritual power of the thoughts and songs of the participants.

Yes, I remember Jerry Kanim. He used to gamble a little bit when I was a kid. My dad was one of his players. He used to fool with people a little bit. He had a lot of good stories. There was one I remember—he was gambling once and when the other side threw the bones back, one of them split in half. He picked it up and no one on the other side noticed. He held the pieces tight together then threw them up into the air. They stayed together. As it came down, he hollered and pointed at it and it split in half. The players on the other side sure got big-eyed. After that he began to win.
—Kenneth Moses, Snoqualmie

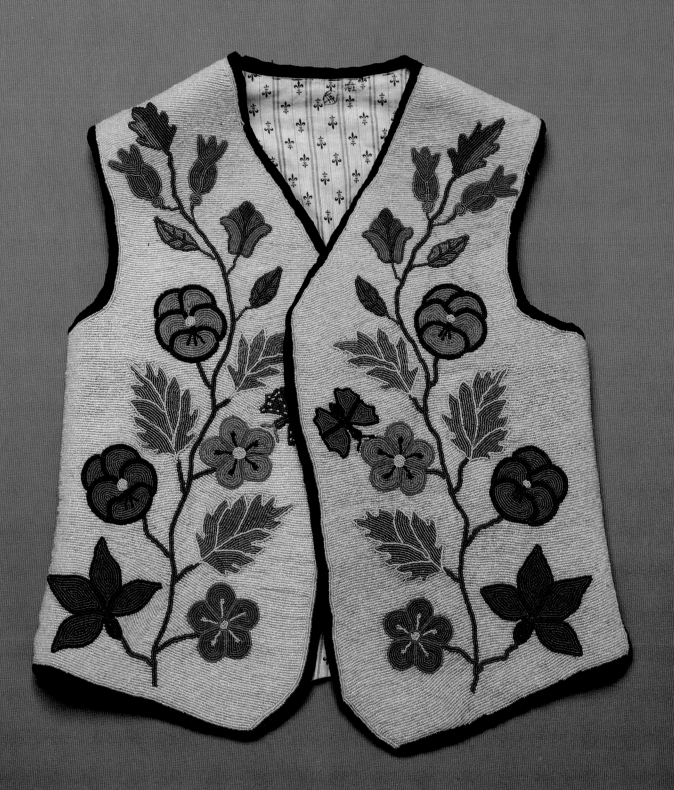

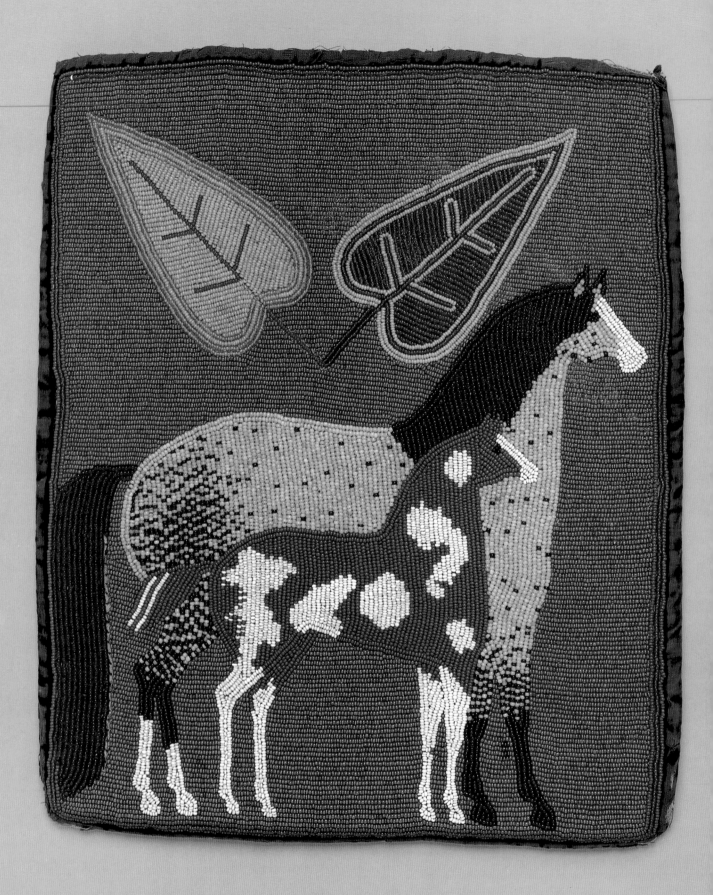

25. **Tobacco Bag** Cascade (?); mid- to late 19th
 century
 Leather, cotton string, glass beads; 19 cm x 8 cm
 Denver Art Museum #1965.271; originally from the
 Maryhill Museum of Art (#LR87-57), the Mary
 Underwood Lane Collection
 Photograph courtesy of the Denver Art Museum

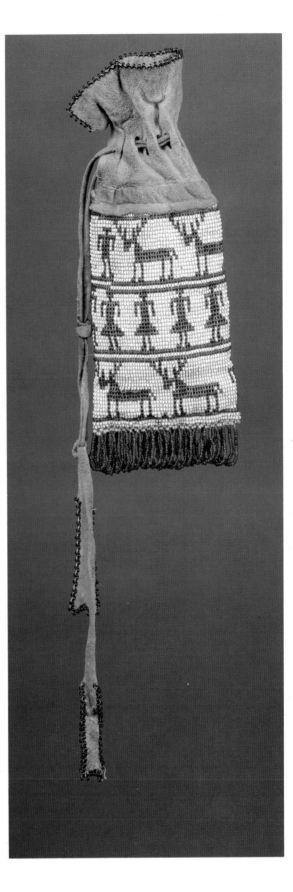

The three bags in plates 25, 26, and 27 are made with a
rare woven beadwork technique. On the Plateau, woven
beadwork was produced during the nineteenth century by
only a few beaders who lived along the Columbia River in
the area of The Dalles. Though very little documentation
for this style of woven beadwork exists, the representations
of human figures, birds, animals, and fish found on woven
beadwork are nearly identical to those used on Wasco/
Wishram twined basketry bags from the same area (pls. 28,
29).

Woven beadwork needs no backing material and con-
sists of a consolidated fabric made up of warp threads and
double weft strings that hold the beads in horizontal rows.
It may be that the technique of weaving beads was intro-
duced to this area by the same Cree and Ojibwa fur traders
who introduced the floral beadwork styles in the early nine-
teenth century (see Duncan, this volume). There are
several Native American techniques for weaving beads. The
most common is to lay a string of beads across a suspended
warp and sew a second weft thread through the beads on
the other side of the warp. A different Plateau woven bead-
work technique is more directly related to techniques of
twined basketry.

This bag, like the one in plate 26, was woven as a
cylindrical tube sewn shut at the bottom, with no seams on
the sides. This bag was produced without the use of a
loom, which would have resulted in a rectangular panel
folded and seamed to make a tube. Two weft threads pass
through each bead and twist between each warp. The weft
threads spiral around the tube very much as basketry weft
threads spiral around a round basketry bag. Thus, there is a
connection not only between the motifs of Wasco/Wishram
basketry and woven beadwork, but between the techniques
of weaving baskets and beads. Here the figures stand on
baselines arranged in horizontal bands that extend around
the tube. A row of female figures, wearing skirts, occupies
the middle band, with deer or elk above and below. Male
figures alternate with the animals.

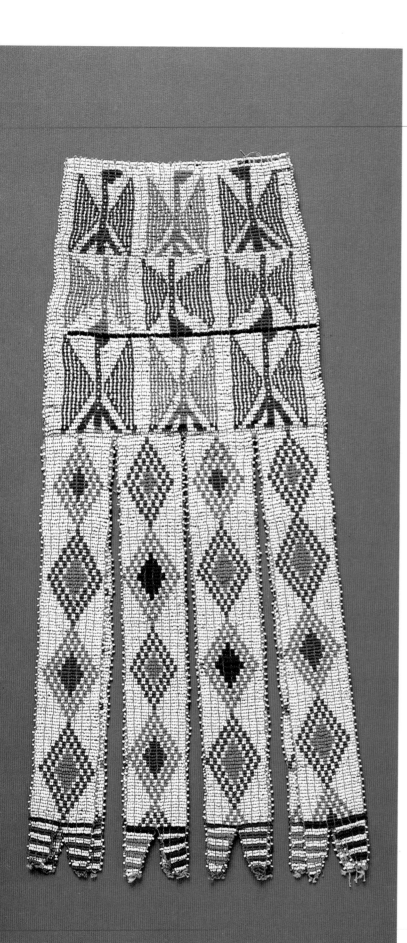

26. **Octopus Bag** Cascade (?); mid- to late 19th
century
Cotton string, glass beads; 43 cm x 17.5 cm
Maryhill Museum of Art #44-68; gift of the estate of Mary
Underwood Lane, received 1940
Photograph by Paul Macapia and Ray Fowler

Beaded "octopus bags," named for the tentacle-like pen-
dants that hang from the bottom, were made by Native
people across North America, from the Creek of the South-
east to the Tlingit of the Northwest Coast. Their designs,
techniques of beadwork, and variations in form sometimes
allow their attribution to specific tribal groups. This
octopus bag clearly falls within the Wasco/Wishram style of
woven beadwork.

The designs on the two sides of this bag are different.
Nine bird figures occupy one side (compare the bird figures
in pl. 29). The three "birds" in the center row appear to be
upside down, with their triangular heads at the bottom,
and lacking the three-part tails seen on the other birds. Per-
haps these tailless figures are butterflies. The opposite side
of this bag is decorated with five large diamonds composed
of stepped squares, with small four-legged animal figures
on either side. These animals are very similar to those
found on the Lewis and Clark basket (pl. 8). Rather than
being arranged on a baseline, they seem to float and fill in
the background areas around the central diamond patterns.
The pendant tabs at the bottom are decorated with dia-
monds on one side and triangles on the other.

Both this octopus bag and the preceding tobacco bag
(pl. 25) belonged to Mary Underwood Lane. Born in 1864,
she was the daughter of Ellen Chenoweth and Amos
Underwood. Ellen Chenoweth, born in 1841, was the
daughter of Chief Chenoweth of the Cascade Tribe. Mary's
father, Amos Underwood, who had moved to Oregon from
Missouri in 1852, married Ellen Chenoweth in 1861. It is
said that the objects donated to the Maryhill Museum of
Art by Mary Underwood Lane in 1940 were her mother's
heirlooms. Ellen Chenoweth may not have made these
bags, but their association with her helps us to identify this
style of beadwork with the Upper Chinookan–speaking
peoples of The Dalles.

27. **Panel Bag** Wasco/Wishram (Cascade?); early to
 mid-19th century
 Glass beads, trade cloth, yarn; 27.4 cm x 16 cm without
 handle
 Natural History Museum of Los Angeles County
 #A.5697.69; collected by Dr. William F. Edgar,
 1849–1850
 Photograph courtesy of the Natural History Museum of Los
 Angeles County

Panel bags are named for the solid decorative panel that
hangs below the bag. As with octopus bags, panel bags
were made by Native people throughout North America.
This panel bag is the only known Plateau example of its
kind with woven beadwork. Dr. William Edgar, an Assis-
tant Surgeon with the United States Army, probably
collected this bag while he was in the Oregon Territory
between 1849 and 1850, and thus provided us with the ear-
liest documentation for this style of beadwork.

Here the woven beadwork that forms both the panel
and the strap is combined with a trade cloth bag decorated
with appliquéd beadwork in simple leaf-like patterns. Birds,
animals and fish decorate the lower beaded panel. Similar
in form to the birds on both the beaded octopus bag (pl.
26) and the twined basket (pl. 28), these birds are arranged
head to head. At the top center of the panel four fish are
arranged with their heads down. These, too, are typical of
fish found on Wasco/Wishram basketry.

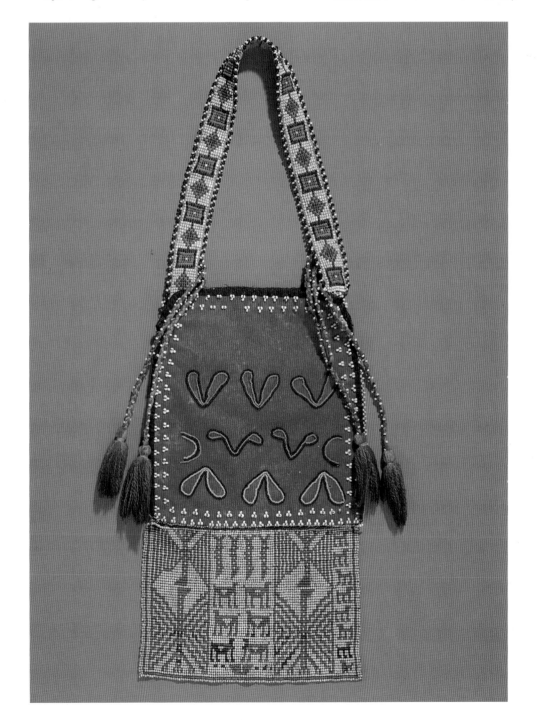

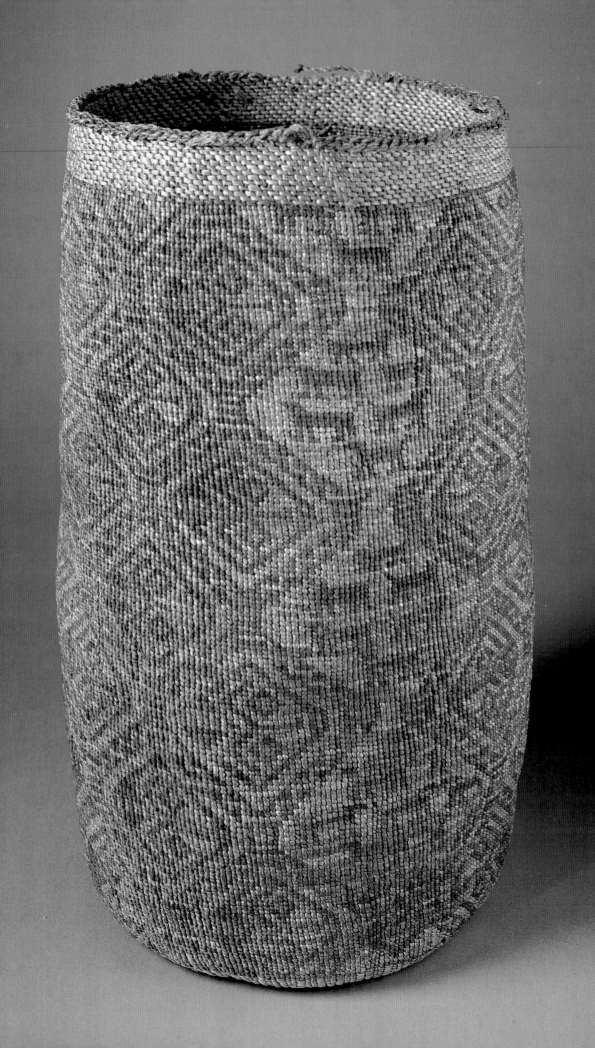

28. **Round Twined Bag** Wasco/Wishram; late 18th
to early 19th century
Vegetable fiber; 17 cm x 30 cm
Peabody Museum of Archaeology and Ethnology, Harvard
University #53160; collected by the Lewis and Clark
Expedition, 1805–1806; received in 1899 from the Bos-
ton Museum, gift of the heirs of David Kimball
Photograph by Hillel Burger, courtesy of the Peabody
Museum, Harvard University

This is the earliest documented Wasco/Wishram basket; it
was collected by the Lewis and Clark Expedition in 1805–
1806. Until recently, the antiquity of the Wasco/Wishram
human and animal designs had been in question; this bas-
ket confirms that these designs were well established at the
time of first contact with Euro-Americans (Schlick 1979).
Stylistic similarities between these basketry designs and pre-
historic bone and stone sculpture from the area indicates
that this design system had a long prehistoric development
among the people of the Columbia River (compare pl. 77).

The two basic basketry techniques used by Native peo-
ple throughout the Northwest Coast and Plateau, twining
and coiling, were also developed in ancient times (see Mil-
ler, this volume). Twined cylindrical Wasco/Wishram
basketry bags such as this one were made with a variety of
soft vegetable fibers. Two-ply hemp twine was often used
for the warp threads; cattail, other rush and grass fibers, and
cornhusk (in later times) were used for the wefts and warps.

A combination of plain- and wrapped-twining is used
on Wasco/Wishram baskets. The areas covered with designs
utilize a wrapped-twined technique which differs slightly
from the Makah wrapped-twined technique (pl. 37). In
Wasco/Wishram wrapped-twining, one plain and one col-
ored weft are carried continuously along, with the dark and
light wefts being alternately brought to the outside to create
the design. With Makah wrapped-twining, a straight weft
strand remains always on the inside of the basket, while dif-
ferent colors of weft strands are alternated to ornament the
outside.

This round bag has a band of plain-twining at the top
and, below, is covered all over with a wrapped-twined
design consisting of diamond-shaped human heads on their
sides, each enclosed within a diamond that is connected to
the neighboring diamond in a grid-like pattern. Breaking
this overall pattern is a column of open diamonds on one
side that contain images of four-legged animals, perhaps
dogs, wolves, or coyotes. These are very similar to the ani-
mals depicted on the woven beaded bags from this same
area (pl. 27).

*These faces on the basket might represent Tsagagla'lal, She-
Who-Watches.*

—Agnes Tulee, Yakima

29. **Round Twined Bag** Wasco/Wishram; mid- to
late 19th century
Vegetable fiber; 17.5 cm x 15.5 cm
Collection of Jerrie and Anne Vander Houwen
Photograph by Paul Macapia and Ray Fowler

The woman who twined this basket displayed her virtuosity
in the small and even twists of the weft strands, as well as
in the subtle variations in the patterns of the birds' wings
and human bodies. Stair-stepped patterns decorate the top

and bottom birds' wings, while the center birds have
straight-sided triangular wings. This arrangement is echoed
in the ribs of the human figures. The Wasco/Wishram bas-
ketry style of depicting the human form—diamond-shaped
heads and eyes, connected V-shaped eyebrows below a tri-
angular lock of hair parted in the middle, and straight
narrow noses—was very consistent throughout the nine-
teenth and early twentieth centuries. Though later in date,
this small, finely twined bag displays the same type of
human head found on the Lewis and Clark bag (pl. 28). In
this case, the heads are attached to bodies, which are
depicted with sharp angular shoulders, long arms, and
short straight legs. The skeletal nature of these figures—
visible ribs and bony limbs—link this style of basketry with
prehistoric stone, bone, and horn sculpture from this area.
The three human figures alternate with three frog-like
creatures, and there are six birds and eight deer-like ani-
mals each with two short horns.

Sometimes known as "Sally Bags," round twined bags
are called *akw'ałkt* in the Wishram language.

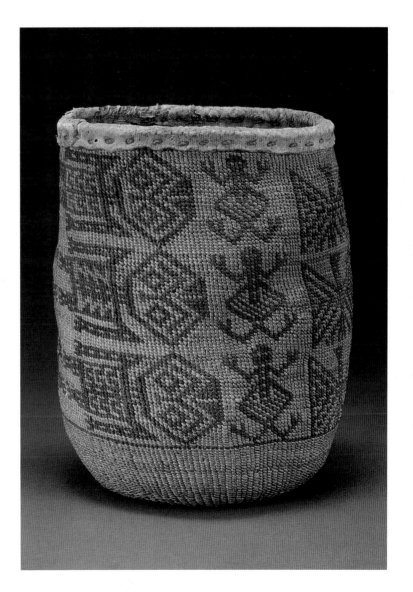

30. **Coiled Basket** Klickitat; early 19th century
Cedar root, beargrass, cedar bark(?), horsetail root (?), leather;
14.5 cm x 6 cm x 6 cm
British Museum #42-12-10-72; collected by Captain
Belcher, 1839
Photograph courtesy of the British Museum

Five human figures stand stiffly in a row on one side of this oblong basket, while two rows of diamond patterns occupy the opposite face. The depiction of human figures on coiled cedar root baskets, as on twined baskets, was done at a very early date. This Klickitat basket was collected in 1839 by British sea captain Edward Belcher.

Cedar root baskets are known as *capxmi* in the Sahaptin language. Cedar root is peeled and split. The rough inner part of the root is used for the inner coil bundles that spiral around; the shiny outer surface, from just below the bark, is split to make the sewing elements that are stitched around the bundles, sewing each coil to the coil below. Coiled baskets are decorated by a technique known as imbrication. Decorative materials such as beargrass, cherry and cedar bark, and horsetail root strips are folded accordion-style, and sewn down with the cedar root on the outside of each coil. Thus the design shows only on the outside of the basket.

Human figures from this early period do not include any indication of clothing that would reveal their sexual identity, though by the late nineteenth century such clothing was sometimes depicted on coiled basketry. In this case, the torsos are long rectangles with small block-like heads or necks; long straight arms and short legs end in block-like hands and feet. It appears that the heads of these figures are missing from the rim, and that only the necks are indicated, but the basket must have been considered finished in this form, since four leather ties attached to the rim indicate that there was once a lid fastened at these points.

This basket looks unfinished because it doesn't have any space at the top—after the pattern. Sometimes, if a basketmaker died and her family wanted someone to have her last work, they would just end the basket where she left off.
—Leona Smartlowit, Cayuse/Umatilla

31. **Coiled Basket** Klickitat(?); late 19th century
Cedar root, beargrass, cedar bark, horsetail root; 46 cm x
23 cm x 17 cm
Collection of Wayne Badovinus
Photograph by Paul Macapia and Ray Fowler

The expert maker of this elegant basket achieved a very subtle variation of design by reversing the brown cedar bark and black horsetail elements on the two sides. The imbricated design covers the entire surface, and continues even in the alternating fully and partially imbricated coils on the bottom of the basket. The patterns on the long front and back faces of the basket are very similar, composed of a zigzag within a zigzag. The outer pattern consists of vertical stripes, and the inner is made up of horizontal stripes on both sides. On the front design, black is used for the vertical outer stripes while the brown is used for the horizontal inner stripes. On the back, the black and brown elements are reversed. On the narrow ends, double black lines crisscross to form a diamond grid pattern.

This basket has an oblong shape similar to the Belcher basket (pl. 30), and probably also once had a lid attached at three points, two in the back and one in the front. Both baskets may have been used to store personal items.

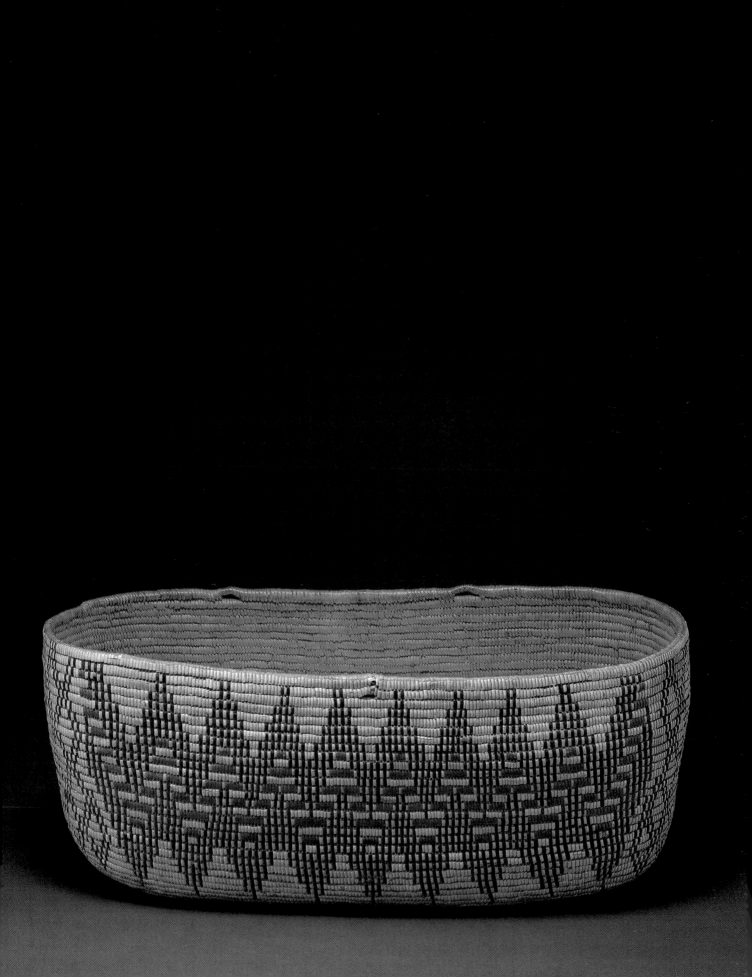

32. Coiled Basket Klickitat; early 20th century
Cedar root, beargrass, horsetail root; 31.5 cm x 28 cm
Burke Museum #2-2316; collected by Caroline McGilvra
Burke (Mrs. Thomas Burke); received 1932
Photograph by Paul Macapia and Ray Fowler

This finely coiled basket displays the complex zigzag pattern made famous by Klickitat basketmakers. Typical Klickitat baskets show a zigzag pattern, a looped rim, and have a flaring cylindrical shape. However, this basketry style is used by Yakima and other Plateau basketmakers as well.

Here, black-dyed horsetail root alternates with both natural beige and yellow-dyed beargrass in a continuous zigzag pattern. Plain beargrass negative spaces become positive triangular areas. It is interesting to note that the maker of this basket was not concerned with the fact that the upper points of the zigzags are cut off by the rim of the basket. As with cornhusk bag makers, the overall proportions of the bag or basket seem to govern the ending point, rather than the relative completeness or symmetricality of the design motifs.

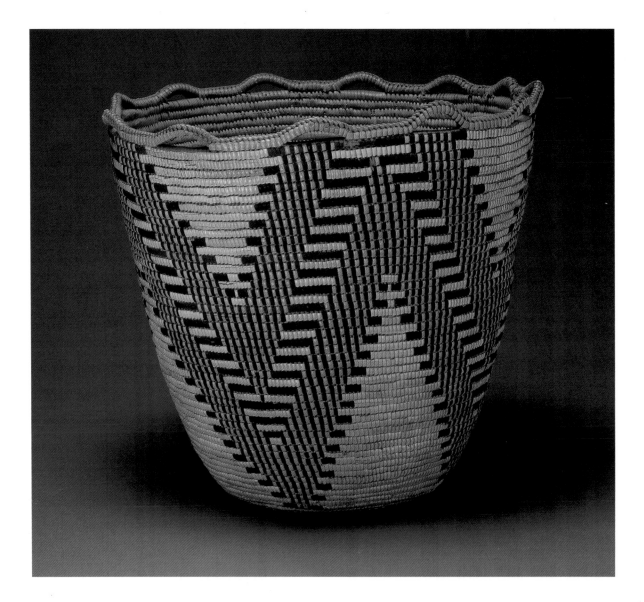

33. **Coiled Basket** Nisqually; late 19th century

Cedar root, beargrass, cedar bark, horsetail root, leather;
28.5 cm x 36 cm

Collection of John and Grace Putnam; collected by Judge
Wickersham, 1899; made by Si-a-gut

Photograph by Paul Macapia and Ray Fowler

This basket was purchased in July of 1899 from its maker, Si-a-gut, an expert basketmaker who was 80 years old at the time. It has an unusually complex design, closely related to the zigzag patterns of Klickitat baskets. The shape is typical of Puget Sound baskets, with a plain rim, oval cross section, and a bulging flare to the sides. Leather ties around the rim were used to attach a tumpline, a strap for carrying the basket.

Close social and trade contacts were maintained between the people inhabiting upper Columbia River areas and the lower Puget Sound. An inland trail between southern Puget Sound and the Columbia River provided a link between the Nisqually and Chehalis people and their Cowlitz and Klickitat neighbors. This closeness is reflected in the similarity of coiled basketry designs produced by these groups.

Here, vertical and horizontal bands of beargrass, cedar bark, and horsetail root imbrication unite in a complex zigzag pattern. The negative triangular spaces between the zigzags are only partially imbricated, exposing the brown cedar root sewing elements. Vertical zigzags and L-shaped bars decorate these open spaces.

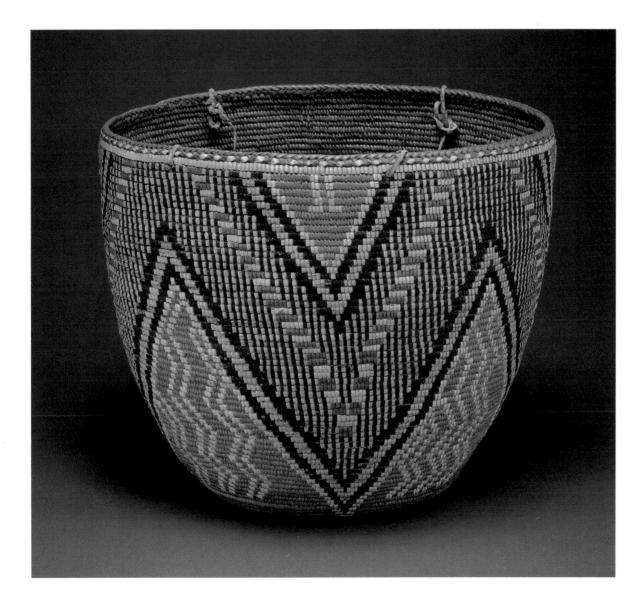

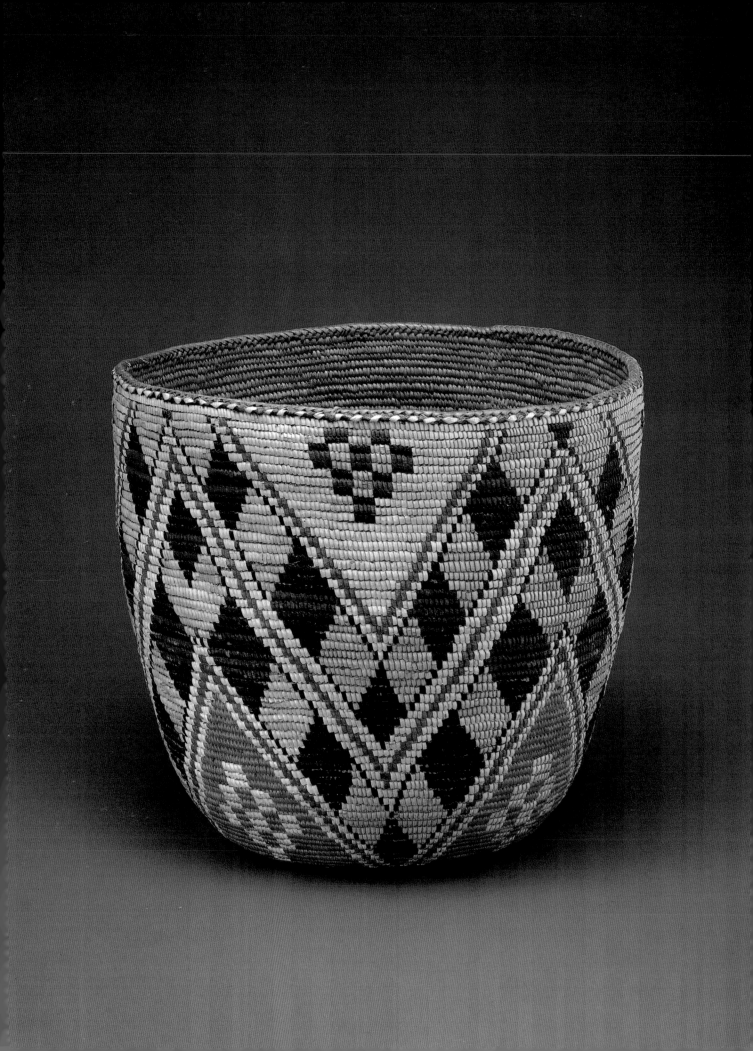

34. Coiled Basket Cowlitz; late 19th century

Cedar root, cedar bark, beargrass, horsetail root; 36 cm x
 31 cm
Collection of Dr. and Mrs. Allan Lobb; collected by Judge
 Wickersham; bought from Louis Yowaluch at Mud
 Bay, 1899; made at Silver Creek on the Upper Cowlitz
 River
Photograph by Paul Macapia and Ray Fowler

The maker of this basket was innovative, producing a bold
and unusual variation on the standard zigzag pattern. Large
yellow diamonds and black diamonds form the double zig-
zag bands. The upper triangles between the zigzag points
are fully imbricated with beargrass and decorated with a
diamond pattern of black and brown checkered squares.
The lower negative triangles offer a variation on this pat-
tern, with beargrass checkered diamonds on a plain brown
cedar root background.

Baskets of this type were made for a variety of pur-
poses, including food storage. The tightly coiled cedar root
formed a watertight container that could be used for cook-
ing by putting hot rocks directly into the liquid in the
basket. Baskets made for sale were also a source of income
to Native women in the late nineteenth and early twentieth
centuries. This is one of many well-documented baskets
collected by Judge Wickersham in 1899 (see also pl. 33),
and was probably made for sale.

35. Twined Basket Quinault; early 20th century

Spruce root, beargrass; 21.5 cm x 25 cm
Collection of Dr. and Mrs. Allan Lobb
Photograph by Paul Macapia and Ray Fowler

Basketmakers from western Washington, like their eastern
neighbors, produced both coiled and twined basketry.
Quinault basketmakers who lived on the Pacific Coast used
split spruce root for their twined baskets. This produced a
stiffer basket than did softer materials such as cattail leaves.
Decorative designs on the surface of the basket are pro-
duced with overlaid beargrass. With this technique, the
basket is plain twined with spruce root wefts, each of which
is paired with overlaid beargrass. When the color of the
design changes, the spruce root weft and its paired strand of
beargrass are twisted so that the strand underneath comes to
the surface.

Here the beige beargrass overlay is used to produce a
complex, vertical meander pattern over the brown spruce
root weft. Negative and positive triangles form a band at
the top. The rim is finished with looped, two-ply spruce
root cording.

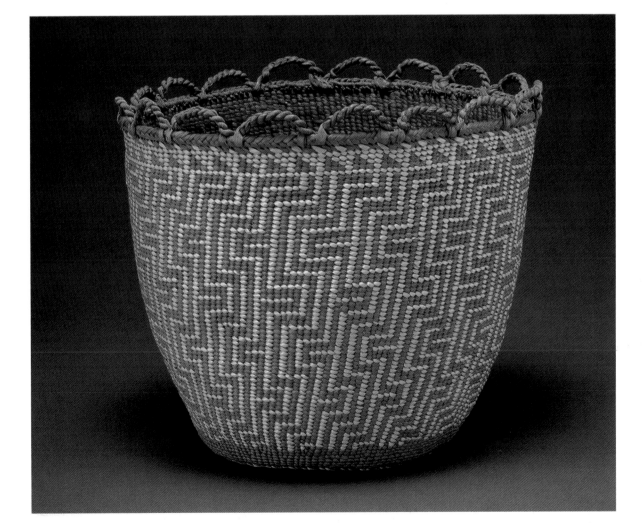

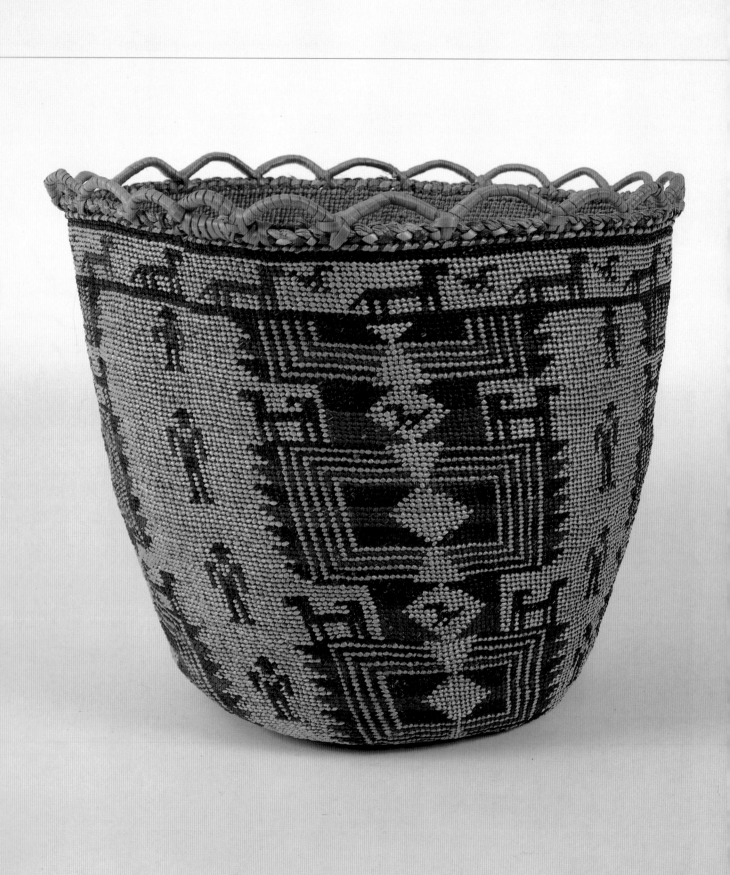

36. **Twined Basket** Twana; late 19th century

Cattail leaves, beargrass, cedar bark; 37 cm x 21 cm x 27 cm
Burke Museum #1-507; collected by Caroline McGilvra
 Burke (Mrs. Thomas Burke); received 1932
Photograph by Eduardo Calderón

Twana baskets such as this one are the most readily recogniz-able of western Washington baskets (Holm 1987: 44–45). They are characterized by a band of animal or bird figures at the rim. Though this feature, in various forms, is found on baskets from neighboring tribes (Chehalis, Quinault, Chinook), it has become an identifier for Twana baskets. The Twana people of Hood Canal are the eastern neighbors of the Quinault and, in technique, their overlay twined baskets are similar. Usually made of cattail wefts and warps overlaid with beargrass or cedar bark, Twana baskets are softer and more flexible than Quinault spruce root baskets.

Descriptive names for both the geometric and figural designs on Twana baskets have been recorded from their makers (Nordquist and Nordquist 1983; Thompson and Marr 1983). The concentric rectangles on this particular basket are described as "boxes" with triangular "crow's shells" on their borders. The open diamond areas are "flounder beds," and the bird figures inside them are called "helldivers." The Twana helldiver has been identified as a horned grebe, though similar bird-like figures depicted on baskets from other tribes are said to represent other species of birds or even supernatural creatures (Thompson and Marr 1983: 46). On the tops of the boxes stand dogs, iden-tified by their curled tails. The rim has wolves, with down-turned tails, alternating with helldivers. In the open areas between the boxes four human figures wearing hats repre-sent men (Nordquist and Nordquist 1983:72). Women, if they were present, would wear skirts.

37. **Twined Basket** Makah; early 20th century

Cedar bark, grass; 9 cm x 10.5 cm x 10.5 cm
Collection of Dr. and Mrs. Allan Lobb
Photograph by Paul Macapia and Ray Fowler

This wrapped-twined basket is especially fine, with tiny stitches adapted to its square form. Makah basketmakers specialized in the production of decorative wrapped-twined baskets such as this one, made for sale in the mid- to late nineteenth century (Marr 1988). These differ in technique from wrapped-twined Wasco/Wishram baskets, in that one of the weft strands passes horizontally across the warp strands on the inside of the basket, while the other, decora-tive, weft is wrapped around both the inside weft and the warp. In Wasco/Wishram baskets the weft strands alternate, first one and then the other being brought to the outside to produce the pattern. The materials used also differ. Makah baskets are made with cedar bark warps, plaited in broad strips at the bottom, and split where the dyed-grass wefts begin. The Makah wrapped-twined technique, done with a Z-twist to the wefts, results in the warp strands slanting to the left and thus producing a diagonal pattern on the surface.

A testament to the virtuosity of the maker, this basket is square, with a square knob on the lid. Pairs of naturalis-tic, flying birds decorate opposite sides of the basket. Abstract concentric rectangles with circular forms decorate the alternate sides, with matching rectangles and birds on the lid. In the Makah language, a square basket is described as *hax̌ʷi·dukšk'uk' piku·ʔu·*, meaning "box-like trade basket."

38. **Basketry Whalers' Hat** Chinook(?)/Clatsop(?);
late 18th- to early 19th century
Spruce root, cedar bark, surf grass; 27 cm x 22.5 cm
Peabody Museum of Archaeology and Ethnology, Harvard
University #53080; collected by the Lewis and Clark
Expedition, 1805–1806; acquired from the Boston
Museum, gift of the heirs of David Kimball, received
1899
Photograph by Hillel Burger, courtesy of the Peabody
Museum, Harvard University

Basketry whalers' hats are very rare; perhaps fewer than
twenty exist in the world today (Vaughan and Holm 1982:
33). It is believed that this hat was collected by Lewis and
Clark during their winter stay at the mouth of the Colum-
bia River (see Wright, "A Collection History," this volume).
Though bought from a Clatsop or Chinook person, this hat
was no doubt made farther north by the whaling people of
the coast of Washington or Vancouver Island.

Whalers' hats, characterized by a distinctive knob on
the top, always depict scenes of whaling. On this hat, the
whales are pursued by canoes with whalers who hold har-
poons; the harpoon lines—complete with inflated seal skin
floats—trail behind the whales. In the portrait painted at
Neah Bay in 1792 by the Spanish artist José Cardero, Chief
Tetacus (Tatoosh) wears a whalers' hat of this type (Wright,
"A Collection History," fig.1, this volume). Worn as a sym-
bol of high social rank and of the prestige associated with
the role of the whaler, hats such as these were reserved for
use by high-ranking people.

The overlay-twining technique used in the old Makah
and Nuu-chah-nulth whaling hats differs from that of the
decorative wrapped-twined baskets made by the same peo-
ple in more recent times (pl. 37). The warp is split spruce
root; the weft is black-dyed cedar bark with an overlay of
white surf grass. These hats are always double, with an
inner hat of more coarsely twined cedar bark joined at the
rim to the outer hat (Vaughn and Holm 1982: 33).

39. **Basketry Hat** Makah(?)/Nuu-chah-nulth(?); late
18th- to early 19th century
Spruce root, cedar bark, paint; 38 cm x 38 cm x 12 cm
Peabody Museum of Archaeology and Ethnology, Harvard
University #53081; acquired from the Boston
Museum, gift of the heirs of David Kimball; received
1899
Photograph by Hillel Burger, courtesy of the Peabody
Museum, Harvard University

This is the earliest known example of a black-rimmed,
painted hat from the Northwest Coast. Made of twined,
split spruce root with an inner hat of twined cedar bark,
this hat has the same flaring shape as the knob-topped

whalers' hats, but lacks the knob. The top, or start of the
hat, is slightly concave. Hats of this type have a broad,
black band painted on the rim, surmounted by red-and-
black painted two-dimensional designs representing abstract
animal forms. This hat was acquired by the Peabody
Museum from the same collection that contained the Lewis
and Clark material, and it is possible that Lewis and Clark
collected it (Vaughn and Holm 1982: 34). Though listed as
"Kwakiutl" in the Peabody Museum's catalogue, this is
probably incorrect. All well-documented hats of this type
come either from the Nuu-chah-nulth (Nootka/Westcoast)
on the west coast of Vancouver Island or from the Makah at
Neah Bay.

On the decorative upper band of this hat, scalloped
borders lead into two triangular forms on opposite sides of
the hat that appear to represent the heads of deer or elk.
Their scalloped antlers extend and join each other around
the top of the hat. Two eyes, with pointed, black eyelid
lines filled in with red, float in the open spaces between the
heads. The design on this hat is unique and tends to con-
firm an early nineteenth-century date for its manufacture.
A later painting style, apparently influenced by northern
formline designs, was developed by Tla-o-qui-aht (Clayo-
quot) artists in the late nineteenth century. Despite the fact
that documentation for this hat is incomplete, it provides us
with an intriguing glimpse of early nineteenth-century
painting styles of the Makah or Nuu-chah-nulth people.

40. **Basketry Hat** Southern Northwest Coast; late
19th century
Cedar bark; 35 cm x 16 cm
Collection of Sylvia Duryee
Photograph by Paul Macapia and Ray Fowler

This was the standard type of basketry hat worn by the
Native people of western Washington. It is made entirely of
split cedar bark twined in a domed, convex shape. As with
the whalers' and black-rimmed hats, an inner and an outer
hat are attached at their rims. A band mounted inside the
crown fits snugly on the head and holds the double hat
away as an efficient rain barrier.

Broad strips of cedar bark are folded and plaited to
begin the inner and outer hats at the top or start of this hat.
The strips are then split into the thin warps of both the
inner and outer hats. Hats of this type were often decorated
with geometric patterns of wrapped-twined beargrass.
Though undecorated with either painted or overlaid
designs, this hat is extremely elegant in its simplicity. Two
rows of three-strand twining form a finish at the rim where
the warps are cut off flush with the last row of twining.

The Makah word for hat, *cikyapux̌s*, is also a word for
mushroom.

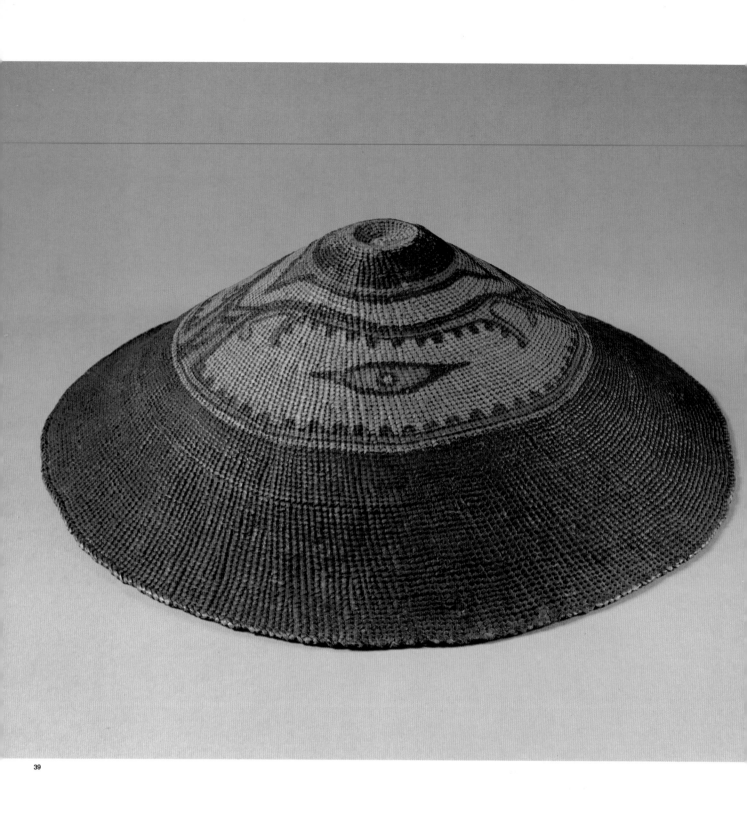

39

41. **Woman's Hat** Plateau; late 18th century
Vegetable fiber (hemp?), beargrass, cedar bark (?), leather;
18.5 cm x 13 cm
Museum of Mankind, British Museum #VAN197; collected
by George Hewitt on the Vancouver Expedition,
Columbia River, 1792
Photograph courtesy of the British Museum

In contrast to the practice in western Washington where
basketry hats were worn by both men and women, on the
Columbia Plateau basketry hats were generally worn only
by women. Still made and worn on important occasions by
Columbia Plateau women today, we know that hats of this
type date at least to the eighteenth century, and probably
well before this. This is the earliest dated Plateau woman's
hat. It was collected by George Hewitt, a member of Cap-
tain Vancouver's expedition, while on a side trip up the
Columbia River in 1792.

The wrapped-twined basketry technique used for
Plateau women's hats is very closely related to that of
Wasco/Wishram twined cylindrical bags (pls. 28, 29), while
the favored zigzag patterns are closely related to Plateau
coiled basketry designs (pls. 31, 32). Hats of this type are
made of a variety of vegetable fibers (hemp, cattail, bear-
grass, cornhusk) in a flaring cylindrical (or fez-like) shape.
Here a broad dark zigzag is relieved by light-colored vertical
bars. An unusual feature in the design of this hat is the
tapering band of chevrons that decorates the rim between
the points of the zigzags.

Women's basketry hats are called *patɬápa* in the
Sahaptin language.

42. **Woman's Hat** Plateau; early 20th century

Wool yarn, vegetable fiber (hemp?), beargrass, cedar bark(?);
 15 cm x 18 cm
Burke Museum #2-3429; collected by Don Greiner ca. 1930;
 purchased from Don Greiner, received 1954
Photograph by Paul Macapia and Ray Fowler

This hat was made after the introduction of trade materials, probably more than one hundred years after the Vancouver Expedition collected its hat. It incorporates green and red wool yarn as wefts to produce a colorful variation on the standard zigzag design. The use of wool yarn in hats coincides with the incorporation of this trade material in twined flat bags (pl. 12), also made by the same weavers.

The designs on Plateau women's hats are nearly always variations on a zigzag pattern. The Vancouver hat shows zigzags as a positive pattern; this hat features negative zigzags—background space between positive triangular shapes. The triangles are bordered by small, banner-like projecting triangles that resemble the quail-feather designs common on northern California baskets as well as on basketry made throughout the Columbia Plateau.

This pattern is known as "quail tracks." There was a time when women and families owned their designs. A woman was very careful about her basketry skills. Her designs and tricks are what made her work special. They increased the value of her work.

—Leona Smartlowit, Cayuse/Umatilla

43. **Woman's Hat** Yakima Reservation; early 20th century

Vegetable fiber, leather, cotton trade cloth, glass beads; 17.5
 cm x 18 cm
Burke Museum #2-404; collected by Mrs. L. J. Goodrich;
 purchased from the estate of Mrs. Goodrich through
 Mrs. Paul D. Moran, received 1932
Photograph by Paul Macapia and Ray Fowler

Sometimes women's basketry hats were covered entirely with appliquéd beadwork and lined with cotton cloth. It is unknown whether the basketry that forms the foundation of this hat has an interlocking triangle/negative zigzag pattern, but the beaded designs on this hat accurately mimic the basketry pattern seen on the hat in plate 42.

Beaded hats are known as *patłápa kàpɨt kàpɨt* means beads in the Sahaptin language.

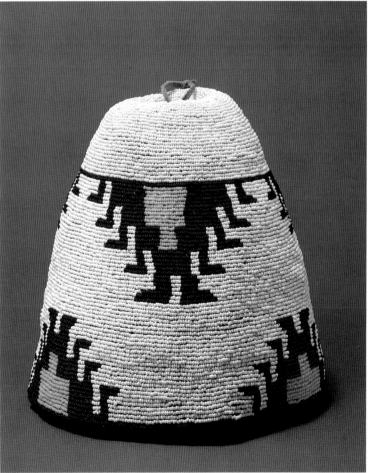

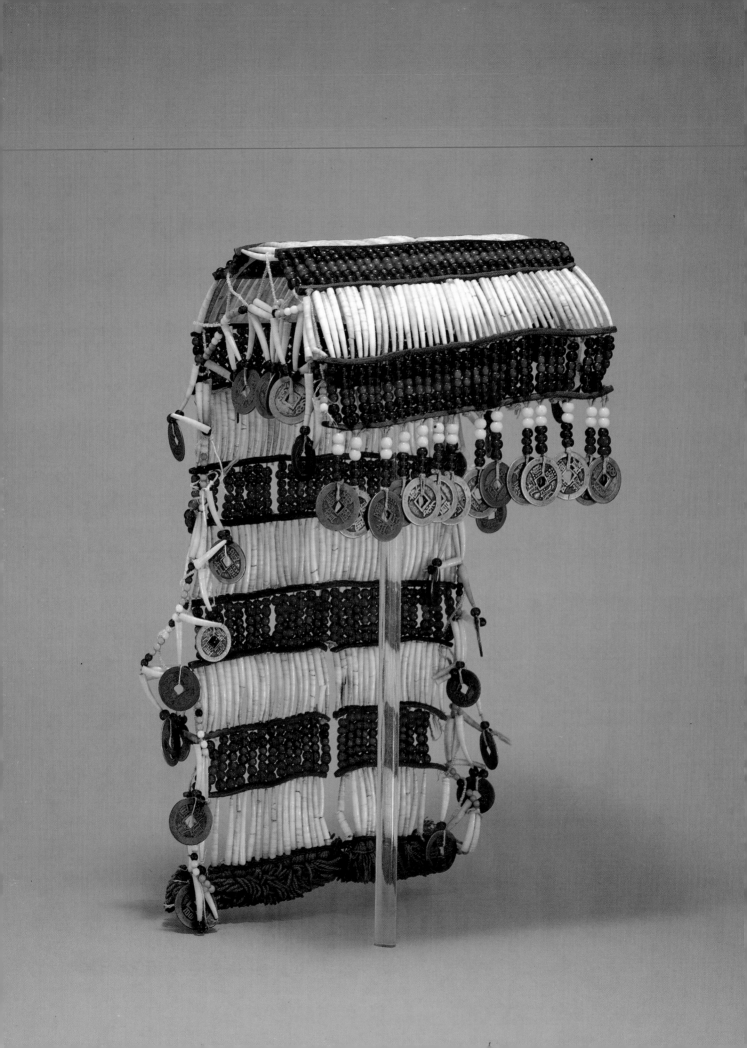

44. Woman's Dentalium Bridal Headdress Yakima
Reservation; early 20th century
Wool yarn, Chinese coins, glass beads, dentalium shells,
rawhide, cotton string; 62 cm x 33 cm
Burke Museum #2-478; collected by Mrs. L. J. Goodrich;
purchased from the estate of Mrs. Goodrich through
Mrs. Paul D. Moran, received 1932
Photograph by Paul Macapia and Ray Fowler

This woman's bridal headdress is a lavish expression of the
wealth of her family. Long white dentalium shells (*Den-
talium pretiosum*) were valued as currency by Native people
throughout North America. Harvested in a very limited
area off the coast of Vancouver Island by the Nuu-chah-
nulth people, these long, tapering cylindrical shells were
graded and valued according to their size. They were
traded the length of the Pacific Coast and across the conti-
nent at least to the Plains in pre-contact times (Andrews
1989). They continued to be highly valued throughout the
nineteenth century, and were used on jewelry and clothing
in combination with other valuable objects such as glass
trade beads and metal Chinese coins introduced by Euro-
American fur traders.

During the nineteenth century, the Yakima and Wish-
ram people made headdresses of dentalium shells, glass
trade beads, and Chinese coins as part of a bride's dowry.
In 1914, a Wishram woman posed in her wedding outfit
wearing a beaded buckskin dress, a dentalium bridal head-
dress, and other bead and dentalium jewelry (see Duncan,
fig. 1, this volume).

In the Sahaptin language, this type of headdress is
called *áxš-áxš*.

*My mother-in-law and daughter are of the Wishram people.
When my daughter saw how beautiful her great-aunt looked
as a Wishram bride, she said, "I want to be married like
that." I am starting to prepare all the pieces of her wedding
outfit. Long ago, that used to be a dowry. Everything a
bride was wearing was given to her in-laws. If both sides
respected their wedding they traded all the time. This was
one way we have of taking care of each other.*
 —Delores George, Yakima

45. Blanket Pin Skokomish(?); late 19th century
Bone, brass; 13.6 cm x 1.7 cm x 0.4 cm
Whitman College #1286; collected by Myron Eells, 1893
Photograph by Paul Macapia and Ray Fowler

This extremely delicate bone sculpture ranks among the
most elegant blanket pins to survive in museum collections.
Mountain goat wool blankets (pls. 1–3) and cedar bark
robes were worn over the shoulders and attached at the neck
with long pins carved of bone or wood. This bone pin was
collected by Rev. Myron Eells for display in the Washing-
ton State Pavilion at Chicago's 1893 World's Columbian
Exposition.

Extremely delicate in form, it represents two opposing
animals nearly touching noses, with feet and tails attached
at the center. The identity of these animals is unknown,
although they resemble the fisher, a weasel-like animal
important in certain religious rituals of the Coast Salish
people.

Circular eyes with central points were produced by the
use of a drill. This motif is repeated on two sides of the
square block just below the animals' tails. The pin is
embellished with four metal disks that hang from brass
rings at the loops of the body and tail. While being worn,
the disks on this functional piece of jewelry would produce
a jiggling effect .

46, 47. Bracelets Coast Salish; late 18th century
Mountain goat horn (7), antler (1), leather (1), copper, dentalium shell; 5.5 cm x 4.5 cm x 2 cm each
Museum of Mankind, British Museum #VAN210 a–d,
VAN211 a–d; collected by George Hewitt on the Vancouver Expedition at Restoration Point, 1792
Photograph courtesy of the British Museum

Only twenty-one Coast Salish bracelets made of mountain goat horn, and only one made of antler, are known in museum collections (Feder 1983: 54). This set of eight is the earliest and largest collection of bracelets made of native materials known from the Northwest Coast. They are believed to have been collected by George Hewitt at Restoration Point on Bainbridge Island in 1792 (see Wright, "A Collection History," this volume). Seven other bracelets, collected by James Yale at the Hudson's Bay Company's Fort Langley on the lower Fraser River, arrived in Scotland in 1833 (Idiens 1987). This is the latest collection date for this type of bracelet and suggests that they were not made much after this time.

Jewelry worn by the Native people of the southern Northwest Coast in prehistoric times consisted of a variety of shell, bone, and horn items: bracelets, necklaces, and pierced ear and nose ornaments. After metals became available in the late eighteenth century, copper, brass, iron, and tin ornaments were cherished more than those made of native materials.

Five of the Hewett collection of mountain goat horn bracelets (and all of the other sixteen known mountain goat horn bracelets) are carved in an abstract curvilinear style characterized by concentric ovals, U-forms, and other narrow connected bands on the plane surface. These two-dimensional designs are defined by cut away T- and crescent-shaped negative spaces. This style of carving is particularly associated with the central (Halkomelem- and Straits-speaking) Coast Salish people who live on southeastern Vancouver Island, the Gulf Islands, the lower Fraser River, and on the southern shore of the Strait of Juan de Fuca. These bracelets were once embellished with inlaid materials. Pitch-like glue remains in many of the negative spaces. One bracelet still retains a bit of inlaid dentalium shell, and another has small pieces of inlaid copper (pl. 47).

Two of the mountain goat horn bracelets (pl. 46) and the one antler bracelet (pl. 47) are carved in a simpler style. They have thin lines and decorative hatching carved along the borders. One is decorated with central leaf-like designs indicated by a stem line and diagonally hatched veins. Each of the mountain goat horn bracelets has a distinctive clasp made possible by the tapering shape of the horn. The broad end has a carved slot into which the narrow tapered end is inserted.

48. **Bowl** Wasco/Wishram; mid-19th century
Mountain sheep horn; 14 cm x 20 cm x 14 cm
National Museum of Natural History, Smithsonian Institution #691; collected by George Gibbs; received 1862
Photograph courtesy of the Smithsonian Institution

Mountain sheep horn bowls are among the most treasured heirlooms of the Native people of this area. The large spiraling amber-colored horns of the mountain sheep (bighorn sheep) were particularly valued by Native American people wherever they were found, from the Plains to the Northwest Coast. This material was used as the flexible foundation of sinew-backed bows as well as for spoons on the Plateau and Plains. Along the Columbia River and throughout the Northwest Coast mountain sheep horns were used primarily for ladles and bowls. These were produced by steaming or boiling, spreading, and reshaping the horn in much the same way that wood was steamed and bent.

People from the area of The Dalles on the Columbia River were especially skilled at making elegant mountain sheep horn ladles and bowls, which were traded throughout the area that is now Washington State and beyond. The bowl shape was roughed out by the removal of the narrow tip and inner edge of the horn. The bowl was then steamed or boiled and spread open, which resulted in its distinctive shape, with raised ends and flaring sides.

This bowl is typical of the Wasco/Wishram style of geometric carving. It is completely decorated with rows of interlocking negative triangles interspersed with long concentric rectangles. The interlocking negative triangles are carved in such a way as to produce positive zigzag lines on the surface of the bowl. The squarely cut raised ends of this bowl echo the patterns that decorate the surface, in the carved triangles cut completely through the horn. Below, long rectangular slots pierce the raised rectangular flanges. This geometric style of carving, which spread from the Columbia River drainage throughout the southern part of western Washington, is dramatically different from the curvilinear style of the central Coast Salish in the northern areas of what is now western Washington (see pls. 46, 47, 66, 67).

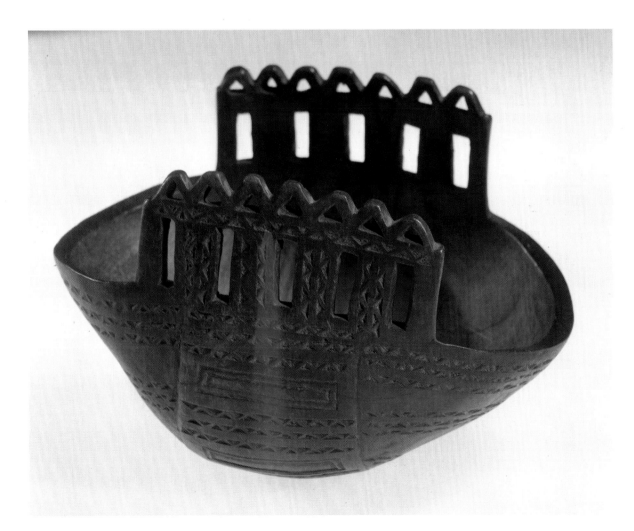

49. Bowl Wasco/Wishram; mid-19th century
Mountain sheep horn; 15 cm x 18.2 cm x 12.5 cm
Collection of Jerrie and Anne Vander Houwen
Photograph by Paul Macapia and Ray Fowler

Two large human figures carved in a geometric, skeletal style are the most distinctive features of this mountain sheep horn bowl. Their bodies, with shared legs, stretch along the broad thick band of the horn that extends from raised rim to raised rim. The skeletal style of depicting the human figure is closely related to the style of prehistoric bone and antler carvings from the Columbia River area (pl. 77), and is linked as well to the depiction of human figures on Wasco/Wishram basketry from the historic period (pls. 28, 29). Human heads, which on basketry are diamond-shaped, are usually circular on Columbia River sculpture. These heads are characterized by three stepped-back planes that define the forehead, cheek, and chin areas. A straight brow line is linked to a straight thin nose. Almond-shaped eyes on the cheek plane are echoed in the curved line of the cheeks below as well as in the form of the mouth on the chin plane. The heads of two small human figures, perhaps representing infants, are held in the hands of the larger figures. Rows of concentric circles flank the human figures, and concentric hourglass forms that resemble the shape of net gauges (pl. 64) decorate the sides of the bowl between zigzag lines.

The meaning of these skeletal Columbia River images remains unknown. Certainly they represent a direct link to the images carved along the Columbia River in prehistoric times. Sheep horn bowls like this one were sometimes placed with other goods at graves. In these cases, holes were chopped in the bottoms of the bowls, presumably to discourage thieves from removing them. We know that sheep horn bowls made on the Columbia River were traded widely among Native people and have been collected both on the Columbia Plateau and from coastal areas where they were treasured family heirlooms.

In the Sahaptin language, bowls or dishes are called *tikáy*.

50. Mortar Wasco/Wishram; 19th century
Wood; 32.5 cm x 28.5 cm
Collection of Mr. and Mrs. Alan Backstrom
Photograph by Paul Macapia and Ray Fowler

The design of this mortar is related to that of mountain sheep horn bowls made in the same area. Functional mortars were made on the Columbia Plateau from the tough burls of various kinds of wood. The knarled grain of the burl prevented splitting when pounded with stone pestles to pulverize dried fish and roots. Though these mortars have tall pail-like shapes rather than flaring sides like horn bowls, their raised flanges and decorative carving are directly related to horn bowls from this area.

On this mortar, rows of negative interlocking triangles create zigzag lines on the raised rim band, and pairs of skeletal figures decorate the rim flanges. Columbia River–style circular heads are seen again here, with three distinct planes for the forehead, cheeks, and chin. Each figure has a thin straight nose, but no eyes or mouth. The bodies also lack hips and legs. The necks are attached to rib cages; angular shoulders extend into arms that join in the middle as if the hands were clasped. The most unusual feature of this mortar is the hollow circular hole carved into the left side of the rib cage of one of the figures. Though both rim flanges have a pair of human figures, the circular hole is found on only one of them. Its meaning is unknown.

In the Sahaptin language, mortars are called *táluš*.

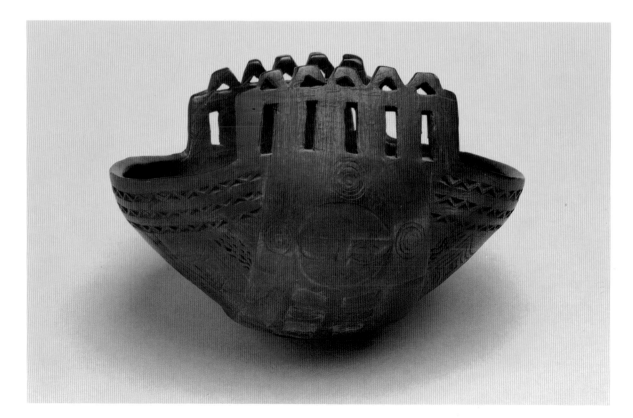

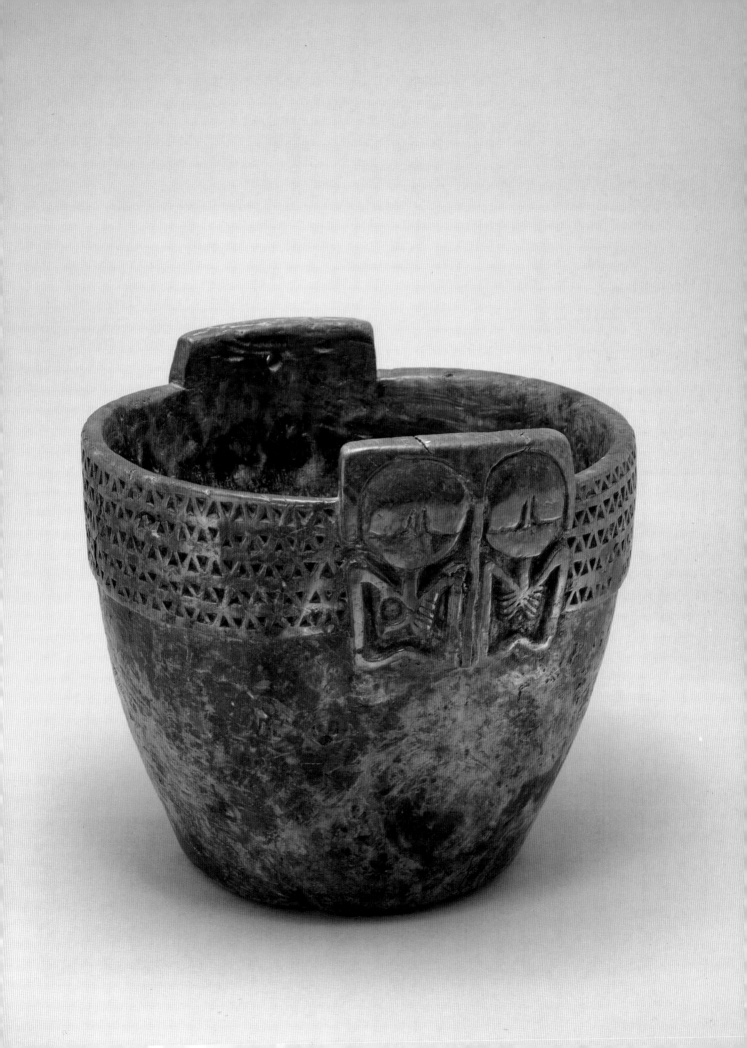

51. **Mortar** Wasco; 19th century
Wood; 14.5 cm x 14.5 cm x 12.5 cm
Peabody Museum of Archaeology and Ethnology, Harvard
University #83982; collected by Grace Nicholson; gift
of Lewis H. Farlow, received 1911
Photograph by Hillel Burger, courtesy of the Peabody
Museum, Harvard University

The unusual three-dimensional handling of two human figures makes this small mortar from the Columbia River area unique. The figures are fully three-dimensional and lack the skeletal details or the flat, circular facial structure seen on more standard Columbia River sculpture. The two humans appear to hang from the rim by their arms while their legs are splayed out around the bowl. Placed where the raised rim flanges normally would be, they face inward toward the bowl rather than outward. Each clasps in its hands an unidentifiable object that extends from its mouth. Perhaps they are eating from the contents of the mortar, or smoking tubular tobacco pipes (see pls. 75, 76).

The figures on this mortar resemble the human figure on the handle of a whale bone D-adze that belonged to Captain Mason (pl. 60). Both of these pieces were collected by Grace Nicholson, though one is documented to come from the Wasco while the other is said to be Quinault. Frequent interaction occurred between coastal and Columbia River people. While this mortar may have been traded to the Wasco from the coast, similarities between the carving styles of the Quinault and the Columbia River people make it possible that such pieces were produced in both places.

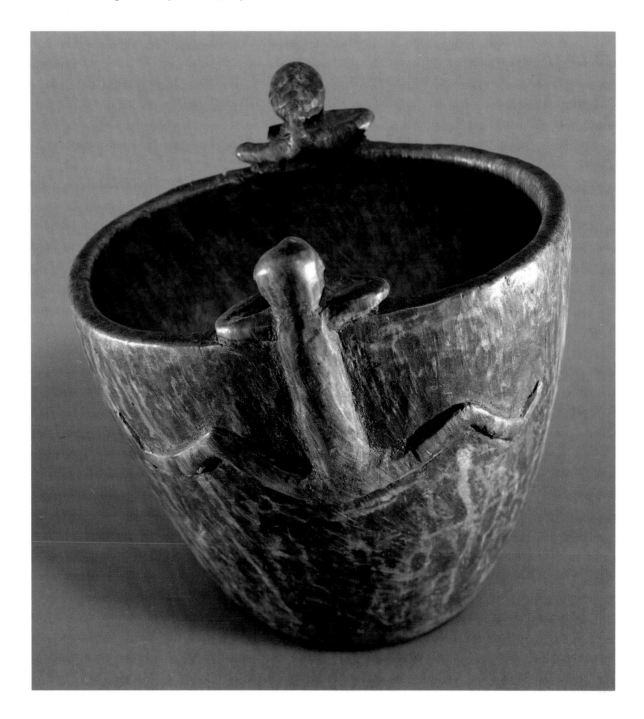

52. Oil Dish Makah Reservation; 19th century
 Alder; 16 cm x 23 cm x 27 cm
 Burke Museum #4616; gift of Mrs. S. W. Hartt, received
 1913
 Photograph by Paul Macapia and Ray Fowler

Oil bowls with rows of abstract animal heads on the raised ends have an ancient origin on the coast of Washington. Several five-hundred-year-old bowls of this type were excavated from Ozette Village (Kirk and Daugherty 1978: 104). Captain Wood collected a small bowl of this type with a single animal head at each end at Fort Nisqually in Puget Sound in 1850 (Pitt Rivers Museum #104G13); a few years later George Gibbs collected a bowl with six heads at each end at Shoalwater Bay on the Pacific near the mouth of the Columbia River (Smithsonian Institution #692). Edward Curtis owned a four-headed bowl that is now in the Denver Art Museum (#1938.390) and has been identified as Wishram (Conn 1979: 254). This bowl was collected from the Makah at the turn of the twentieth century, and since prehistoric evidence also places bowls of this type in this region, an origin for this type of bowl on the Pacific Coast of what is now Washington State seems the most likely.

The animal heads on bowls of this type are remarkably uniform, always with a carved groove that extends from between the ears down the back of the heads and necks, very similar to the groove carved at the prow of a canoe for resting the shaft of a harpoon (pl. 85). These bowls may represent fleets of canoes. Their similarity to the prows of Westcoast canoes further links the animal-head bowl to the Makah people and their coastal neighbors.

As with Columbia River mortars, the form of wooden oil dishes from the southern Northwest Coast is often directly related to the shape of mountain sheep horn bowls. The raised flanges on the ends of this bowl resemble the raised rectangular rims of horn bowls. The flat end panels with parallel raised bands extending beneath the animal heads are placed where the thick portion of the horn extends around horn bowls, and the flaring sides imitate the shape of a horn bowl. Perhaps the carvers deliberately sought to imitate the form of the valuable horn bowls in the more readily available wood.

In the Makah language, an oil bowl is called *kàtsac; kàt* means oil, *sac* means container.

53. Oil Dish Lummi; 19th century
 Alder; 14 cm x 12 cm x 6 cm
 Burke Museum #7801; purchased from Mrs. Julia C. Baker,
 received 1918
 Photograph by Paul Macapia and Ray Fowler

The elegant form of this small oil bowl makes it a masterful work of art. As with many wooden bowls made in western Washington (pl. 52), the raised and pierced rectangular rim flanges and low flaring sides reveal a close relationship to the form of mountain sheep horn bowls.

Bowls such as this one were used to hold various kinds of oils, primarily seal and sea lion oil in this area. The oil was used as a condiment, for dipping dried fish and other foods, and a preservative for meats and berries. Bowls that have been saturated through many years of use exude this oil, which accumulates on the surface, especially on the end grains of the wood. This is particularly noticeable after a few years' storage on museum shelves (pls. 52, 54). While the bowl was in use, this accumulation of oil would have been wiped clean.

54. Oil Dish Quinault; 19th century
 Alder(?), glass beads; 30 cm x 11.5 cm x 15 cm
 Whitman College #1243; collected by Myron Eells, 1893
 Photograph by Paul Macapia and Ray Fowler

A fantastic four-legged creature—scalloped dorsal and ventral fins on the front and back of its long neck, and a circular tail—is depicted on this remarkable bowl. Though it has an undulating rim, this bowl is less directly related in form to those of mountain sheep horn bowls and takes its shape from the creature being represented, with four short legs as supports (Holm 1987: 68). While this creature may superficially resemble a horse, it is probable that it represents another type of being, perhaps a sea-monster.

Two bands of interlocking negative triangles, identical to those carved on Columbia River bowls, decorate the sides; white glass trade beads inlaid for the eyes, down the neck, and around the rim of the bowl add to the charm of this piece. It was collected by Rev. Myron Eells from the Quinault on the Pacific Coast, and was exhibited in the Washington State Pavilion at the World's Columbian Exposition in Chicago in 1893 (Castile 1985: 101).

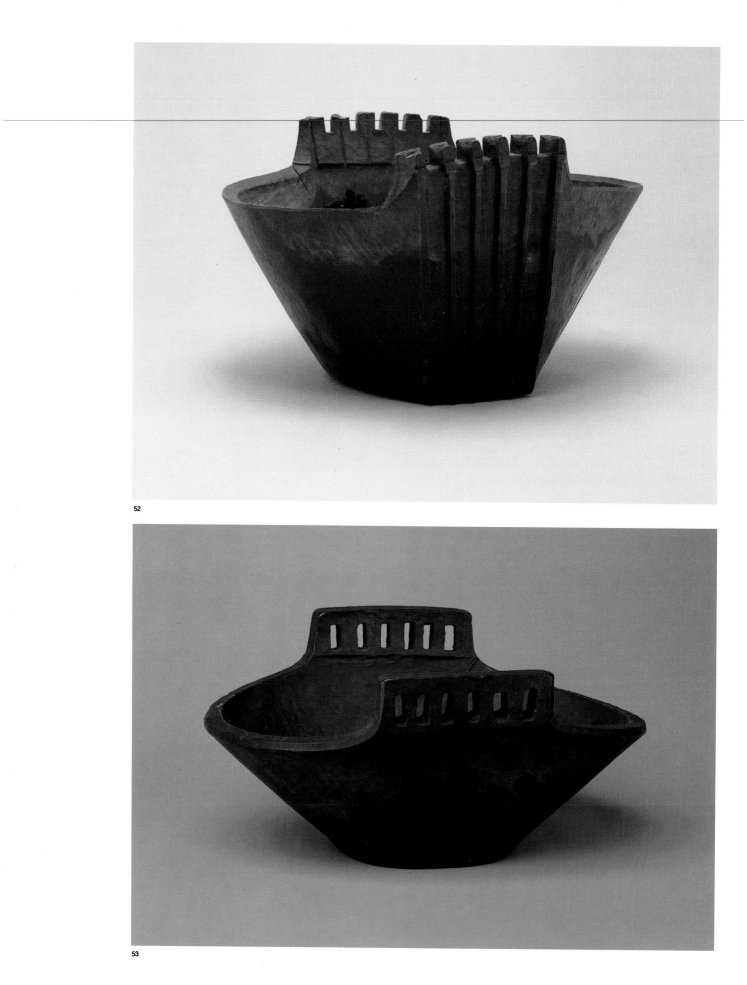

52

53

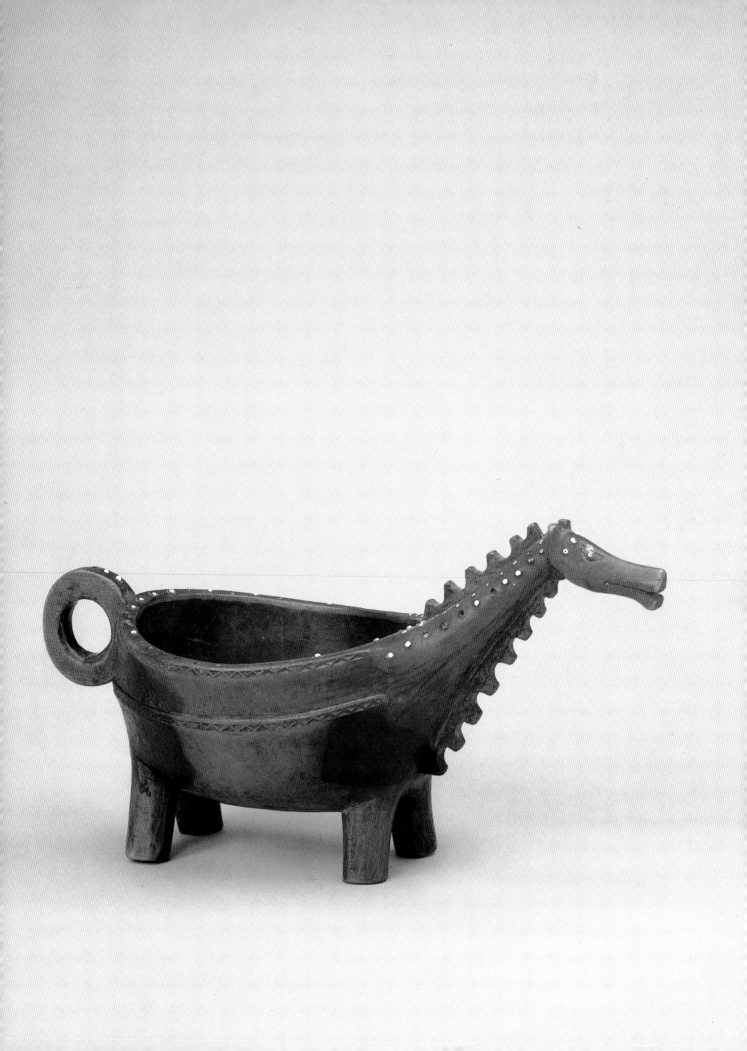

55. **Ladle** Chinook(?); early 19th century
Alder(?); 21 cm x 15 cm x 5.5 cm
Museum of Mankind, British Museum #42-12-10-71; col-
lected by Captain Belcher, 1839
Photograph courtesy of the Museum of Mankind, British
Museum

The pointed ends of this lower Columbia River ladle and the groove that runs around the inner rim of its bowl, like a canoe's gunwale groove (pl. 84), suggest it may represent a canoe. A flat pierced handle extends from one end; two birds sit on a bar at the end of the handle facing the bowl of the ladle, their tails projecting out. These birds are similar to marine birds described as helldivers, often depicted on Chinook, Clatsop, Quinault, and Twana baskets (pl. 36).

Under the flat handle of this lower Columbia River spoon, there is a slight ridge that continues the line of the ridge at the back of the bowl; the bottom of the bowl has been flattened to form a solid base. The flattened base and tapering "bow and stern" of this Chinook ladle closely resemble canoe-shaped bowls excavated from Ozette Village (Kirk and Daugherty 1978: 104). This ladle was collected by Captain Belcher in 1839, probably at or near the mouth of the Columbia River (see Wright, "A Collection History," this volume).

56. **Ladle** Columbia River; mid-19th century
Mountain sheep horn; 21 cm x 11 cm x 14 cm
National Museum of Natural History, Smithsonian Institu-
tion #701; collected by George Gibbs, received 1862
Photograph courtesy of the Smithsonian Institution

This ladle was collected from the Chinook people at the mouth of the Columbia River, though it may have been made further upriver by the Wishram or Wasco. The technique of spreading and the style of carving is identical to that used on Wasco/Wishram mountain sheep horn bowls. A skeletal animal figure with a long tail, perhaps a dog, wolf, or coyote, stands on the end of the handle. The ribs are indicated by chevrons, though the rest of the animal is only minimally carved. As on the mountain sheep horn bowls from this area, interlocking negative triangles form-ing rows of zigzags extend around the rim and decorate the sides and back of the handle. Two rows of large stacked chevrons flanking concentric circles decorate the flattened underside of the bowl that extends from the handle.

In the Sahaptin language, spoon is *súxas*, mountain sheep horn spoon is *tnuun-mi yúkaas*.

57. **Ladle** Columbia River; 19th century
Mountain sheep horn; 22.5 cm x 10 cm
Burke Museum #4858; collected by H. B. Ferguson at Cape
Flattery, 1915
Photograph by Paul Macapia and Ray Fowler

The very unusual animal on the handle of this ladle has two sets of front limbs. Though similar to the one on the previous spoon (pl. 56), this long-tailed animal has carved toes and an open mouth. Perhaps representing a transfor-mation into human form, this animal has human-like arms that are bent at the elbow, and hands that grasp its own snout. The collection of a Columbia River ladle at Cape Flattery, the extreme northwestern tip of Washington, testifies to the extensive trade networks that spread moun-tain sheep horn objects and other valued art throughout what is now Washington State.

58. **Ladle** Nisqually; 19th century
Mountain sheep horn; 23 cm x 12.5 cm x 7 cm
Peabody Museum of Archaeology and Ethnology, Harvard
University #66378; collected by Grace Nicholson; gift
of Lewis H. Farlow, received 1906
Photograph by Hillel Burger, courtesy of the Peabody
Museum, Harvard University

Mountain sheep horn ladles with wide, shallow bowls and short, flat handles have been collected in Puget Sound and along the Strait of Juan de Fuca from the earliest years of contact between Native people and Euro-Americans. This Nisqually ladle, collected in the early twentieth century, is nearly identical in form to a mountain sheep horn spoon collected by Hewitt from the Klallam people at Discovery Bay in 1792 (British Museum #VAN121; see Wright, "A Collection History," this volume).

With this style of mountain sheep horn ladle, the long, tapering tip of the horn, used as the handle of Columbia River horn ladles (pls. 56, 57), has been removed. The short, flat rectangular handle is pierced with a square opening and has a scalloped edge, the only deco-rative carving. The shape of this handle reminds us of the Belcher ladle (pl. 55), though it lacks the birds and canoe-like shape. This may be further evidence that the different styles of ladles and bowls made throughout western Wash-ington were traded and shared among many tribal groups.

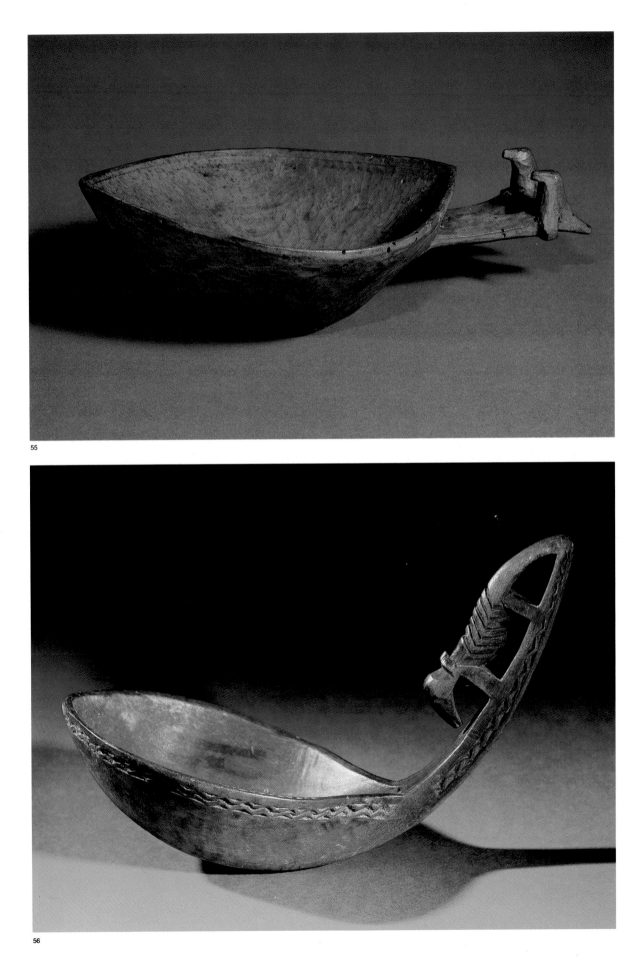

55

56

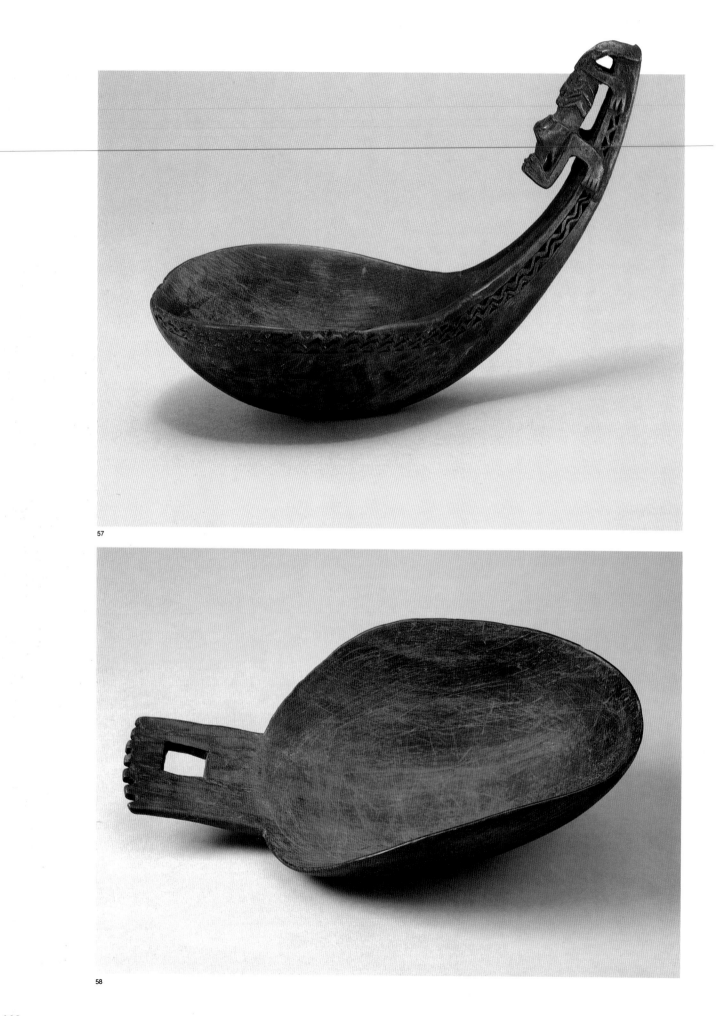

57

58

59. **Straight-Adze Handle** Columbia River; early
to mid-19th century

Elk antler; 22 cm x 5 cm x 7 cm

Peabody Museum of Archaeology and Ethnology, Harvard
University #139; acquired from the Boston Ath-
enaeum, 1867

Photograph by Hillel Burger, courtesy of the Peabody
Museum, Harvard University

This straight-adze handle is both a carving tool and a stellar example of Columbia River sculpture. Straight adzes were used only on the southern Northwest Coast, primarily in southern Puget Sound and the lower Columbia River. The blade of this adze would have been lashed at the bottom, in line with the handle, thus constituting a straight adze. On other types of adzes the blade is hafted differently, either in line with the knuckle guard, as on D-adzes (pl. 60), or at an angle, as on elbow adzes.

The human face on this adze handle has gracefully curved horns sweeping back from its forehead. These horns attach at both the front and back of the head, and are pierced at the base in a long, tapering groove. This may have been done to lighten the weight of the handle, or for aesthetic reasons, or both. Concentric circles serve both for eyes and for decorative patterns on the short knuckle guard. The three-step facial structure on this adze identifies it as the work of a lower Columbia River carver. The figure would face the carver when the adze was in use. A thumb-shaped depression just below the figure's chin fits the hand perfectly and helps to balance the tool when in use.

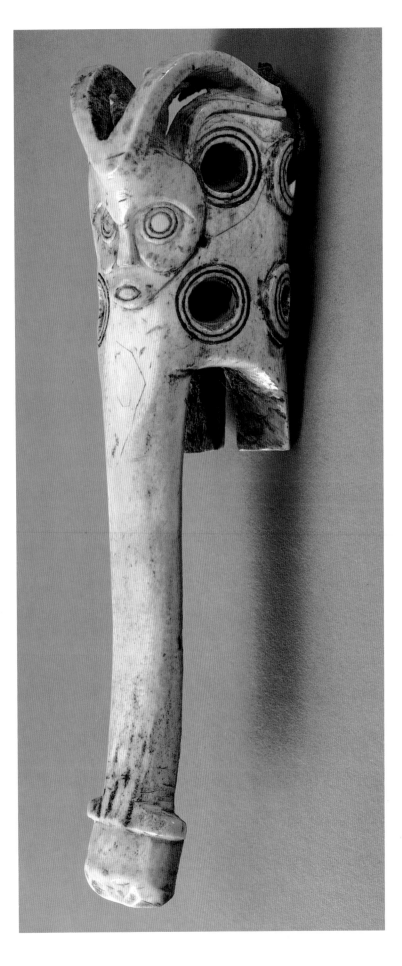

60. **D-Adze** Quinault; 19th century
Whale bone, iron, rawhide; 25.5 cm x 9 cm x 5 cm
Peabody Museum of Archaeology and Ethnology, Harvard
 University #65509; Grace Nicholson Collection; gift of
 Lewis H. Farlow, received 1905
Photograph by Hillel Burger, courtesy of the Peabody
 Museum, Harvard University

Northwest Coast carving tools are usually both functional
to use and beautiful to view, perfectly balanced and made
to fit the hand. This adze has a D-shaped handle. Like the
Columbia River straight adze (pl. 59), there is a slightly
hollowed thumb depression near the hands of the carved
figure. This human figure springs up from the handle to
face the user. Piercing between the arms and legs lightens
the weight of the handle and adds energy to the posture of
the figure. The flare at the base of the handle serves as a
brace to the heel of the hand. An iron axhead serves as the
blade, attached in line with the knuckle guard. The hole in
the blade, originally made for a wooden axe handle, pro-
tects the rawhide lashing from abrasion.

 This whale bone D-adze belonged to Captain Mason,
a Quinault leader, who used it for making canoes. Probably
made by one of his ancestors, it is one of the most beautiful
adzes known.

The little figure represents the spirit that helped carve the
canoes. He was a helper and when they'd get tired, he'd help
them keep going.

 —Oliver Mason, Quinault,
 great-grandson of Captain Mason

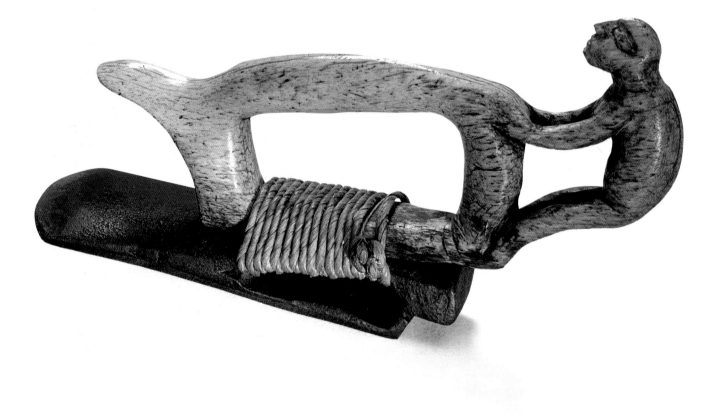

61. Bark Shredder Western Washington; 19th
century

Whale bone; 26 cm x 17 cm x 1.2 cm

National Museum of Natural History, Smithsonian Institution #73290; George Catlin collection, received 1884

Photograph courtesy of the Department of Anthropology, Smithsonian Institution

This unique whale bone bark shredder is a work of art. The handle features stylized animal figures with circle-and-dot motifs for their eyes; the blade is embellished with a rectangular pattern of the same motif. This tool was part of George Catlin's collection of Native American artifacts, exhibited in Europe in the 1840s, which came to the Smithsonian Institution in 1884. It was illustrated in the Smithsonian's Annual Report of 1886 in Willoughby's "Indians of the Quinaielt Agency" (Willoughby 1889: 269). The whale bone material and the style of carving indicate that this shredder may have been made on the coast of western Washington.

The smooth inner bark of both red and yellow cedar is peeled from the trunks of trees in the spring when the sap is running, separated immediately from the rough outer bark, and dried for future use. Cedar bark is prepared in a variety of ways, depending on its intended use. Wide strips of unprocessed bark were made into boxes, canoe bailers, and harpoon sheaths. Narrow strips of bark, split into even widths either by hand or using a small tool with pairs of sharp metal blades, were used for plaited mats and basketry.

Shredded red cedar bark was used for toweling, babies' diapers, and rope or cording in the past, and it continues to be used today for ceremonial headdresses and clothing. To shred cedar bark, long dried strips are laid over the edge of a sharp wooden board. In the past an old canoe paddle was frequently used. The bark is drawn over the edge of the sharpened board and caught in the scissors-like action between the shredder blade and the board, which separates and softens the fibers. The shredded bark can then be further softened by hand. Yellow cedar bark, used for soft capes and robes, is tougher than red cedar bark. Yellow cedar bark was first soaked in salt water to soften and then pounded with a flat, grooved tool.

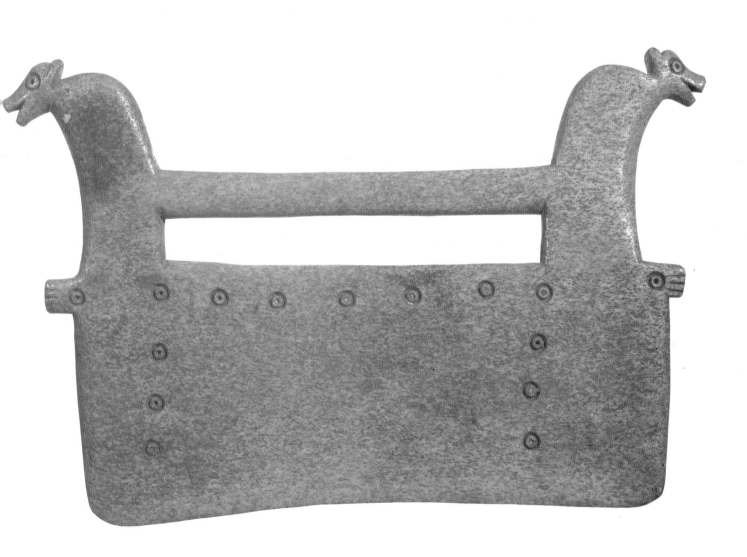

62. **Mat Creaser** Western Washington, 19th century
Maple(?); 18 cm x 6.4 cm x 1.3 cm
Portland Art Museum, Oregon, #48.3.221; Rasmussen Collection of Northwest Coast Indian Art
Photograph courtesy of the Portland Art Museum

A classic example of western Washington art, this mat creaser combines abstract animal heads, similar to those on Makah wooden bowls (pl. 52), with Columbia River–style zigzag lines, formed by carved interlocking triangles (pls. 48–50, 54, 56, 57). Though its tribal origin is unknown, this mat creaser was obtained by Axel Rasmussen from Standley's Olde Curiosity Shoppe in Seattle in 1931 (Gunther 1966: 48, 259, cat. no. 440). Its stylistic similarity with Makah wooden bowls suggests a Makah origin for this piece.

63. **Mat Creaser** Hoh River; 19th century
Wood; 21 cm x 6.5 cm x 3.5 cm
Peabody Museum of Archaeology and Ethnology, Harvard University #65497; Grace Nicholson Collection; gift of Lewis H. Farlow, received 1905
Photograph by Hillel Burger, courtesy of the Peabody Museum, Harvard University

This mat creaser combines two bird heads with a double row of circle-and-dot motifs, similar to those on the whale bone bark shredder (pl. 61). The rounded shape of the handle of this tool would have fit comfortably in the hand.

The leaves of cattails were used to make baskets, bags, rain tunics, and mats. Large cattail mats were used extensively to sleep on, to line canoes, for serving food, for the walls of temporary shelters, and as screens, room partitions, and insulation in cedar plank houses. In making cattail mats, the long cattail leaves are sewn together by means of a long, triangular needle threaded with cord. The mat creaser, with its V-shaped groove, is pressed along a needleful of leaves to crimp them and minimize splitting when the cord is drawn through.

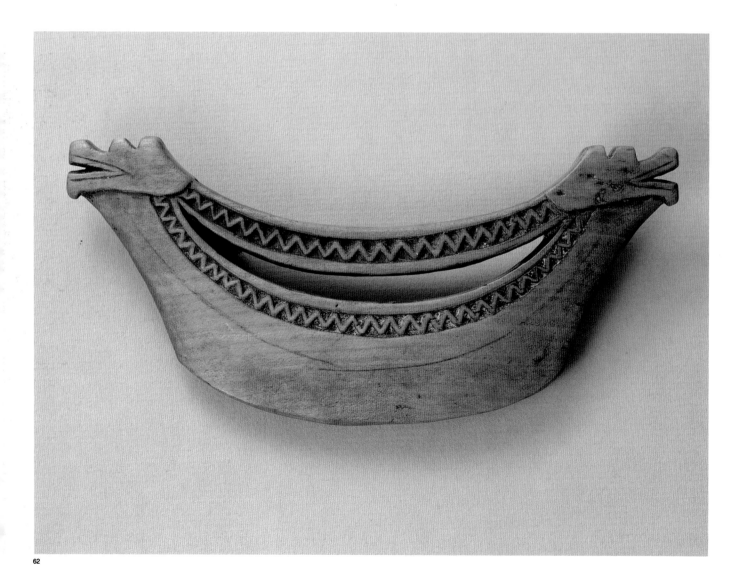

62

64. **Net Gauge** Wishram, The Dalles, Columbia River; 19th century

Elk antler; 7 cm x 7 cm
Burke Museum #2-3845; gift of Mr. and Mrs. Leon Tabor, received 1955
Photograph by Eduardo Calderón

This elk antler net gauge is remarkable for its unusual design with two flying birds, perhaps eagles. One bird, whose head extends beyond the edge, holds a fish in its claws. Tools such as this were used in the manufacture and repair of fishing nets. Twine was wrapped and knotted around such flat rectangular gauges to produce nets with mesh of uniform size. This net gauge was purchased in 1955 from its Wishram owners who considered it a family heirloom (Holm 1987: 26).

In the Sahaptin language, net gauge is *sap-aw x̱t-kʷaixʷ*.

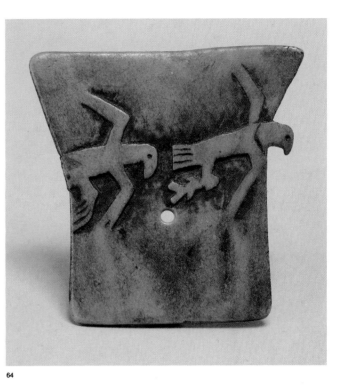

64

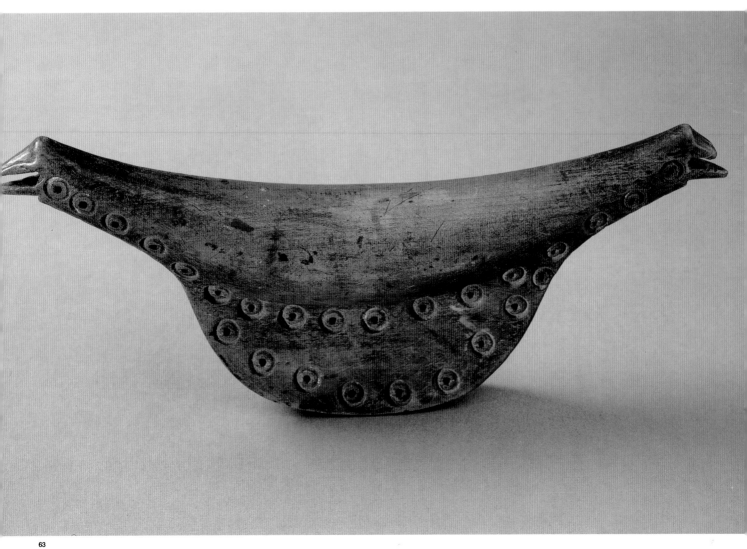

63

107

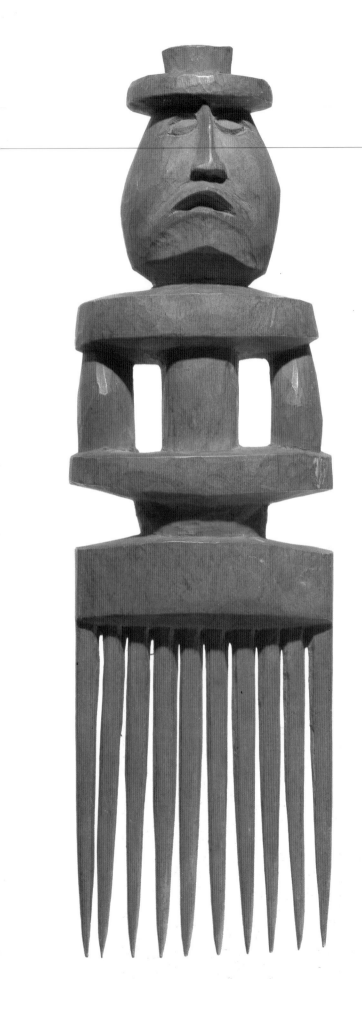

65. Comb Coast Salish; early 19th century

Wood; 18 cm x 5.5 cm x 3 cm

National Museum of Natural History, Smithsonian Institution #2702; collected by the Wilkes Expedition, 1841

Photograph courtesy of the Department of Anthropology, Smithsonian Institution

This comb depicts a human figure wearing a Euro-American style hat. Euro-American clothing, first obtained from maritime explorers and fur traders during the late eighteenth century, was prestigious and thus was quickly adopted by Native people along the Northwest Coast (Wright 1986). This is often reflected in carved motifs. Other Northwest Coast combs depicting human figures wearing Euro-American hats are known (Maidstone Museums and Art Gallery #604; British Museum #1949-AM2246). Wooden and bone combs were among the most highly decorated objects on the Northwest Coast for several centuries. While plain combs on the southern Northwest Coast date to the third or fourth century B.C., decorated combs first appear in the archaeological record dating to around A.D. 1250. On the northern Northwest Coast, decorated combs have been found at somewhat earlier levels, around A.D. 800 (Borden 1983: 163; MacDonald 1983: 107).

Combs such as this one may have been used in weaving to align the fibers and remove tangles before the wool was spun, or to push wefts up during the weaving process.

66. **Comb** Coast Salish; late 18th century

Wood; 19.5 cm x 5 cm x 2 cm

Museum of Mankind, British Museum #VAN219; collected
by George Hewitt on the Vancouver Expedition at Res-
toration Point, 1792

Photograph courtesy of the British Museum

This comb is among the earliest sculpture collected from
the southern Northwest Coast (see Wright, "A Collection
History," this volume). It is carved in the classic two-
dimensional style of the Straits- and Halkomelem-speaking
Salish. This ancient system of carving depicts abstract ani-
mal forms in a curvilinear two-dimensional style by cutting
away crescent and triangular T-shapes. Here, a wolf-like
animal is shown, its snout to the right. Its circular eye is
defined by negative triangles. The snout has triangular nos-
trils and an open mouth with a narrow tongue. Below, ribs
are defined by cut-away crescents; a clawed paw extends
downward.

On the other side the design is more abstract. Two rec-
tangular panels have central circular motifs, flanked by
hourglass shapes defined by negative T-shaped and crescent
reliefs (Wright, "A Collection History," fig. 3, this volume).
A very similar comb, excavated from the Ozette Village
site, has an animal head and claw on one side, with the
body and hind leg wrapped around on the other (Wright,
"A Collection History," fig. 4, this volume; Daugherty and
Friedman 1983: fig. 10.10.). The remarkable similarity of
these two pieces suggests that the circular motifs on the
back of this comb may represent the abstract hip joints of
the animal.

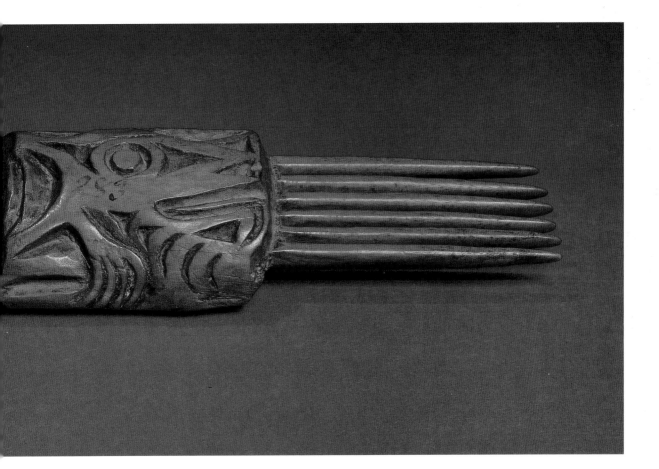

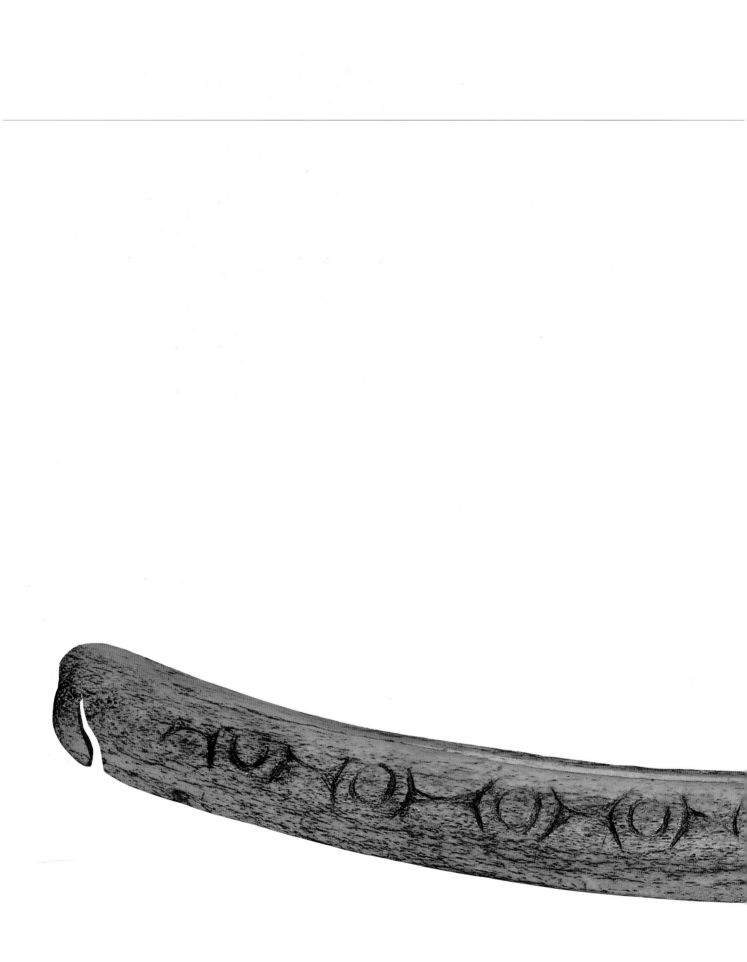

67. **Club** Klallam(?); late 18th century
 Whale bone; 53 cm x 5 cm x 3.5 cm
 Museum of Mankind, British Museum #VAN94; collected
 by George Hewitt on the Vancouver Expedition at Port
 Discovery, 1792
 Photograph courtesy of the British Museum

Many whale bone clubs were collected by the earliest European explorers on the Northwest Coast. Clubs from the west coast of Vancouver Island and the Olympic Peninsula usually have a bird-like head on the pommel with an open hooked beak, upturned eye, and eyelid line. They are generally straight with a flaring blade, which is often embellished with interlocking triangles defining zigzag lines or circular motifs with eyelid-like lines (King 1981: pl. 47, color pl. 8).

Serpent-shaped clubs are more rare; only two are known. Serpent clubs take advantage of the distinctive natural curve of the whale's rib bone. George Hewitt collected this club at Discovery Bay in 1792 (see Wright, "A Collection History," this volume). Its head at the pommel has a mouth full of teeth; a slot carved at the end of the blade seems to represent a downturned tail. The eyelid line has a peculiar upward turn at the back of the eye. The second serpent-shaped club is in the collection of the Pigorini

Museum in Rome (Museo Nazionale Preistorico Etnografico "Luigi Pigorini" #AM.15098/G). It has a serpent-headed pommel, and a complete serpent engraved on the curved blade. Interlocking triangles extend down the body of the engraved serpent.

The blade of the Hewitt club has circles flanked by joined negative T- (or H-) shapes with solid positive U's between them. These designs suggest scales and/or spinal joints, but can also be read as a row of eye-forms. On the top of this blade, interlocking negative triangles create a running zigzag line. The consistent use of these two types of geometric patterns on the blades of whale bone clubs is intriguing, and it is probable that their use is symbolic as well as decorative. Whale bone clubs with bird heads are thought to represent thunderbirds, supernatural eagles with the ability to capture whales in their talons. Their supernatural associates were lightning serpents who could be hurled as lightning bolts, the thunderbirds' harpoons, to impale whales. The zigzag line formed by interlocking triangles on the blade of each of the serpent clubs may symbolize the lightning bolt and identify this figure as the lightning serpent. Similar zigzag lines on the blades of some bird-headed whale bone clubs may also refer to the association between these two supernatural creatures.

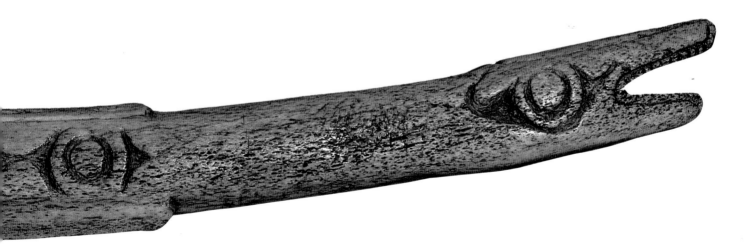

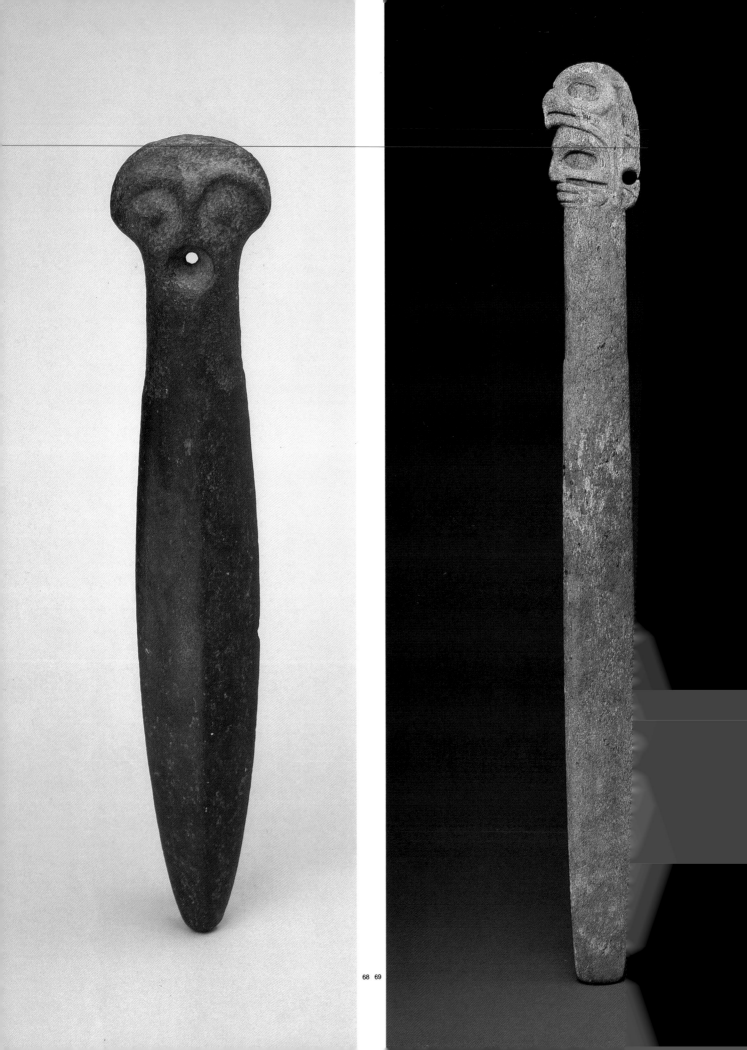

68. **Club** Skokomish; prehistoric

Basalt; 40.5 cm x 6 cm x 4.5 cm
Whitman College #1450, collected by Myron Eells, 1893
Photograph by Paul Macapia and Ray Fowler

Made from hard basalt by laborious pecking with a harder
pebble, this club is elegantly designed. Though collected in
the late nineteenth century, it is ancient in style. The cir-
cular eyes and mouth are similar to many Northwest Coast
petroglyphs (Hill 1974). The mouth is pierced to hold a
leather thong that would have been wrapped around the
wrist of the owner. According to Eells:

> I have a second of stone....When shown to an old
> Indian, it made his eyes sparkle, and seemed to fill
> him with new life, as he went through the warlike
> motions and showed in how still a manner they
> formerly crept up to kill a sleeping enemy (Castile
> 1985: 144).

69. **Club** Hartstene Island; prehistoric

Whale bone; 59.5 cm x 6 cm x 2.6 cm
Burke Museum #9033; collected by A. G. Colley, Museum
 Expedition, received 1923
Photograph by Paul Macapia and Ray Fowler

This weapon is one of the finest sculptural works of Native
art from Puget Sound (Holm 1987: 38). It was found during
this century, but may be as many as 2,500 years old.
Though it is similar to the bird-head whale bone clubs col-
lected from the west coast of Vancouver Island during the
late eighteenth and nineteenth centuries, its closest coun-
terpart was excavated from the Boardwalk site near Prince
Rupert in northern British Columbia, and dates to 500
B.C. (MacDonald 1983: fig. 6:16). Both clubs have human
heads surmounted by animal-form headdresses. The hol-
lowed oval eyes of the human faces and their surmounting
headdresses were probably once inlaid with shell. The same
hollowed eyes and band-like lips link these two clubs with
other prehistoric bone sculpture from Puget Sound and the
coast of British Columbia (pl. 78). Such close similarities
in sculptural forms between widely separated areas of the
coast may reflect the exchange of materials through exten-
sive trade or warfare. However, this evidence also indicates
that prehistoric art throughout the Northwest Coast may
have been more unified in style than the later tribal art
styles would suggest.

70. **Ceremonial Owl Club** Ozette Village; prehis-
 toric, ca. 1550 A.D.

Yew wood; 45 cm x 10 cm x 9 cm
Makah Cultural and Research Center
Photograph by Paul Macapia and Ray Fowler

This club is one of the most striking sculptures excavated
during the 1970s from the Ozette Village archaeological
site. The large bird's head has been identified as an owl. A
second owl's head on the handle has a small face carved on
the back. Though similar to fish killing clubs, this elabo-
rate club may have been used ceremonially. It shows no
evidence of the wear normally found on utilitarian clubs,
and its finely sculptured form suggests that it had a special
purpose (Daugherty and Friedman 1983: 195). In the
Makah language, *tukʷtukʷadi* means "owl," *ʔuštaqui·c*
means "belonging to an Indian Doctor."

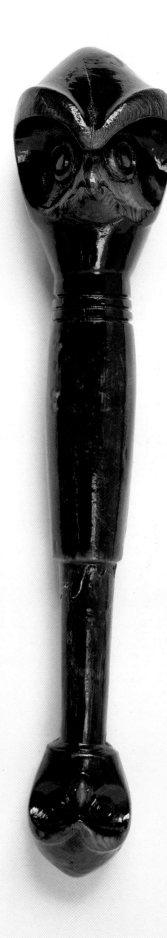

70

71. **Seated Human Figure Bowl** Shaw Island,
 prehistoric
Vesicular lava; 30 cm x 37 cm x 20 cm
Collection of Dr. and Mrs. Allan Lobb
Photograph by Paul Macapia and Ray Fowler

Only about fifty "seated human figure bowls" are known, found in an area centered just north of the San Juans (Duff 1956: 22). The few that have been scientifically excavated, from the Marpole site near Vancouver, are from 1,500 to 2,500 years old (Borden 1983: 150). Seated human figure bowls often have additional reptile or animal figures. On this bowl, the figure's arms and legs surround a shallow bowl from which another face stares. The human head is flanked by snake heads. Typically, a small knob is carved on the back of the head, as if for the attachment of hair or a headdress.

This unusual bowl was found on Shaw Island in the San Juans (Holm 1983: 121). According to Louise M. Gamble, it was found around 1925 or 1926:

> My father and brother were going to remove a large tree stump from a plot of ground to plant grain. They used some dynamite to blow it up. After the blast the stone carving sat up as though it was reborn. It had been lying face down in the pathway between our house and the chicken coop we had walked over many times a day (Gamble 1981).

72. **Seated Human Figure Bowl** Western Washington, prehistoric
Soapstone; 22 cm x 17 cm x 8.5 cm
Museum of the American Indian, Heye Foundation
 #1/9485; collected in 1870, acquired from the Free
 Museum
Photograph by David Heald, courtesy of the Museum of the
 American Indian, Heye Foundation

The elaborate carving on this seated human figure bowl is precursor to the two-dimensional art styles that developed on both the northern and southern Northwest Coast. The oval eyes with pointed eyelids and band-like lips are characteristic of later Salish sculpture. The three-dimensional details of the faces—carved cheek lines, rounded nostrils, and bulging eye orbs—are intriguingly similar to northern Northwest Coast sculpture. Many other seated human figure bowls also display stylistic features, particularly in the treatment of eyes, nose, and cheeks, that link these prehistoric sculptures to more northern historic art. This puzzling link could be interpreted in a number of ways. It may suggest the migration of peoples from south to north. It may be, as with the Hartstene Island and Boardwalk-site clubs (pl. 69), that prehistoric art on the Northwest Coast was relatively uniform geographically, and only later did it differentiate into distinct tribal styles.

Unusual features of this bowl are the prominence of the large protruding animal face on the front of the bowl, and the secondary face, on the human figure's back, with an open mouth and a protruding tongue. According to the Heye Foundation's records, this bowl was found in a shell midden, six feet below the surface, in western Washington (Duff 1975: 67, 174, no. 41).

Though these bowls have not been made for well over a thousand years, there is some ethnographic evidence that they were used by shamans and in women's puberty rituals in more recent times:

> Mr. MacKay (Indian Agent for the Kamloops district) states that at the end of the puberty ceremonies the shaman led the girl back from seclusion to the village in grand procession. He carried a dish called tsuqta'n, which is carved out of steatite, in one hand. The dish represents a woman giving birth to a child, along whose back a snake crawls. The child's back is hollowed out and serves as a receptacle for water. In the other hand the shaman carries certain herbs. When they returned to the village the herbs were put into the dish, and the girl was sprinkled with the water contained in the dish, the shaman praying at the same time for her to have many children (Duff 1956: 56; Boas 1890: 90).

Other accounts describe the use of stone bowls used by shamans in their curing work or to read the future or see what was happening in distant places by gazing into water in the shallow bowl (Duff 1956: 56). Though their basic structure is the same, no two seated human figure bowls are exactly alike, and it is likely that their designs reflect the individual power or spirit helpers of the owners.

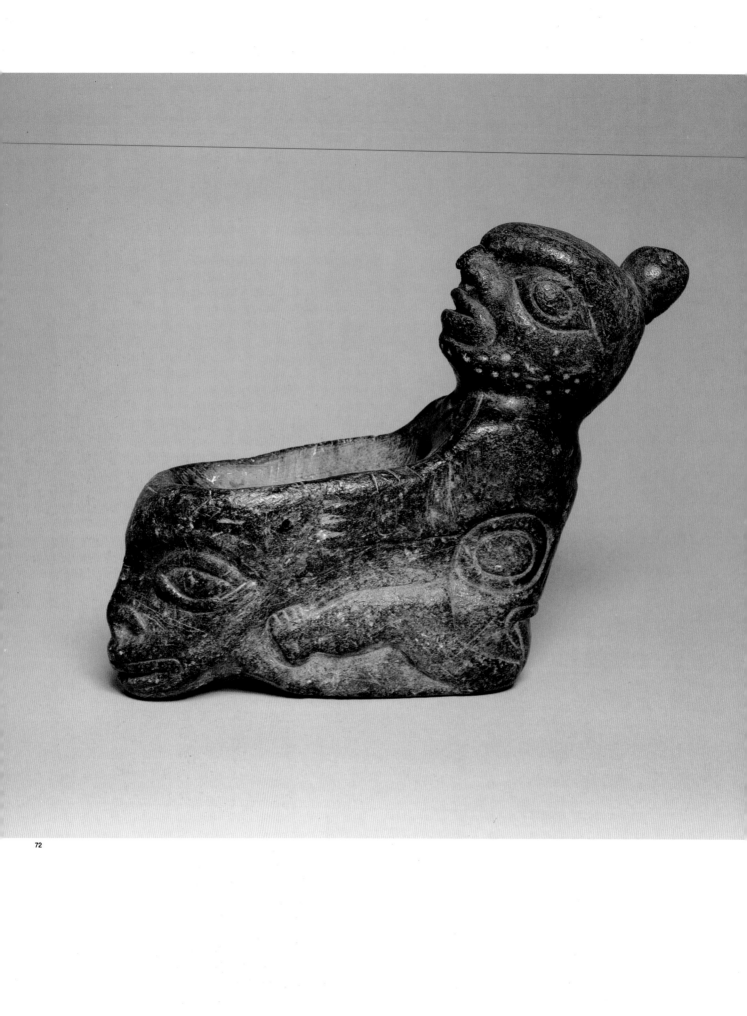

73. **Double Mortar** The Dalles, Columbia River;
 prehistoric
Vesicular basalt; 28 cm x 19 cm x 13 cm
Maryhill Museum of Art #TL 1944.12, Walter Klindt fam-
 ily collection
Photograph by Paul Macapia and Ray Fowler

The small face may represent a baby carried on the back of
the larger figure (compare pl. 77). This double mortar was
found on the Klindt family farm, west of The Dalles
(Wingert 1952: pl. 24, cat. no. 34). It displays many of
the classic features of prehistoric stone sculpture from the
Columbia River basin. The almond-shaped eyes, thin
straight nose, and skeletal ribs are characteristic of pieces
produced on the lower Columbia 1,500 to 2,500 years ago.
The double zigzag motif, which forms a headband on the
larger head, persisted on sculpture from this area into the
nineteenth century (pls. 48–50, 56, 57). Shallow depres-
sions in these two heads suggest that this piece might have
been used as a mortar, though it is also possible that it
functioned as a shaman's receptacle.

I remember my grandfather used something like this. He
would turn the face and make an offering in the bowl—
then the weather would change.

 —Charlie Pierce, Yakima

74. Stone Head Dalles/Deschutes River; prehistoric
Vesicular basalt; 23.2 cm x 23.2 cm x 15 cm
Oregon State Museum of Anthropology #1-110; collected by
Thomas Condon before 1872; received in 1907
Photograph courtesy of the Oregon State Museum of Anthropology

Large stone heads of unknown use, found along the Columbia River, are rare and ancient in origin (Wingert 1952: pl. 27, cat. no. 81). Made by the technique of pecking and grinding with a harder stone, they generally utilize the natural shape of the boulder. The forms are created by removing the minimal amount of stone needed to define the features, usually representing animals, humans, or birds. This piece resembles the head of a mountain sheep. It has a small depression at the bridge of the nose and two others on the top and back of the head. The small mortar-like hollows, and the head itself, may have had a ceremonial function. It was collected before 1872 near the confluence of the Deschutes and Columbia rivers.

These carvings existed way before anyone can remember, even before the old people. There were only stories about them. No one remembers a time when they were made or how they got here. They are found all along the Columbia River. Maybe people migrated along these routes or traveled back and forth. No one really knows.

—Agnes Tulee, Yakima

75. Tubular Pipe Moses Coulee; prehistoric
Steatite, cedar, cedar bark; 27.5 cm x 6.5 cm x 7 cm (case);
20 cm x 5 cm (pipe)
Collection of Dr. and Mrs. Allan Lobb
Photograph by Paul Macapia and Ray Fowler

The "Moses Coulee pipe" is the only prehistoric pipe ever found with a wooden case. It is the most famous, and most frequently published, pipe from the Columbia Plateau (Hill-Tout 1934; May 1942; Strong 1960: 137; Kirk and Daugherty 1978: 68). It was found in 1934 by a rancher who was excavating a cave on his land, in Moses Coulee, a channel formed by the ancient Columbia Basin floods, near Wenatchee. The pipe, enclosed in a wooden case and padded with cedar bark, had been placed in a bundle of sagebrush matting in a niche in the cave wall. This niche, four and one-half feet below the level of the cave floor, was exposed only after forty tons of dirt and debris had been removed by a team of horses with a scraper.

The case is decorated with a zigzag pattern at the bowl end. In contrast to the zigzags carved on mountain sheep horn utensils consisting of negative interlocking triangles, these negative zigzag lines are inscribed in the surface. Three stick-like figures, two human and one animal, decorate the stem-end of the case. Only an important ceremonial object would be encased with such care (Hill-Tout 1935, May 1942).

76. Tubular Pipe Pot Holes Site, ca. late 18th century
Stone; 6.8 cm x 3.4 cm x 3.8 cm
Burke Museum #9256; Museum Expedition, F. S. Hall, 1920
Photograph by Paul Macapia and Ray Fowler

This small pipe is beautifully carved to represent a bird, probably an owl, with its head on the bowl and its feet at the mouthpiece. Tubular stone tobacco pipes are the oldest type of pipe found in North America. They first appeared in the cultures of the Great Basin 9,000 years ago, and spread north to the Columbia Plateau about 2,000 years ago (Jennings & Norbeck 1964: 154). The distribution of pipes corresponds to the distribution of the native species of tobacco, *Nicotiana attenuata*, which extends from the Great Basin to the interior of British Columbia (Goodspeed 1954: 40). This pipe, excavated from the Potholes Site near Trinidad, Washington, is about 200 years old (Crabtree 1957: 66). Pipes such as this were smoked until recent years in southern British Columbia (Duff 1956: 84).

Prehistoric tobacco pipes are found in far fewer numbers along the lower Columbia and Fraser rivers, west of the Cascades. The practice of smoking tubular pipes apparently fell into disuse in these areas before the arrival of Europeans (Duff 1956: 84). During the late eighteenth and nineteenth centuries, elbow pipes were brought to these areas by Euro-American fur traders, and the custom of smoking was reintroduced. On the Columbia Plateau during this period, elbow pipes—often inlaid with lead as were Plains pipes—soon replaced the more ancient tubular pipes.

In the Sahaptin language, *čálamat* means "pipe." This no doubt comes from the word calumet, from the French *chalumeau*, meaning reed or flute, which refers to the ceremonial pipes and their stems used throughout the Eastern Woodlands and the Plains (Wright 1980: 78).

74

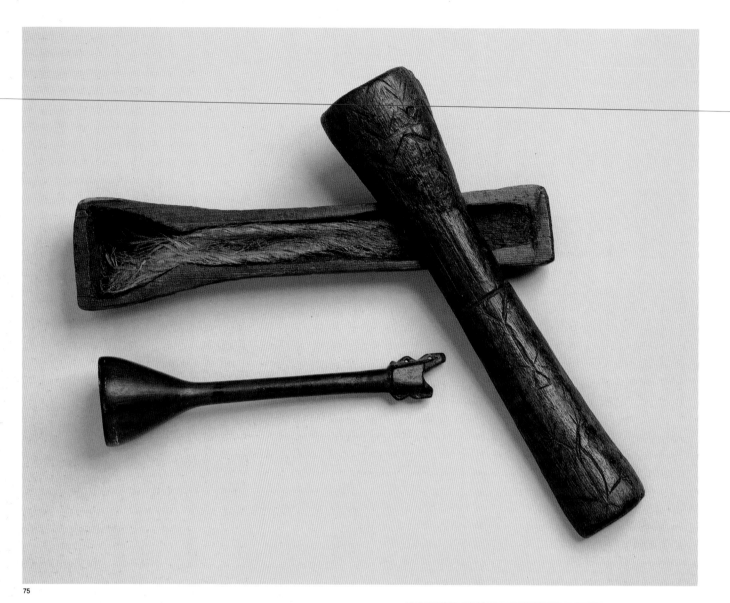

75

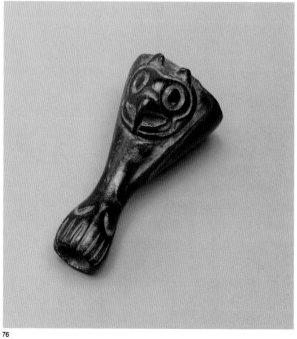

76

77. **Human Figure** Multnomah, Sauvies Island;
 prehistoric, pre–A.D. 1600
Elk antler; 19 cm x 5 cm x 5 cm
Burke Museum #2-3844; acquired from Mr. and Mrs. Leon
 Tabor, received 1955, R. B. Stewart Wakemap Project
Photograph by Paul Macapia and Ray Fowler

This woman, carved in elk antler, carries a child in a cra-
dle on her back (Holm 1987: 30). She wears a short skirt,
perhaps of cattail leaves, like the one collected by Lewis
and Clark (pl. 5). She is carved with a skeletal structure and
geometric detail, a prime example of the prehistoric lower
Columbia River style. Sauvies Island, located at the conflu-
ence of the Willamette and Columbia rivers, once had
several villages and a large Native population, estimated at
over 6,000 when Lewis and Clark first visited. By the
mid-1830s the Native population was entirely gone, due to
severe epidemics of smallpox and malaria (Strong 1960: 20,
98). This figure was found at the Bridge Camp Site, occu-
pied for about 700 years, but abandoned before A.D. 1600
(Butler 1965: 7).

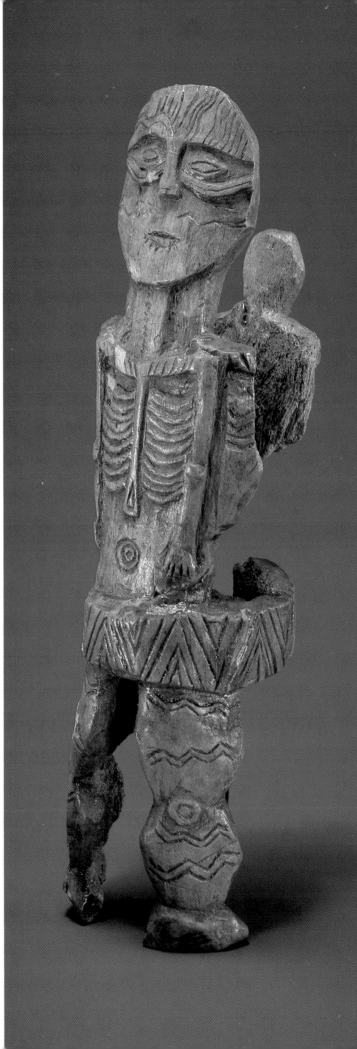

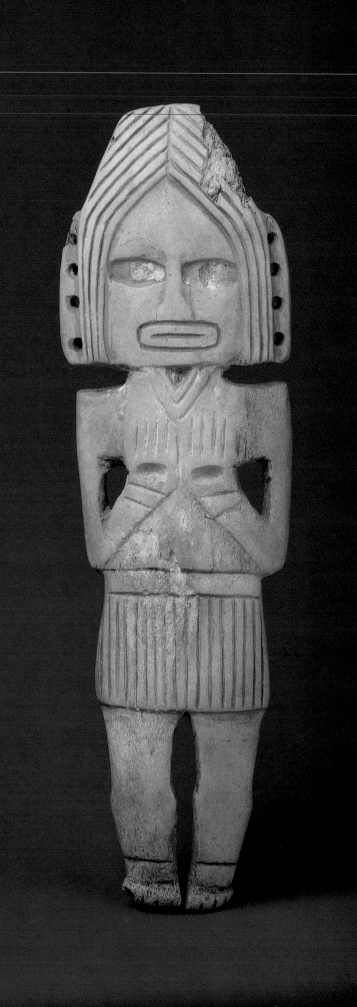

78. **Human Figure** Sucia Island; prehistoric
 Elk antler; 22.5 cm x 7 cm x 1.5 cm
 Burke Museum #2.5E603; gift of Edwin R. Monk, received
 1976
 Photograph by Paul Macapia and Ray Fowler

This woman is identified by her fringed skirt, bracelets and
anklets, and hair parted in the center on a high forehead
(Holm 1987: 52). On the southern Northwest Coast the
heads of infants were shaped, by controlled pressure in the
cradle, to beautify them. Females' heads were usually flat-
tened more than males'; the depiction of an elongated head
can identify a figure as a woman. The eyes of this figure
were probably once inlaid with shell; the holes along the
side of the head may represent pierced ears that once had
pendants inserted.

 Found in a cave on Sucia Island, this is the largest of
five similar antler figures found in an area ranging from the
San Juan Islands to the central British Columbia coast (see
Wright, "A Collection History," fig. 5, this volume). They
are believed to date between A.D. 200 and 1200 (Carlson
1983: 124, 201; Kirk and Daugherty 1978: 87). Perhaps they
served as shamans' power figures.

79. **Human Figure** Coast Salish(?); late 18th
 century
 Wood, hair, leather, glass, dentalium shells, copper; 35 cm x
 8.5 cm x 6 cm
 Museum of Mankind, British Museum #VAN160; collected
 by George Hewitt on the Vancouver Expedition at Res-
 toration Point, 1792
 Photograph courtesy of the British Museum

This mysterious figure, among the earliest sculptures col-
lected in Washington, has hands held up, as does the even
earlier Sucia Island woman (pl. 78). It is sculpted in the
round with swelling hips, knobby knees, and rounded
calves. Typical of historic Coast Salish sculpture, the face is
a flat oval with a thin, straight nose. However, the eyes and
lips are raised bands, rather than being flat slits cut into the
planes of the face.

 The hat, with its leather tassels strung with bits of
dentalium shell, matches hats worn by Makah women in
1792, the same year this piece was collected (see Wright, "A
Collection History," fig. 2, this volume). Perhaps the figure
represents a woman. Human hair is pegged in under the
hat, and bits of copper have been inlaid on it. A large piece
of glass once was glued in the rectangular depression on the
belly.

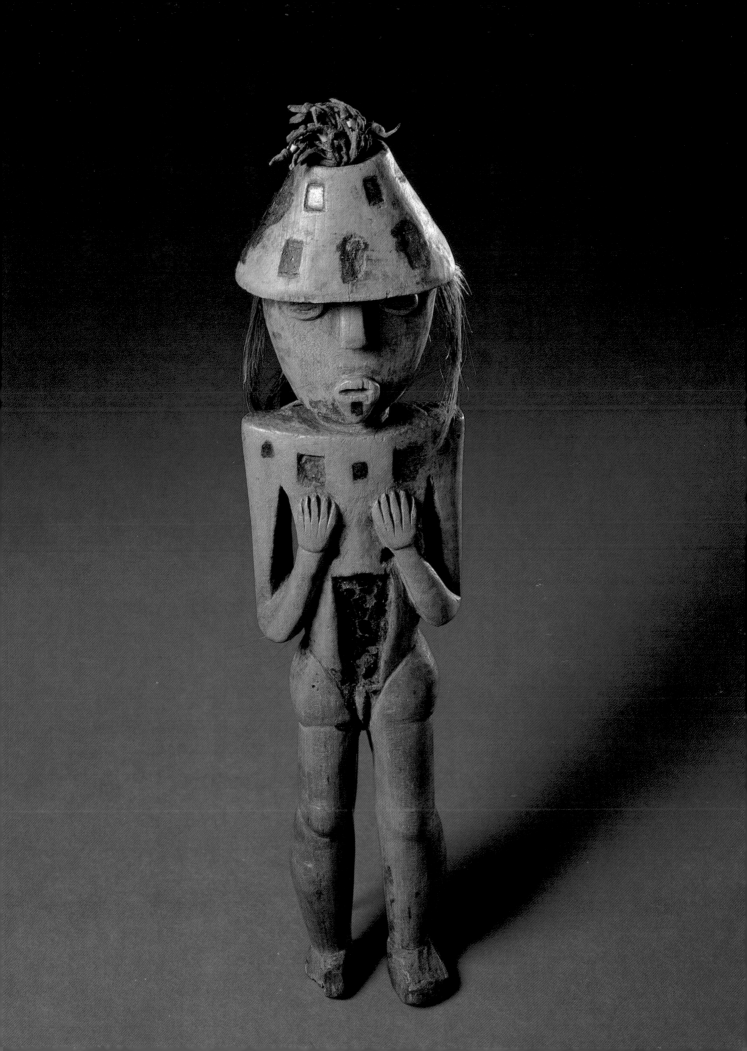

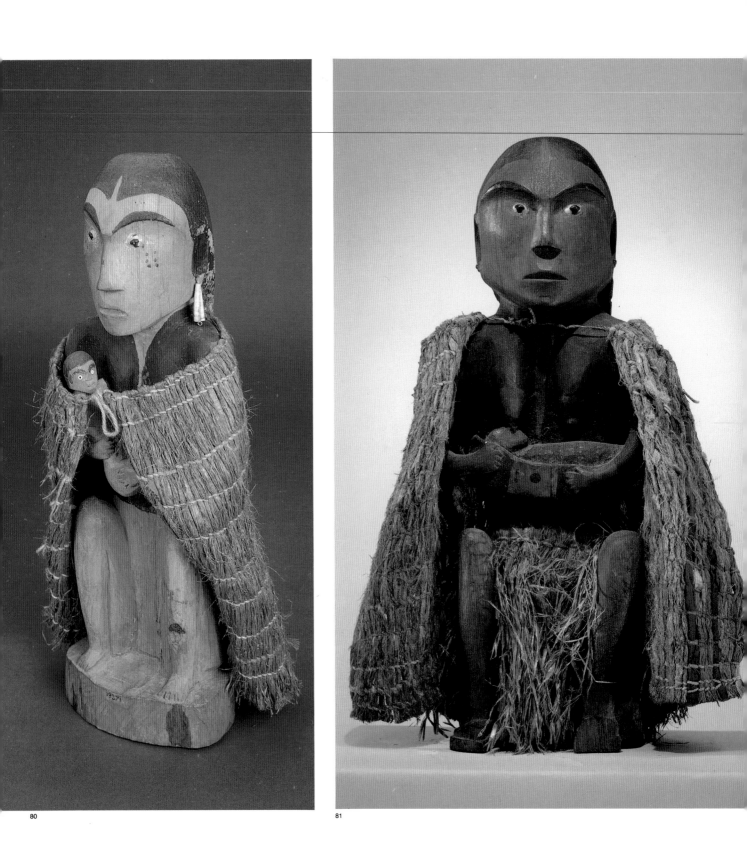

80. **Female Figure** Makah, made by Allabush; late
 19th century
 Wood, cedar bark, shell; 36 cm x 12 cm x 9 cm
 Field Museum of Natural History 19371; collected by W. E.
 Dickinson, received 1905
 Photograph by Ron Testa, courtesy of the Field Museum of
 Natural History

81. **Female Figure** Makah, made by Allabush; late
 19th century
 Wood, cedar bark, shell; 36 cm x 16 cm
 Private Collection
 Photograph courtesy of Douglas Ewing

Dolls of mothers holding babies were owned and enjoyed
by Makah children, and were also made for sale to out-
siders. In the late eighteenth century, Captain James Cook
collected similar dolls on Vancouver Island (King 1981: figs.
83-85). One hundred years later Allabush, Ɂeˑlabuš, a well-
known Makah carver, produced these two. Allabush was
photographed in Neah Bay in the 1890s with several carv-
ings in progress (fig. 1; Marr 1987: 62). At least five
Allabush dolls reside in museums and private collections
(Washington State Historical Society Museum; Field
Museum of Natural History #19373). All the dolls are
seated in a squatting position; their carved, braided hair
hangs down their backs, their oval ears are shallowly hol-
lowed, and their eyes are painted shell. Three of these
female figures hold babies and are wearing cedar bark or
skin robes. One wears a cedar bark skirt as well.

In the Makah language, *yaˑdakiɁeł* means "imitation
of a baby," and *xadɁakiɁeł* means "imitation of a woman."

82. **Female Doll** Coeur d'Alene; late 19th century
 Buckskin, trade cloth, sinew, hair, glass beads; 60 cm x
 31 cm x 8 cm

83. **Male Doll** Coeur d'Alene; late 19th century
 Buckskin, trade cloth, hair, sinew, glass beads, wood,
 feathers; 63 cm x 25 cm x 8 cm
 National Museum of Natural History, Smithsonian Institu-
 tion #213523 and 213522; collected by Lieutenant
 Babcock at Vancouver Barracks, 1901
 Photographs courtesy of the Smithsonian Institution

Dolls such as this were made for cherished children, and in
the late nineteenth century were also made for sale. This is
the largest and most detailed pair of Plateau dolls known.
They accurately depict the traditional style of Plateau cos-
tume, down to the beadwork, jewelry, and facial paint
(compare pls. 6, 8, 9, 18). The male doll also wears a
quiver, complete with bow and arrows.

Figure 1. Makah carver, Ɂeˑlabuš (Allabush), with partially
completed dolls. Photograph by Samuel G. Morse, 1896–
1903, courtesy of the Washington State Historical Society,
Tacoma.

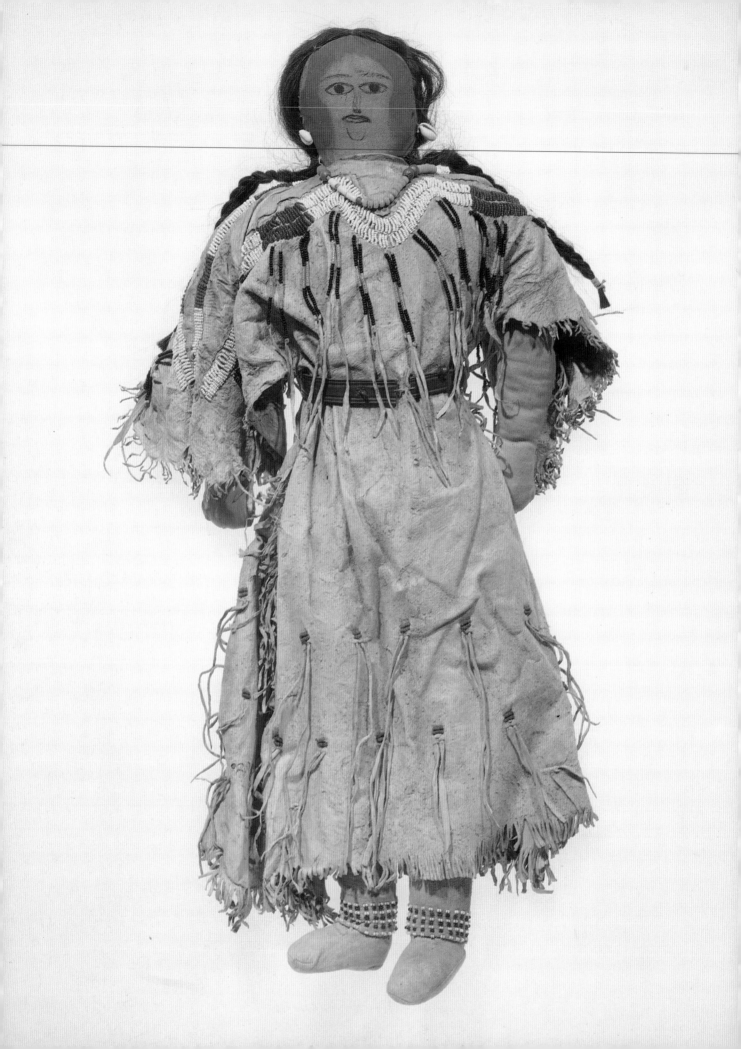

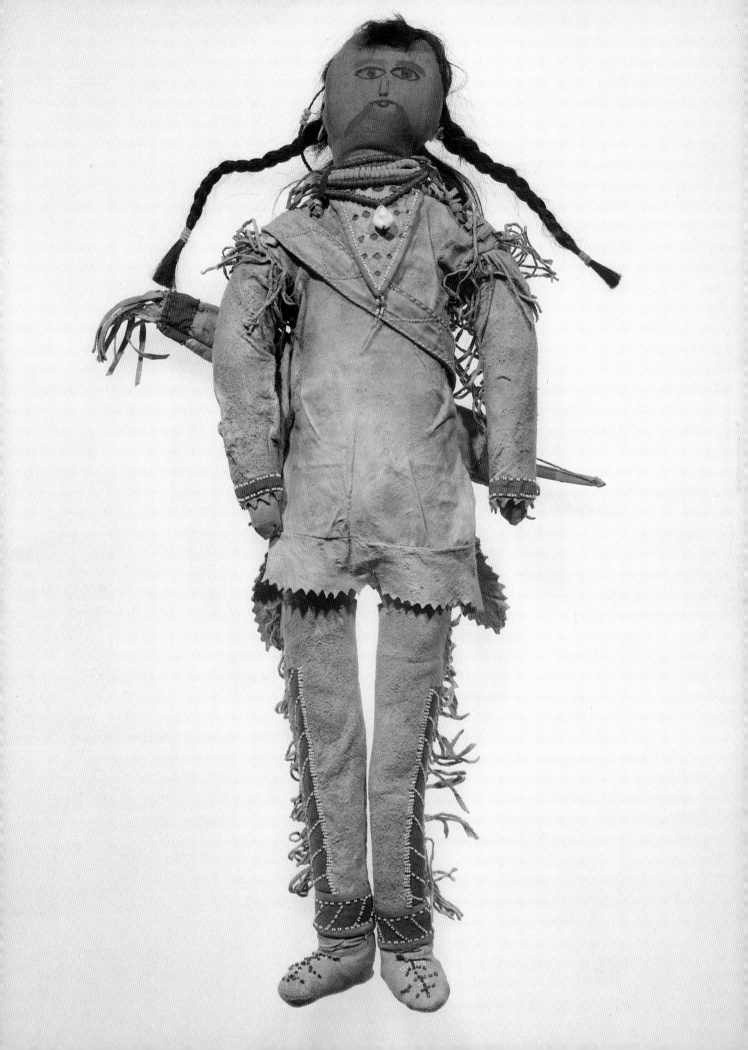

84. Canoe Model Coast Salish; early 19th century
Wood, leather; 58.5 cm x 15.5 cm x 11.5 cm
Perth Museum and Art Gallery, Tayside, Scotland
#1978.502.1; collected by James M. Yale at Fort Lang-
ley; Colin Robertson Collection, received 1833
Photograph courtesy of the Perth Museum and Art Gallery

This is one of three model Salish canoes, the best and ear-
liest known, collected at Fort Langley on the Fraser River
around 1830 (see Wright, "A Collection History," and
Holm, this volume). These are sturgeon fishermen. The
figure in the stern paddles the canoe, while the figure at the
bow holds a long sturgeon spear. The spear is a separate
piece that slips into the hands of the fisherman. Since the
paddle is carved from the same piece as the canoe, the lim-
ited size of the wood caused the carver to bend the paddle
at the gunwale. Though darkened with age, the canoe
appears to have been painted red on the inside and black
on the outside. The man at the bow seems to be either
singing or speaking, but the accompanying description of
sturgeon fishing suggests that he may be grunting:

> Represents Indians fishing for sturgeon...That this
> may be better understood—take the handle of the
> spear which will be found in three pieces, join them
> together as is always done when to be made use of,
> then place the barbs on the forks, the string in the left
> hand, and the spear in the right, so that it may incline
> downwards over the bow of the canoe and fancy the
> steersman to be paddling up the stream with all his
> might. The bowman grunting as loud as possible (for
> this likewise in their imagination is essentially neces-
> sary) and pushing up and forward his spear in to the
> water, when the spear is brought to a perpendicular
> position...they will drift down keeping the bow of the
> canoe against the current—the bowsman taking care
> to keep his spear straight and near the bottom where
> the sturgeon most commonly are—when it comes in
> contact with anything he instantly perceives from the
> feel what it is and seldom misses pushing it into the
> fish. This may be somewhat strange considering the
> depth of the water which is in part of the river from 70
> to 90 ft. Some days prior to going out on this kind of
> exercise they scour themselves all over the body with
> brooms of cedar and pine branches, rub off large
> patches of skin off the cheeks and smear themselves
> with red earth and abstain from every kind of
> uncleanliness, even a smile at this time would contrib-
> ute to lessen their success they imagine (Idiens 1987:
> 50).

85. Canoe Model Makah; late 19th century
Wood, cedar bark, glass beads, bird skin, shell, cotton string,
bone, iron; 119.4 cm x 25.4 cm x 28 cm
National Museum of Natural History, Smithsonian Institu-
tion #73740; collected by James G. Swan; received
1884
Photograph courtesy of the Smithsonian Institution

This detailed model whaling canoe comes complete with a
crew of eight and all of their equipment. It was probably
commissioned by James G. Swan specifically for the
Smithsonian Institution's collections. The whaling harpoon
and lanyard, paddles, and sealskin floats, as well as plaited
cedar bark mats and baskets, complete the equipment on
board. Particularly interesting are the elaborate hair styles
worn by the whalers. Curiously, one of the crewmen, sec-
ond back on the port side, wears a bird skin cape, and his
body ends in a flat flange, rather than fully carved legs like
the other crew.

Č'a·pacⁱʔeɬ means "model canoe" in the Makah lan-
guage; *č'a·pac*- means "canoe," and *ⁱʔeɬ* means "imitation
of."

84

85

86. **Wolf Mask** Makah; late 19th century
Yellow cedar, hair, cotton string, nails; 47 cm x 18 cm x 18 cm
Burke Museum #2.5E1543; collection of Sophie Frye Bass, received from the Museum of History and Industry, 1980
Photograph by Ray Fowler

87. **Wolf Mask** Quileute; early 20th century
Wood; 76 cm x 21.5 cm x 18 cm
Denver Art Museum #1952.382
Photograph courtesy of the Denver Art Museum

The Klookwalli was the most spectacular masked ceremonial of the Makah people (Holm 1987: 84). Its purpose was the initiation of those who inherited the important privileges associated with the wolf dances. The initiates were taken away by supernatural wolves and, after several nights of dancing, were ritually rescued by their human families. Elaborate headdresses representing wolves were worn in the "Whirling Wolf" dance, often reserved for the oldest son of a chief. This mask, fringed with human hair, once had inlaid eyes. It is a fully carved, "Whirling Wolf" type of forehead mask.

Wolf headgear in the Makah language is *hili·kub*.

This wolf mask, carved of a solid piece of wood, was made by a Quileute carver. The Klookwalli was acquired by many Native people of the Washington coast through marriage ties. Headdresses worn in the final performances of the Klookwalli represent wolves, lightning serpents, or thunderbirds. Though the full Klookwalli ceremonial has not taken place in Washington for many years, dances with wolf masks are still performed by the people of the coast.

87

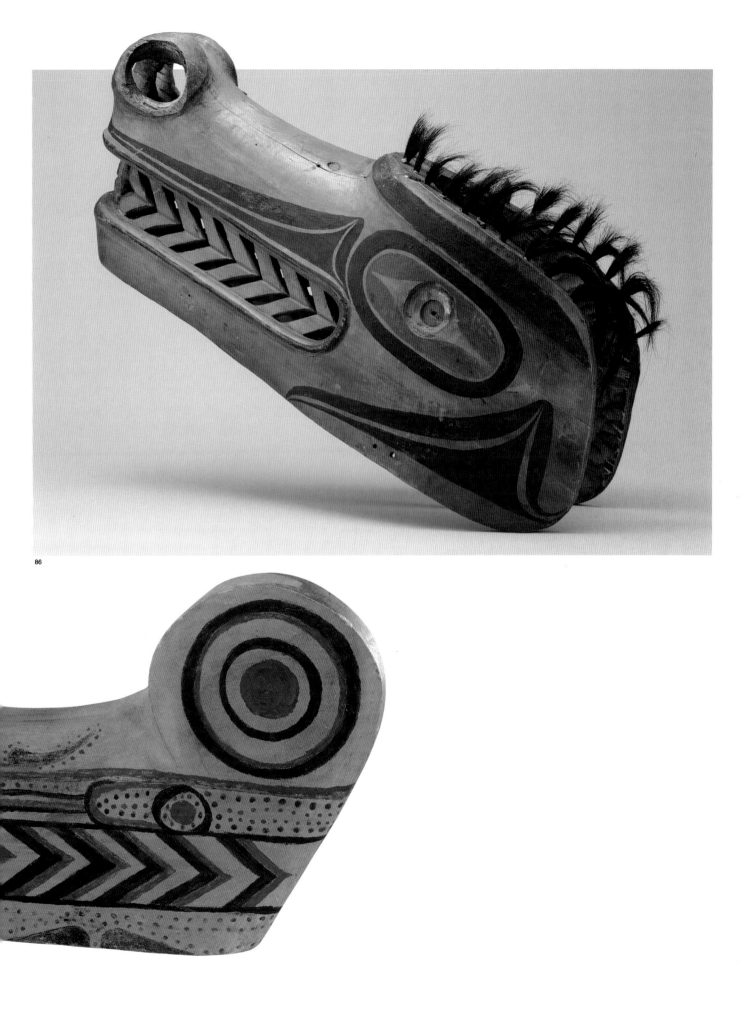

86

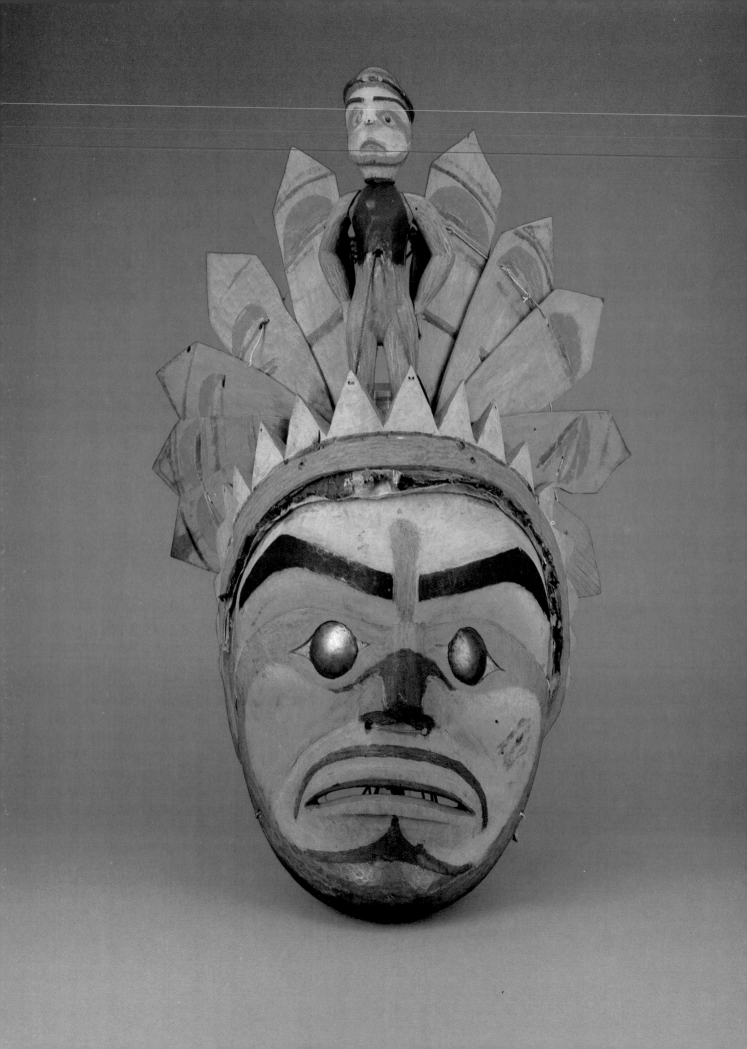

88. **Humanoid Mask** Makah; late 19th century
 Wood, brass, cotton cloth, foil, nails, cotton string; 63 cm x
 42 cm x 28 cm
 Field Museum of Natural History #61927; collected by
 George Dorsey, museum expedition, 1900
 Photograph by Diane Alexander White, courtesy of the Field
 Museum of Natural History

This humanoid sun mask is also a spectacular mechanical
device. It was made for a dance owned by an individual
family. By manipulating strings behind the mask, at a cer-
tain dramatic moment the dancer could make the small
human figure at the top pop up, and the corona of sun's
rays fan out. Although made famous by the Kwakiutl peo-
ple of northern Vancouver Island, many mechanical masks
like this were constructed by Makah and Nuu-chah-nulth
(Nootka) carvers as well.

 This mask is said to have been made by Atliyu
(ʔeˑɬyuˑ), a Tla-o-qui-aht (Clayoquot) carver from Van-
couver Island, British Columbia (see Marr 1987: 63).

89. **Eagle Mask** Makah; late 19th century
 Wood, human hair, cotton cloth, cotton cord; 30 cm x
 18 cm x 14 cm
 Field Museum #61904; collected by George Dorsey,
 museum expedition, 1900
 Photograph by Fleur Hales Testa, courtesy of the Field
 Museum of Natural History

The bold curve of an eagle's beak dominates the design of
this forehead mask; the smoothly contoured surfaces of the
eagle's head are the foundation for the painted motifs. Black
and red paints define eye, eyelid, and eyebrow. Masks rep-
resenting eagles and thunderbirds were brought out in the
final dances of the Klookwalli ceremonial. This small eagle
headdress is an excellent example of the nineteenth-
century carving style of Makah and Nuu-chah-nulth
artists.

 In the Makah language, ʔakwatiˑd means "eagle,"
łuˑtłuˑtš means "thunderbird."

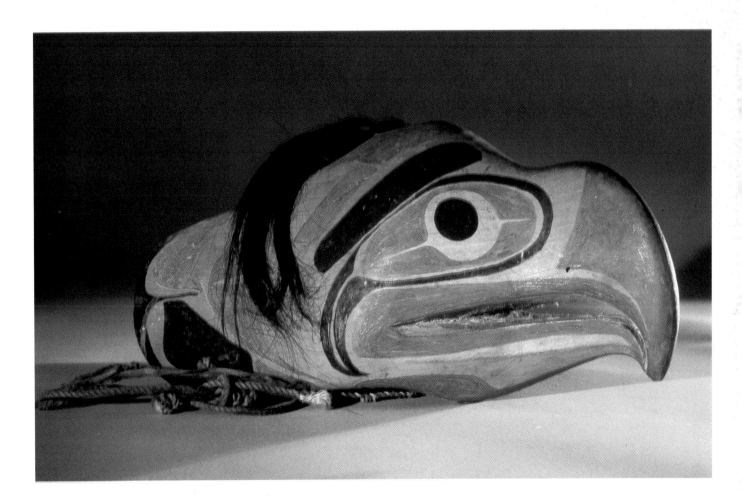

90. **Grouse Rattle** Makah; 19th century
Wood (alder?), glass beads; 32 cm x 11 cm x 11 cm
Burke Museum #4857; purchased from Mrs. H. B. Fer-
 guson, received 1915
Photograph by Eduardo Calderón

Carved in the form of a grouse, this is among the most dis-
tinctive and elegant of all Northwest Coast bird rattles. The
bulbous body has a flattened chest that sweeps up to a nar-
row neck and triangular head. Triangular slots cut into the
neck and below the beak lighten the rattle and make it
more resonant. White glass beads inlaid for the eyes and
down the neck add to the richness of this simple and beau-
tiful form.

Rattle is *bu·xʷi·c'* in the Makah language.

91. **"Kwa' Laba Kuth"** Greg Colfax, Makah; 1988
Cedar, cedar bark, paint, feathers; 42 cm x 30 cm x 28 cm
 without cedar bark
Burke Museum #1989-22/1
Photograph by Paul Macapia and Ray Fowler

This Kwa' Laba Kuth, or "Wildman," mask represents one
of the ghost-like forest spirits that appear during the Makah
Klookwalli ceremonial. Similar ghost-like spirits are repre-
sented in mask form among neighboring tribes: Pukmis and
Ahlmako of the Nuu-chah-nulth, and Bukwus of the
Kwakiutl. Their ghostly qualities are sometimes represented
by skull-like heads with hooked noses and bared teeth in
grimacing mouths.

Greg Colfax was trained as an educator and in creative
writing, with degrees from both Western Washington Uni-
versity and the University of Washington. He has taught
both in the Native American Studies Program at Evergreen
State College and in elementary and high school at Neah
Bay. He began his training as a carver in 1978 under Art
Thompson, George David, Steve Brown, and Loren
White. He has been described as an "artist, fisherman,
canoe company manager, poet, and philosopher" (Whiley
1988: 63). Two of his pieces were included in the travelling
exhibition "Lost and Found Traditions," a drum, and an
innovative bentwood whaler's box that was featured on the
cover of the exhibition catalogue (Coe 1986: 277, cat. nos.
350, 352).

In 1985 a twelve-foot figure of a woman drumming
was carved by Colfax for the Native American Studies Pro-
gram at Evergreen State College in Olympia where it now
stands. In addition, Colfax was recently commissioned by
the city of Tukwila to produce a fifty-foot carved and
painted cedar mural as a public art project for Tukwila City
Hall. Colfax has researched the collections at the Burke
Museum, Royal British Columbia Museum, and the
Makah Cultural and Research Center, and consults with
Makah elders about the meaning and uses of art objects
and utensils. Today he is considered a master carver in
Neah Bay, working with apprentices. In addition to his
many commissions for original carvings, Colfax also
restores old pieces.

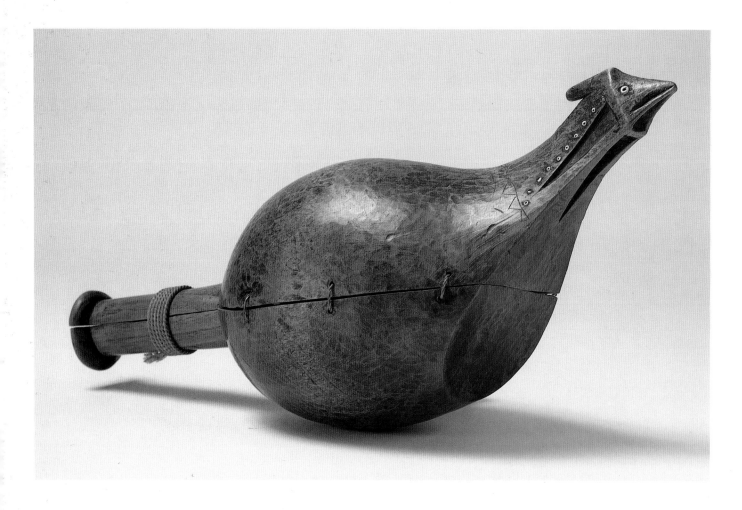

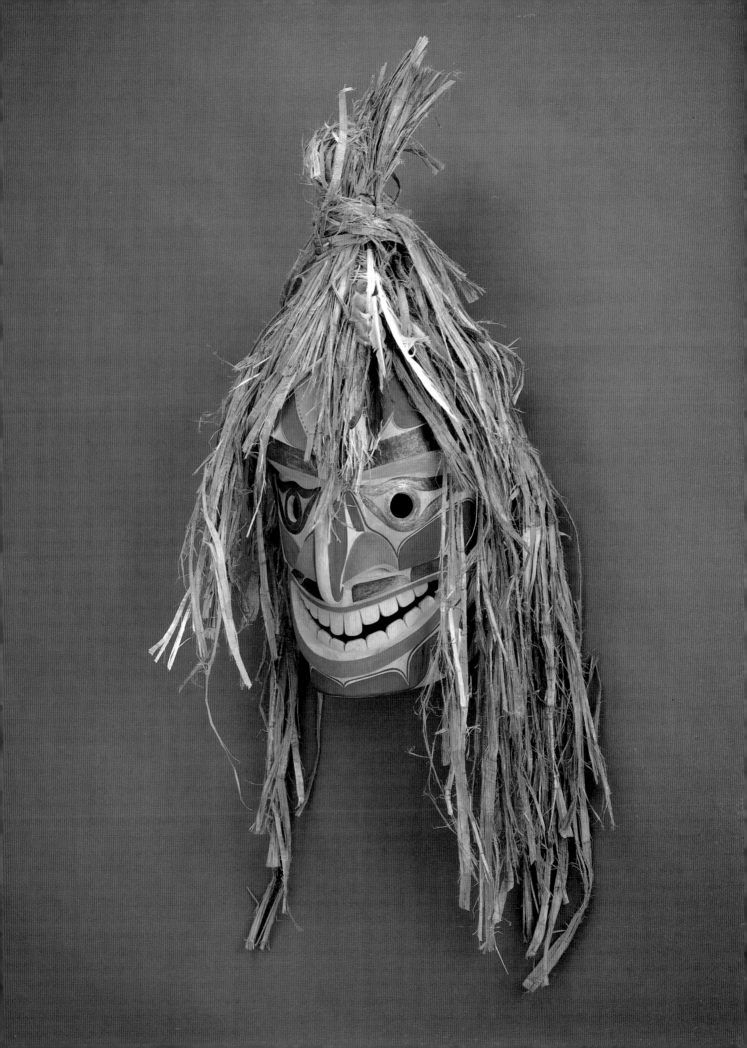

Figure 2. Greg Colfax. Photograph 1981, by Eduardo Calderón.

Figure 3. Lillian Pitt. Photograph by Elizabeth Woody.

92. **"She-Who-Watches"** Lillian Pitt,
 Yakima/Wasco/Warm Springs; 1988
 Anagama fired clay, bone hair pipes, red pipestone, glass
 beads, brass tubes, abalone shell, golden pheasant
 feathers, sea urchin spines; 24 cm x 28 cm x 8 cm
 without feathers
 Burke Museum #1988-92/1
 Photograph by Paul Macapia and Ray Fowler

*For thousands of years, my ancestors lived on both sides of
the Columbia River. My father's mother (Y-yuten, Charlotte
Edwards Pitt) lived at Five Mile Rapids under the gentle
gaze of Tsagagla'lal (She-Who-Watches), the ochre-stained
pictograph. I can only assume that Y-yuten's ancestors lived
there and shared with my mother's (Mohalla, Elizabeth
Thompson Pitt) ancestors at Celilo Falls.*

*I have respectfully taken the elegant form of She-Who-
Watches, given her dimension, infused my profound sense of
identity, the spirit of the clay combined with the mystery of
the firing, and finally, my desire for the continuity of The
People, The River, The Earth.*

—Wa k'a mu, Lillian J. Pitt

As a ceramicist/sculptor, Lillian Pitt works primarily with
the mask form to express her own vision. Though the
Yakima/Wasco/Warm Springs people from whom she
descends were not traditionally mask-makers, she draws
inspiration from the rich culture of these Columbia River

people. The legends involving Coyote (see Louie, this vol-
ume), the spirits of animals and people, and particularly
the pictographic image of She-Who-Watches are reflected
in her work. She-Who-Watches was the last of the Women
Chiefs, who taught the people to live in the right manner
before Coyote changed her into a rock to watch over her
people and the Men Chiefs that followed her.

In her work Pitt has used two ancient techniques of fir-
ing clay: the sixteenth-century Japanese *raku* process, and
the eighth-century Korean Anagama method. Located at
Willamina, Oregon, the Anagama kiln used to make this
mask fires up to 2500° F. and is stoked manually by a crew
for 56 continuous hours with three and one-half cords of
Douglas fir, then is allowed to cool for a week. With this
process, the artist controls only the original form of the clay
and its placement within the kiln. The tremendous forces
of heat, fire, and ash within the kiln usually result in the
loss of half of the pieces. Each surviving piece is conse-
quently a testimony to its own endurance and the result of
the transforming properties of the raw flame.

In addition to many one-woman shows, Lillian Pitt's
work was included in the travelling exhibits "Women of
Sweetgrass Cedar and Sage," "New Directions Northwest:
Contemporary Native American Art," and "Beyond the
Blue Mountains" (Gallery of the American Indian Com-
munity House 1985; Oregon Art Institute 1987). Her masks
are in collections throughout the United States as well as
Saudi Arabia and Sapporo, Japan.

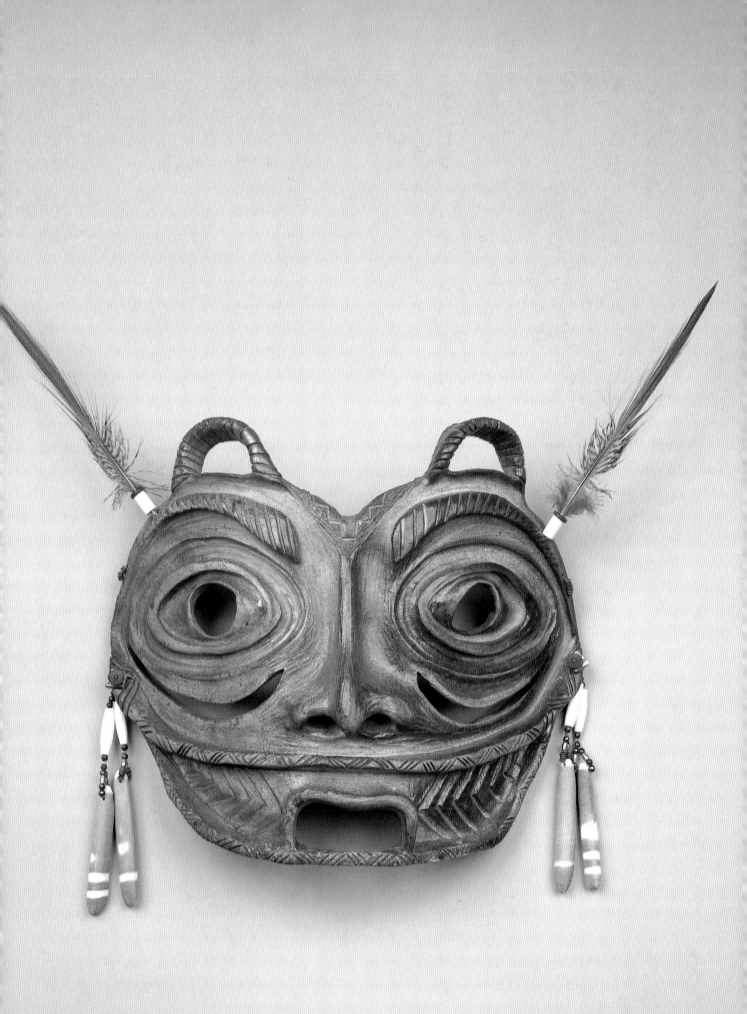

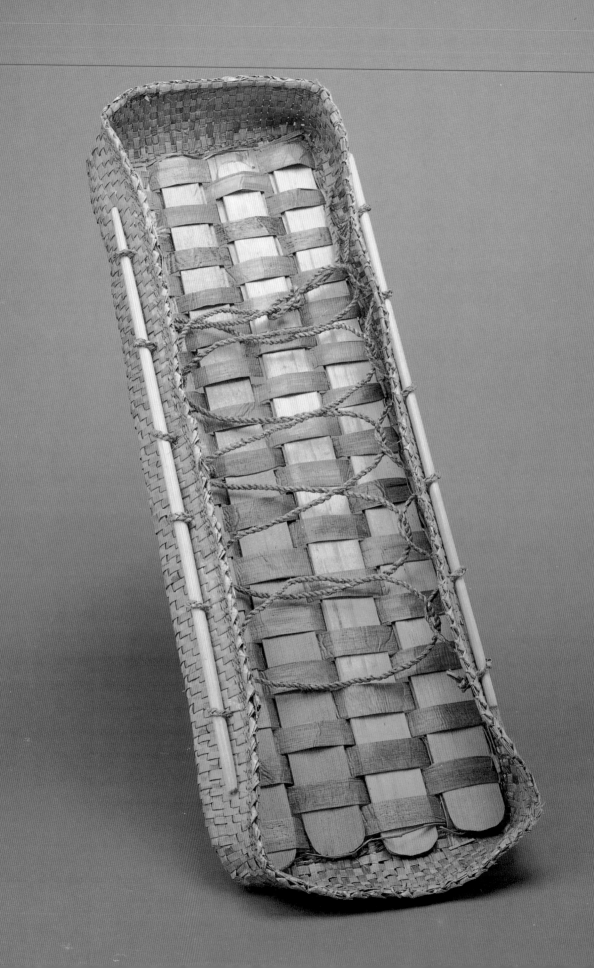

93a. **Cedar Bark Cradle** Norma Pendleton, Makah;
 1988

> Cedar, cedar bark; 82.5 cm x 28 cm x 9 cm

93b. **Cedar Bark Canoe Basket** Norma Pendleton,
 Makah; 1988

> Cedar bark; 82 cm x 82 cm x 44 cm
> Burke Museum #1989-102/2; #1989-102/1
> Photograph by Paul Macapia and Ray Fowler

These two pieces are replicas of plaited cedar bark objects
excavated from the Ozette Village archaeological dig. The
cradle is designed to hold a small infant, laced snugly in
place. The large basket is the type used in whaling canoes
to hold the long, coiled whaling harpoon line.

 Norma Pendleton, a member of the Makah tribe, has
lived most of her adult life at Neah Bay, where she is an
active participant in the ceremonial life of her tribe. She
has taught basketry for seven years, and is known for her
replicas of large-scale canoe baskets. She also weaves a vari-
ety of smaller cedar bark baskets, makes drums, spins wool
and knits sweaters, makes olivella shell necklaces, and owns
a silk-screen printing shop. Her large canoe baskets are dis-
played by the Makah Cultural and Research Center in
Neah Bay, the Royal British Columbia Museum in Victo-
ria, and the U.S. Department of Interior Craft Shop in
Washington, D.C.

Figure 4. Norma Pendleton. Photograph by Keely Parker.

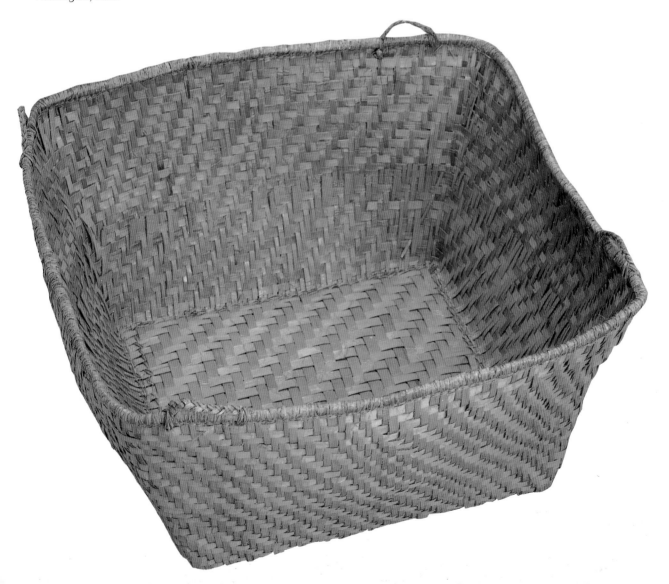

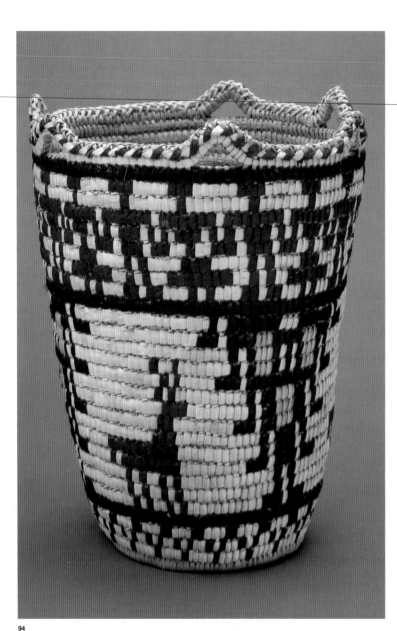

94

94. **Coiled Basket** Nettie Kuneki, Klickitat; 1989
Cedar root, beargrass, cedar bark; 25 cm x 28.5 cm
Burke Museum #1989-15/1
Photograph by Paul Macapia and Ray Fowler

The butterfly design means well wishes, good luck, and everlasting happiness. It is used on wedding or trade baskets, or for a gift for somebody special. Eight pairs of men and women are at the top, a spider web design is at the bottom, and deer placed between fingers designs are used in the central panel.

—Nettie Jackson Kuneki

Nettie Kuneki's training as a basketmaker began under the tutelage of her grandmother, Matti Spencer Slockish. She uses traditional materials to make the coiled huckleberry baskets of her ancestors. Her pieces are owned by the Whitman Mission National Historic Site Museum, Walla Walla, the Metropolitan Museum of Art, New York, and the Institute of American Indian Art Museum in Santa Fe. Her work was also exhibited in the travelling exhibit "Lost and Found Traditions" (Coe 1986: 41). Her basketry as well as her publication *The Heritage of Klickitat Basketry: A History and Art Preserved* have helped to sustain and extend this important tradition (Kuneki 1982).

95. **Beaded Buckskin Capote** Maynard Lavadour White Owl; Nez Perce/Cayuse; 1988
Smoked deerskin, glass beads, cloth, ink; 124 cm x 67 cm
Burke Museum #1988-119/1
Photograph by Paul Macapia and Ray Fowler

A *capote* (French for "greatcoat") is a long hooded coat, usually made from a torn blanket. During the fur trade period, these coats were made from Hudson's Bay blankets, and were worn by both Euro-American fur traders and Native people. This capote, unusual in its use of smoked buckskin and beaded decoration, has the typical fringe and pointed hood.

Maynard Lavadour White Owl, Nez Perce/Cayuse artist, was raised on the Umatilla reservation and trained in traditional Plateau arts by his grandmother, Eva Lavadour, and his great-grandmother, Susie Williams. He attended the Institute of American Indian Arts from 1978 through 1983. He worked at the Whitman Mission National Historic Site Museum (National Park Service) from 1980 to 1982, which now displays six full outfits of traditional clothing made by White Owl. Leggings, a capote, and a tipi cover by White Owl were included in the exhibit "Lost and Found Traditions" (Coe 1986: cat. nos. 222-224). In addition, his work is owned by the Metropolitan Museum of Art in New York and the Institute of American Indian Art Museum in Santa Fe.

96. **Robe** Fran and Bill James, Lummi; 1988
Mountain goat wool, domestic sheep wool; 233 cm x 97 cm
Burke Museum #1988-84/1
Photograph by Paul Macapia and Ray Fowler

This Salish blanket is the first in recent years to be made in Washington of mountain goat wool. By the early twentieth century, these traditional blankets had been replaced by commercial trade blankets. It was not until the 1960s that

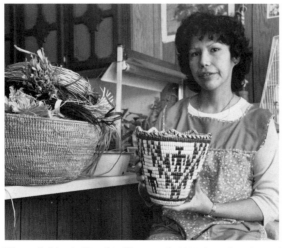

Figure 5. Nettie Kuneki. Photograph 1981, by Eduardo Calderón.

Salish weavers, using domestic sheep's wool, began to revive their traditional weaving arts, first at Sardis, British Columbia, and more recently at Musqueam, British Columbia, and Lummi in Washington.

Fran James and her son Bill have been instrumental in reviving and continuing the traditional weaving and basketry skills of the Lummi people. Fran was raised by her grandmother on an island where they raised 500 head of sheep. Her grandmother knitted and sold socks for about 25 cents a pair. Fran learned from her grandmother to spin and knit at the age of nine. She also learned to gather traditional basketry materials, and has become a skilled basketmaker.

Fran, in turn, taught her spinning and basketry skills to her son, Bill, who began to weave traditional blankets about 20 years ago. At that time no one on the Lummi reservation was weaving blankets. He studied Salish weavings in books and experimented with traditional designs, using the twill-weave technique. Both Fran and Bill have taught weaving and basketry at Lummi Community College. Their blankets are owned by the Burke Museum, the Heard Museum in Phoenix, and by Pope John Paul VI in Rome.

In addition to the robe woven for the Masterpiece Gallery, Bill and Fran James were commissioned by the Burke Museum to produce a partially woven blanket, cedar bark and root baskets, and knitted caps and socks for inclusion in the western Washington cedar plank house in the exhibit "A Time of Gathering."

97. "En-tee-teeq'w," Spring Salmon Steve Noyes, Colville/Puyallup; 1989
Soapstone; 56 cm x 21 cm x 9.5 cm
Burke Museum #1989-11/1
Photograph by Paul Macapia and Ray Fowler

As we came together to fish, that's what I consider a time of gathering. My Dad's from Kettle Falls and my Grandpa, Pet Noyes, was probably the last of the Salmon Chiefs. He was there when the dams stopped the fish. At the First Salmon Ceremony, all the fish were divided. Everyone got a share. Spring Salmon was the first to come up the river. He was special—one of the Chiefs.

—Steve Noyes

Steve Noyes, trained in a variety of media and styles, has been carving for over twenty years. A member of the Colville Confederated Tribes, Noyes also has Puyallup ancestry. He attended the Institute of American Indian Art in Santa Fe in 1963–64 where he studied jewelry and metal sculpture with the Hopi jeweler, Charles Loloma. In 1973 he began a two-year apprenticeship with Leon Anderson, an Aleut carver who works in soapstone, wood, and ivory. In 1975–76 he taught soapstone carving for United Indians of All Tribes in Seattle, and was apprentice to Tom Jones, a Nuu-chah-nulth carver. From 1983 through 1985 he taught soapstone carving at Omak High School and has also taught at Omak Alternative High School.

In addition to the sculpture for the Masterpiece Gallery, Noyes was commissioned by the Burke Museum to produce several hands-on objects—drums, spoons, bowls, and tools—for inclusion in the Plateau tule mat winter lodge in the exhibit "A Time of Gathering."

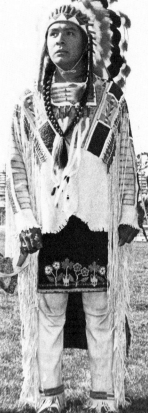

Figure 6. Maynard Lavadour White Owl. Photograph courtesy of M. L. White Owl.

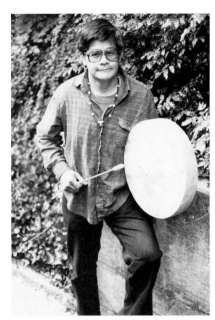

Figure 8. Steve Noyes. Photograph 1988, by Roberta Haines.

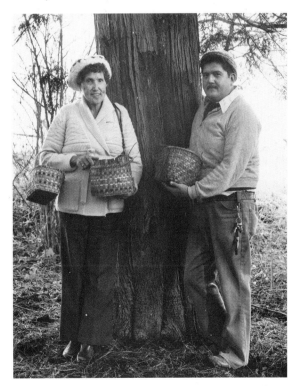

Figure 7. Fran and Bill James. Photograph 1981, by Eduardo Calderón.

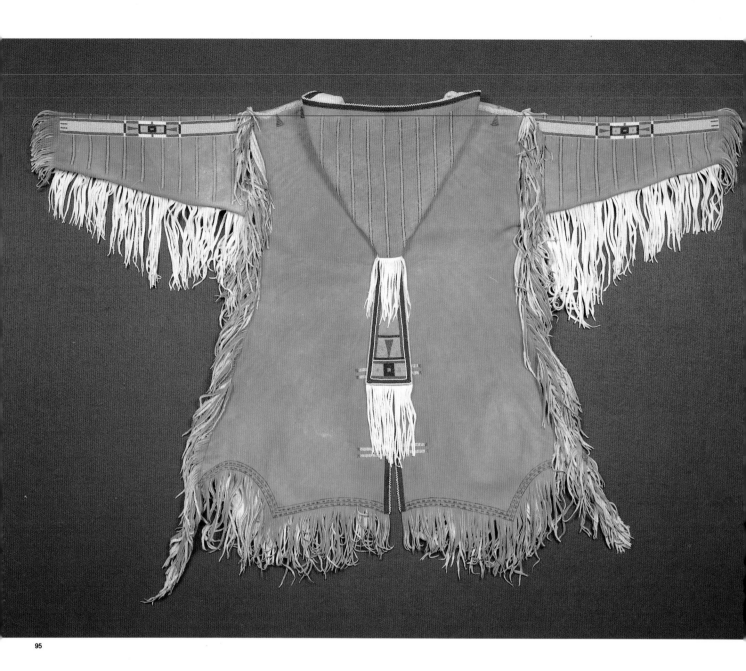

96

97

143

98. **"Journey"** Marvin Oliver, Quinault/Isleta-
Pueblo; 1989
Cast glass (crystal), inlaid cut waterglass, cast marble base;
85 cm x 57 cm with base
Burke Museum #1989-21/1
Photograph by Paul Macapia

*This contemporary cast glass sculpture reflects the tradi-
tional patterns of Salish design, set in motion by the
presence of the human figure within the whale fin. The
sculpture celebrates Washington's spirit and rich traditional
Indian heritage of yesterday, today, and tomorrow.*
—Marvin Oliver

Marvin Oliver has taught studio classes in graphic and
wood design for the American Indian Studies Center at the
University of Washington since 1974. He received the
M.F.A. degree from the University of Washington in 1973,
specializing in the traditional northern formline style of
Northwest Coast design (Monthan 1977). Drawing from his
own Quinault heritage, Oliver has most recently been
exploring traditional Coast Salish design using innovative
media of cast bronze and glass sculpture. His work has
been exhibited internationally, and commissioned pieces
are owned by both the Seattle Arts and Washington State
Arts commissions, Neutrogena Corporation in New York,
and Daybreak Star Center in Seattle.

Most recently, Oliver has been working for the Wash-
ington State Centennial Celebration, assisting tribal
members to carve traditional canoes by teaching carving
techniques and the making of traditional carving tools (see
Oliver, this volume). In addition to the sculpture for the
Masterpiece Gallery, Oliver was commissioned by the
Burke Museum to produce several hands-on objects—a
Salish loom, and wooden bowls, spoons, and tools—for
inclusion in the western Washington cedar plank house in
the exhibit "A Time of Gathering."

Figure 9. Marvin Oliver. Photograph courtesy of Brigette
Ellis.

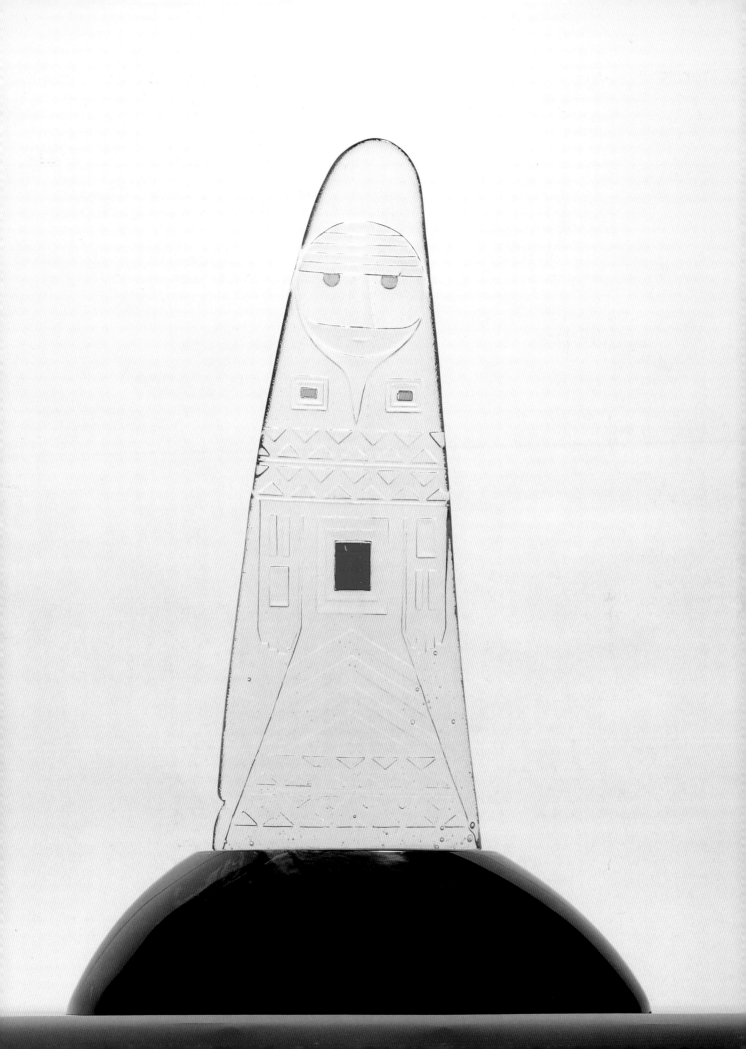

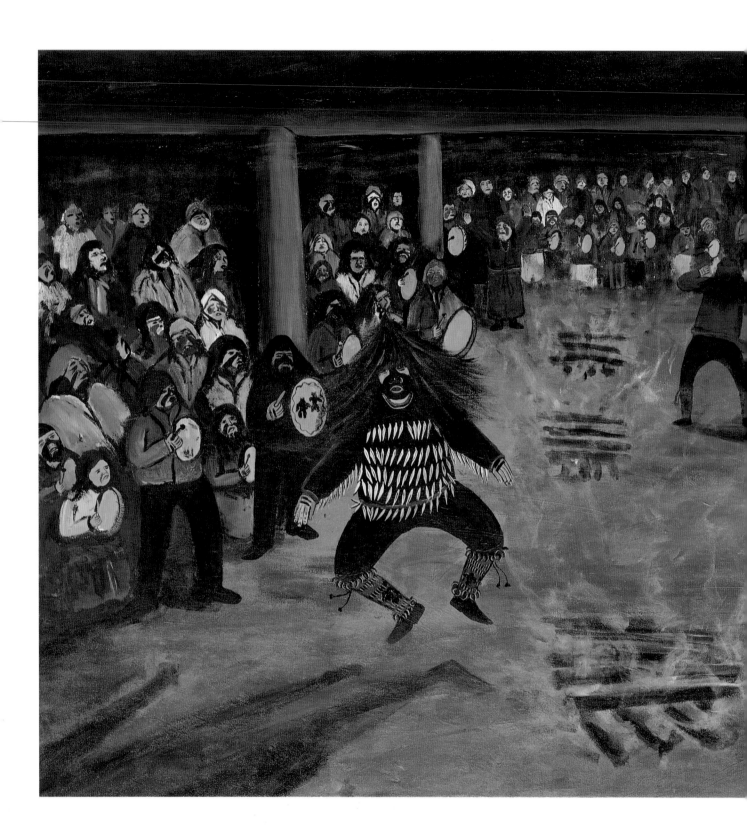

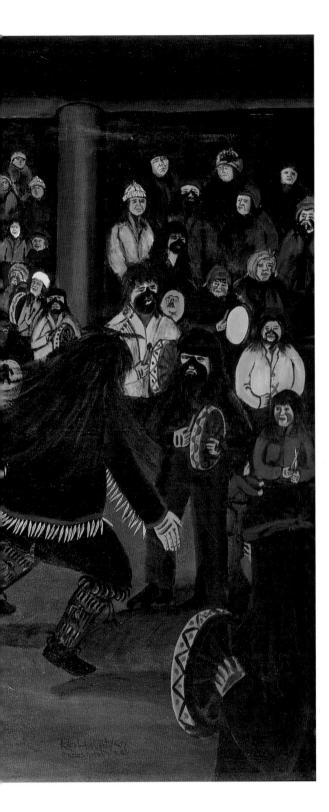

99. **"Spirit Dancing: The Practice of Our Ancestral
Religion—Pigʷədalʔtxʷ"** Ron Hilbert Coy
(x̌adəsqidəb), Tulalip/Upper Skagit; 1988
Acrylic on canvas, cedar frame; 175 cm x 119 cm
Burke Museum #1988-101/1
Photograph by Paul Macapia and Ray Fowler

*My son's art reflects the spirituality of our ancestral religion.
The forms speak to those who are a part of our culture. We
are forbidden to detail an explanation to outsiders. The
practice is private and knowledge and interpretation are
within each individual carrying the responsibility of respect-
ing that which is the sacred trust of our culture. Future
generations, as always, will carry inherited information
within family groups to be transmitted orally to responsible
carriers of this trust. This tradition has kept the strength of
our spirituality a living force among our Native American
families, our people. x̌adəsqidəb's art is a reminder that
our sacred practices are alive and will live through the ages,
because we honor and respect the teachings passed down to
us by our ancestors; that our Creator gave us access to a
communion with the spirituality of our world.*

—Vi (taqʷšəblu) Hilbert

Ron Hilbert Coy's paintings and cedar relief carvings depict
the traditional winter dances of the Native people of Puget
Sound. Drawn from his experience as a participant in this
vital Native religion, Hilbert Coy is able to express the
intense atmosphere that pervades the interior of a smoke-
house, the traditional longhouse, during the winter spirit
dances.

Trained in early childhood education, Hilbert Coy
also studied art at Burnley School of Professional Art and
Cornish School of Fine Art in Seattle. His work is owned
by the Seattle Arts Commission, Daybreak Star Art Center,
the Bureau of Indian Affairs in Everett, and many private
collectors. Hilbert Coy is also known for his book illustra-
tions (Amoss 1978; Hilbert 1985; Hilbert and Bierwert
1980).

Figure 10. Ron Hilbert Coy. Photograph by Len Boudrous
Studios.

147

100. **"Omak Encampment, 1988"** Caroline Orr,
 Colville; 1988

Acrylic on canvas, triptych format; 245 cm x 152.6 cm,
 side panels 76.5 cm x 152.6, center panel 91 cm x
 152.6 cm
Burke Museum #1989-2/1
Photograph by Paul Macapia and Ray Fowler

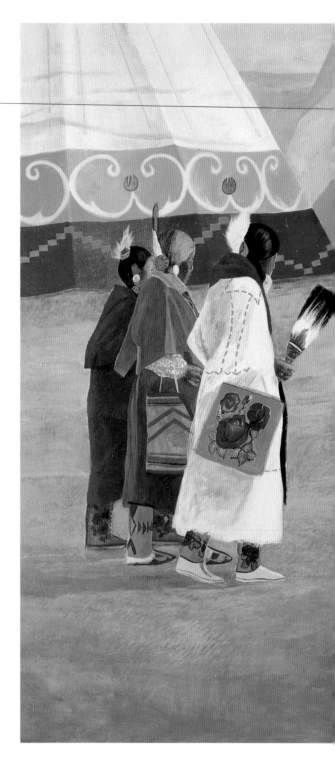

*Perhaps my interpretation in visual images can help further
an understanding of my culture.*

—Caroline Orr

A striking contrast to Hilbert Coy's painting of the firelit
interior of a smokehouse during a Puget Sound winter
dance (pl. 99), "Omak Encampment" depicts a brightly lit
outdoor dance scene of an eastern Washington powwow.
Both images represent contemporary cultural events that
are central to the lives of many Native people in Washing-
ton. Though visually, environmentally, and ceremonially
different, both function as a confirmation and vitalization
of cultural identity and heritage.

Caroline Orr grew up on the Colville Indian Reserva-
tion and began painting at an early age. She was an
apprentice to Seattle muralist, Ernest Norling. She holds
both a B.A. in Fine Art and a B.F.A. in Painting from the
University of Washington, and studied printmaking with
Arnold Saper at the University of Manitoba. She has
worked as a scientific illustrator, and her paintings have
been acquired by the Heard Museum in Phoenix, the Col-
ville Confederated Tribal Agencies, and numerous private
collectors. In addition to her interest in the portrayal of
people, her fascination with Plateau culture and mythology
is also reflected in her paintings and prints (see Louie, fig.
1, this volume).

Figure 11. Caroline Orr. Photograph 1988, by Roberta
Haines.

148

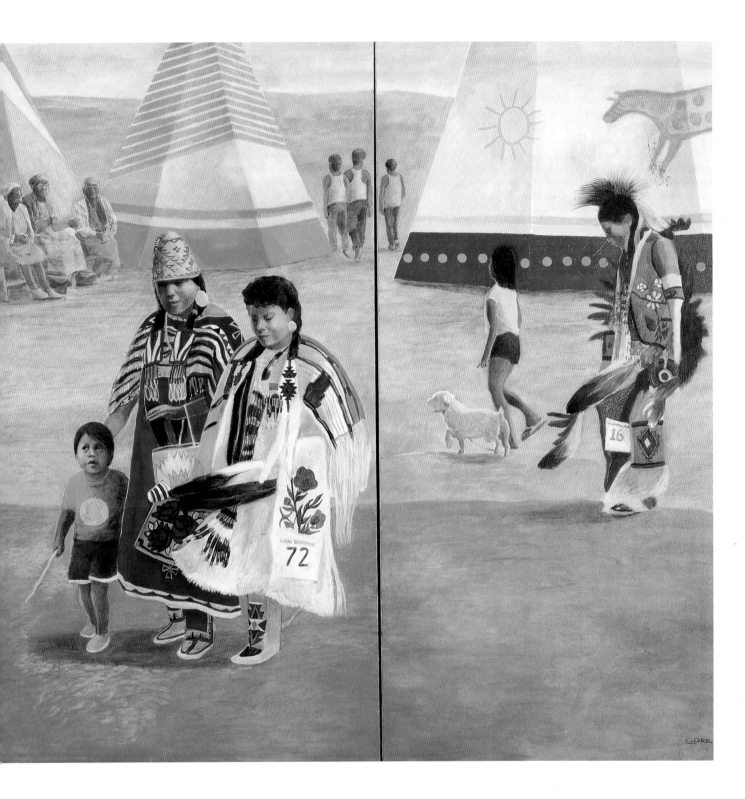

149

REFERENCES

Amoss, Pamela. 1978. *Coast Salish Spirit Dancing: The Survival of an Ancestral Religion*. Seattle: University of Washington Press.

Andrews, Rebecca W. 1989. Hiaqua: Use of Dentalium Shells by Native Peoples of the Pacific Northwest. Master's thesis, Department of Anthropology, University of Washington, Seattle.

Belcher, Capt. Sir Edward. 1843. *Narrative of a Voyage Round the World. Performed in Her Majesty's Ship Sulpher, During the Years 1836–1842, Including Detail of the Naval Operations in China from Dec. 1840–Nov. 1841.* 2 vol. London: Henry Colburn, Publ.

Biddle, Nicholas. 1962. *The Journals of Lewis and Clark*. New York: The Heritage Press.

Boas, Franz. 1890. The Shuswap. *Sixth Report on the Northwestern Tribes of Canada*. British Association for the Advancement of Science.

Borden, Charles E. 1983. Prehistoric Art of the Lower Fraser Region. In Roy L. Carlson ed., *Indian Art Traditions of the Northwest Coast*. Burnaby, B.C.: Archaeology Press, Simon Fraser University.

Butler, B. Robert. 1965. Perspectives on the Prehistory of the Lower Columbia Valley. *Tebiwa* 8 (1): 1–16.

Castile, George Pierre. 1985. *The Indians of Puget Sound: The Notebooks of Myron Eells*. Seattle: University of Washington Press; Walla Walla: Whitman College.

Carlson, Roy L. 1983. *Indian Art Traditions of the Northwest Coast*. Burnaby, B.C.: Archaeology Press, Simon Fraser University.

Cheney Cowles Memorial Museum. 1974. *Cornhusk Bags of the Plateau Indians*. Spokane, WA: Eastern Washington State Historical Society.

Coe, Ralph T. 1986. *Lost and Found Traditions: Native American Art 1965–1985*. Seattle: University of Washington Press, American Federation of Arts.

Conn, Richard. 1979. *Native Art in the Denver Art Museum*. Denver: Denver Art Museum.

Crabtree, Robert Herre. 1957. *Two Burial Sites in Central Washington*. Master's thesis, Department of Anthropology, University of Washington, Seattle.

Daugherty, Richard, and Janet Friedman. 1983. An Introduction to Ozette Art. In Roy L. Carlson ed., *Indian Art Traditions of the Northwest Coast*. Burnaby, B.C.: Archaeology Press, Simon Fraser University.

Duff, Wilson. 1956. Prehistoric Stone Sculpture of the Fraser River and Gulf of Georgia. *Anthropology in British Columbia* no. 5; Victoria: British Columbia Provincial Museum.

Duff, Wilson. 1975. *Images Stone B.C.: Thirty Centuries of Northwest Coast Indian Sculpture*. Saanichton, B.C.: Hancock House Publishers, Ltd.

Feder, Norman. 1983. *Incised Relief Carving of the Halkomelem and Straits Salish*. American Indian Art Magazine 8 (2): 46–55.

Fletcher, Robert S. 1930. The Spalding-Allen Indian Collection. *The Oberlin Alumni Magazine*, February.

Gallery of the American Indian Community House, New York. 1985. *Women of Sweetgrass, Cedar and Sage: Contemporary Art by Native American Women*. New York: Gallery of the American Indian Community House.

Gamble, Louise M. 1981. Letter to Erna Gunther, Oct. 10, 1981. Seattle: Burke Museum Ethnology Division Archives.

Goodspeed, Thomas Harper. 1954. *The Genus Nicotiana: Origins, Relationships and Evolution of its Species in the Light of their Distribution, Morphology and Cytogenetics*. Waltham, Mass.: Chronica Botanica Co.

Gunther, Erna. 1927. *Klallam Ethnography*. Seattle: University of Washington Publications in Anthropology 1 (5).

Gunther, Erna. 1966. *Art in the Life of the Northwest Coast Indians*. Portland: Portland Art Museum.

Gunther, Erna. 1972. *Indian Life on the Northwest Coast of North America: As Seen by the Early Explorers and Fur Traders during the Last Decades of the Eighteenth Century*. Chicago and London: University of Chicago Press.

Gustafson, Paula. 1980. *Salish Weaving*. Seattle: University of Washington Press; Vancouver, B.C.: Douglas & McIntyre.

Hilbert, Vi. 1985. *Haboo: Native American Stories from Puget Sound*. Seattle and London: University of Washington Press.

Hilbert, Vi, and Crisca Bierwert. 1980. *Ways of the Lushootseed People: Ceremonies & Traditions*. Seattle: United Indians of All Tribes Foundation.

Hill, Beth, and Ray Hill. 1974. *Indian Petroglyphs of the Pacific Northwest*. Seattle: University of Washington Press.

Hill-Tout, Charles. 1935. The 'Moses Coulee' Pipe. *Transactions of the Royal Society of Canada* 29, sect. 2: 219-24.

Holm, Bill. 1981. The Crow-Nez Perce Otterskin Bowcase-Quiver. *American Indian Art Magazine* 6(4): 60–70.

Holm, Bill. 1983. *Box of Daylight: Northwest Coast Indian Art*. Seattle: Seattle Art Museum and University of Washington Press.

Holm, Bill. 1987. *Spirit and Ancestor: A Century of Northwest Coast Indian Art at the Burke Museum*. Seattle: Burke Museum and University of Washington Press.

Idiens, Dale. 1987. Northwest Coast Artifacts in the Perth Museum and Art Gallery: The Colin Robertson Collection. *American Indian Art Magazine* 13 (1): 46–53.

Jennings, Jesse D. and Edward Norbeck. 1964. *Prehistoric Man in the New World*. Chicago: University of Chicago Press.

Kent, Kate Peck. 1985. *Navajo Weaving: Three Centuries of Change*. Santa Fe: School of American Research Press.

King, J.C.H. 1981. *Artificial Curiosities from the Northwest Coast of America: Native American Artefacts in the British Museum collected on the Third Voyage of Captain James Cook and acquired through Sir Joseph Banks*. London: British Museum Publications Ltd.

Kirk, Ruth, and Richard Daugherty. 1978. *Exploring Washington Archaeology*. Seattle: University of Washington Press.

Kuneki, Nettie, Elsie Thomas, and Marie Slockish. 1982. *The Heritage of Klickitat Basketry: A History and Art Preserved*. Portland: Oregon Historical Society.

MacDonald, George. 1983. Prehistoric Art of the Northern Northwest Coast, in Carlson, Roy L. (ed), *Indian Art Traditions of the Northwest Coast*. Burnaby, B.C.: Archaeology Press, Simon Fraser University.

Marr, Carolyn J. 1988. Wrapped-Twined Baskets of the Southern Northwest Coast: A New Form with an Ancient Past. *American Indian Art Magazine* 13 (3): 54-63.

Marr, Carolyn J. 1987. *Portrait in Time: Photographs of the Makah by Samuel G. Morse, 1896–1903.* Neah Bay, Washington: Makah Cultural and Research Center, in cooperation with the Washington State Historical Society.

May, Alan G. 1942. The Moses Coulee Pipe. *American Antiquity* 8 (2): 166–69.

Monthan, Guy, and Doris Monthan. 1977. Marvin Oliver: A Northwest Coast Artist. *American Indian Art Magazine* 3 (1): 62–67.

Newcombe, C.F. 1923. *Menzies' Journal of Vancouver's Voyage, April to October 1792.* Victoria: printed by William H. Cullin.

Nordquist, D. L., and G. E. Nordquist. 1983. *Twana Twined Basketry.* Ramona, California: Acoma Books.

Oregon Art Institute and The Evergreen State College. 1987. *New Directions Northwest: Contemporary Native American Art.* Portland: The Oregon Art Institute; Olympia: The Evergreen State College.

Schlick, Mary D. 1979. A Columbia River Indian Basket Collected by Lewis and Clark in 1805. *American Indian Basketry Magazine* 1 (1): 10–13.

Strong, Emory. 1960. *Stone Age on the Columbia*; Portland: Binfords and Mort Publishers.

Thompson, Nile, and Carolyn Marr. 1980. The Twined Basketry of the Twana, Chehalis and Quinault. *American Indian Basketry Magazine* 1 (3): 12–19.

Thompson, Nile, and Carolyn Marr. 1983. *Crow's Shells.* Seattle: Dushuyay Publications.

Vancouver, George. 1798. A *Voyage of Discovery to the North Pacific and Round the World. . . Performed 1790–1795 with the Discovery and the Chatham under Captain George Vancouver.* 3 vols. London: G.G. and J. Robinson, and J. Edwards, Pall-Mall.

Vaughan, Thomas, and Bill Holm. 1982. *Soft Gold: The Fur Trade and Cultural Exchange on the Northwest Coast of America.* Portland: Oregon Historical Society.

Whiley, Joan. 1988. The Art of Greg Colfax. *Peninsula Magazine.* Spring: 63–4.

Willoughby, Charles. 1889. Natives of the Quinaielt Agency, Washington Territory. In *Annual Report of the Board of Regents of the Smithsonian Institution for the year ending June 30, 1886*: 267–82; Washington, D.C.: Government Printing Office.

Wingert, Paul. 1952. *Prehistoric Stone Sculpture of the Pacific Northwest.* Portland: Portland Art Museum.

Wright, Robin K. 1980. Lead Inlaid Catlinite Pipes, in *Plains Indian Design Symbology and Decoration.* Gene Ball and George P. Horse Capture , eds. Cody, Wyoming: Buffalo Bill Historical Center: 77–83.

Wright, Robin K. 1986. The Depiction of Women in Nineteenth Century Haida Argillite Carving. *American Indian Art Magazine* 11 (4): 36–45.

EASTERN
WASHINGTON
HERITAGE

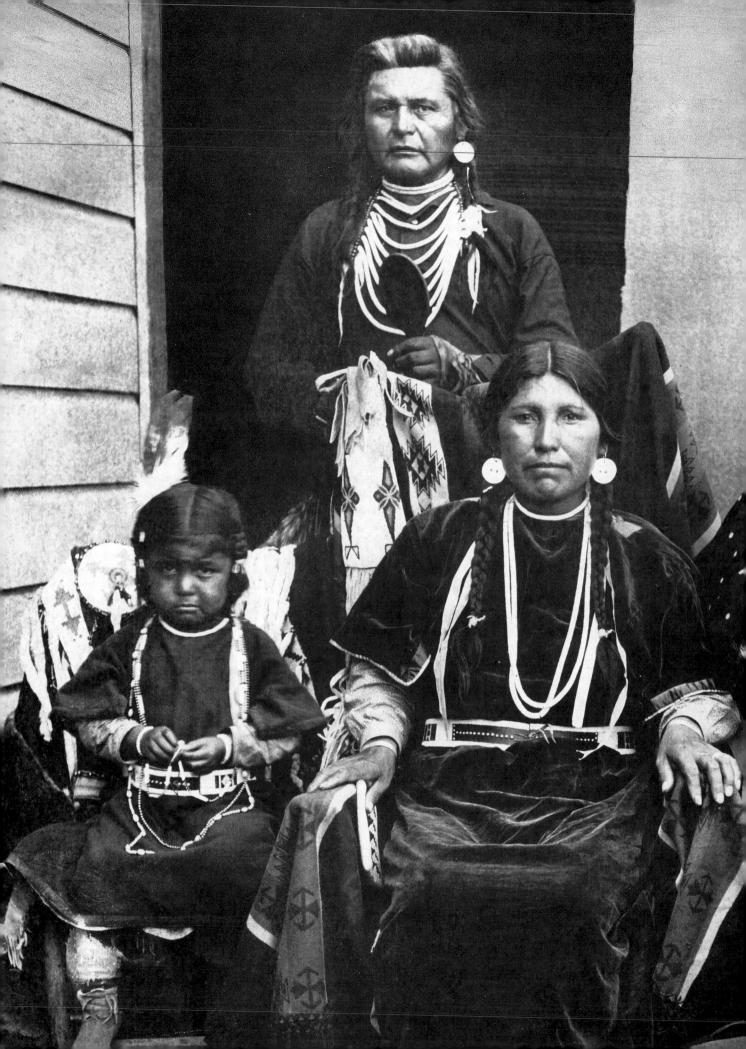

EASTERN WASHINGTON NATIVE PEOPLES
A PERSONAL INTRODUCTION

Roberta Haines

An introduction can be thought of in many ways, but perhaps the best is as a beginning. The word "beginning" invites our contemplation of the process that is to follow: from creation to growth, change suggesting future. The beginnings of my people—the Native people of eastern Washington—are still, through centuries of abundance and hardship, very much a part of our contemporary existence. In our modern lands and lifestyles, although dramatically altered by Euro-American settlement, we retain the kernel, the living heart, of our ancient values and beliefs. Our very names, like Wishram, Palous, San Poil, Wenatchee, Methow, Oche chotes, and Kah-milt-pah, may seem foreign. Yet, we have lived as citizens of the United States since those rights were bestowed in 1924. You know us perhaps by the names of our confederations—the Yakima Indian Nation or the Colville Confederated Tribes, to name two. In this introduction, I hope to share with you a sense of our beginnings and invite you to a strengthened relationship with us.

We think of our ancestors and, through them, ourselves, as the First People. We accepted the place

Roberta Haines, a member of the Moses Band of the Wenatchee tribe (Colville Confederated Tribes), was Co-Curator of the exhibition "A Time of Gathering: Native Heritage in Washington State." In addition to other curatorial duties, she developed the tribal displays at the exhibit entrance, organized the competitive selection of contemporary art pieces for the exhibit Masterpiece Gallery, and managed the outreach to tribal communities throughout the state. She has also written culture-based curriculum for the Paschal Sherman Indian School (Colville), taught political science and Native history for Wenatchee Valley College, and authored historical fiction for children (in A Horse's Tale, 1988, Parenting Press, Seattle).

designed for us by the Creator, the Plateau area. Our homeland is cradled between two immense mountain ranges. Here, between the Rockies and the Cascades, the land is laced by a great river. The great Columbia flows from Canada through generous pine forests, carving deep canyons through flat, thirsty plateaus on her way to the Pacific Ocean. She and her many tributaries have always held and nourished our land and people. These are the rivers that brought beloved Salmon to the Plateau from beyond the Cascades: rivers that cleansed and fed us, that bathed spirit and mind. These are rivers that startled our eyes with their striking color in the vast brownness of the basins; rivers that transported our souls as well as our bodies.

Long ago, it is said, the Creator sent Coyote through the world to prepare it, to make it safe for the New Ones, the First People. Legend describes this earth as a hazardous place, filled with ominous people-eating monsters. It was also known to have been populated by minerals, plants, then animals, long before the First People. These non-human peoples made their knowledge and gifts ready for the New Ones according to Coyote's instructions.

Legend illustrates that the needs of the human people would continue to be met through these gifts only as long as the gifts were used respectfully. Further legends describe the natures of the plant and animal people in terms that human people, the First People, could understand. The legends dictate a proper, considerate use of these resources. Much of this traditional wisdom is interpreted through Coyote.

Coyote was the agent of the Creator's transformation of the earth. This figure represents the link between worlds: the world populated by plant and

Plateau family (detail). See Figure 1, p. 157

animal people and the new world populated by the First People; between people and animals; between our higher selves and our craftier earthbound natures; between the self that seeks the highest truth and the self that indulges in earthly play—riveted to the trivial, preoccupied with the power of its own elimination and defecation.

Yet, more than a link is represented in this character. Coyote is a mover and a shaker—a Transformer, a Changer—active in the process of transition. Accepting the Creator's assignment to change the people-eaters, Coyote pursues it with relish. Through these legends Coyote shows us our humanly arrogant attitude toward spiritual guidance and the inevitable price of this foolishness. Coyote provides us a humorous glimpse of the limitations of our own humanity. Perhaps, through these glimpses, we are given a key to our own spiritual growth, as well as a clue to a happier, less hazardous experience in the physical world. Coyote continues to roam in the minds and stories of the Plateau, reminding us of our youthful strength and foolishness and of our bond to our beginnings.

The Native people of eastern Washington retain this birthright, striving to maintain a style of living based upon an attitude toward the universe, a respect for the Creator and creation, that enables them to live on this planet in perpetuity. Respect for and acceptance of environment lies at the heart of this perspective. It is surrounded by a gentle humor at the more mundane aspects of reality. Environment includes not only the land, but also the plants and creatures that live upon it, especially people. In the scheme of creation, people are the youngest—children to the minerals, the plants, the animals. As children grow and mature through their parents' nurturing care, they in turn care for and nurture their elders. So it is, on the plateaus and basins of eastern Washington. So it is that care is given to the environment, the parent that nurtures.

Coyote set this balance that the First People respected and built their lives around. The nations of the Columbia Plateau expressed this balance in their early institutions and lifestyles. That expression was subtle and disturbed the earth only slightly. It projected little artificial structure on the people or the land. Yet it maximized the resources, the gifts the Creator had bestowed. Contemporary eastern Washington tribal governments reflect these concerns for balance with the environment and ask that everyone share this responsibility. A close involvement with food and medicine preparation, hunting, fishing, and resource management keeps the bonds with the earth sacred and makes the give-and-take of life an honored reality.

The semi-nomadic nations of Native people in eastern Washington forged a regional loyalty through marriages and through the bonds of mutual gathering grounds and shared fishing areas. Their tribal centers, established along rivers, were occupied seven to eight months of the year. Each fall people returned home from their harvests of various crops. They brought the winter's supply not only of food, but also of information. Tribal members used these months to recount the historical foundations of the tribe, to share news about people seen during the summer travels, and to teach skills for successful living. Prophecies and dreams were shared and decisions about their significance were reached.

The winter months were also a time of planning for the future. People exchanged information about changes in the terrain that they had seen on their travels. In this way, tribal leaders assessed the relation of the parts of the region to the whole. Crop and soil information, including changes in alkaline deposits, floods, and mud slides or other erosion, was exchanged. Data about animal behavior, changes in color, and habitats were noted. Information about the weather, clouds, and stars was related as the people considered future weather patterns and potential food resources.

The late winter months were also a time of spiritual regeneration. This coldest, darkest time of the year, the time in which the life force withdraws into itself, into hibernation, was a time of deep, steady internal growth for the plant and animal world and for the First People. The deep winter was a time of preparation for the new year's efforts—a time of spiritual gathering, of drawing close to the highest spiritual force. This spiritual centering was expressed in ritual feasts and dances that required most of the tribe's energies. A glistening moment of this experience might be described thus:

Deep in the crystal nights of frosted breath, Coyote looked skyward, aware of his beingness for only a moment before the stars struck awe and mystery into his heart through his eye. Coyote smiled with the burning joy of it, howled with the thrilling joy of it, and turned inside out.

Then, there was nothing but the freezing water in an eye, a tear stunned by the majesty and cold. The chuckling, barking Coyote giggle, frozen in the crystal night, clear and ringing, vibrated through to the seed, the heart of life, and set it singing.

This spiritual striving for oneness and completion continued until the warm Chinook winds caressed the plateaus and basins with their breathy promise of spring roots.

Some villages were partially occupied throughout the year by people who chose to remain and by others in need of care or too elderly to travel. By spring, however, most people were ready to leave for root harvests and fishing. Roots were dug in the

spring and early summer, then berries and nuts were gathered. Leaves, stems, and flowers of various plants were harvested when ready. These traditional foods, rich in vitamins and minerals, constituted nutrition sources and medicinal supplies. The variety of the food itself was the result of the various soils in which it had grown and the differing elevations of the harvest areas.

The harvesting was usually done by women. It was an enormous task to provide food for hundreds of people for an entire winter, October through May. The digging was hard work, and as the summer progressed the weather became intensely hot. Harvesting was usually done for a few hours during the earlier, cooler part of the day. Root skins would slip easily if removed while moist, but became more difficult to work when hot or dry. The heavy heat of the day was a time for more sedentary activity—cleaning and drying the foods gathered in the morning.

Summer temperatures on the arid Plateau could easily reach 115° F. Roots and berries could be dried relatively quickly and with little effort once they were harvested and cleaned. These foods were stored in baskets, ready to return to the winter village. Fish were filleted and dried on racks in the sun. The strips of fish were dried hard and layered in baskets. Some dried fish were pounded to a powder and stored to be used in soups, or mixed with roots and berries. Since most foods in eastern Washington had very little fat, nuts were an important source, as were the smoked fish and fish oil traded from the coast. Wild mustard, sage, and various seeds added zest and variety to main dishes.

Large families traveled to their own harvest areas or met other families, often related through a well-known leader. These bands could make the most effective use of resources, and could as well rekindle familial ties. The Plateau nations chose to make their resources available to each other rather than to maintain rigid territorial divisions. Each of these semi-nomadic groups was dependent on the others for security throughout the region it traveled. The more secure a tribe was and the more united with the other tribal groups in the Plateau, the more freely it could partake of natural resources.

A substantial part of this interdependence was achieved through marriages. Strong familial bonds were maintained through one's extended family. A good marriage partnership meant the couple enjoyed the support of, and were protected by the influence of, each of their families. Women and men were equally valued as contributors to the tribal unit. First cousins were held in much the same favor as siblings and treated with similar rights and affection. The familial influence was thereby broadened to include many people, touching several tribes. Since the elder tribal members were held in highest esteem, the

Figure 1. Plateau family. Burke Museum Ethnology Division Archives, #2.4L113

Figure 2. Kootenay bark canoe. Photograph courtesy of the Canadian Museum of Civilization, #NMCJ8484.

Figure 3. Joseph Umtush's house, Yakima. Harrah, Washington, 1923. Photograph courtesy of the Smithsonian Institution, #56812.

familial influence was generational as well.

Tribal members shared a strong bond to their particular tribal region. They were also closely allied to their family leaders in other tribes. A network of intertribal influence therefore existed, weaving the Plateau tribes together as a strong, yet flexible, political and economic system. Families were free to live with the regional tribe or other family band members. Some families changed their place of residence periodically to develop all of their relationships. This arrangement gave the individual a great amount of flexibility, ensuring a welcome in most of the tribes and bands of the Plateau. Through this intricate system of multiple allegiances, the tribes of eastern Washington secured a peaceful existence.

Leadership in this system was neither absolute nor singular, for decisions were reached by consensus after lengthy discussion. Still, the many activities and moves the tribes undertook required individuals with strong personal power and insight to lead in numerous independent ways throughout the year and periodically throughout their lives. Strong leaders acted decisively when their skills were required, yet deferred to other leaders when circumstances changed. In this way, members of bands united to

live and work together for parts of a year. Individuals, families, even groups moved apart, then blended again for different efforts.

The Plateau people were keepers of vast resources. In their attitude toward these resources, they combined the practical with the spiritual. They accepted the gifts bestowed by the Creator, while acknowledging their own needs and responsibilities. They took agricultural techniques from the environment, working with it. For example, recognizing that some plants would not grow if overshadowed, while others needed high temperatures for seeds to germinate, the people used fires to keep berry-picking sites clear and fertile. The people in the Plateau did not overharvest areas of tuberous plants. They did not pollute their water with refuse. They lived these principles of conservation based on generations of careful study of their environment.

Food, considered a precious gift, required proper consideration and handling. Plants and creatures were offering their very lives for the nourishment of the Plateau people. In humble respect, the people acknowledged this gift through designated feasts held at each harvest. Throughout the Plateau, leaders with special affinities, skills, and knowledge about certain

plants, fish, or animals were responsible for beginning the harvest of each of the foods. More importantly, they represented the formalized union of the spiritual and practical approaches the Plateau people valued for their way of life. These leaders exercised personal discipline, prayed and fasted, and studied their special field of plants or creatures. They became encyclopedias of data about elements that affected their field of interest. They used all their resources—spiritual, intellectual, and political—to assist their people in securing and maintaining abundant harvests.

Before plants were dug or picked, before the first meat or fish was hunted, the ceremony leader prepared services of thanksgiving. The honoring feasts that followed echoed the joy of receiving and helped to reinforce the expected attitude toward harvest and daily food preparation. Perhaps this personal, intimate knowledge of the value of food is the foundation for the care with which the Plateau peoples walk the earth. Following this design, they found a balance with the environment that sustained them for thousands of years.

Peace throughout the Plateau was the apparent rule. The highly valued personal freedom that produced leaders like Peo peo mox mox and Kamiakin was nurtured by the abundant resources of the Plateau and secured by the integrative political system. The independent nature, characteristic of the Plateau individual, was the twine for the intricate design of societal relationships that secured cooperation throughout the area.

While family bonds may have been the strongest proponent of pacific, generous behavior within this region, trade relationships were a powerful incentive to outside nations to maintain peaceful communication. The natural river and mountain borders generally protected the Plateau area from outside attack. There were times, however, when food was scarce in neighboring areas; then attacks by raiding parties did come to the Plateau. The Plateau nations that traditionally occupied the borders of the area, such as the Northern Okanogan or the San Poil peoples, were sometimes subject to attacks. They developed weapons and strategies to protect themselves and their territory and to discourage future attacks. Yet, the Plateau was well known for its trade goods, and visitors came more often to trade than to fight. Trade routes here were eventually followed by foreign traders and explorers, some routes developed into major passages to the Northwest Coast or the Great Plains.

The great pride of the peoples of the Plateau expressed itself most clearly in their finely tailored and decorated clothing. The craftspeople who cured and tanned the hides were among the finest in the world, and the quality and variety of the skins spoke

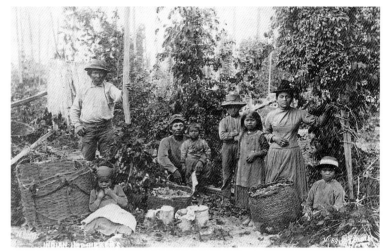

Figure 4. Hop-pickers. Burke Museum Ethnology Division Archives, #2.4L114.

Figure 5. Science class, Fort Spokane Indian Boarding School, 1902. Photograph courtesy of the Museum of Native American Cultures, Spokane, Washington.

highly of the Plateau trappers and hunters. Plateau goods—smoke-tanned elk or deer skins or soft, leather goods—were highly valued and were sought by people far from the Plateau. Artisans decorated the robes, shirts, dresses, and moccasins with bead-work, quillwork, shells, coins, and other items to create striking designs.

What desirable commodities were not found within the borders of the Plateau were purchased from the Northwest Coast or the Plains at one of the major trade sites along the Columbia River system, such as The Dalles, Kettle Falls, or Spokane Falls. Supplemental diet essentials, such as the moister, oilier coastal dried fish, oils from fish and sea mammals, and smoked fish and shellfish, created a sound trade foundation. Luxury items such as the long, tapering dentalia shells made trade enjoyable and profitable. Plateau baskets, especially those from the Klickitat and Wishram peoples, leather and leather goods from the Okanogan and Wenatchee tribes, and twine, dried fish, berries, roots, and nuts were used to acquire such items. Once the fur traders arrived on the scene, glass beads, metal cookware, mirrors, metal tools, and weapons were added to the exchange.

Trading generated a festive atmosphere, and everyone took pride in facilitating a good exchange. Often trading activities were conducted in conjunction with major Plateau fishing enterprises. Summer and fall runs of salmon brought the Plateau peoples to the river confluences to fish. The fishing season was a gathering time, a time when the people came together in a labor whose results would sustain them throughout the winter. Massive quantities of fish were needed to feed everyone, so men and women worked long, hard hours. The fishing season was also a time for people to reacquaint themselves with friends and family members living in other parts of the land. It was, as well, a time to meet new people from the Plateau and from beyond.

Though the work of fishing and food preparation filled the long summer days, the fun-loving Plateau people balanced their evenings with lively games and competitions. The stick game was one of the most important. In this game, sometimes referred to as the hand game or bone game, valuable goods were wagered against one team's guess as to the position of certain gaming pieces placed by the other team. Teams were separated by two sticks on the ground, often long lodgepoles. Team members pounded on them in rhythm with their lead player. Players matched the other team's wagers with their own, blanket for blanket, coin for coin. The items were piled between the two poles and claimed by the win-ning team. Powerful gambling songs accompanied the rousing beat of the sticks and hand drums. As the gentle evening breezes cooled the day, surprised shouts could be heard as points were won or lost.

As artisans and traders, merchants with love and humor toward their environment, the Plateau people maintained their pacific, generous attitude in the face of threatening, and sometimes fatal, forces from without. Within the experience of one generation, trade with a new and welcomed population of Euro-Americans exploded into conflict, bringing sickness and death. Missionaries promised various forms of salvation to the unsuspecting nations. In a fight to fill their churches, the competing Protestant forces—Congregational, Anglican, Presbyterian—pitted their influence against the Catholic Oblates and Jesuits. This internal battle among the Euro-American churches did not go unnoticed by the Plateau people. When Chief Moses was asked if he wanted a mission located on his reservation, he refused, observing that missions were teaching his people to fight about God. In a realm where the individual's relationship with spiritual influences was most highly prized, mis-sionaries created the specter of heaven and hell and the fear of a foreign god of dichotomy and ultimatum.

On the political front, the years between 1853, when the Washington Territory was created, and the end of the nineteenth century were devastating to Native populations. Within a single generation treaties were written and broken; reservations were established, dissolved, and rearranged. Whole com-munities were dismembered; entire nations were decimated. Hordes of Euro-Americans eagerly waited for their government to "open" the territory and "make it safe" for them. Some were ordinary citizens looking for a better life. Many were land-hungry or gold-hungry. There were wheelers and dealers in land development and railroad interests. There were mis-sionaries, merchants, and the military.

The reservation system was supposed to be a compromise. A reservation was land reserved by the tribal peoples, through their leaders, in formal nego-tiations with the people of the United States, through their leaders. Sometimes reservations were established by treaty, sometimes by other means, including Exec-utive Order. Access to the resulting reserved territory was supposed to be prohibited to Euro-American civilians. Nevertheless, the fevered lust for land, gold, and power spurred open and immediate disregard for the newly established boundaries. Often where there was gold or other coveted resources, reservation bor-ders were changed despite tribal needs or rights. Open conflict could not be avoided. Beyond the land issues, treaties usually addressed other concerns. Tribal leaders stood firm in their efforts to secure the futures of their people, negotiating for the economic and social foundation they knew was critical. Tribes reserved their most important economic resources, their hunting and fishing sites. Additionally, many

Figure 6. Agriculture class, Fort Spokane Indian Boarding School, 1902. Photograph courtesy of the Museum of Native American Cultures, Spokane, Washington.

treaties included clauses addressing health and education for the future, as well as interim food and clothing requirements.

While tribal groups were expected to abide immediately by the covenants of a treaty, the United States government did not fulfill any of its obligations until ratification—often several years later. Tribes quickly learned that the new law was no law. Tribal people on reservations began to realize that they were becoming prisoners on rapidly dwindling resources. In truth, tribal peoples were often forced to stay within the confines of the reservation border; enforcement was often managed by vigilante groups.

In eastern Washington, fourteen different tribes and bands who had previously lived in various areas throughout central Washington negotiated the Treaty of 1855, creating the Yakima Indian Nation Reservation. Most of these tribes traditionally travelled much farther north and east than the reservation borders they agreed to observe. Unfortunately, as soon as the treaty negotiations with the Yakima Nations were completed, and years before the treaty would actually become law, official announcements were made to the public that the lands in eastern Washington were open for settlement. Traditional living areas were overtaken immediately, as were fishing, hunting, and gathering sites. Any governmental agreements to supply food, clothing, medical care, housing, or education to the Yakima people would not be forthcoming until the negotiated treaty wound its way through ratification and then through the bureaucracy for appropriations and administration. Meanwhile, the Euro-American settlers disregarded the property rights of tribal peoples and encroached even upon the newly created reservation boundaries. When the Yakima Nations could no longer tolerate the infringements, they fought for their rights and their territory.

Even though the original United States governmental goal had been to force all Native people in the state to one reservation, the powerful, angry, organized resistance this met required other solutions. When Congress decided that no more treaties would be made, several tribes living east and north of the Yakima country formed the Colville Confederated Tribes and occupied a reservation, formed by Executive Order in 1872, which extended south from the Canadian border and was bounded on the south and east by the arc of the Columbia River. The western border was the Okanogan River. In 1879, Chief

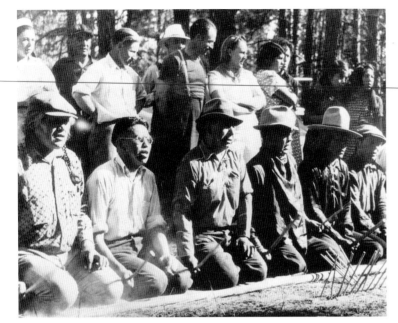

Figure 7. Men playing the stick game. Photograph courtesy of the Colville Confederated Tribes Archives.

Moses of the Columbia-Sinkiuse negotiated an adjacent reservation, which extended west from the Okanogan River and south from the Canadian border to Lake Chelan (see Wright, "Introduction," fig. 12, this volume). There were already Euro-American settlers here, and miners who were impossible to keep out. This reservation was terminated by sale in 1884, and many of its inhabitants moved to the Colville Reservation. About this time, Chief Sarsarpkin, another influential leader of the Sinkiuse, negotiated about 40 superior allotments for himself and his people along the beautiful and fertile river system from Lake Chelan to the Okanogan River.

The results of the new reservation system were to be long-term and the adjustment painful. Where arrangements could not be made with one Native leader, they were made with another. Sometimes, even the illusion of legitimacy was abandoned by the United States government. In 1879, after long, fruitless struggles to return to the Wallowa Valley in Oregon, Chief Joseph expressed his frustration with this duplicity in a thoughtful article (see Suggested Reading, Joseph 1879). The Dawes Act, or Allotment Act of 1887, represented another devastating force— another way to take land from Native control and weaken the tribal holdings. Individual tribal members were to be alloted land; the rest was to be sold off and made available for Euro-American settlement.

Needless to say, the outside forces influencing the Plateau peoples during this time would not accommodate a nomadic style of living. The mighty Columbia and her tributaries, as well as all the resources of the mineral, animal, and plant peoples,

became objects of conflict. The balance established by the Creator through Coyote and known here for thousands of years began to change.

With political sanction, mission boarding schools were established; agents in horse-drawn wagons made the rounds collecting children, sometimes at gunpoint. Rations to the parents, now virtually prisoners, were withheld when the children's truancy became difficult to control. Traditional foods, which required constant tending by the people of the Plateau, became inaccessible. Berry- and root-gathering grounds became overgrown from lack of care. Cattle and sheep began to graze out other gathering areas and to take over the habitats of deer and elk. Traditional fishing sites became outposts for large transport vessels; streams and rivers became clogged with the debris of logging efforts. Leaders of the ceremonies and harvests died or were restricted to reservations removed from their people.

Within a generation, the entire diet of the Plateau had changed. Government commodities, when they were available, became the core; white flour, shortening, and sugar replaced salmon, camas, and the other roots and berries.

It did not take the Plateau peoples long to realize the seriousness of their plight. European diseases had taken a devastating toll throughout the nineteenth century. Whole villages had succumbed to smallpox. Influenza was another of the frightening killers. With the restriction of people to small areas and the decline of traditional diets, starvation was always on the horizon. It seemed that the children were safer in the boarding schools, even though they were punished for speaking their language and all association with traditional Native culture was condemned.

The outside forces that the Plateau peoples had to face increased in strength and variety as Washington Territory moved toward statehood. Those properties along the rivers and tributaries that had been traditional homes also attracted agricultural interests, settlers, and developers. Gold drew miners to mountains and streams, and crews of dam builders were found in the coulees. One of the railroad's paths to the Pacific Ocean was being completed across the Columbia Plateau, through traditional villages and grounds. Townsites were granted, many on lands already designated for reservations.

In the face of the enormous demands made on them, the Plateau people found the strength in their spiritual legacy to meet these changes and to develop creative ways of living with them. For thousands of years, the Plateau people had chosen a pacific lifestyle, accepting the path that the Creator had bestowed. In the face of Euro-American oppression, they were able to make that choice again, despite the death and destruction they were to face for generations.

The fruits of the old teachings are seen in the successful adaptation of Native Plateau youth to modern technology. Tribal people are stepping forward to manage the complex natural resources most reservations contain. Tribal schools and businesses are now under control of tribal governments; children, the most precious resource, are no longer forced by outside governmental and religious agencies into non-tribal homes or schools. Extended family relations are maintained so that children develop varied role models and sources of support. Elders share traditional skills, whether they be crafts or food preparation techniques. Each imparts love and respect to the learner, the child or the grandchild. It is understood that each child has a spiritual legacy, and each is nurtured accordingly.

Through all the outward changes, an internal rhythm remains in the Plateau. The joyful celebration of new growth has always been preceded by the careful introspection of bitter cold and darkness. And as in the older times, through the coldest times, when the days are shortest, stories are exchanged to warm the hearts and inspire the imagination. Through ritual, the chuckling, barking Coyote grin, frozen in the crystal night, clear and ringing, vibrates through the generations to the seed, the heart of life, and sets it singing. The generations of gathered history, tradition, song, dance, and laughter are protected by a hard shell. It has always been a potent seed, a kernel capable of sustaining generations to come.

SUGGESTED READING

Chance, David H. 1986. *People of the Falls*. Kettle Falls, WA: Kettle Falls Historical Center.

Coffer, William E. 1979. *Phoenix: The Decline and Rebirth of the Indian People*. New York: Van Nostrand Reinhold Co.

Fahey, John. 1986. *The Kalispel Indians*. Norman and London: University of Oklahoma Press.

Gidley, M. 1979. *With One Sky Above Us: Life on an American Indian Reservation at the Turn of the Century*. Seattle: University of Washington Press.

———. 1981. *Kopet: A Documentary Narrative of Chief Joseph's Last Years*. Seattle: University of Washington Press.

Haines, Francis. 1955. *The Nez Percés: Tribesmen of the Columbia Plateau*. Norman: University of Oklahoma Press.

Hayes, Susanna Adella. *The Resistance to Education for Assimilation by the Colville Indians, 1872–1972*. Spokane: Spokane School District #81.

Joseph (Chief). 1879. An Indian's View of Indian Affairs. *North American Review* 528 (April): 412–33.

Mourning Dove (Hum-ishu-ma). 1927. *Cogewea The Half-Blood: A Depiction of the Great Montana Cattle Range*. Boston: Four Seas Co. (Reprint 1981, Lincoln, Nebraska, and London: University of Nebraska Press.)

———. 1933. *Coyote Stories*. Caldwell, Idaho: The Caxton Printers (Reprint 1984, New York: AMS Press.).

Neils, Selma. 1985. *The Klickitat Indians*. Portland, Oregon: Binfords and Mort Publishing.

Ray, Verne F. 1933. *The Sanpoil and Nespelem: Salishan Peoples of Northeastern Washington*. Seattle: University of Washington Press.

Roe, Joann. 1981. *Frank Matsura: Frontier Photographer*. Seattle: Madrona Publishers, Inc.

Ruby, Robert H. and John A. Brown. 1965. *Half-sun on the Columbia: a Biography of Chief Moses*. Norman: University of Oklahoma Press.

———. 1970. *The Spokane Indians: Children of the Sun*. Norman: University of Oklahoma Press.

Scheuerman, Richard D. 1982. *The Wenatchi Indians: Guardians of the Valley*. Fairfield, Washington: Ye Galleon Press.

Spier, Leslie, and Edward Sapir. 1930. *Wishram Ethnography*. Seattle: University of Washington Press.

Teit, James. 1930. "The Salishan Tribes of the Western Plateaus," *45th Annual Report of the Bureau of American Ethnology, 1927–28*: 23-396. Washington, D.C.: U.S. Government Printing Office.

Williams, Chuck. 1980. *Bridge of the Gods, Mountains of Fire, A Return to the Columbia Gorge*. New York: Friends of the Earth and Elephant Mountain Arts in cooperation with the Columbia Gorge Environmental Center.

TALES OF COYOTE
EASTERN WASHINGTON TRADITIONS

as Told by Martin Louie, Sr.

To me, my thinking, when I enter Sweatlodge it's like entering a great cathedral in Europe. It's quiet, you know—powerful—beautiful. I feel that.

—Martin Louie, Sr.,
Colville Confederated Tribes

These stories were recorded by Martin Louie, Sr., during January of 1988. They provide a sample of the many Plateau traditions involving the important mythical trickster/creator, Coyote. Coyote is important as a benefactor who transformed the world into its present state, but there are many sides to his character. In addition to his creative contributions, he is frequently shown to be greedy, deceitful, or obscene. In these stories one of Coyote's most important contributions is described: bringing salmon up the rivers to the Plateau people.

Martin Louie, Sr., also known as Snpa<u>k</u>tsín, First Light in the Morning, is an elder of the Colville Confederated Tribes. He was born in 1906 and grew up in the Colville tradition, fishing, hunting, and gathering plants. He has extensive knowledge of eastern Washington traditions, and through the years has shared his expertise with many people. He made the model sweat lodge included in the exhibit "A Time of Gathering" (fig. 2). We are grateful for his guidance. Our thanks to Roberta Haines for facilitating the taping, and for transcribing and editing these stories. Thanks also to Randy Bouchard for his advice on linguistic and geographical details in the stories (see Bouchard and Kennedy 1984: 359; Kennedy and Bouchard 1975: 37; and Turner, Bouchard, and Kennedy 1980: 158–60).

The people of the Plateau take sweat baths in small private structures, built with willow frames.

Rocks are heated in a fire outside the structure and brought inside with tongs. When water is sprinkled on the hot rocks, their intense heat transforms the water into a pore-penetrating mist. On the Plateau, Sweatlodge, or Q'uil sten, is believed to be a spiritual gift to be used for healing, prayer, meditation, and spiritual growth. For some, the construction of Sweatlodge is a sacred process, filled with symbolism. Each of the willows used is important, and together they represent the major elements of life on this planet: earth, water, sun, and air.

HOW THE SWEATHOUSE WAS MADE

1. THE PEOPLE NEED FISH

In a time before humans, there were plant people and animal people. The animal people were at Kettle Falls, and they had only scrub fish. They couldn't get any salmon because there was a weir across the river, the Columbia River, down at Celilo. What is known as Warm Springs, Oregon, now. There were four women there that controlled the salmon, controlled the river: Seagull, and Snipe, Killdeer, and Kingfish. Four ladies. And the chiefs, the chiefs called a meeting at the Council Tipi. And there were four chiefs. The first, the leader, was Mr. Bear. The second chief was Cougar. The third chief, Bald Eagle. And the fourth chief was Salmon. All the people were there and they wanted some better fish. They wanted to select somebody wise who could get the salmon.

And Coyote, he was tricky. Nobody liked him. So they didn't invite him to this meeting at Kettle Falls. He went anyway and he lay outside of the tipi and listened. The chief said, "We have to select somebody brave, somebody with power. There's peo-

ple to be descended here, on earth, the human beings. They have to have fish. They have to have better fish than what we have now." So, Coyote listened and the chief said, "Well," he said, "not only that, but the human beings have to have a medicine house, a sweat lodge, to clean their bodies, their souls, their luck if they're in a bad luck streak. They have to have somewhere to go pray to the earth, pray to the Creator."

So, Coyote got through listening. He thought, "I'm the man. I'll go down." And Coyote had power. So he went, on the east side of the Columbia River, all the way down and he got to thinking. Around Davenport or Wilbur, he got on the prairie. He went south and he kept thinking, "I wonder what the chief meant by 'medicine house for the coming people'?" When he had gone as far as Soap Lake he thought, "Well, maybe I've got it." So there was a patch of brush—willows—there. So he started cutting.

First he cut four poles and erected them for the four directions: east, north, west, and south. That's the four directions. So he cut four more and he erected them to make the sweathouse. That's the four seasons. That's winter, spring, summer, and autumn. That's the four seasons. Then he thought…sat there for a while and he thought, "Now what?" So he thought about the four foods. So he erected four more sticks for the sweathouse: bitterroots, serviceberries, salmon, and meat. That's the four foods. Now, the four colors: the east is yellow; the north is white; the west is black, that's the resting time; and, the south is green. Now he erected four more sticks: the four winds. The north wind, the west wind, south wind, eastern wind. That's the four winds. Now, the four nations. He thought, "Can't be just one nation. It's got to be four. So, the four nations: America, Europe, China, and Japan. Now, the four moons: the new moon, first quarter, full moon, last quarter.

And one stick he cut, put it around the bottom of the sweathouse. That one stick, clear around, means the world, clear around. Now, the major things of this earth are the earth, water, sun, and air. All these elements compose the Indian Sweatlodge.

2. COYOTE BRINGS OUT THE SALMON

So Coyote went down from that sweat lodge. He went down. He got close to Celilo Falls and he wondered. "Those women are awful sharp-eyed and they're awful smart. How am I going to get there to break that weir and bring the salmon out?" So, he transformed himself into a little baby. He got a piece of bark and he lay on there and he started floating towards the falls. And the four women were there, guarding the falls. They heard a baby cry. They looked around; they saw that piece of bark floating down towards the falls. One of them jumped in, got

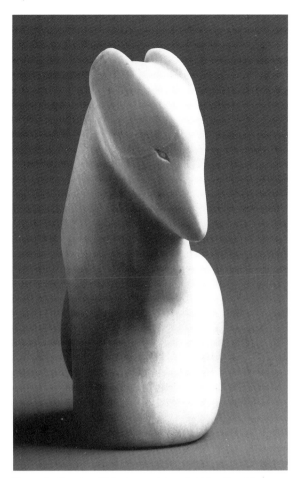

Figure 1. Coyote. Alabaster sculpture by Caroline Orr, 1986 (see pl. 100). Photograph by Paul Macapia.

the bark and the baby, brought it over…a little tiny baby. The oldest one didn't like it. "Somebody must be trying to get our salmon." The other three outvoted her. They took the little baby back.

These women, every morning they'd go dig roots, pick berries, get ready for the winter. They'd all go and they tied this little baby for safety, inside. When they left, Coyote untied himself and he ran to the falls where they had the salmon stopped. And, he looked it over. Finally he found a way. He thought, "Well, I can dig a channel around this over here and break that dam. The salmon, I can bring them up." So, before the ladies came back to the tipi, he went back and tied himself and put dirt on his face. He looked like he had been playing around in there.

Finally, on the fourth day, he had the dam pretty near broken. He took a ladle, soup ladle, made out of a buckhorn sheep horn. He put that on his head. And he thought, "If those women catch me on my last job, they can't brain me. They can club me but I won't feel it." So he put this ladle on his head and he went over there and he started digging again. He wasn't quite through—the water was just seeping through and the salmon were all behind him.

165

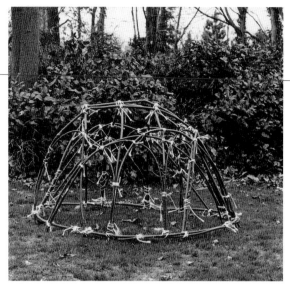

Figure 2. Sweat lodge frame, built for the exhibit, "A Time of Gathering," by Martin Louie, Sr., 1989. Photograph by John Putnam.

So, the ladies got back and there was no baby there. The oldest one said, "I told you! Let's run for the weir." They went down there and Coyote was just about to dig through. It was already seeping. They started pounding him on his head. And, they couldn't hurt him because of the ladle he had on his head. Finally, he broke through and he started running up the east side of the Columbia River. Told the salmon to follow him. So, they followed.

The first river he came to was on the west side of the Columbia. And that river is called the Yakima River. So he took the salmon up there and he traded for a young woman. So her people got salmon. When he left from there he came up the river a ways and he came to a place they call Entiat, or Nt'iyátkw. He traded some salmon there for another woman. Then he left from there. And he came to the Wenatchee River. . . . He traded some salmon there for another woman. He left from there. And, he came to Okanogan, mouth of Okanogan. He took the salmon up, all the way up, to Okanogan Falls and he put a dam in there, where the people could fish. He traded the salmon there. Then he went north from there. Went over the hill and he sat there. He was looking north. He was looking at Penticton, or Snpintktn. They sent a crippled woman over to trade for salmon. Coyote got embarrassed. He didn't want her. He said, "You people will have little bitty salmon." So, he took the fins off the salmon, threw them up the river. And that's how those Kickinees got up there. They are the fins off of the big salmon.

So, from there he came back down. Then he went up the Spokane River. He went up all the rivers. He traded for everything: food, medicine, everything.

Then he went back to his sweat lodge at Soap Lake. When he got there, he distributed the food, the medicine, everything. And, he told the people, he said, "In due time, when the people are descended here, the human beings, that'll be their hospital. They'll call it Medicine House. Anybody—the sick, gamblers, Indian Doctors, Medicine People—all classes of people, will go over there and get rid of their stress, their bad luck."

And the last time that I know of, people used to go over there and have a ceremony—a ceremony there for one day. They'd leave some food—meat or fish—for Coyote. And the Chief would face four directions and turn, turn to his left. First, he faced to where the sun comes up and he turned the way the world turns. That's what they call Creator: the sun; it brings the warmth; the berries will berry; the little birds, the little animals will grow; and the fruit, roots, and everything will grow. They used to say that the east brings the happiness. Then he faced the north. The north changes the world. In the winter the snow comes, covers the land. When it breaks in the spring, the mountains and the hills will gather all deteriorated stuff and bring it down to the Columbia, the main channel, and take it away. The water gathers all deteriorated stuff and takes it south, piles it up on each side of the shore and what goes out on the ocean will never return. And we have a brand new world in spring. The high waters take everything out, wash everything down. That's why we pray to the water, every morning and night. You talk to everything. Everything has to be alive on this earth. Everything is alive. And, if it wasn't for Mother Earth, we wouldn't be alive. If it wasn't for Father Water, nothing would live. Water holds everything's life on this world: the grass, the trees, the fruit, the animals, the birds, the human beings, everything. It wasn't for water, I guess we'd never survive. We'd turn into rock or something. . . Then the leader turned to the west. That's when everybody is supposed to rest. You become a new man, a new woman, in the morning. He turned to the south at the last. That's where all the good comes from. The animals, the birds that leave for the south return, the fruit will come, the roots will grow, and the salmon will return.

3. COYOTE MAKES FISH TRAPS

Well, Coyote got back from bringing the salmon up the Spokane River as far as Little Falls. Then he came up, gave salmon to all these creeks, Hall Creek and Barnaby Creek. He brought salmon to the Colville River, then he went on back to Kettle Falls.

There he told the people, "Now," he said, "we'll have to figure out what the coming people will use to catch the fish when they are descended here." He

started by making traps (*tsèlíʔ*, J-shaped basketry traps) on the Colville River.[1] He made some at Skwekwán't, "little waterfall" (Meyers Falls), way up the river. Then he made some at Kettle Falls. Everywhere he'd hang that fish trap, he'd name the place. At Kettle Falls, the first fish trap was hung at the place they call Nʔawʔáwyakn, "hanging upside down." That's on the east side of the river. The next one, hung on the east side, they call Skt'ak', "crossing."

Then he made a scaffold and spear points. He made a pole; made a spear. And he said, "That's what the coming people will use." He named all the places. Then he told his daughter, "In between Skt'ak' and Snk'eplanwʔíxwtn, 'cut-line-deliberately-place', sit in the middle of the river. Face downstream. The coming people will fish there, spear salmon. Hang your traps there." That's the one called Kiʔantsútn, "keep-things-to-oneself-place."

He made a scaffold for harpooning salmon on the west side, calling it Weyíʔstn, "fallen-vegetation-place." Then he named another place that had a swift ripple, a point. They call that Nkwuʔt, "back eddy." Then he made a place where the people could cross on the canoe. They call that the crossing, St'at'ak'mtn, "crossing place." This is still a place of crossing. Now both bridges are there: the highway bridge and the railroad bridge cross at St'at'ak'mtn, and land on the east side.

He made a channel on the east side for the people from up north. That is now known as Hayes Island. Tkwumáks, "long point," is the name of the camping spot of the original Kettle Falls people. Nmxiynm, "having a grove of cedar trees," they spear salmon there too. That's on the east side. On the west side is a place they called Snkeltínaʔ, "up-on-top-side." That's where the campground is for the Kettle River people and the Okanogans. The place below the bridge is called Nlhaʔmínaʔ, "close to the side." That's the Columbia River people's campground.

At the place Tkekxísxn', "crawl-over rock," north on the west side, the Kettle River people, the Okanogan people...all the tribes from Marcus on down, met. He took the salmon from there. He went up the Kettle River—went way up and then he made a falls.

4. COYOTE CONFESSES

Coyote gathered all the people. Then he confessed to the chiefs. "When you guys wanted a smart man to go down and get the salmon, I was listening outside. I know you people don't like me because I'm tricky. But," he said, "I went down and got the salmon. Now," he said, "about the house—place to pray to the world. I made one," he told them, "down on the

prairie. It'll be there when the people are descended here. That's where they'll go: the sick, the poor, for their health, for their future, for everything. Now," he said, "I'll show you people how I made it."

So, he made a sweathouse on both sides of the river. And he told them, "This is where you pray to the world, to the Creator." All right. The people said, "Thank you, Coyote. We don't dislike you, but you're awful, you're so tricky."

So Coyote said, "All right," he said. "This sweathouse is made. When the people come, that's where they will do their praying, do their wishing: for their health, for everything. Young and old."

He said, "Four directions—the food is there, every direction, the food. And the four colors of the earth." He said, "Now, I'm finished."

Then, that's the end of that story. Thank you.

COYOTE BROTHERS

This story here is about Coyote. He had a brother younger than him. Before they left home, their grandfather gave them two packages of power. They could do anything. They could wish for anything and it would come true. So, they travelled their own ways—travelled and used their power. Sometimes they tried something big and couldn't do it.

Finally, they met up at Hall Creek. They used to call that Ntsaʔlíʔm (Inchelium). Way up there another creek comes in from the north. They call that Ntektekiy'ám. Now, the English name for that creek is Buckhorn. There were a bunch of people there—a whole bunch of people camped there—hunting, gathering food for the winter. So, older Coyote peeked over and there were sure a lot of people there. He ducked back. Sitting there, he heard somebody coming down the hill. He looked up and, by God, there was his kid brother. Ahhh, they were happy.

They shook hands and said, "Where have you been?"

"Oh, I've been up Kettle River and up the Lake—Arrow Lakes—and all over. Where have you been?"

"Oh, I've been down on the flat, down here." Meaning around Davenport—Coulee City and all through there. "Along the Columbia. That's where I came back. And I came back up Ntsaʔlíʔm (Inchelium). So here we met."

Older Coyote said, "Well, what kind of luck did you have all the way through? I could do a lot of things. But some big things, I can't do. I haven't got the power. I only have two bags." He had already figured out how he was going to swindle his kid brother—rip him off his power.

Younger Coyote said, "Well, Coyote, what can we do about it?"

The older said, "Don't call me Coyote. I'm not Coyote. You're the Coyote."

His kid brother told him, "No," he said, "we're both Coyotes. We have the same mother and same father, grandfathers and grandmothers. We're all Coyotes."

The older said, "No. My name is different."

The younger asked, "What is your name?"

"Well, my name is Another One."

"No," he said, "You're a Coyote, just like me."

"No," he said, "you wanna prove it?"

"Sure," the kid brother said. "Sure. I want to prove it."

The older said, "All right, peek over the hill, towards the west."

They peeked over the hill. Gee, there were a lot of people there. They ducked back and the older Coyote said, "You run on that side hill. You see that little draw over there? You listen good to what they say, you listen good—they'll all holler 'Coyote'. When you get on the side in that little draw, you wait there and listen good again. And if they call you Coyote and they call me Another One, then I'll win your two bags of power."

All right. They made a bet. They piled their bags of power there. So Coyote, the young brother, ran on the side hill.

Everybody hollered, "Oh! Oh! Look, look at Coyote running there. That Coyote!"

He got out of sight in that little draw. He listened as his brother ran.

"Oh! Oh! Looka! Look! There's another one, 'nother one."

When the older brother got there, he said, "OK. You satisfied? My name is Another One. I'm not Coyote. You're the Coyote."

Kid brother said, "All right." So, he lost his two bags of power. And now, that's how we got these common coyotes out here. And they, the Indians, claim that the smart one is out on the sea somewhere. He'll be back here when the earth comes to an end. That's as far as that story goes.

COYOTE RACES

1. CRAWFISH OUTWITS COYOTE

...Crawfish said, "All right. You see this trail? It goes up to the south end of Chalk Grade. There's a log there on the south side of a little lake. We'll run our race from here over there and whoever jumps over that log first will win."

Coyote laughed. When he got tired of laughing, he said, "All right. I'll race you."

So, Crawfish told him, "I'll give you a head-start. You stand in front of me. Then, when I say 'Go', you start running." Coyote was pretty tricky

and smart and thought this would be an easy race. So, he stood there and he put his tail straight out. Well, Crawfish had pinchers on his two arms and he clamped his pinchers on Coyote's tail, "Go!"

Coyote started running. After he had run a ways, he was going to look back. Crawfish hollered from right behind him, "Run! Don't look back! I'm catching up on you."

By God, Coyote ran and ran and ran and every time he was going to look back, Crawfish would holler at him, "I'm right behind you."

Finally, they got close to the finish and Crawfish quit hollering at him. Coyote ran to the finish line, but he didn't jump over the log. He swung around to look. When he swung around, his tail swung over the little lake. Crawfish let go and fell into that little pond. There, he started plucking his whiskers with his pinchers. Coyote got there to the log and he started looking back. Finally, he hollered, "Crawfish! Where are you?" He hollered two, three times and looked back. Then, he said, "By God, I must have left my friend."

Finally Crawfish answered from behind him, in the lake, "What are you hollering about? I've been waiting for you here a long time. What have you been doing?"

"Eeeeee," Coyote didn't know what the hell to think. He looked over there, and there was Crawfish lying in that pond pinching his whiskers out. By God, he didn't know how Crawfish had outsmarted him. He just couldn't figure out how Crawfish had beaten him.

2. COYOTE OUTWITS BULLFROG

So, Coyote left. He went over to Kettle Falls on the north side, overlooking Marcus Flat. He kept thinking about how Crawfish had ever managed to beat him. It bothered him. So, by God, he sat down in front of a tree to think and began looking at the crowd. Aieeeeee, there were a lot of people: birds, animals, and everything. There was a big lean-to there that they had made. The champion runner of the world, Bullfrog, was lying under the lean-to. He had a long tail. [Animal people often bet their tails in a race. Lots of them had lost their tails to Bullfrog.]

So, Coyote began wondering how he could outsmart that champion. He sat there and looked below him in that little slough. There were four brothers lying there. They had their faces painted and their backs. Their backs were decorated and they were all the same color. They were Turtles. There were four brothers of them. The turtles still had their tails then.

Coyote was sitting there looking at these four brothers. By God, he got an idea of how to swindle that champion out of his tail. He went down to see the Turtles.

"Hello, my friends."

"Hello," they said, "did you just get here?"

"Yeah," he said, and began to talk about the races.

"We're holding on to our tails. We know we can't beat Bullfrog. We might just as well give our tails to him as to try to race. We can't run."

"Well," he told the Turtle brothers, "I have an idea and I'll tell you my idea. We'll be running tomorrow, about midday. You guys are going to beat him."

One Turtle said, "How are we going to beat him?"

"All right, it's like this," Coyote said. "You all have the same markings: your paint on your faces, your backs, fronts, and everything. You all look the same. Tonight, I'll go and challenge him. I'll tell him I have four friends. One of my friends will race. Tomorrow, midday, we'll run."

Coyote challenged Bullfrog and said, "And I'll bet my tail, too. But, I won't race you." Bullfrog said, "OK."

So, that night, Coyote dug holes and buried three of his friends in them. Just their heads were sticking out along the track. He left one guy. He told that first Turtle, "When you start, you get down on the ground and take the dirt and throw it ahead of you. Then, Bullfrog can't see. You holler. This second guy that I buried about one-third of the way along will jump up and holler. When your dust settles down, that second guy will holler. It's like you'd be way up there. And this third guy that I buried two-thirds of the way along will jump up and holler. And the last guy, I buried him right at the mark, right at the place where they cross the line—at the finish line." Coyote explained, "And when the third guy throws the dirt up and hollers, that last guy, that fourth Turtle, will jump over the finish line and start dancing. Then," Coyote grinned, "I'll tend to Bullfrog's tail."

"OK," they agreed.

In the morning, Coyote brought his friend Turtle over and introduced him to Bullfrog. Coyote said, "I'll have to pack my partner to the north end of the starting line." Bullfrog agreed. The starting point was at the north end of Marcus Flat. Coyote packed his friend over there. It was a sandy place. And by God, Turtle got down, digging his hands into the ground.

"Go!," Coyote hollered.

By God, the first Turtle threw up the dirt and hollered. Dirt flew up and Bullfrog couldn't see.

When that dirt settled down, by golly, the second Turtle hollered from way up ahead.

"Ach, how in the hell did he pass me?" So, Bullfrog, he built up his speed and took after the second Turtle. He caught up with this Turtle and this second Turtle threw dust up in the air. Bullfrog couldn't see. This second Turtle lay down. When the dust settled, by golly, the third Turtle hollered. He was pretty nearly to the finish line.

"Aieeee," cried Bullfrog.

So, Coyote got his friend Eagle to give him a ride to the finish line. He was there to watch the end of the race. By God, the third Turtle threw the dirt up. When the dust settled down, old Bullfrog looked—hell, that guy was dancing across the finish line. Old fourth Turtle was singing, "Hyo, hyo, hyo, heyo, yo, yo, yo . . ."

Coyote started dancing. Bullfrog got there and Coyote walked up to him, "Well, take that tail off," he said, "and we'll give it back to the owners."

Bullfrog tried to stall, "Well, wait until I get my wind."

Coyote replied, "You never give anybody a chance like that." He stepped on Bullfrog's neck and broke his tail off way up his backbone. By golly, Bullfrog was so ashamed, he jumped into the slough.

"All right," Coyote said, "your kids, when they're born, will have little tails, but when they grow up they'll lose them. Those little tadpoles, they'll lose their tails. You got so ashamed your behind was showing and you jumped in the lake. So be it." So, Coyote, he started distributing. Everybody got their tail back. They thanked Coyote. That's the end of that story.

NOTES

1. For descriptions of J-shaped basketry traps, see Kennedy and Bouchard 1975: 37–42; Bouchard and Kennedy 1984: 359–61.

BIBLIOGRAPHY

Bouchard, Randy, and Dorothy Kennedy. 1984. *Use and Occupancy in the Franklin D. Roosevelt Lake Area of Washington State*. Final report prepared for Colville Confederated Tribes and U.S. Bureau of Reclamation.

Kennedy, Dorothy, and Randy Bouchard. 1975. Utilization of Fish by the Colville-Okanagan Indian People. Unpublished ms., Victoria, British Columbia, Indian Language Project.

Turner, Nancy J., Randy Bouchard, and Dorothy Kennedy. 1980. *Ethnobotany of the Okanagan-Colville Indians of British Columbia and Washington*. Victoria: British Columbia Provincial Museum No. 21, Occasional Paper Series.

Native Place Names on the Columbia Plateau

Eugene S. Hunn

Native American peoples survived for millenia in the Pacific Northwest not solely because of their ingenious fishing and food processing technology, but by virtue of their detailed knowledge of the land and its resources. Education focused on *learning the land,* with dramatic accounts of the adventures of mythological creatures such as Coyote reinforcing their recall of critical information. For example, a single text dictated from memory by Jim Yoke, an Upper Cowlitz Indian, to Melville Jacobs (1934:228–37) in the late 1920s cites 275 named places and provides a capsule cultural annotation and resource inventory for each. The names were recalled systematically from a mental map of Yoke's home country.

Learning a landscape is not simply a matter of naming all the rivers and mountains. In fact, rivers and mountains per se are rarely named in Native American languages. The naming of such features of the land reflects rather a peculiarly Western perspective—one set *above* or *outside,* rather than *within,* the landscape and motivated by the needs of a society bent upon dividing it up. From this perspective, features of the landscape are *objects* to be named. The Native American perspective, in contrast, emphasizes *places* where significant human-landscape interactions occur. Thus, while a few prominent peaks may have been named in the native languages—for example, taxúma[2] (in the Puget Salish language) for Mt. Rainier or lawilayt-łá (in Sahaptin), literally "the smoker," for Mt. St. Helens—other peaks of equal prominence were known simply as *pátu,* a general Sahaptin term for "snow-capped summit."

The Native names now assigned to many Northwest rivers referred in the original languages to major villages or fishing sites on those rivers. Táytin (Tieton) named a spear-fishing site at the outlet of Clear Lake high up the Tieton River. In Sahaptin, łátaxat (Klickitat) named the key Klickitat River fishery at the falls just above the river's mouth. Iyákima (Yakima), literally "the pregnant ones," indicated a string of hills near the present-day city of Yakima named for their resemblance to five pregnant women of a mythological account. Place names reveal a great deal about how a people appreciate the world they live in.

Josephine Andrews, a leading elder of the Yakima Indian Nation who was raised in the Naches River area, provided a key interpretation: naxčíiš, literally "first water," refers to the fundamental role that the Naches basin's waters play as a source of life for the whole of the mid-Columbia plain. Her fears for the destruction of that water source brought into sharp focus the spiritual, as well as material, cost of a dam recently proposed on a tributary of the Naches.

The sacred mountain lalíik (fig. 2), the easternmost prominence of the Rattlesnake Hills which now mark the southern border of the Hanford Nuclear Reservation, marks an angle in the boundary of the lands ceded by the 1855 treaties. (In the Yakima treaty the name of the mountain is misrepresented as "La Lac," and interpreted as a "lake" [Doty 1978:97].) Rising 3000 feet above the river, the summit dominates the skyline for miles about. The Priest Rapids prophet smúxala (Smohalla) sought a visionary source of spirit power here (Relander 1956:52, 70, 72). Today the mountain serves the elders as a weather vane; lingering snows on its summit augur a late spring growing season.

The ecological relationships forged by the Native cultures over the millenia of their occupation

Eugene S. Hunn is Professor of Anthropology at the University of Washington. [1]

170

of this land are embodied in their place names. When and where may a plant or animal species be most reliably found or efficiently harvested? Success in hunting and gathering rests on a strategic choice of seasonal moves—a succession of camps established to provide a family access to a sufficient abundance and diversity of food and essential materials to sustain them each year. This is the *seasonal round* of those who live by gathering, fishing, and hunting; its precise shape is conditioned by the local landscape, but it is a cultural product nonetheless, a creation of the human mind.

Many places are named for particularly noteworthy plants, animals, or minerals found there, or for related activities accomplished there. Some examples:

Kalamát, "yellow pond lily" (*Nuphar polysepalum*), names a meadow and pond in the southern Cascade Mountains of Washington where berries were picked in late summer; it is also the site of a historic Indian horse racing track (Norton, Boyd, and Hunn 1983).

Pank̓ú, the edible root *Tauschia hooveri*, gives its name to the area just above Sentinel Gap, near present-day Vantage on the Columbia River (Relander 1956:32).

Tiskáya, "Skunk," as a character in myth, is the name of a mountain a few miles below present-day Packwood in Lewis County (Jacobs 1934:32).

Wawyúk̓-ma, "common poorwills," designates both a village on the lower Snake River (Rigsby 1965:39) and the lower Snake River people (Jacobs 1931:94).

More often a plant or animal name is modified by a reduplication (doubling part or all of a word—this usually suggests small size or large numbers of something in Sahaptin) or by adding the possessive suffix -nmí or the suffix -aš ("place of") or some variant thereof. Some examples:

Nánk-nank, "many cedars," for a place below Cowlitz Falls on the Cowlitz River (Jacobs 1934:230).

Púuši or Púušpuuši (Hymes 1976:20), "of junipers" or "many junipers," for present-day Redmond, Oregon, and for a dip-netting site just below Alderdale, Klickitat County, Washington.

Šq'ʷla-nmí, "of mountain beaver," for a big mountain near White Pass (Jacobs 1934:231).

Taxús-as, "Indian hemp place," for lower Crab Creek, Grant County; it is reputed that Indian hemp (*Apocynum cannabinum*) here was of such fine quality that battles were fought to control it (Relander 956:312).

Xʷún-aš, "large-scale sucker place," for Moses Lake, Grant County, or for a campsite on the lake; this name also indicates a creek two miles above Nesika, Lewis County (Jacobs 1931:230).

Xʷiyał-nmí, "of white agates," for a stream that

Figure 1. Each spring Plateau Indian elders of the Wáashani faith—also known as the Seven Drums or Longhouse religion—prepare to give thanks to the Earth and Sun for the annual regeneration of their sacred traditional foods. Select groups of elders are sent out the week before the thanksgiving feast (*káʔwit*, in Sahaptin) to gather roots and greens and to catch a supply of fresh salmon. These foods are brought to the longhouses, prepared, and served to the congregations the following Sunday. Here James Selam, Sara Quaempts, and Delsie Albert Selam offer prayers before collecting bitterroot (*Lewisia rediviva; pyaxí,* in Sahaptin) for the Rock Creek Longhouse feast. Photograph by Eugene Hunn.

Figure 2. The high eastern prominence of the Rattlesnake Hills dominates the Tri-Cities skyline. It is called Lalíik in Sahaptin and is sacred: a way station for spirits of the dead rising to heaven. Photograph by Eugene Hunn.

171

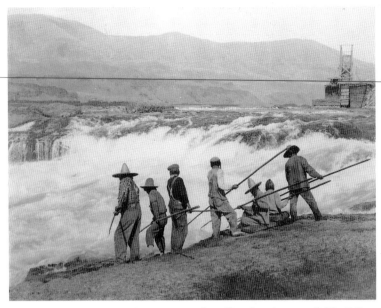

Figure 3. Native people gaffing for salmon at Celilo Falls, east of the Dalles, about 1900–1920. Photography by A.M. Prentiss, courtesy of Special Collections Division, University of Washington Libraries neg. #NA 745.

heads near White Pass (Jacobs 1934:234).

Pnáy-pnay, "many pestles," for a spring camp-site on Alder Creek, Klickitat County, where roots are pounded and dried.

Q̇íyak-awas, "gaff-hooking place," for a fishing site at Celilo Falls.

Sapawilalat-pamá, "for set-netting," another site at Celilo Falls, where large-mouthed dip-nets were fixed by lines beneath a fish jumping place.

Place name nomenclature always reflects an individual point of view. An exhaustive inventory of a region's place names, however, will considerably exceed any single individual's repertory.

CELILO FALLS

A few miles below the mouth of the Deschutes a basalt ridge cuts across the Columbia River's course. This is Celilo Falls. [The Celilo Falls area is now flooded by the Dalles Dam.] Here and for the next ten miles the full force of the Columbia is shunted through a series of narrow passages. (The lower reaches of this tumultuous stretch of river were called "the dalles" by the early French-Canadian fur trappers. The namesake Oregon city is located a few miles further downstream.) At high water in June the river surges up and over these obstructions, but when the flood recedes channels open through which the salmon force their way, driven to return to spawn in their natal streams. The salmon surge past in sharp pulses: spring Chinook salmon in early May, blue-back salmon in July, then summer runs of Chinook and steelhead followed in early September by the heavy fall Chinook run and in October by silver salmon. The complex configuration of channels and eddies on this stretch of the Columbia provided excellent fishing for men armed with dip-nets, gaff-hooks, or spears (fig. 3). A large surplus of fish was dried and stored for later use or for barter and trade. Local fishermen hosted several thousand visitors during summer and fall while they waited for the runs to pass. The region of the great falls and the dalles was a great emporium that brought together peoples within a radius of several hundred miles.

James Selam, a fluent native speaker of the Columbia River Sahaptin language, was born in 1918 and raised between Rock Creek and the John Day River some thirty miles upriver from Celilo Falls. His father shared rights by inheritance to use certain fishing stations at the Great Falls. Thus James Selam witnessed Native fishing practices there as a child and young adult during the 1920s and 1930s. By consulting a map that showed the contours of the falls before they were inundated by the Dalles Dam, James Selam recalled 15 named sites within the single square mile encompassing the falls (fig. 4). By his own admission his recollection of named sites there is far from complete, yet the details he can still recall graphically illustrate the complexity of traditional geographic perceptions at this key fishery. Most of these names denote fishing sites that belonged to particular families and were often named for the fishing practices appropriate to each site.

The Columbia River itself is known throughout the Sahaptin speech area simply as nč̓i-wána, "big river." Some major villages are occupied during the summer, others during the winter or year-around. These village names apply not only to the villages themselves, but also to the region immediately surrounding the village. As such, the term might subsume other named sites.

The name of a village might also be used for the group of people who lived there. Thus wayám was the summer village on the Oregon side of the river at Celilo Falls; the people of that village were the wayam-ɬáma, though they retired during the winter months to the more sheltered village site of tq̓ux at the mouth of the Deschutes River (Rigsby 1965:54) or to a village just up the Deschutes called wanwáwi (Murdock 1938:397).

Their closest neighbors were the sk̓in-ɬáma, residents of the permanent village of sk̓in on the Washington shore at the falls. This village, built on a sandy beach just below the falls, is named for a prominent rock formation on the Washington shore at the lip of the falls. This rock resembled a cradle-board—which is the literal meaning of sk̓in—and alludes to a myth of the origin of salmon. In this

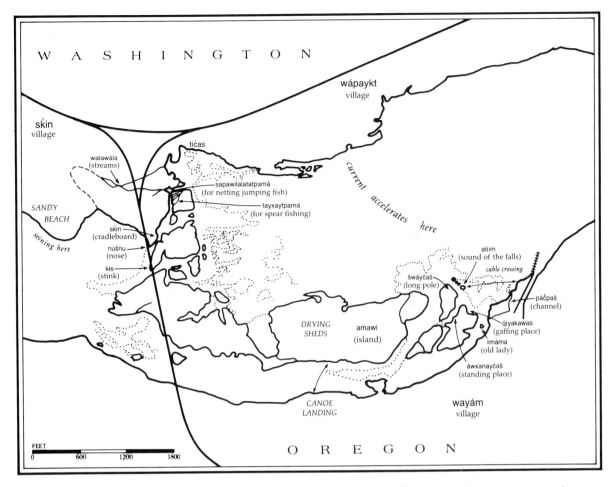

Figure 4. Celilo Falls fishing sites, 1930. James Selam named and located these sites in 1987. Because his family belonged to the community at S̓k̓in, he claimed limited knowledge of the fishing places on the Oregon side of the Columbia River. Selam described how he and other children used to fish at Tíc̓as, one of his family's sites, in the 1920s.

The village was built on the rocks above the sandy beach at the foot of the falls. There were many drying sheds (*tyáwtaš*) there. S̓k̓in people seined off the sandy beach and set a gillnet just below Núšnu. This net was 300–500 feet long; the catch was shared by all families of the village. The village women worked together to make the long net. The Walawála area was a high-water fishing site. At Tayxaytpamá, a bed of pale flat stones under clear water facilitated spear fishing. At Sapawilalatatpamá, the river fell 8 to 10 feet. Fishermen held their dipnets below the falls in order to catch the leaping salmon. Drying sheds were set up in summer on Amáwi (later known as "Big Island" by Wayam [i.e., Celilo] fishermen). The materials and gear were brought across by canoe or boat. Awxanáyc̓aš

("standing place") was a site where seven men stood in a line dipping into the rushing current (the whole island was subsequently named "Standing Island"). In the early days it was necessary to swim from Awxanáyc̓aš to reach Šwáyc̓aš. A dipnet on a long pole (over 20 feet long) was needed to reach the current here. This site belonged to Chief Tommy Thompson's family and thus the island came to be known as "Chief Island." The rock called Atíim stood at the very lip of the falls. In the early 1930s it came to be called "Albert's Island" after the family that claimed it then. It was accessible at low water by boat, though a cable was stretched across to it from Taffe's fishwheel early in this century. Pác̓paš was the location of several high-water fishing sites. It was a narrow channel favored for catching "eels," apparently the same as that known as Downes' Channel. The current here turned the best of Taffe's fishwheels (Donaldson and Cramer 1971: 110). "Old Lady" rock was tabooed.

From Hunn, E.S., with J. Selam and Family. 1990. *Nch'i-Wana, "The Big River": Mid-Columbia Indians and Their Land.* Seattle: University of Washington Press.

Figure 5. Delsie Albert Selam holds a "cous" root (*Lomatium cous*) in her hand. Cous—a name borrowed from Nez Perce originally—is one of a dozen species of the genus *Lomatium* (of the carrot family) named and used as food or medicine by Native peoples of eastern Washington. Photograph by Eugene Hunn.

Figure 6. The camas lily (*Camassia quamash*) in flower. Camas, an important edible bulb, was abundant at Kittitas east of Ellensburg and near Glenwood in Klickitat County before the meadows were plowed by settlers. Hundreds of Indians camped on these meadows for a week or two in June harvesting a year's supply of camas, an occasion for horse racing, gambling, and intense social activity. The word "camas" comes from the Nez Perce. Photograph by Eugene Hunn.

myth the Swallow Sisters (five mythological beings in the form of birds) have dammed the river, preventing the salmon from migrating upstream to spawn and thus depriving the upriver peoples of their livelihood. The mythological superhero Coyote, disguised as a baby, straps himself to a cradleboard and floats down the river to Celilo. There he deceives the Swallow Sisters who take him in as a foundling. While the sisters are away digging roots in the nearby hills (as the women of skin families still do), Coyote destroys the dam and releases the salmon to return to the streams of their birth (cf. Beavert 1974:34–37). (See article by Martin Louie, this volume.) The cradle-shaped rock for which this village and its people were named was destroyed during construction of the railroad bridge across the west end of the falls.

Lewis and Clark described Celilo Falls: "…The waters is divided into Several narrow chanels which pass through a hard black rock forming Islands of rocks at this Stage of the water, on those Islands of rocks…I observe great numbers of Stacks of pounded Salmon neetly preserved…" (Thwaites 1959, vol. 3:148). The two largest of those islands are known locally as "Kiska" and "Big Island." "Papoose," "Chief," and "Standing" are local names for smaller islands that split the main channel between Big Island and the mainland at the head of the falls on the Oregon side.

Native nomenclature—as James Selam recalls it—departs again from Euro-American conventions in that the islands themselves were not named. "Kiska Island" is a corruption of the Sahaptin term

kis, literally "stinking," which denoted a fishing site on the northwest side of the island at which dead fish became trapped in a pool on the rocks, where they decomposed. Kis was opposite a prominent rocky point on the Washington shore known as núšnu, "nose." The rock called skin, "cradleboard," was just upstream, as were two fishing sites named for the fishing methods used there. At tayxayt-pamá, "for spear fishing," flat pale-colored rocks just beneath the surface of the current highlighted the migrating fish so they could be easily speared. At sapawilalat-pamá, "for set-netting," fish leaped from the water in their efforts to surmount the falls. A wide-mouthed net tied with lines caught the fish as they fell back.

Big Island was called simply amáwi, "island." It was located immediately opposite the village of wayám (about where the Celilo Longhouse stands today) and was reached by canoe from the wayám landings. About the turn of the century, an overhead cable was stretched to Big Island from the Seufert brothers' Tumwater fish wheel and fish processing operation on the Oregon shore to transport Native fishermen and their catches (Donaldson and Cramer 1971:92). Drying sheds were built on Big Island to service a number of fishing stations on the island's northeast point, but James Selam could not recall the names of these sites. "Chief Island" was so called because Chief Tommy Thompson, last of the traditional salmon chiefs—leaders with the spiritual authority to regulate fishing—had had his fishing places, collectively designated šwáyčaš, there. "Standing Island" was named for a fishing site at the channel between it and Chief Island. It was known in Sahaptin as awxanáyčaš, which means something like "standing at the lip of the falls." Here seven men standing could dip-net salmon together. The fishermen swept their long-handled dip nets with the current, feeling for fish in the roiling water. Whenever a fish was netted, the successful fisherman stepped back to be replaced by another.

A small rock between the northeast corner of Standing Island and the Oregon shore was called ɬmáma, "old woman." Just above was an island at the top of the falls where I. H. Taffe set up three fish wheels and a cannery about 1890 (Donaldson and Cramer 1971:109). Just below these wheels was páč'paš, "channel," a good site for catching "eels" (Pacific lamprey). "Gaff-hooking place," q'íyak-awas, was located on the north shore of Standing Island.

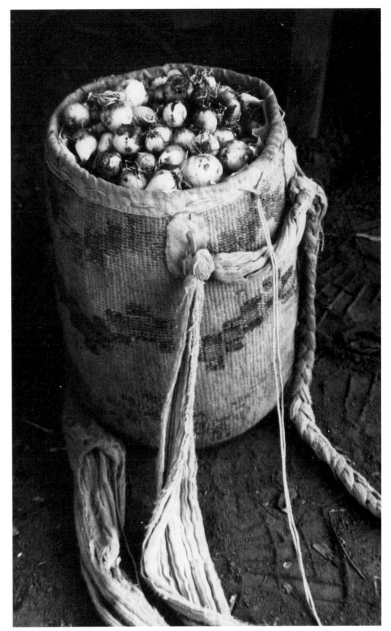

Figure 7. A large collecting basket (anpš) full of camas bulbs (xmaaš or wáka'mu) ready to be cleaned prior to baking in the underground oven. Photograph by Eugene Hunn.

ALDER CREEK

Sixty miles upriver from Celilo is Alder Creek, an obscure stream that drains the Horse Heaven Hills in extreme eastern Klickitat County, Washington. This is a land of sere hills, of high winds, of extremes of

heat and cold, relieved by an occasional creek crowded with thirsty alders, cottonwoods, and willows. As was true of virtually every Columbia tributary, a village was situated at the confluence of Alder Creek with the Big River, a small village known as náwawi.

The old winter village was built on the Columbia River flood plain just below the mouth of the creek. (It was occupied only during winter low-water periods, when flooding was no problem.) When Delsie Selam (James Selam's sister-in-law) and Sara Quaempts (Delsie Selam's cousin) were young girls in the late 1920s, they lived in a tule-mat longhouse on Alder Creek at its junction with Six-Prong Creek, a few miles above the mouth of Alder Creek. Here they were sheltered from the winds that whip up the Columbia River by a high ridge known as áwtaš, literally "wound." They climbed to its summit in winter to harvest the corms of mariposa lily (*Calochortus macrocarpus*), an emergency winter ration. From there they could see the whole of the Sahaptin world. Today their ancestral burial ground rests on the southeastern shoulder of the ridge.

Early each spring the Alder Creek families traveled up the creek through a series of camps, biding a week or so at each until the nearby root supplies were exhausted. Sweat Lodge Camp, xʷiyayč-mí, was visited twice each spring, very early, to harvest the first Indian celeries, the sprouts of Gray's desert parsley (*Lomatium grayi*), and later for roots. Pnáy-pnay, "Many Pestles," is an important bitterroot (*Lewisia rediviva*) ground on the ridge west of Spring Canyon, an area Sara Quaempts and Delsie Selam still regularly visit on root-gathering excursions. "Many Pestles" may refer to the rhythmic percussion of the women pounding desert parsley (*Lomatium*) roots in their oak mortars. The root meal was then molded with the fingers to make a cake that kept indefinitely when dried. Cottontails, for which Cottontail Burrow Camp, aykʷs-mí tánawt, was named, were pulled from their burrows with a specially shaped stick. The meat was eaten and the pelt made into warm winter socks. The sweat lodge at Sweat Lodge Camp played a key role in Native life. Each morning at dawn, first the men and then the women entered the lodge, a willow frame some four feet high sealed with robes, earth, and grass. River cobbles heated white-hot were placed on a hearth just inside the entrance, then sprinkled with water laced with medicinal herbs. The bathers called out prayers to the Sweat Lodge spirit in the stifling darkness, then emerged into the cold dawn air. This daily ritual purified body and spirit.

Each camp was located where a side canyon joins that of Alder Creek. Each was well sheltered from the cold winds that buffet the ridge crests where the food roots must be dug. Each was well supplied with water in the early spring; tall sagebrush was available in abundance for firewood. The spring gathering season was short, for the low hills above the Columbia at Alder Creek are soon baked dry. This necessitates a second, longer journey across the Columbia into the Blue Mountains of Oregon, which rise above 6,000 feet at the headwaters of the North Fork of the John Day River, and remain rich and green well into June. A special desert parsley root grows here that is found neither on the lower hills near Alder Creek nor in the Cascades north of the Columbia. This is the famed xawš (*Lomatium cous*, fig. 5), a term borrowed from Nez Perce and translated into the local English vernacular as "cous" and applied quite indiscriminately to a variety of distinct Indian root foods. When the cous harvest was finished, Delsie Selam and Sara Quaempts moved on to imáayi (now known as Fox Valley) for camas (*Camassia quamash*). Many Columbia River Native people gathered there in early summer to dig these wild lily bulbs and to bake them in earthen ovens until they were sweet (fig. 6, 7).

Indian Heaven

James Selam's family, by virtue of their kinship ties to skʹin, fished the summer and fall salmon runs at Celilo. From there they trekked each summer to their huckleberry camp southeast of Mt. St. Helens to a place called áyun-aš, "lovage place" (for áyun, *Ligusticum canbyi*, a medicinal root), in the area now known as Indian Heaven. Here they could escape the oppressive August heat of the Columbia Valley. The women gathered and dried a winter's supply of huckleberries and wild blueberries while the men hunted deer or ranged down into the Columbia Gorge to fish at the mouths of the White Salmon, Little White Salmon, and Wind rivers. According to James Selam, each community had a traditionally recognized camping and berry-picking area on this high, forested plateau. The Klickitats camped ten miles north of áyun-aš at pswawas-wáakuł, "saw-like," now called the Sawtooth Huckleberry Fields. All gathered to socialize, trade, and race horses at kalamát, "yellow pond-lily," a broad meadow astride the Klickitat Trail (see Norton, Boyd, and Hunn 1983).

Pond lilies are rare in high mountain meadows; however, when James Selam and I hiked in — bushwhacking along the overgrown path he had taken with his parents over 50 years before — there were a few pond lilies in a shallow tarn at the meadow's edge. An incongruous heron flushed squawking at our approach. Although the pond lily was a staple food of the Klamath people of southern Oregon, it was not used by local Native groups. Thus this meadow's namesake was memorable not so much for its economic value but for its surprising presence far from its expected haunts.

In conclusion I wish to correct the impression I may have given that Native American nomenclature is largely economically motivated. For native peoples, topographic forms may reflect deeper mythical realities. At a spot just off State Highway 14, high above the Columbia River opposite the mouth of the Deschutes, James Selam indicated the exact spot where Coyote hid when he taunted nayšłá, the "Swallowing Monster" that dwelled long ago in a deep pool in the river below. Selam pointed to a narrow defile below us that led down to the water. This had been gouged by Coyote as he was dragged into the monster's cavernous maw. Coyote found all sorts of people trapped inside. Grizzly Bear, Wolf, Rattlesnake, all sorts of powerful beings were powerless to escape. But Coyote had come prepared. He pulled out tinder, kindling, and flint, built a fire beneath the monster's heart, and proceeded to hack at its moorings with his knife. Coyote led the Animal People to freedom from the belly of the dying beast, some escaping by its mouth, others in the opposite direction.

NOTES

1. The research on which this article is based was supported by grants from the National Science Foundation, the Melville and Elizabeth Jacobs Research Fund, the Graduate School of the University of Washington, and the Phillips Fund of the American Philosophical Society. I would like to express my appreciation for the collegial assistance I have received over the years of my Sahaptin research from Helen Schuster, David and Kathrine French, Bruce Rigsby, and Virginia Hymes. I am indebted more than I can say to the Columbia River Indian people who have shared their vision of the world with me, most especially to my mentor, James Selam.

2. Indian words are written in a phonemic alphabet based on Rigsby (1965:156). Consonants with a superscripted apostrophe are "glottalized," pronounced with an explosive burst of air from the throat. The symbols š and č are equivalent to "sh" and "ch" of English orthography, as in the words "shore" and "chore" or "fish" and "rich." The "barred l" (ł) sound is pronounced more or less like the "thl" of "athlete." The barred lambda" (λ) is pronounced more or less like "tl." The "barred i" (ɨ) is pronounced more or less like the "i" of "bit." A superscript "w" following a consonant indicates rounding. The q is a "k" sound pronounced far back toward the throat. The x is likewise pronounced far back toward the throat, but sounds more like the "ch" of Scottish "loch." I have left off the subscripted dot as the "back x" is the only "x" sound in these examples. A question mark without the dot is a "glottal stop." The accent mark indicated the most heavily stressed syllable of a polysyllabic word.

REFERENCES

Beavert, Virginia. 1974. *The Way It Was; Anaku Iwacha, Yakima Indian Legends.* Franklin Press for the Consortium of Johnson O'Malley Committees, Region IV, State of Washington.

Donaldson, Ivan J., and Frederick K. Cramer. 1971. *Fishwheels of the Columbia.* Portland, Oregon: Binfords & Mort.

Doty, James. 1978. *Journal of Operations of Governor Isaac Ingalls Stevens of Washington Territory in 1855.* Fairfield, Washington: Ye Galleon Press.

Hymes, Virginia. 1976. Word and Phrase List of Warm Springs Sahaptin. Manuscript, Warm Springs Confederated Tribes, Warm Springs, Oregon.

Jacobs, Melville. 1931. A Sketch of Northwest Sahaptin Grammar. *University of Washington Publications in Anthropology* 4:85–292.

Jacobs, Melville. 1934. *Northwest Sahaptin Texts*, Part 1. Columbia University Contributions to Anthropology No. 19.

Murdock, George P. 1938. Notes on the Tenino, Molala, and Paiute of Oregon. *American Anthropologist* 40:395–402.

Norton, Helen H., Robert Boyd, and Eugene S. Hunn. 1983. The Klickitat Trail of South-central Washington: A Reconstruction of Seasonally Used Resource Sites. In R.E. Greengo, ed., *Prehistoric Places on the Southern Northwest Coast*, pp. 121–52. Thomas Burke Memorial Washington State Museum Research Report No. 4.

Relander, Click. 1956. *Drummers and Dreamers.* Caldwell, Idaho: Caxton Printers.

Rigsby, Bruce J. 1965. Linguistic Relations in the Southern Plateau. Ph.D. diss., Department of Linguistics, University of Oregon, Eugene.

Thwaites, Reuben Gold, ed. 1959. *Original Journals of the Lewis and Clark Expedition, 1804–1806*, 8 volumes. New York: Dodd, Mead & Co.

Basketry Styles
of the Plateau Region

Lynette Miller

Introduction

The Native people of the Plateau region made a variety of types of baskets in differing styles and techniques. Among the best known are undoubtedly the brightly colored "Nez Perce cornhusk bags" and intricately patterned "Klickitat baskets." Each of these styles is made across a large area of the Plateau, in spite of the localized tribal names commonly assigned to them. These, and other, Plateau styles were woven to fill a range of practical functions. Baskets were an integral part of Plateau life, filling symbolic as well as practical needs. Although they were originally made primarily as practical containers, the baskets are also beautifully decorated, their designs displaying a rich variety of colors and patterns.

The region which anthropologists have labeled the Plateau lies inland from the northwestern coast of the Pacific Ocean. The Cascade Mountains mark the western boundary of this territory, which extends eastward from there to the Rocky Mountains. The northern and southern boundaries are less clearly defined: individual scholars delineate them differently. In its broadest expanse the Plateau includes the Klamath and Modoc people of southern Oregon and northern California, as well as the people who live along the Thompson and Fraser rivers in central British Columbia. However, in any definition of the

Plateau, eastern Washington lies at the heart of the region.

The term Plateau was applied to this territory because the bulk of the region comprises a series of high plateaus, drained by the Columbia River and its tributaries in the south and by the Thompson and Fraser rivers in the north. The climate in this area exhibits extremes of heat and cold in the summer and winter. The entire region is rather dry, and is classified as desert through much of its central and southern portions.

The Native inhabitants of the Plateau at the period of Euro-American contact belonged to two major language groups: the Penutian and the Salishan. In general, the Salishan-speaking groups occupied the northern part of the Plateau, including the northeastern portion of modern Washington State, southeastern British Columbia, and northern Idaho. These tribes include the Coeur d'Alene, Colville, Lilooet, Okanogan, Spokane, Sanpoil-Nespelem, Thompson and Fraser River, and Wenatchee. The Penutian-speaking groups lived in the southern portion of the Plateau: southeastern Washington, northeastern Oregon, and central Idaho. Most of these people spoke languages belonging to the Sahaptin family of the Penutian phylum. The largest of these tribes are the Klickitat, Nez Perce, Umatilla, Walla Walla, and Yakima. Other sub-groups of the Penutian phylum, including the Chinookian-speaking Wasco-Wishram, the Cayuse-Molala, and the Klamath-Modoc, lived in the southern part of the Plateau.

Despite these language distinctions, the Native people of the Plateau were culturally quite homogeneous. Their way of life was seasonally nomadic; the people moved from place to place to take advantage

Lynette Miller is the Director and Curator of the Museum of Native American Cultures, Spokane, Washington. She recently curated the Native American collections at the Maryhill Museum of Art in Goldendale, Washington. An expert on Plateau cornhusk bags, she is currently in the doctoral program of the Division of Art History, School of Art, at the University of Washington.

of a variety of food resources as each became available during the year. Salmon and other migratory fish were a major source of food for people living along the rivers. Those who lived away from the rivers shared fishing sites with other groups, or obtained dried fish through trade. In non-fishing areas, hunting for elk, deer, and other game animals took on more importance. Both fishing and hunting were men's occupations, while women processed and dried the fish and meat needed for the winter food supply.

Vegetable foods, in the form of wild plant roots, were an equally important food resource throughout the Plateau. Camas, cous, and bitterroot were the staple root foods, but Plateau groups commonly used as many as twenty different varieties of plant roots. Women were responsible for gathering the roots which grew in great abundance. Roots were sometimes eaten fresh, but most of them were dried and stored for future use. Dried roots were either stored whole or ground into flour which was then made into cakes. These were easily stored and could be carried while travelling. Dried roots and root cakes were cooked to make mush or added to meat stews.

Lewis and Clark were the first Euro-Americans to record contact with Plateau people. The expedition travelled westward through the region in 1805 and returned eastward in 1806. This initial contact was followed by a succession of other Euro-American groups. In the period between 1806 and 1850, other explorers, fur traders, and gold miners moved through the Plateau. However, it was the settlement of Christian missionaries in 1836 and the subsequent expansion of the Oregon Trail in the 1840s that initiated a steadily increasing stream of wagons carrying families of permanent settlers. The rapid expansion of Euro-American settlement put increasing pressure on the indigenous population. From the middle of the nineteenth century onward, Plateau people were forced to give up their nomadic way of life. Fish and game animals became less plentiful, and many root fields were plowed and planted with crops by Euro-American farmers. By the last quarter of the nineteenth century, Plateau people had been forced to live in reservations and many became farmers themselves. Although some aspects of traditional life remained, by 1889, the year in which Washington became a state, the Plateau way of life had changed dramatically. Thus, in many ways, Washington statehood marked the culmination of these historical trends.

PLATEAU TWINED BAGS

The changes which occurred in Plateau life are, of course, reflected in basketry as well as in many other types of objects made and used by Plateau people. An examination of one type of Plateau basket, the

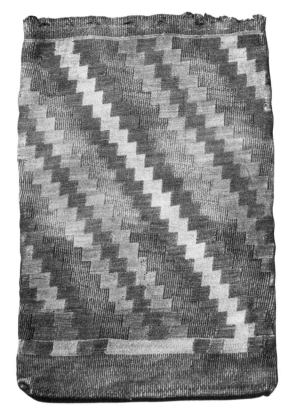

Figure 1. Flat twined Plateau bag, early style, circa 1850–1875. Indian hemp and cornhusk; 61 cm x 42 cm. Burke Museum #2.4E139. Photograph by Lynette Miller.

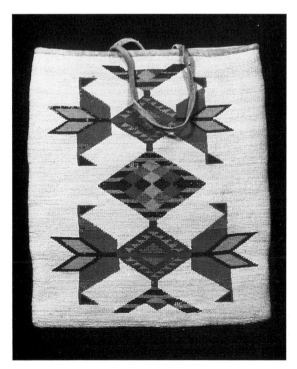

Figure 2. Flat twined Plateau bag, late style, circa 1900–1925. Cotton cord, cornhusk, wool yarn, and leather; 29 cm x 26 cm. Burke Museum #2.4E99. Photograph by Lynette Miller.

"cornhusk bag," will serve as an example of the effects of these changes. These flat baskets, sometimes called wallets, were probably the most common type of basket made on the Plateau. They were woven in either square or rectangular shapes and ornamented with a wide variety of geometric and naturalistic designs.

The earliest form of flat bag, used primarily for root storage, is typically large and rectangular. These bags measure up to two by three feet, and are decorated with simple repeated geometric motifs (pl. 11 and fig. 1). A wide band at the bottom and a narrower top band are left undecorated. The warp and weft elements are of two-ply Indian hemp cord (*Apocynum cannibinum*) and the decorative false embroidery is usually corn husk (*Zea mays*). The colors are muted browns, greens, and yellows, either in undyed natural shades, or dyed using vegetal materials. These older bags generally have a drawstring closure. Made in the period before about 1880, they are beautiful for their subtlety and simplicity.

The later form of flat bag is dramatically different: more nearly square in shape and smaller in size, usually about 12 by 12 inches or less (fig 2). The design is often extended over the entire surface of the bag, leaving no undecorated top or bottom band. The designs of these bags are often geometric, although representations of plants, animals, or people are also common. The geometric designs found on these bags frequently differ from those on older bags and are characterized by complex combinations of motifs. Natural cornhusk usually forms the background for designs woven in aniline-dyed cornhusk or, more commonly, brightly colored manufactured wool yarn. Commercial cotton twine often replaces Indian hemp for the warps and wefts, particularly on the concealed interior of the bag. The bag is sometimes finished with a fabric binding or lining; a pair of loop handles or ties is used instead of a drawstring.

What stimulated these dramatic changes in nearly every aspect of Plateau bag weaving? If we examine the period in which these changes took place, it is clear that they were largely a result of contact between Plateau people and Euro-Americans and the subsequent relocation of Native populations by the American government. While some changes began to appear in bags as early as the 1840s, the new form of Plateau bag developed in the period between 1860 and 1900. As tribes were restricted to reservations, roots became more difficult to obtain and, consequently, there was less need for large bags in which to gather and store them. Increasingly, introduced foods and containers began to replace traditional Plateau foods and twined bags.

The techniques used for weaving and decoration—the heart of bag making—remained unchanged by Euro-American settlement. Bags continued to be woven in plain twining with decoration added in false embroidery.

Three structural weaving elements are used in plain twining: a set of warp elements and two weft elements. In this technique, a pair of wefts is passed around the front and back of each warp and crossed with a half-twist between warps. The design is created by a fourth, non-structural, element which is wrapped around each weft as it appears on the bag's exterior surface. Although woven into the surface, this decorative technique is called false embroidery, because the design simulates embroidery but appears only on the outer surface of the bag.

Also unaltered by Euro-American contact was the basic format of the twined bag's design, which remained varied on each of the bag's two sides. On most bags, the sides are completely different in both design and color. Even in the few bags in which the sides are alike, some variation in color or shape distinguishes the two designs.

While the format and technique used in bag weaving were consistent throughout the period of Euro-American settlement, nearly every other aspect of the craft changed. As the traditional large root bag became obsolete after about 1875, Plateau weavers began to make smaller bags for use as containers for personal belongings. While bags had probably always been used in this way, this function now became primary. In fact, these smaller bags eventually came to function in much the same way as women's purses do in Euro-American society. As a result, bags were smaller, square, and more finely woven. Weavers now were more concerned with fine technique and the aesthetic appeal of the designs than with capacity and durability.

Even before the bag's function began to change, new materials had been introduced into bag weaving. Anthropological and historical accounts invariably report that the earliest bags were made of Indian hemp with false-embroidered decoration of bear grass (*Xerophyllum tenax*). However, examples of bags including bear grass are virtually non-existent, leading to some doubt regarding the common or widespread use of bear grass.

Cornhusk is the decorative material usually found on early bags. Not native to this part of the New World, corn was introduced to the Plateau region by early settlers in the 1820s. Thererfore, earlier bags must either have been decorated with bear grass or some other material, or left undecorated. Among the earliest type of bag, cornhusk is used for decorative elements set off against a background of plain twining, or patterns of dyed and undyed cornhusk cover the entire surface of the bag.

Wool yarn appeared in Plateau weaving as early as the 1840s. The earliest examples are items reportedly collected by Rev. Henry Spalding during his

tenure as a missionary among the Nez Perce between 1836 and 1847. These pieces include two hats in which small amounts of wool yarn are used as decoration. By the 1860s and 1870s, manufactured wool yarn had become quite readily available. At this same period, Indian hemp became harder to obtain and commercial cotton twine began to replace it. The ready-to-use cotton and wool materials were obviously great labor savers, and the bright hues of wool colored with aniline dyes (invented in 1856) must have been very attractive to Plateau weavers. As the use of these materials increased, bags became more highly decorated, with more intricate multi-colored designs.

Designs on earlier bags are usually rather simple repeated geometric motifs such as diamonds, triangles, zigzags, or squares, often in alternating colors. Another common arrangement consists of bands of motifs which might be oriented horizontally, vertically, or diagonally across the surface of the bag. This band arrangement remained popular even after other types of designs had come into general use.

Three additional design types developed after the use of wool yarn became widespread. Centralized designs consist of one large, complex geometric motif placed in the center of the bag. In some bags, the design is surrounded by a frame or border, while in others the design is simply placed against a neutral background.

A second design format appears to be associated with traditional Plateau symbolism, although it developed after Euro-American contact. The design has five parts, one in the center of the bag and one in each corner. The five geometric motifs are usually basically the same, with the central one larger, differently colored, or varied in some other way from the corners. Like many other Native American groups, Plateau people assigned sacred or significant meaning to certain numbers. For the Plateau, significant numbers were three, five, and seven. In Plateau legends, for example, actions were ritually performed five times before they were considered to have taken effect (Schuster 1975, vol. 1:111; Tokle 1979:39). This number symbolism is somewhat unusual, since many Native Americans regard four as the sacred number. Thus, the use of five motifs in bag designs suggests a possible association with this numerological symbolism.

The final type of bag design was clearly the result of Euro-American influence. These designs are pictorial or naturalistic, depicting humans, animals, plants, alphabet letters, the American flag, and many other objects (pl. 12 and fig. 3). Weavers observed the Euro-American culture around them and drew their designs from those sources. Even though these motifs are Euro-American in origin, their arrangement usually follows one of the traditional Plateau formats

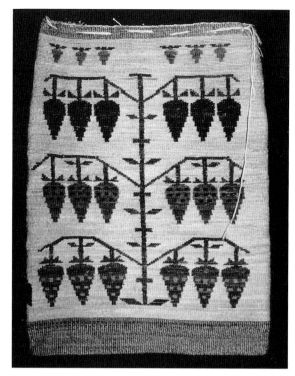

Figure 3. Pictorial flat twined bag representing a tree with fruit, Umatilla, circa 1875–1900. Indian hemp, cotton cord, cornhusk, and wool yarn; 51 cm x 39 cm. Burke Museum #2-1521. Photograph by Lynette Miller.

discussed previously. Most commonly, pictorial motifs are centrally placed or arranged in bands.

These basic design categories can convey only part of the rich diversity to be found in flat bag design. It seems that innovation and variety were watchwords for Plateau bag weavers, since no two bags are ever exactly alike. This inventive approach to design, in combination with various historical and cultural factors, makes the association of particular designs with specific Plateau tribes very difficult. The common practice of intermarriage between Plateau tribes, an extensive system of inter-tribal trading, and a lack of accurate data for most collections of historic Plateau material all contribute to the problem. At present there is no reliable rule for distinguishing the work of one Plateau tribe from that of another.

The available information does indicate that the production of flat twined bags was concentrated in the central part of the Plateau, the area where the states of Washington, Oregon, and Idaho come together. It would thus appear that the Sahaptin-speaking tribes were the primary makers of twined bags. Although flat bags were made by some of the more northerly Salishan groups, it seems quite possible that they acquired the craft from Sahaptin-speaking tribes as some scholars have suggested (Shawley 1975).

Although twined bags were primarily practical everyday objects, they also played an important role in the ritual trades held on certain ceremonial occasions. Among these, the trades associated with marriage were most significant. A marriage was not simply the union of two individuals, but the lifelong alliance of two families. The wedding trade served not only to validate the marriage, but also to solidify relationships between members of the two families.

The first trade usually took place a few months after a couple began living together. The groom's family held the first trade, hosting a feast and giving gifts to members of the bride's family. Later the bride's family held a reciprocal feast and trade. In each exchange individuals traded with their counterparts in the other family. For example, the groom's paternal aunt traded with the bride's paternal aunt. The couple themselves did not participate in the exchange. Each side served foods and gave gifts appropriate to the gender of the person being married. The groom's side gave dried fish and meat, rawhide parfleches, buckskin, buffalo robes, and sometimes horses. Cornhusk bags filled with dried roots and berries, baskets, shell bead wampum, buckskin clothing, and glass beads and beaded items were given by the bride's side. The types of goods given by each side appear to have represented the important contributions the bride and groom would each make to the welfare of their family.

Whether their use was practical or ceremonial, bags were highly valued in Plateau society. In fact, they were too valuable to discard simply because they were damaged. Some older bags have been patched with pieces of leather, or a raveling rim has been reinforced with a leather binding. In other cases, where the problem was more severe, the damaged section was cut off and the bag sewn together again to make a smaller bag. Often this type of alteration has reoriented the bag, causing originally horizontal designs to run vertically. Occasionally, bags were cut apart and reassembled to create a new object. For example, a beautiful pair of Walla Walla leggings (pl. 10) were made from a large bag which was cut down the center into two equal pieces. The cut side was seamed and leather fringe was added along the edge to complete the leggings. In another case, a flat bag was converted to a Plains-style pipe bag by the addition of a leather pouch sewn to the top and a long fringe sewn to the bottom (Museum of the American Indian, Heye Foundation 24/646).

In the period after 1875, as Plateau bags were made to fit new functions, other non-traditional forms were developed. In some instances these new objects were made for use by Plateau people themselves, while others were clearly made to accommodate non-Indian tastes and purposes. Among the items made for Indian use were Plains-style dresses with woven cornhusk yokes, men's vests of woven cornhusk, saddle bags, martingales (pl. 14), and other horse gear (pl. 13). Folded pouches, often with loops for attachment to a belt, became a common part of women's traditional dress.

Other items, such as Victorian-style wall pockets for holding mail, were probably made for sale to non-Indians. More recently, items like round purses with leather drawstring tops, cornhusk belt-buckle insets, and woven cigarette lighter covers have been made and sold to Indians and non-Indians alike. The trend toward making smaller bags has culminated in the production of miniature bags, two by three inches in size, which are worn on a cord as a necklace.

OTHER TWINED BAGS OF THE PLATEAU

Although flat bags were probably the most common type of Plateau twined basket, several other forms of twined basketry were made in the region. Among these, round or cylindrical bags and basketry caps were the most common.

Round twined bags were made by the same Plateau groups who made flat bags. They are quite common, but seem to have been made in somewhat fewer numbers than flat bags. Although the materials used to make them were usually the same, round bags were often simpler than flat bags in both technology and design. Many were woven entirely in plain twining, with a design of simple horizontal stripes created by varying the color of the materials. In other designs, simple false-embroidered motifs were scattered on a background of plain twining. In the most elaborate examples, decorative bands of false embroidery or wrapped twining were alternated with bands of plain twining. Round bags were used for most of the same purposes as flat bags.

Another type of round twined bag was made by the Wasco and Wishram tribes who lived in the area of The Dalles on the Columbia River in central Washington and Oregon states. These two closely related Chinook-speaking tribes made a type of soft basket often referred to as a "sally bag" (pl. 29). While the origin of the name is uncertain, we do know that these bags were often carried while travelling; hence it has been suggested that the name derives from the expression "to sally forth." A second explanation asserts that the term came from a well-known basket-maker named Sally whose name came to be associated with this type of basket (Shackleford 1904). Neither of these stories has been substantiated and the term remains unexplained.

Wasco-Wishram sally bags are commonly cylindrical in shape and are made in varying sizes. Large bags up to two feet in depth were used for storing supplies of dried food. These bags tend to be decorated with simple band designs. Smaller cylindrical

bags are more elaborately decorated and sometimes have attached covers. There are also some flat bags in the Wasco-Wishram style, but they are much less common than cylindrical ones. Their shape differs from that of other Plateau flat bags; they are either square or horizontally rectangular, rather than vertically rectangular.

The designs of Wasco-Wishram bags are unusual in Plateau twined basketry in that many are representational rather than geometric. Although rather abstract and stylized, they clearly represent humans and various types of animals, including fish, deer or elk, butterflies, and birds. It is unclear whether such motifs are traditional or the result of Euro-American contact in the late eighteenth or early nineteenth century. However, a Wasco-Wishram basket collected by Lewis and Clark in 1805 or 1806 (pl. 28) suggests that representational designs probably were an aboriginal tradition.

The human figures on Wasco-Wishram bags are particularly interesting because many are depicted in a "skeletalized" form. In complete human figures the rib structure is often very clearly delineated. This effect is reminiscent of the rib structure found on carved mountain sheep horn bowls (pl. 49), wooden mortars (pl. 50), and pre-historic antler carvings (pl. 77) from the Columbia River area. This similarity, along with the likeness to rock art of the Plateau region, also suggests the possible antiquity of these representational designs.

Wasco-Wishram bags are woven in wrapped twining (fig. 4). In this technique, one weft is carried along the inside of the weaving while the other weft remains on the surface. The two wefts are twisted around each other between warps. The design is created by alternating the positions of two differently colored wefts, bringing each to the surface as it is needed to form the pattern. The designs on these baskets are usually limited to two colors, often dark brown or black against a light tan background. A variety of materials including Indian hemp, cattail, and several unidentified fibers appear to have been used in these baskets.

Wrapped twining is also used in weaving the fez-shaped basketry caps worn by Plateau women. However, in caps, the technique is varied slightly. The two weft elements differ, one being more rigid than the other. The stiffer weft stays on the interior of the work, while the second, more flexible, weft wraps around it. This technique is easily distinguished from false embroidery because the design appears in its entirety on the inside of the basket.

The warps and stiffer weft used in twined hats were of Indian hemp, while the flexible outer weft which formed the background was usually bear grass. The characteristic yellow color was obtained by dyeing the bear grass with Oregon grape root bark

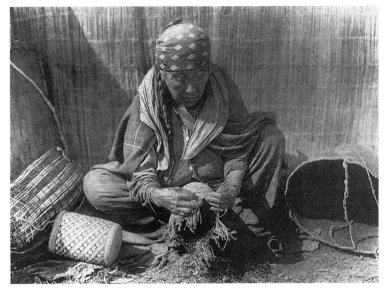

Figure 4. Basketmaker, Wishram, early 1900s. The weaver is surrounded by several types of Plateau baskets. She is weaving a twined cylindrical "sally" bag. To her right are another "sally" bag and another twined bag with widely spaced wefts. On her left lies a coiled basket. A cattail mat is hung behind her as a backdrop. Photograph by Edward S. Curtis, courtesy of Special Collections Division, University of Washington Libraries, neg. #NA 167.

(*Berberis nervosa*). Wool yarn and unidentified dark materials (perhaps cedar root bark) were used to form the designs. There are some twentieth-century hats in which cornhusk is used as the background material instead of bear grass. These hats are usually woven in false-embroidered plain twining rather than wrapped twining. The change in technique indicates that the weaver has borrowed both the material and technology from flat-bag weaving.

Hat designs follow a rather restricted pattern. The design usually consists of a horizontal band of either zigzags (pl. 41) or triangles (pl. 42). These two designs might be regarded as a reversal of one another, with the negative space of one being the design area of the other. Designs nearly always consist of a set of three parts: either three complete zigzags or three pairs of triangles, half of which are attached to the top band and half to the bottom. There are a few unusual examples with a four-part design.

Basketry caps were worn primarily by women, although at least one report mentions a cap worn by an elderly man (Shawley 1975:209). Caps have been associated with the root harvest. The ritual gathering of the first roots was led by a senior woman wearing a basketry cap (Schuster 1975, vol. 2:433). Caps are also worn as part of traditional Plateau women's dress at powwows. It seems likely that in this context the basketry cap serves to assert and maintain Plateau cultural identity.

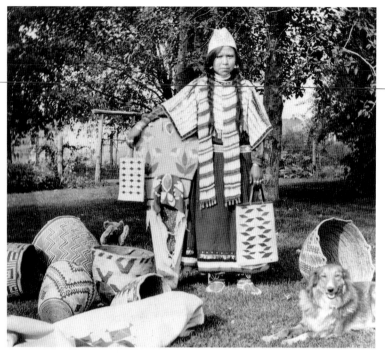

Figure 5. Laxslii Cloud, Yakima, 1909. This young woman is displaying different types of Plateau baskets. On the ground are large coiled baskets with elaborate imbricated designs. She holds a flat twined bag in each hand and wears a twined basketry hat. Burke Museum Archives neg. #2.4L197.

PLATEAU COILED BASKETRY

The basketry discussed thus far has all been twined. Now let us turn to coiling, the second commonly used basketry technique on the Plateau. By contrast with the twined baskets just discussed, coiled baskets are rigid rather than flexible. This feature made them particularly suited for certain functions. They were commonly used in food gathering and storage, especially for foods like soft berries which required a protective container. They were also widely used as cooking vessels. Mush or stew was put into large baskets with rocks which had been heated in the fire. Newly heated rocks were added until the food was cooked.

In coiled baskets, a continuous foundation coil is wrapped and sewn with a second element. An awl is used to pierce a hole in the coil for the sewing element to pass through. The coil may consist of a bundle of materials, a few rods, or a single slat.

In the Plateau region, coiled basketry is decorated by imbrication. In this technique a separate decorative element is folded and held parallel to the coil. The stitch which wraps around the coil is then used to catch the folded edge of the imbrication material. The decorative material is then folded back over the stitch, and the process is repeated. The

imbrication completely covers the stitches and forms rows of small rectangles. Imbrication may be used to form scattered designs or may cover the entire surface of the basket.

Coiled and imbricated basketry was made in two separate areas of the Plateau. In the southern Plateau, coiled baskets were made by Sahaptin-speaking people living along the Columbia River in present-day Washington State, while in the north they were made by Salishan-speaking tribes along the Thompson and Fraser river systems in British Columbia. Although the technique was nearly the same in both areas, the baskets themselves differed in shape and design.

Southern Plateau coiled baskets are often referred to as "Klickitat" baskets in reference to the tribe with which they are most closely associated. However, the coiled baskets of the neighboring Yakima, Nez Perce, and others were very similar (fig. 5). Older baskets from this area were oblong in shape (pl. 31), while later baskets were usually cylindrical, with a relatively small base and flaring sides (pl. 32). Small looped projections, or "ears," were used to finish the rim. A similar construction was sometimes used within the body of a basket to create an open-work effect.

The foundation coil in southern Plateau baskets was usually a bundle of finely split cedar roots, with a flat cedar root splint used as the stitching material. Cedar root bark, bear grass, cherry bark, and the skin of horsetail rhizomes were among the materials used for decorative imbrication. They were used either in their natural colors or dyed with various natural materials. The colors of Klickitat baskets were usually tan, brown, black, red-brown, and yellow. There has been almost no change in the materials used in Plateau coiled basketry.

Imbricated designs on Klickitat-style baskets were often quite elaborate and covered the entire surface of the basket. The designs are varied in format, with zigzags and horizontal or vertical bands of geometric forms being most common. Stylized representations of human beings and animals are also found on some baskets. A basket collected by Captain Belcher in 1839 includes a row of human figures on one side of the basket (pl. 30).

In construction and materials, Plateau coiled baskets are quite similar to coiled basketry made along the coast of western Washington. However, the shapes of the baskets and the designs used to decorate them differ in the two areas. Coiled baskets from western Washington are typically oval, rather than cylindrical, and are often slightly constricted at the rim. In addition, they usually do not have looped rim projections as Klickitat baskets do. The designs found on baskets from the two areas can be quite similar, consisting of zigzags and bands. Those from western Washington seem rather delicate by compari-

son with the larger and bolder designs used by the tribes further east.

Coiled and imbricated basketry was also made by tribes living along the Thompson and Fraser rivers in the interior of southern British Columbia. These northern Plateau baskets differ substantively in shape and design from those made in the south. Globular and rectangular shapes were the most common of a wide variety of basket types made in this area. Rectangular shapes were either flared or straight-sided; the latter were often fitted with lids.

The construction of northern coiled baskets was similar to that of southern baskets. A foundation coil of split cedar root, with split cedar root stitching, was typical. In large rectangular baskets a flat splint or slat of cedar was often substituted for the bundle. These baskets are distinctive for their flattened coils.

Imbrication was the typical decoration on northern coiled baskets. It was usually used only to create the design, with the coiled structure of the basket serving as a background. Designs were primarily geometric, with relatively little use of representational motifs. The decorative materials and colors used in southern baskets were also found in the north. Cherry bark, horsetail root, bear grass, and other grasses were widely used.

PLATEAU MATS

Matting is the final type of Plateau basketry to be considered. Both tule (*Scirpus acutus*) and cattail (*Typha latifolia*) were used in mat-making throughout the Pacific Northwest. Plateau people most commonly used tules for mats, since tules were longer than cattails, permitting the construction of the larger mats needed to cover mat lodges. This structure and the technique used to make tule mats are discussed elsewhere in this volume (see Sampson, this volume).

Cattail mats were made by sewing the leaves together just as tule mats were made. Instead of a stick, a band of plaited cattail was attached to the short sides of the mat. On the long sides of the mat, the ends of the cattails were woven together to form a finished edge.

SUMMARY

In summary, we see that basketry produced by the Native American inhabitants of the Plateau was of two basic technical types: imbricated coiling and twining in several variations. These different techniques, combined with the use of different materials, produced two distinctive types of Plateau baskets. Coiled basketry was tightly stitched of stiff materials, resulting in a hard, rigid container. These baskets were used for cooking food and storage. Twined baskets were also tightly woven, but of more pliant materials. These baskets, bags, and hats were therefore quite soft and flexible, yet strong. They were used primarily for the storage of food supplies and personal belongings. The distinction between the two styles has remained intact, in spite of the extensive use of commercial Euro-American materials in twined basketry. By contrast, Euro-American influence seems to have had relatively little effect on the coiled basketry of eastern Washington. Its design and materials have remained quite traditional in comparison to those found in Plateau twining. Basket-makers who make coiled baskets today use basically the same materials and designs found in much earlier baskets (pl. 94). Although some twined baskets are now made in traditional materials and designs, these are a revival rather than a continuation of the earlier style. The changes of the late nineteenth and early twentieth centuries continue in the twined baskets of today.

Basket-making is part of a rich and distinctive Plateau tradition. Whether the craft has retained its traditional forms or changed to accommodate new influences, the spirit and ingenuity of the weaver have endured, endowing each basket with its own particular beauty.

REFERENCES

Schuster, Helen Hersh. 1975. Yakima Indian Traditionalism: A Study in Continuity and Change. Ph.D. diss., University of Washington, Seattle.

Shackelford, R.S. 1904. The Wasco Sally Bag. *Sunset*, Jan. 1904, p. 259.

Shawley, Steven Douglas. 1974. Nez Perce Dress: A Study in Cultural Change. M.A. thesis, University of Idaho.

_____. 1975. Hemp and Cornhusk Bags of the Plateau Indians. *Indian America* 9(1):26.

Tokle, John F. 1970. Motif Categorization of Idaho Indian Mythology. M.A. thesis, University of Idaho.

TULE MAT-MAKING:
A YAKIMA TRADITION

Amelia Sohappy Sampson

Amelia Sohappy Sampson is a Yakima mat-maker from Wapato, Washington. She made many of the tule mats used in constructing the mat lodge on display in the museum of the Yakima Nation Cultural Center in Toppenish, Washington.

Our thanks to Lynette Miller for her work in compiling this article.

The architecture of Plateau people was based on the common tule or bulrush (*Scirpus acutus*). A deceptively weak-looking plant, which grows abundantly in marshy areas, the tule was made into mats used not only in the construction of traditional Plateau lodges, but also for a variety of other purposes.

Amelia Sohappy Sampson learned to make tule mats in the traditional way from her grandmother. As a child of nine or ten she began to watch as her grandmother worked and then tried to imitate what her grandmother did. Her questions were answered with the suggestion that she watch more carefully. Sometimes her grandmother gave her a few spare pieces of materials to work with, and when she made a mistake she was corrected.

Most Plateau women learned to make tule mats, which were used in quantity by every Plateau family. Although men usually built the mat lodges, only women made mats. Today there are relatively few mat-makers, most of them older women. Like many other traditional Native American crafts, mat-making is a time-consuming process which is not widely practiced today. Many younger women either do not have the time to make mats or are not interested in making them.

Mat-making has also been inhibited by an increasing scarcity of tule rushes. Modern agri-cultural expansion, the draining of marsh areas, and roadside spraying of herbicides have all had an effect on the availability of tules. Areas which the farmer regards as a wasteland of weeds are often the same areas where native foods and raw materials were traditionally gathered. Mrs. Sampson says of the people who unthinkingly destroy such areas, "They don't know what they do to us." The effect of these actions is felt in the decline of traditional crafts.

Mat-making begins with gathering the necessary materials (fig. 1). Tules are collected in the late summer or early fall when the plants are mature. The plants are cut off near the base and must be dried before they can be used. Medium-sized and small stems are preferred to the larger stems which do not work as well. The tules must not be bent when they are gathered or dried, or they will not be usable. After the materials are completely dry, they can be stored for several years before they are used. When the mat-maker is ready to begin work, she sorts her materials by size and trims them to an even length. The tules are then moistened with water and allowed to become uniformly damp overnight.

The tules are laid out side by side in small groups of two, three, or four stems. These groups alternate directions, with the bases of one group placed next to the tops of another group. This arrangement helps to equalize the size difference between the top and bottom of the tule. A row of plain twining is woven along one end of the arranged stems, forming one long side of the mat. A willow stick is attached parallel to the tules at each short end. These willow sticks strengthen the mat and help prevent it from bending when it is rolled.

After the tules are arranged, they are sewn together using a narrow, flat, wooden needle about

six inches long. The sewing is done in parallel rows, approximately four inches apart, running the length of the mat and piercing each stem. The sewing cord is continuous, looping around the willow stick at each end before being returned through the tules. After the rows of sewing are done, the mat is finished with another row of plain twining. The ends of the tules at the edges of the mat are usually evenly trimmed, forming a straight edge. A more decorative border is sometimes made by cutting the small groups of tules in different lengths to form a stepped pattern along the edges of the mat.

The cord traditionally used to sew mats was spun from fibers obtained from the stem of *Apocynum cannabinum*, commonly called Indian hemp. In more recent times, various manufactured cords such as baling twine and cotton hop-tying twine have been used. Today, most mat-makers use commercially produced cotton or synthetic cord for sewing their mats.

Mats were made in a variety of sizes appropriate for different purposes. The mat-maker planned the mat's size based on its intended function. Mats varied in width from about three to seven feet and measured as much as twelve feet in length. Smaller mats were more likely to be used for holding food, while the larger ones were intended to cover the exterior of the mat lodge.

Mats were used in processing a variety of foods. Meat, fish, roots, and berries were gathered and spread on tule mats to dry in the sun. Today, baskets of prepared foods, ready for serving, are set out on tule mats in the Longhouse.

The traditional Plateau winter lodge consisted of a framework of poles covered with large tule mats. The floor of the lodge was formed by a pit dug several feet below the surface of the ground, helping to insulate the structure. The pole framework was constructed in much the same way as Plains tipis were made, but the typical cone shape of the tipi was usually extended to create a large, communal, A-framed lodge. Lewis and Clark reported seeing a lodge of this type which was 150 feet long and housed about 50 families, but lodges more typically measured between 20 and 70 feet in length. A Wanapam winter village included lodges of several different sizes (fig. 2).

The wooden framework of the lodge was covered with two or three layers of tule mats (fig. 3). The layers of pithy rushes provided excellent insulation from both heat and cold. Inside the lodge, mats were used on the floor and also covered the door opening. Although it has been reported that mats were used for sleeping, Mrs. Sampson instead recalls using loose piles of cattails as bedding.

While mat lodges are rare today, tule mats are still a vital part of Plateau life. A few are made for

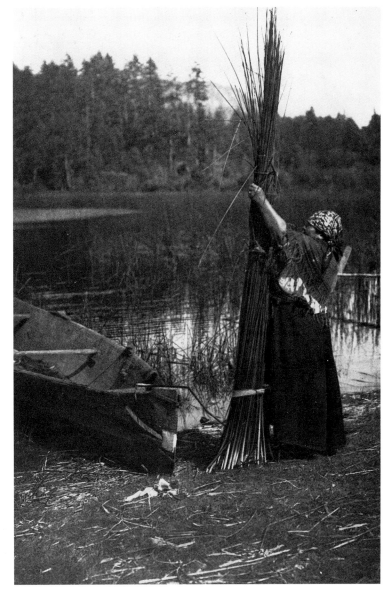

Figure 1. Cowichan woman gathering tule rushes, British Columbia, circa 1910. People throughout the Northwest gathered and used tules for making mats. Photograph by Edward S. Curtis, courtesy of Special Collections Division, University of Washington Libraries, neg. #NA 267.

Figure 2. Tule mat lodges in Wanapam winter village, Priest Rapids, Washington, circa 1941. Photograph courtesy of Special Collections Division, University of Washington Libraries, neg. #NA706.

Figure 3. Detail of tule mat lodge. Yakima Nation Cultural Center, Toppenish, Washington. Photograph 1988, by Lynette Miller.

sale, but most are made for use within the Native American community. Mats are used in the Longhouse as a part of traditional religious services. They are also fundamental to traditional Plateau burials.

Although mat lodges are no longer in daily use on the Plateau, occasionally they are part of museum exhibitions on traditional Plateau life. These reconstructions, along with the images of lodges found in historic photographs, offer glimpses of an architectural form which is both beautiful and practical.

BEADWORK ON THE PLATEAU

Kate Duncan

Bright and bold, beadwork has been important to Plateau peoples for nearly two centuries. When Lewis and Clark encountered Native people along the cascades of the Columbia River in 1805, blue and white beads were much sought after and already held an established place in commerce. Clark reported that the people of the Columbia would trade nearly anything they had for beads, which were in turn traded to tribes farther up the river for skins, beargrass, roots, and other goods. Beads were used for personal ornament; blue ones were the most coveted. Higher class people wore "many strands of beads...drawn tight around the leg above the ankle" and used "blue beads threaded & hung from different parts of their *ears* and about their neck and around their wrists...." (DeVoto 1953: 290).

These early glass beads were large ones 7 mm or more in diameter, now called necklace beads, and smaller ones 3 mm to 4 mm in diameter, now called pony beads. Both were European-made and came into the country via the fur trade. As beads became more available in the nineteenth century, women of the Columbia River and Plateau used them not only for personal adornment, but also on garments, particularly dresses. When the tiny cut beads and seed beads (1 mm to 2 mm in diameter) became abundant several decades into the century, these also were applied to clothing—shirts, leggings, moccasins, gloves, and dresses—and to other important objects such as bags, cradles, and horsegear.

Some time after the mid-nineteenth century, Plateau beadwork literally "flowered" as women began to bead striking semifoliate arrangements on bags. By late in the century floral work dominated on a number of items, and the outlined, loosely floral motifs of earlier years had given way to solidly beaded, more identifiably floral ones. At the end of the century the flowers, sometimes realistic, sometimes fantastic, were augmented by animals and landscape scenes, especially on bags. At the same time, particularly in the eastern Plateau, women also worked in the geometric Transmontane style (see Loeb, this volume) and with other geometric patterns related to designs on flat, twined root bags.

The Plateau beadworker was acutely aware of the visual impact of color. In the geometric Transmontane style this involved a subtle, ambiguous optical interplay between background and foreground, using colors predominantly of the same value, especially pinks and aquas. In floral work it was the bold statement that could be made with sharp contrasts. A few large motifs in bright colors, often the primaries plus green, stand stately against a brilliant solid backdrop.

When Plateau people first acquired glass beads, they used them for personal adornment in ways such as those observed by Lewis and Clark. European-made glass beads joined an already established but limited tradition of Native-made beads of stone, bone, and shell. By the nineteenth century both men and women wore neck, hair, and ear ornaments of glass necklace and/or pony beads, usually combined with dentalium (haiqua) shells obtained in trade from the Northwest Coast. Both beads and dentalium shells were very valuable in those early years and were used for a time as a medium of exchange. One literally wore one's wealth.

Formerly assistant professor at Seattle University, Kate Duncan is now assistant professor in the School of Art at Arizona State University.

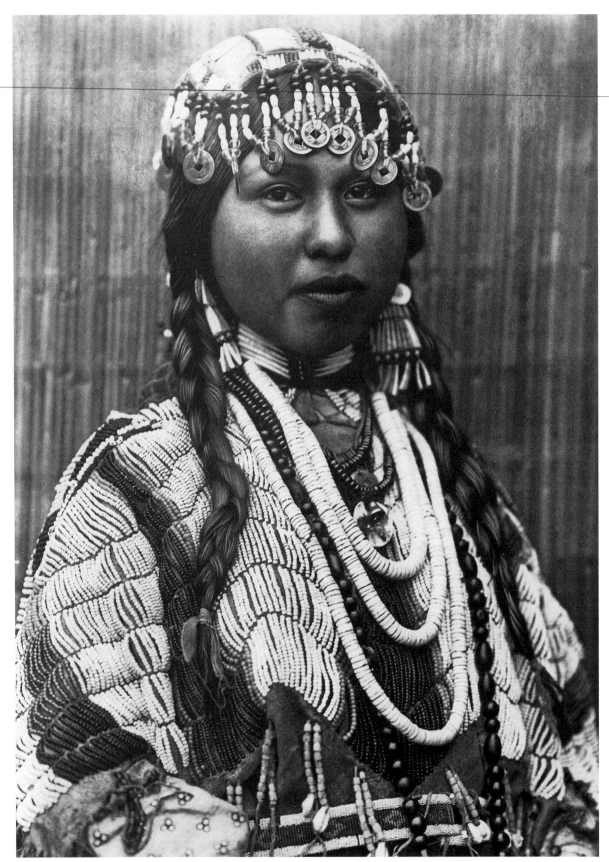

Figure 1. "Wishham Bride," taken by Edward S. Curtis in 1910. This woman wears the dentalium-shell headdress worn by young Wishram and Wasco women, and the beaded jewelry and two-tail dress worn by women throughout the Plateau. Photograph courtesy of Special Collections Division, University of Washington Libraries, neg. #NA 214.

As elsewhere on the continent, blue, white, black, and red were the most common early bead colors. With them, the Plateau woman created elegant rhythmic syncopations by countering differing-width bands of colored beads with bands of the white horn-shaped dentalium shells, tightly interlocking bands of texture within a grid of opposing bands of color. The most elaborate article constructed in this manner was the veil that was worn by a young woman at the time she reached womanhood and became marriageable (fig. 1; pl. 44).

Pony and necklace beads were also used on the Plateau two-tail dress (pl. 6). Women on both the Plateau and Plains wore the two-tail dress, a garment constructed of two deer or mountain sheep hides turned tail up, then folded down a few inches front and back to create straight shoulder seams. The edge of the skin itself with the haunches and tail formed an undulating contour which was formally echoed by a broad band of ornament applied across the upper front and back of the garment. In contrast to the solidly seed-beaded yokes of Plains dresses of the nineteenth century, Plateau beadworkers preferred the larger pony or necklace beads during this period, massing them in two heavy waves of wide lazy-stitch bands across the front and back. In some cases, seed beads were used for the yoke and larger beads for the fringes. In one of the two most popular Plateau configurations, a broad solid-colored background is interrupted at intervals by bold vertical triangular or rectangular blocks of one or more contrasting colors. Another style features repeated horizontal stripes created when a different color is used for each lazy-stitch band. Sometimes the two styles are combined.

Pony beads were also applied to men's shirts and leggings (pl. 8, 9), often to form large repeated geometric blocks similar to those of earlier quill-ornamented examples, and sometimes were combined with quillwork (see Loeb, this volume).

Evidence from Fort Vancouver on the Columbia River indicates that seed beads and cut beads were present there during the second quarter of the nineteenth century, particularly among the community of French-Canadian voyageurs who lived there with their Native wives. By the last decades of the century, however, seed beads were readily available to women of the entire Plateau and it is then that they became a favorite medium for the ornamentation of clothing items such as flat bags, leggings, moccasins, gloves, vests and, early in the twentieth century, the two-tail dress.

Nineteenth-century Plateau women eagerly embraced the artistic potential of seed beads and floral designs, and almost immediately developed their own distinctive styles. Floral beadwork from tribes of the central Subarctic and greater Great Lakes appears to have provided the initial stimulus for floral work in the Plateau. When Plateau women first began sewing with seed beads, they sometimes experimented with floral designs related to those they had seen on the treasured firebags and shot pouches belonging to men who had moved west into the Plateau in the nineteenth century with the fur trade. Some were Cree, Ojibwa, Iroquois, or Metis men; others were Canadian voyageurs married to women of these tribes.[1]

At mid-century the earliest Plateau floral style emerged, used for moccasins and particularly for a type of round-bottomed bag (pl. 20). The bag was used by men for carrying personal effects (flint and steel with which to start a fire, tobacco, and later, shot), and was worn as a prestige item on dress occasions (Gogol 1985). These early bags are curved on the bottom and taper slightly toward a straight top. They are usually made of red wool, but occasionally of hide, and are beaded on one or both sides. Designs are bold, symmetrical, semifloral arrangements typically composed of a stem and a few prominent motifs placed against a solid-colored background. Motifs include loosely organic rosettes, hearts, and teardrop shapes which function as blossoms, buds, and leaves. They are usually outlined with one or two narrow rows of one or more colors, then left open or beaded-in solidly. On the earliest bags the hide or wool forms the background. On later ones the background is filled in with beadwork.

Floral motifs were sewn using the couching technique (also called overlay or spot stitch). With it the beadworker can create curved as well as straight lines. Beads are first strung on one thread, then, with a second thread, a stitch is taken between every two or so beads, securing the stringing thread to the surface. Beads usually follow the contour of the motif; normally, the beadworker outlines a form, then beads inward, laying a new row of beads against the previous one. A solidly beaded background may be beaded in straight lines or in sections following the contours of various edges of the motifs.

In the last decades of the nineteenth century, a more elaborate Plateau style emerged. It was used especially on women's flat bags which, by the 1880s and the reservation period, had joined cornhusk bags as items to be carried on dress occasions and exchanged in trade and gift giving (pl. 21 and see Miller, this volume). Once beads became plentiful, the flat bag became an important canvas for the Plateau bead designer. Most beaded bags incorporated floral designs, and beadworkers expanded their repertoires, enthusiastically exploring the possibilities of more detailed and realistic floral forms, from those surrounding them in the Euro-American culture to fantastic flowers created from imagination. Flowers from greeting cards, transfer patterns, and fabric all

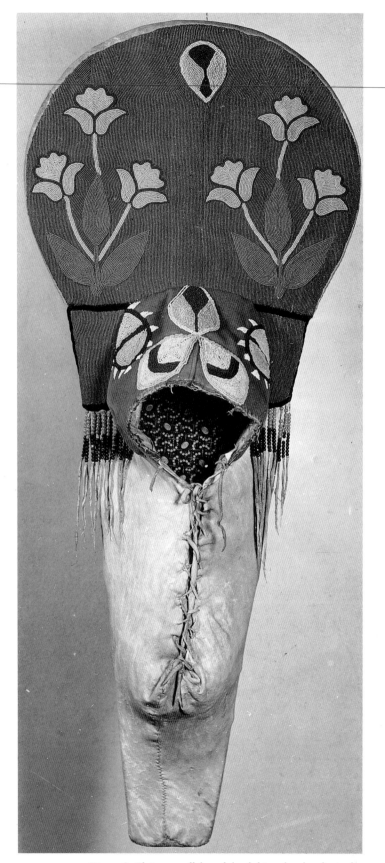

Figure 2. Plateau cradleboard; buckskin, glass beads, trade cloth, wood; 125 cm x 41.5 cm. Collected on the Yakima Reservation, received from Mrs. Paul D. Moran, 1932. Burke Museum #2-502.

provided inspiration for bag designs. Flat bags from this period are usually rectangular and beaded solidly on only one side.

Animal life is not common in Native American beadwork, except on the Plateau, where horses, deer, elk, cougars, bears, and birds often appear on flat bags (pl. 24). One popular configuration at the turn of the century featured a solid background on which a pony or deer is framed by an arbor of blossoms. More recently, trees and geographic landmarks have been added to create a landscape through which animals move. The American eagle and flag have been popular for some years on bags as well as on entire outfits of matching garments and on horsegear designed for parade display. Today other motifs such as cartoon characters have joined the ever-popular floral designs.

Many other traditional articles, such as the large upper back board typical of many Plateau cradles, were embellished with beadwork. Early cradles (pl. 7) were often beaded in geometric bands similar to those on women's dresses. Late nineteenth-century cradles were often beaded florally, in an asymmetrical tripartite layout of a few large, multicolored flowers and/or leaves, cheerful and bold against a solid backdrop (fig. 2). The child was laced into a plain or minimally decorated pouch of soft, tanned hide. On flat items like cradleboards, the background is almost always solidly beaded in a single color, either by working in straight, horizontal lines or by outlining each motif several times in the background color then filling in the remaining spaces. As on flat bags handled in the same way, a linear background becomes a stately backdrop, a contoured one a gentle organic echo.

In the late nineteenth century, as today, beaded vests, gloves with wide cuffs (gauntlets), and wide cuffs alone were important dress attire for men on the Plateau. Moccasins (fig. 3) were important for all. When floral designs were used on these items, they were most often symmetrical and composed of a few large blossoms and leaves against a solid ground. In general, earlier examples were more semifloral than later ones.

On gloves (fig. 4), the most common arrangement places three prominent blossoms and their leaves on the gauntlet and a single motif on the back of the hand. At times the hand is left plain. The hide may provide the background on both hand and cuff, or the cuff area may be solidly beaded. Plateau women also sometimes used embroidery floss when ornamenting gloves.

Beaded leggings (pl. 22) and moccasins also continue to be very important. Women's leggings of red or navy wool beaded with bold contrasting floral patterns are among the most colorful of late nineteenth-century Plateau beadwork. The side-seam

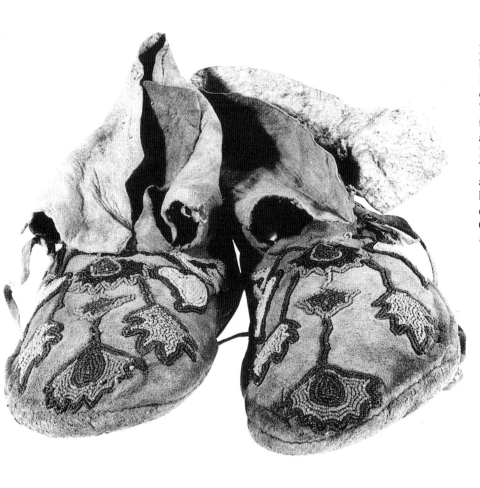

Figure 3. Beaded moccasins; buckskin and glass beads; 24.5 cm. These moccasins came to the Otago Museum in 1939 along with a collection of other objects said to have belonged to Chief Moses (See Wright, Introduction, this volume). They are from the collection of Sir Percy P. R. Sargood, who had acquired them in Portland after their display at the Lewis and Clark Centennial Exposition in 1905. The label indicates that these moccasins were acquired from Chris Miller, a north Yakima storekeeper, and that they belonged to Chief Moses's daughter, Cathrene. Photograph courtesy of the Otago Museum, Dunedin, New Zealand #D43.198.

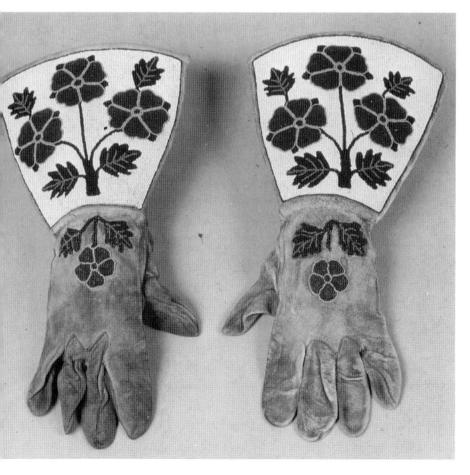

Figure 4. Beaded men's gauntlets, 36 cm x 20 cm; buckskin, glass beads. Collected on the Yakima Reservation from Sadie Olney by Mrs. L. J. Goodrich in 1904; received from Mrs. Paul D. Moran, 1932. Burke Museum #2-374.

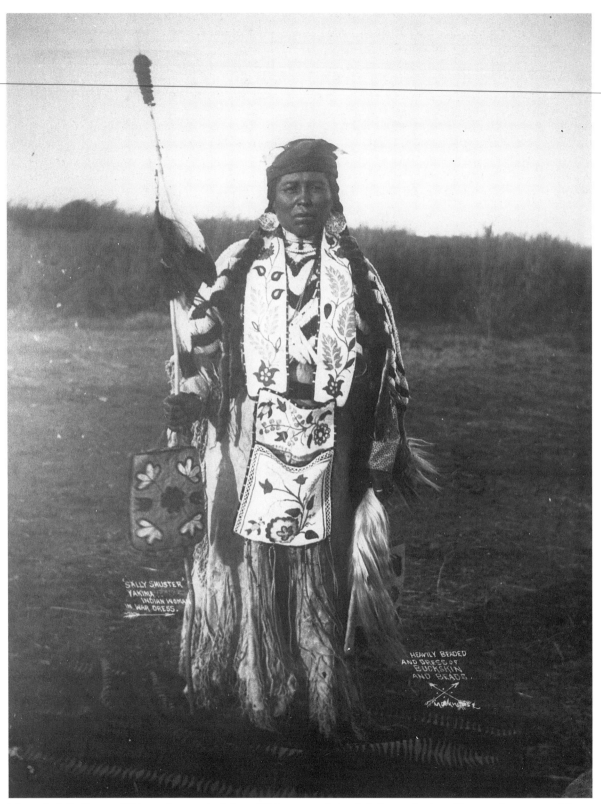

Figure 5. Sally Shuster, Yakima, photographed about 1900 by Moorehouse. She wears a heavily beaded two-tail dress, a beaded Ojibwa-style bandoleer bag, and carries an earlier style beaded Plateau flat bag. Photograph courtesy of the National Anthropological Archives, Smithsonian Institution, neg. #2880-C-10.

194

moccasin is the most common Plateau type. Its construction, from a single piece of tanned hide folded and seamed along one side to cover the foot, produces a broad frontal area available for decoration. Again, the popular tripartite arrangement of bold blossoms and leaves beaded against a solid hide ground is typical (fig. 3). Today women often wear solidly beaded side-seam moccasins with an attached high cuff, elegantly beaded. Plateau women also have made Cree-cut moccasins with a central toe seam and a small inserted tongue, beading the tongue or, more often, both the tongue and the moccasin front.

In the early twentieth century, as the broad yokes of two-tail dresses began to be beaded with seed beads, some of them also blossomed with roses, morning glories, and other flowers. Today, separate beaded yokes are sometimes worn over fabric dresses or shawls, and geometric designs are as common as floral ones.

Woven beadwork constitutes a small but important category of Plateau work that can be traced to the period when Plateau people first began creating floral designs. Plateau woven beadwork is found on octopus bags, panel bags, and small pouches constructed entirely of beads. Both the octopus bag, named in reference to the four pairs of long tabs, and the panel bag—a fabric pouch with a single woven-beaded panel hanging at the bottom—were used by Algonkian-speaking peoples of the upper Great Lakes region by at least the 1760s. Both bag forms spread west, with Cree and possibly with Ojibwa speakers involved in the fur trade, to the Plains and Plateau at mid-century and later to the Tlingit of the Northwest Coast.[2] On the Plateau both bag types were made for a short time beginning in the 1840s, primarily by the Wasco-Wishram women of the Columbia River.

Occasionally conventional fabric octopus bags were made on the Plateau, but the bead-woven octopus bag (pl. 26) of the Wasco-Wishram is unique to the region. The woven bags consist of a pouch, usually unlined, with four single tabs or pairs of tabs hanging free. The pouch section of the bag is constructed tubularly, without a frame, using a technique similar to the twining used in making root

bags. The beads are strung in groups on a double weft that passes on either side of vertical warp threads. The designs on these woven bags are figural compositions of angular, stylized eagles, deer, and humans, and geometric patterns of triangles and plain and articulated diamonds—all motifs found on Columbia River Wasco-Wishram twined fiber bags. The motifs are formed most often in red plus blue or green, against a white ground.

The same basketry motifs in the same color scheme also appear on the woven panel of a rare Plateau panel bag (pl. 27). As on most of the early nineteenth-century panel bags from the Upper Great Lakes (Phillips 1984), the pouch of this 1840s Plateau panel bag is made of red wool on which a few cursory motifs are outlined.

The third type of woven-beadwork bag, a small pouch usually finished at the bottom with a series of bead-strung loops, was made later in the century (pl. 25). From this later period there are also several pouches and panel bags which feature birds and flowers similar to those on commercial cross-stitch and needlepoint patterns. This type of woven beadwork was popular almost solely in the Wasco-Wishram region and ceased at about the turn of the century. In the 1920s a type of bead weaving using a board frame was introduced to the girls at the boarding school at Fort Simcoe on the Yakima Reservation by a woman who "came from the east" to teach (Gogol 1985).

Beadwork, some using geometric patterning, some in the lively Plateau floral tradition, continues to be important today. Flat bags, moccasins, and dress clothing are particularly important for dress occasions. Pendants, earrings, and barrettes are made for sale as well as for personal use. Arm bands, hair ties, dress yokes, suspenders, gauntlets, and headbands are made to wear at powwows and on dress occasions. Whether floral or geometric in style, the beadworker continues to enjoy bold—even flamboyant—forms, bright colors, and forceful contrasts, continuing the long-established Plateau tradition of presenting her family in the finest ornament.

Notes

1. The brigade that accompanied Ross Cox when he departed Astoria on April 16, 1817, reflected the variety of peoples involved in the trade at that time. "Our party consisted of eighty-six souls, and was perhaps the largest and most mixed that ever ascended the Columbia. With it were five Scotchmen, two English, and one Irish; thirty-six Canadians, twenty Iroquois Indians, two Nipisings [Chippewa], one Cree, and three half-breeds; nine natives of the Sandwich Islands; with one boy, a servant, two women and two children." (Cox 1831, vol. 2: 66)

2. In 1841, Lieutenant Charles Wilkes (1845: 370) described the voyageurs at Fort Vancouver as wearing the usual "tobacco and fire pouch...worked prettily in beads. The simple bag does not, however, afford sufficient scope for ornament, and it has usually several long tails to it...." These were surely octopus bags. Particularly popular among Cree- (and to a lesser degree Ojibwa-) speakers of the Upper Great Lakes and the Red River area, the octopus bags which Wilkes saw at Fort Vancouver were probably made by Cree or Cree-Metis wives originally from these regions (see parish marriage and baptismal records for the fort, in Nichols 1941). Plateau women shared friendships and ideas with these women, and some made bags in this newly introduced form.

References

Conn, Richard. 1986. *A Persistent Vision: Art of the Reservation Days.* Denver: Denver Art Museum.

Cox, Ross. 1831. *Adventures on the Columbia River, Including the Narrative of a Residence of Six Years on the Western Side of the Rocky Mountains Among Various Tribes of Indians Hitherto Unknown, Together with a Journey Across the American Continent.* London: Henry Coburn and Richard Bentley.

DeVoto, Bernard (ed.). 1953. *The Journals of Lewis and Clark.* Boston: Houghton Mifflin Co.

Gogol, John M. 1985. Columbia River/Plateau Indian Beadwork. Part I: Yakima, Warm Springs, Umatilla, Nez Perce. *American Indian Basketry* 5(2): 3–28.

Nichols, Marie Leona. 1941. *Mantle of Elias.* Portland: Binfords and Mort.

Phillips, Ruth. 1984. *Patterns of Power, the Jasper Grant Collection and Great Lakes Art of the Early Nineteenth Century.* Kleinburg, Ontario: The McMichael Canadian Collection.

Quimby, George. 1977. Women on the Lower Columbia River in the Early Nineteenth Century. Anthropological Papers, University of Michigan, no. 61, *For the Director: Research Essays in Honor of James B. Griffin*, pp 230–41.

Schlick, Mary, and Kate Duncan. 1989. "Wasco-Wishram Woven Beadwork: Merging Artistic Traditions." Unpublished paper [contact author].

Warren, Esther. 1977. *The Columbia Gorge Story.* The Dalles, Oregon: Itemiser-Observer Press.

Wilkes, Charles, U.S.N. 1845. *Narrative of the United States Exploring Expedition*, Vol. 4. Philadelphia: Lee and Blanchard. (Republished 1970, Upper Saddle River, New Jersey: Gregg Press.)

DRESS ME IN COLOR:
TRANSMONTANE BEADING

Barbara Loeb

The colorful Transmontane style[1] thrived in the late nineteenth century when women all over the Plains and Plateau were exploring new beading designs. The art form uses large diamonds, hourglasses, and other simple geometric shapes with straight edges. Light blue or pink fills backgrounds, and single strands of white beads or wider borders of dark blue crisply outline the main motifs and add extra pizazz to color combinations (fig. 1). Vivid red wool provides visual intensity, and long fine fringe often contributes the final embellishment, swinging with the movement of the wearer and adding a kinetic touch. Most art works in this mode are made with glass seed beads approximately 1 mm to 2 mm in diameter, but a few are done in the slightly larger pony beads approximately 3 mm to 4 mm in diameter, popular in the early 1800s. This suggests that the Transmontane designs may have developed by 1850 or earlier, which would make the style an important forerunner in beadwork. By 1910, new fashions predominated and the Transmontane motifs waned, but admiration for the genre has continued unabated.

Transmontane designers appear to have included the Crow of the Plains; several Plateau tribes, especially the Nez Perce, Cayuse, and Flathead; and a small number of Great Basin people. This means the art extended west from central Montana, across Idaho and Utah, to eastern Washington and Oregon (Loeb 1980, 1983, 1984).

Among Plateau groups this fashion would have spread easily, for these peoples recognized few tribal boundaries, intermarried often, and sent many possessions from one area to another at marriages, deaths, and other major events. Beadwork was sometimes among the items exchanged. However, if Plateau and Plains people were to share these aesthetic concepts, the Transmontane artform had to leap both the physical barrier of the Rocky Mountains and the cultural boundaries that exist naturally between distinct societies.

One bridge connecting the two regions was the friendship between Nez Perce and Crow. Members of these tribes were observed travelling and trading together by a number of nineteenth-century European explorers. Other early visitors mentioned Nez Perce crossing the Rockies to hunt with the Crow, an enterprise that could have involved lengthy stays on the Plains. Today, Crow still refer to that old friendship. The similarity in their art suggests that the two groups shared ideas willingly and identified with each other visually. In that sense, the Nez Perce–Crow friendship resembles the alliance between the Sioux, Cheyenne, and Arapaho of the central Plains.

The type of object adorned helps to distinguish Plateau from Crow beadwork. Certain pieces, such as lance cases and six-strap cradles, were owned almost exclusively by Crow while others, such as gun cases, otter skin quivers, bandoleer bags, blanket strips, saddle drapes, and a different cradle, belong primarily to the Plateau. The Plateau pieces are described below.

The **Transmontane gun case** (fig. 2), traditionally owned by men, represents only one of many types made by tribes all over the West. The distinctive Transmontane version has one design on the barrel and a second on the stock; many other types use the same composition for both. Other Plateau traits include long strips of red and blue wool that edge the barrel and sections of vermilion wool within the stock decoration.

Barbara Loeb is Assistant Professor of Art History at Oregon State University in Corvallis, Oregon.

Figure 1. Transmontane-style bandoleer bag; 114.5 cm x 47 cm; buckskin, glass beads, trade cloth, brass bells; Honnen collection. (See detail, p. 2.) Photograph by Paul Macapia and Ray Fowler

The maker covered the narrow end of the gun case with solid beading that she stitched onto a separate piece of hide, folded around the end of the case, and sewed closed. This type of decoration often exemplifies a "visual pun" because the designer started with an element such as a large diamond that becomes two triangles when folded in half. These half images look complete in themselves.

Fringe adds texture and movement to the cases. That at the end of the stock is short and broad, and moves only slightly, but the fringe along the barrel is long, fine, and twisted, and it contributes a wavy pattern and swings easily. Men held the cases out to their sides, so the lenthy strands moved freely but did not touch the ground or become entangled with other gear.

Otter skin quivers, made from three otter skins, are spectacular combinations that include cylindrical arrow and bow containers, several pieces of beading, and copious fur (pl. 18). The quiver hangs down the back from a wide strap slung over the wearer's shoulder. Like gun cases, quivers were primarily men's gear.

To make these quivers, women beaded six different surfaces: two long, triangular flaps, two sleeves that were rolled into cylinders, and two smaller, tube-shaped tabs (Holm 1981). In typical Transmontane fashion, the beader created different designs, one each for the flaps, the sleeves, and the tabs. The many parts of the quiver jut from the wearer's body at slightly different angles, creating a three-dimensional, sculptural quality rare in beadwork.

These assemblages differ from the quivers of other tribes, and because they incorporate fur, are distinct from all other Transmontane beaded objects. The dark, lush, otter pelts accentuate the handsome designs, which reach a pinnacle of beadwork luxury.

Bandoleer bags consist of a large pouch approximately 25 cm x 18 cm, a strap approximately 13 cm wide, and a red or dark blue "drop": a large wool panel suspended from the lower edge of the bag (fig. 1). Although this purse-like piece of apparel probably developed from the mundane European shot bag, its generous size and impressive decoration are anything but prosaic.

The history of this type of object is complex because it includes shifts in tribal ownership, gender association, and use. Between the 1860s, when Euro-American photographers first reached the West, and the early 1880s, Ute men in the Great Basin seem to have owned most of the bags. They wore them slung over their shoulders with the pouch at the hip. During the 1880s bandoleers began to appear in the hands of Plateau people, who hung them around the necks of parade horses, primarily those of women. Today, some Plateau people still parade with the old bandoleers swinging at their horses' chests.

Figure 2. Transmontane-style gun case; 124.5 cm x 16.5 cm; buckskin, glass beads, trade cloth; Honnen collection. Photograph by Paul Macapia and Ray Fowler.

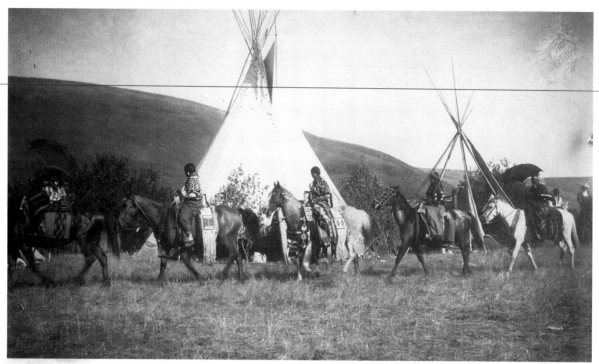

Figure 3. Nez Perce women parading on horses, Lapwai, Idaho, 1900. Across the rumps of the two center horses are epishamores (horse drapes) with long, swinging fringes. Photograph courtesy of the National Anthropological Archives, Smithsonian Institution, neg. #2975-D-2.

The pouch is a large, rectangular envelope that opens at the top and is solidly beaded on its front, but it is the sizable strap that is the real "show stopper." Some sections of this wide band contain striking combinations of white and red, created with extremely elongated hourglasses of white beads interlined with tall diamonds of crimson wool. These red-and-white patterns alternate with colorful, geometric designs sandwiched between end panels of solid light blue or white.

Blanket strips are long and narrow and are sewn horizontally across the centers of skins or other robes. When a person donned one of these garments, the colorful band wrapped around the hips (pl. 15, 16). The convention may have originated to cover the central seam of a buffalo hide in the days when women sometimes cut the massive skins in half before the heavy labor of tanning. When they finished their work, they sewed the two pieces back together, leaving a seam that might be concealed by an ornate strip.

The Transmontane version was constructed with a series of alternating rectangles and circles (rosettes). All parts were cut separately, decorated, and laid end to end before being sewn together. Like the gun case, this object is part of a broader tradition: many Plateau, Great Basin, and Plains tribes made beaded blanket strips. The Transmontane type can be distin-

guished by the characteristic geometric designs with white outlines or blue borders, and its rectangles are decorated with geometric elements placed between plain blue, pink, or white end panels much like those on bandoleer straps.

Horse drapes, or **epishamores**, are large buckskin rectangles folded into long, narrow "envelopes" approximately 110 cm x 25 cm. Today they function as parade gear laid flat over the rumps of women's horses (fig. 3), but a century ago they may have been used as suitcases and might have looked like large, stuffed sausages draped behind the saddle.

Decoration of an epishamore consists of two large beaded panels, a colorful border that edges one long side, and very long fringe. The two panels, which are almost identical, formerly employed bold Transmontane designs but are likely to use more modern geometric and floral motifs today. The long fringe hangs from the ends of the saddle drape and swings elegantly with each step of the horse.

Cradles on the Plateau include a type constructed on a long, flat board that is wide and curved at the top and tapers almost to a point at the bottom (pl. 7; see Duncan, fig. 3, this volume). The maker covered this board with cotton cloth or buckskin and left an opening in front that formed a kind of sack. This pouch held the baby and was laced shut, while its top acted as a hood to shelter the infant from sun,

rain, and other weather. These baby carriers were effectively designed. They could be hung from a saddle for transportation, laid flat on the ground, or propped against a tree so the young one could look out on the world. Through all activities, they held the baby securely in place.

Plateau cradles feature a solidly beaded upper board and smaller beaded sections next to the hood. The cradlemaker occasionally trimmed the hood itself and often hung fringes at the sides of the baby's face, where attached bells or large beads amused the child with their tinkling. If the craftswomen made an apron to wrap around the lower part of the structure, they often beaded that, too. The Plateau cradle shares a number of important construction traits with the Crow version, including the long, tapering, flat board, and the solidly decorated upper portion.

Another possible connection between Plateau and Crow decorated items is quillwrapped horse hair, which was used to decorate blanket strips, men's shirts, and a small number of moccasins. Designs on these items share many of the aesthetic ideas of beading but are constructed of slender bundles of horse hair wrapped in porcupine quills. Most are accompanied by seed beading, like that on the borders of the shirt (pl. 8) or the rectangles of the blanket strip (pl. 15). This combination of the two media makes it clear that the technique remained in use even after small beads became available in the mid-nineteenth century. The fashion may have co-existed with seed beading through the rest of the century but declined by the twentieth century. Old photographs and documented examples of the quilling are only slightly more common from Plateau tribes than from the Crow, thus it is difficult to confirm who produced this striking art form.

Parfleches and other painted rawhide cases were once used by many tribes to store and transport belongings (pl. 17). In the Transmontane area, these hard containers were decorated with geometric images remarkably like beadwork designs. We do not know, however, whether the painting style developed before, after, or with the beading designs, and whether it began with Plateau or Crow people.

Plateau people owned and still own a number of items almost identical to those possessed by Crow. These include clothing such as mirror bags (pl. 19), moccasins, leggings (pl. 9), and men's shirts (pl. 8), as well as stirrups, saddle flaps, horse collars, and keyhole bridle ornaments. If both groups were making all these pieces, they were passing their artistic ideas back and forth across the formidable Rocky Mountains, yet were keeping those ideas intact. This is an extraordinary artistic feat.

Perhaps it is the close friendship of the Nez Perce and Crow that has allowed them to influence each other so deeply. But they also had to be willing to copy their companions' art. That willingness is beautifully illustrated in a brief comment by an elderly Crow woman looking at Nez Perce and Crow horse collars. "One copied from the other," she said, "we both had them" (Lillian Hogan, pers. comm. 1980). Her words tell us that their sharing was the natural thing to do.

Notes

1. Transmontane is a new term developed to include Crow people east of the Rocky Mountains and Plateau people west of the Rockies. Earlier names for the style include "Crow" and "Intermontane."

References

Holm, Bill. 1981. Crow–Nez Perce Otterskin Bowcase-Quivers. *American Indian Art Magazine* 6(4): 60–70 (August 1981).

Loeb, Barbara. 1980. Mirror Bags and Bandoleer Bags. *American Indian Art Magazine* 6(1):46–53, 88 (Winter 1980).

——— . 1983. Classic Intermontane Beadwork. Ph.D. diss., Division of Art History, School of Art, University of Washington, Seattle.

——— . 1984. Crow and Plateau Beadwork in Black and White: A Study Using Old Photographs. In *Crow Indian Art; Papers Presented at the Crow Indian Art Symposium, Sponsored by the Chandler Institute, April 1981, Pierre, South Dakota*, pp. 15–26. Mission, South Dakota: The Institute.

WESTERN
WASHINGTON
HERITAGE

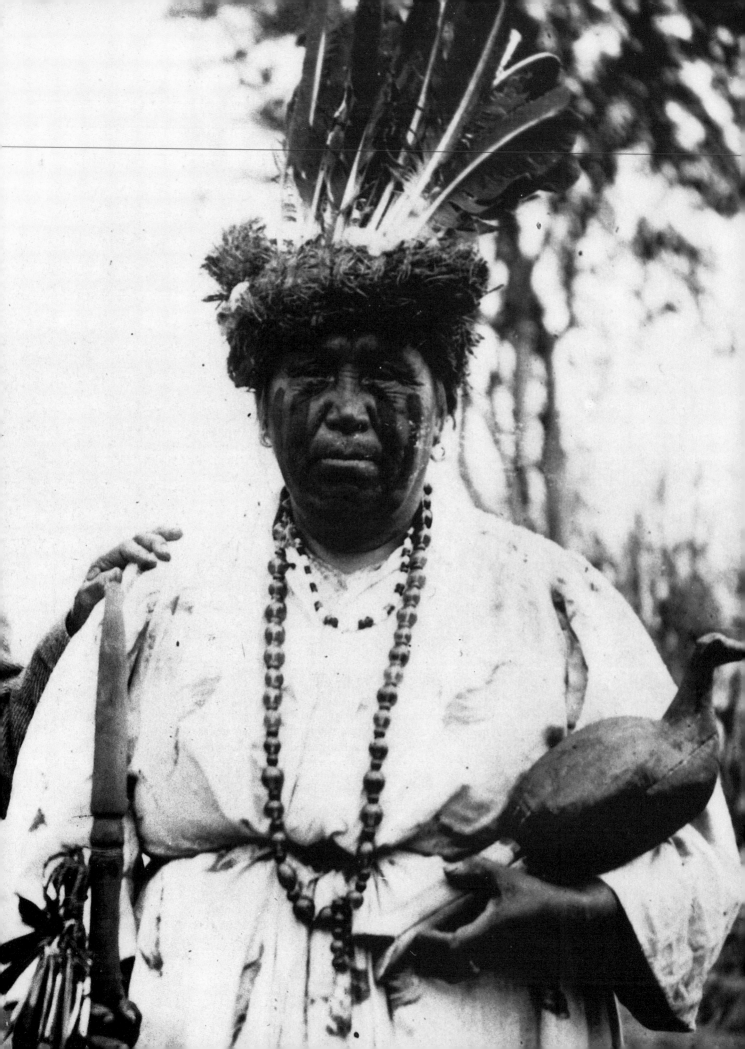

HISTORY OF WESTERN WASHINGTON
NATIVE PEOPLES

ᕼᎾᕼᎾᕼᎾᕼᎾᕼᎾᕼᎾᕼᎾᕼᎾᕼᎾᕼᎾᕼᎾᕼᎾᕼᎾᕼᎾᕼᎾᕼ

Leonard Forsman

The Native inhabitants of the territory roughly known as western Washington have continuously occupied its coasts, islands, riverbanks, and lakefronts for at least ten thousand years. Puget Sound and its many drainages were the primary hosts of these people, who led a rugged yet productive life dependent on the generosity of their particular environment, whether it were upriver meadow, river mouth, marine shoreline, sea coast, or marshy lakefront. The salmon was the primary staple of the Native diet and it was generously supplemented, and on occasion replaced, by shellfish, deer, fowl, roots, wild potatoes, berries, and numerous other wild plants. This bountiful environment and the highly developed technology used to exploit its resources provided opportunity for Native societies to flourish beyond subsistence, and to evolve into complex and dynamic cultures. Unfortunately for the first peoples of this region, this lifestyle would not continue to prosper and develop uninterrupted as it had for centuries, for soon they were to be invaded and displaced by a foreign race and culture that would change their world forever.

The first recorded contacts with European civilization occurred when Spanish explorers Bruno Heceta and Don Juan Francisco de la Bodega y Quadra led 106 men to the Washington coast in the summer of 1775 (see Wright, "Collection History," this volume). They were followed by a series of explorers including Captain Charles Barkley in 1787, Captain Robert Gray in 1788 (who in 1792 was the

first white man to cross the bar and enter the mouth of the Columbia River), and several more Spaniards (Eliza, Fidalgo, and Quimper). While Europeans had been plying the waters of the Strait of Juan de Fuca, Georgia Strait, and the ocean coast for 17 years, the first European expedition to enter Puget Sound and witness its indigenous inhabitants and natural features was that of Captain George Vancouver of Great Britain in the spring of 1792. While in the sound, Vancouver also took the liberty to rename many of these features after his crew members and his friends at home. This marked the beginning in the Puget Sound area of the cultural, economic and, especially damaging for the Native people, physiological exchange between the Old World and the New World people.

Tragically, disease had disastrous effects upon the Native people in Washington. Smallpox, whooping cough, and other contagious ailments quickly eradicated some tribes and greatly weakened others. The people had no immunity to disease organisms that were transported from overseas by explorers and traders. The resulting tragic epidemics frustrated tribal leaders and Indian doctors who sought cures for a whole range of unfamiliar symptoms. Soon the Native people began to question their medicinal and religious powers; this crippled their societal traditions. This was a disturbing situation for the tribes, and it made them vulnerable to the religious, economic, and cultural influences that were soon to follow.

The earliest Euro-American immigrants to travel to the Northwest Coast were a hearty group of trappers and traders, anxious to profit from the fur industry, and a handful of idealistic missionaries eager to convert the Native peoples to Christianity. From the early to mid-1800s fur trappers and traders

Leonard Forsman is Director of the Suquamish Museum and Secretary of the Suquamish Tribal Council. He is a member of the Suquamish Tribe and lives on the Port Madison Indian Reservation. Forsman holds a degree in Anthropology from the University of Washington.

Annie Rodgers. See Figure 1, p. 206.

Figure 1. Siddle (Muckleshoot) and Annie Rodgers (Suquamish), about 1910–1916. Rodgers' cedar and feather headdress and mussel shell beads are of her own production. She is holding a tamahnous stick and bird rattle. Photograph courtesy of Suquamish Tribal Photographic Archives, neg. #1357.

introduced new technologies, products, and economic opportunities that significantly altered the economies and cultures of the tribes. The major introduction that actually improved the standard of living for the Native people was iron. It allowed carving to become more efficient, resulting in a proliferation of Native woodworking. Economic opportunities presented by the fur trade also altered the daily lives of the people, but had both positive and negative effects. While the fur trade provided a new industry for the Native peoples, it also undermined traditional economic systems through its emphasis on individual wealth, in contrast to the community-based ethic of old.

The early missionaries—led by Jason and Daniel Lee in 1834, Marcus Whitman in 1836, and Francis Blanchet and Modeste Demers in 1838—began arriving in the Northwest in response to the opportunities for religious conversion of the Native people. This movement was triggered by the delegation of Nez Perce and Flatheads who visited William Clark in St. Louis in 1831 seeking out the new religion offered by the "Black Robes." The missionary period in Washington peaked in the early 1840s; missions were established at The Dalles, Fort Clatsop, and Fort Nisqually. Yet by 1844, of these three, all but the mission at The Dalles were closed. Despite this relatively short era of mission establishment, there were tremedous effects on the religious, economic, and social lives of the Native peoples. The missions were reponsible not only for religious conversion, but also for the increased settlement of tribal lands by Euro-Americans.

Despite these near-catastrophic disruptions of economy, religion, and physical health, most of the Washington tribes were able to maintain a measure of their identity and retain many of their traditions. Tribal unity was essential for survival and was desperately needed in this period of increased white settlement in order for many tribes to maintain some control over their land and resources.

Soon after the missionary and trade period exposed the Northwest to outsiders, and the prospects of a transcontinental railroad were becoming real as a result of Isaac Stevens' 1853 survey, a steady stream of pioneers and entrepreneurs came into the area seeking fortunes in timber, farming, fishing, and other early industries. Inspired by the Oregon Donation Act of 1850, which encouraged settlement of Indian lands through its homesteading provisions, many settlers willfully encroached on valuable Indian resource bases. As a result of these infringements, conflict between these settlers and the Native peoples erupted in 1848 when Patkanim, a war chief of the Snoqualmie people, attacked Fort Nisqually. During the next few years, as settlers continued to swarm to the area, sporadic violence broke out. This culmi-

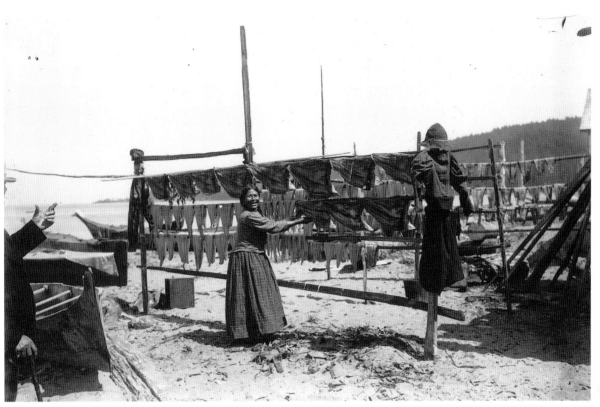

Figure 2. Woman drying fish, Neah Bay, early 1900s. Photograph courtesy of the Museum of History and Industry, McCurdy collection, neg. #55.970.470.23.

nated in 1855 when a number of settlers were killed in the White River Valley by a group of warriors led by Leschi, a war chief of the Nisqually. He later attacked the survivors who fled to the settlement at Seattle. These conditions prompted the United States government to exercise its treaty-making authority with Indian nations as a way of extinguishing Native land titles and of legitimizing settlement of the area, and to prevent further warfare with the powerful tribal alliances.

The period of the treaties and their negotiation was a crucial time in the history of the United States and the Indian nations. Each participating tribe wanted to set aside a portion of its own territory for its exclusive use, as well as to secure certain rights and privileges adequate for its survival. The Federal government, represented by Governor Isaac Stevens, desired a speedy resolution to land title issues in order to prepare for the future railroad. The terms of the treaties were intended to include Indian rights to education, fishing, and reservation lands in exchange for the transfer of millions of acres of land to the United States.

The treaty negotiations were conducted by Governor Stevens in great haste, and were carried on in Chinook Jargon, a limited trade language made up of a combination of words from French, English, and various Indian languages. Many Native people

did not speak this trade language. The treaties were read in English, translated into Chinook Jargon, and from it into several Native languages (see Hilbert, "When Chief Seattle Spoke," this volume). Misunderstandings were generated by the limitations of Chinook Jargon and the multiple translations required. Many Native leaders were unsure of the content of the documents they signed. Others did not wish to enter into treaties at all, but were coerced into doing so by threats from Stevens that their land would be taken forcibly with no compensation if they did not settle. Stevens assumed that certain cooperative village leaders could sign for people outside of their villages, and continued to hold to this position even when bands protested that no one who had signed had the authority to do so in their name. Due to distrust, disagreement with the terms of the treaty, the absence of a political structure that was recognizable to the uninformed white negotiators, or a lack of communication, some tribal groups did not attend the treaty meetings at all.

Despite these obstacles, the United States government did eventually sign, in 1854 and 1855, a series of treaties with some of the tribes across what is now Washington State (see Wright, "Introduction," fig. 11, this volume). More than 20 tribal groups were parties to the Treaty of Point Elliott, signed near Mukilteo on north Puget Sound, on January 22,

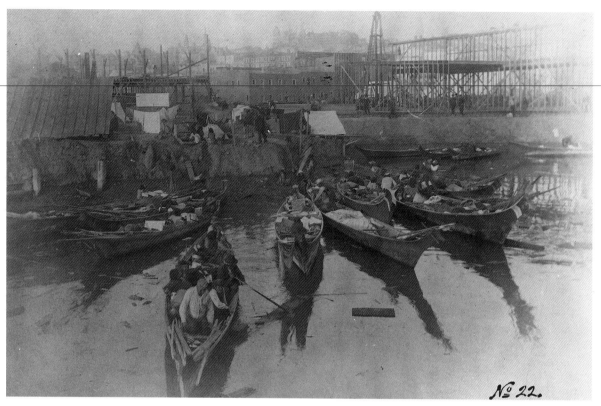

Figure 3. Canoes trading at Seattle waterfront, about 1890–1893. Photograph by Boyd and Braas, courtesy of Special Collections Division, University of Washington Libraries, neg. #NA 1443.

1855. This was the second of five treaties which Territorial Governor Isaac Stevens negotiated with tribes in western Washington. However, the treaties were not ratified by Congress until four years after the negotiations, and in the mean time their provisions were violated. This long delay in establishing a bureaucratic structure through which annuities could be paid to the tribes created serious problems. The Federal-Indian relationship that gave some tribes a measure of sovereignty began only after Congress ratified the treaties. Only a portion of the area's Indians (perhaps 50%) ever settled permanently on reservations. The others never received a land base. Shortly after ratification, the Civil War began and the Indians and their treaty assurances were largely ignored by the United States. The Indians' primary needs were cash payments, education, sufficient reserved lands, and health care. These needs were only minimally addressed by churches and their missionaries, and sometimes by the Indians themselves. Later, as the country began to rebuild after the war in the South, the "Indian problem" in the West had to be addressed.

A plan to remedy the problem was soon formulated and later implemented on reservations across the nation. This plan was known as "Americaniza-

tion" and it has formed most aspects of Federal Indian policy ever since. "Americanization" was based on the belief that if the Native peoples learned American customs and values they would soon merge tribal traditions with Euro-American culture and peacefully melt into the greater society. Traditional religious ceremonies were outlawed during this period. Among other religious suppressions, in the 1870s the acting agent at Port Madison ordered the burning of Old Man House, the physical and spiritual heart of the Suquamish community.

Although some Native children attended reservation day schools and others local public schools, for many, Americanization included rigid training in government boarding schools that they were forced to attend. At many of these institutions the children were not allowed to speak their native language, practice cultural traditions, or return to their homes during the nine-month school term, and therefore they lost most of the cultural traditions that remained. One of the most damaging effects of the process was the identity crisis it created for the generation of that era. Many were ashamed of, or even resented, their Indian heritage and would not pass on traditions to their descendants.

The Dawes Act of 1887, another by-product of

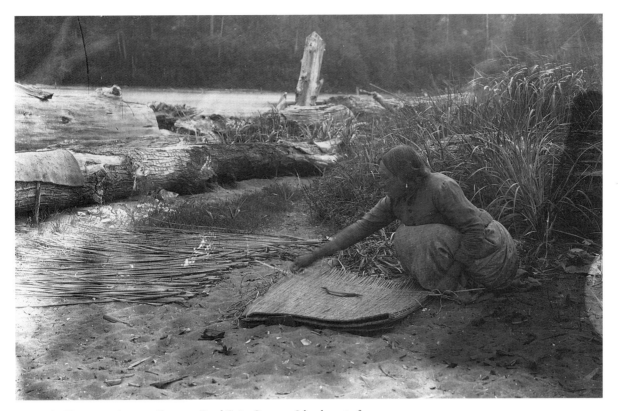

Figure 4. Woman sewing cattail mat at Sand Spit, Camano Island, east of Utsalady, near Stanwood, Washington. Note the cattail mat creaser lying on the mat, and the very long needle piercing the cattails. Photograph by Harlan Smith, courtesy of the American Museum of Natural History, neg. #12134.

the Americanization policy, was perhaps the single most damaging piece of Indian legislation implemented by the United States government. It brought land reform through allotment of the reservations to individual Indians. Indians were expected to "improve" their allotments by raising crops and livestock upon them. The Native peoples of Washington State were primarily fishermen, hunters, and gatherers, and the efforts to turn them into farmers were fruitless, especially on heavily forested reservations where land was unsuitable for agriculture.

Through the turn of the nineteenth century and into World War I the assimilation policy continued, until the 1920s when it was finally deemed a failure. The boarding schools were declared no longer mandatory and eventually many were closed. Many of the Washington tribes and their young members were then left without a tribal land base, treaty rights protection, cultural knowledge, or natural resources.

Citizenship for Native people was finally granted in 1924, after many had served in World War I. The Indian Reorganization Act of 1934 recognized tribal governments and marked the official end of Americanization as a policy. Soon after this, World War II began; Native men and women served in the Armed Forces only to return home to continued discrimina-

tion. The most disheartening and shameful act of the post-war era was the Termination Act of 1953 in which the United States government sought to extinguish its trust responsibilities to Indian tribes. This act attempted to extinguish Indian rights to their resources and Federal government benefits, and to dissolve their sovereignty, placing them under state jurisdiction. The most damaging effect of the Termination Act was the injury it caused to morale. Tribes were disbanded and individuals no longer felt part of a Native American community. This policy has since been abandoned and several disabled tribes have been reinstated.

The 1960s and 1970s were a time of struggle for the new generations of Native people in Washington who initiated attempts to exercise their treaty rights to fish, to gather shellfish, to hunt game, and to function as sovereign tribal governments. The inspiration for these actions came from the civil rights movement, a new generation of educated Indian people, and guidance from Indian elders who, with assistance from idealistic American citizens and organizations, worked together to create a better "Indian country." Native people and their governments continue today to work, preserve, and improve their lifestyle.

As the twentieth century comes to a close, tribes

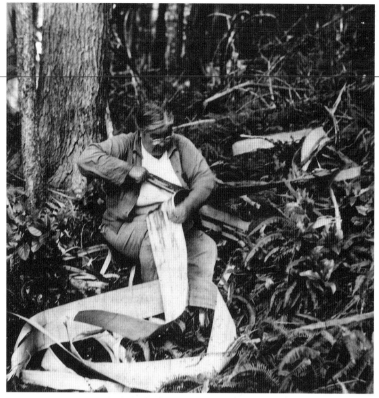

Figure 5. Ada Markishtum separating the usable inner cedar bark from the coarse outer material. Photo 1954, near Neah Bay, Burke Museum neg. #25A489.

look to the future with uncertainty and look to the past for strength and guidance. Cultural activities such as the establishment of museums, language and oral history programs, canoe building, and a resurgence of Native religions are part of a cultural renaissance in western Washington.

The centennial year has been a unique opportunity for Native and non-Native people alike to cooperate in rejuvenating many of the traditions unique to this region. The State's 100th birthday also challenges other state citizens to take responsibility for helping protect and nurture the Native way of life and for cooperating with tribes on important enviromental and economic issues today and in the future.

SUGGESTED READING

Buerge, David. 1980. 'Seattle' 3000 B.C.–1851 A.D. *The Weekly*; Dec. 17.

Collins, June McCormick. 1974. *Valley of the Spirits: The Upper Skagit Indians of Western Washington.* Seattle and London: University of Washington Press.

Gunther, Erna. 1945. *Ethnobotany of Western Washington: The Knowledge and Use of Indigenous Plants by Native Americans.* Seattle and London: University of Washington Press.

———. 1972. *Indian Life on the Northwest Coast of North America: As Seen by the Early Explorers and Fur Traders during the Last Decades of the Eighteenth Century.* Chicago and London: University of Chicago Press.

Haeberlin, Hermann. Mythology of Puget Sound. *Journal of American Folklore* 37 (143–144): 371-438.

Haeberlin, Hermann, and Erna Gunther. 1930. *The Indians of Puget Sound.* Seattle and London: University of Washington Press.

Heuving, Jeanne. 1979. *Suquamish Today.* Seattle: United Indians of All Tribes Foundation.

Hilbert, Vi. 1980. *Ways of the Lushootseed People: Ceremonies and Traditions of the Northern Puget Sound Indians.* Seattle: United Indians of All Tribes Foundation.

Kirk, Ruth. 1986. *Tradition and Change on the Northwest Coast: The Makah, Nuu-chah-nulth, Southern Kwakiutl, and Nuxalk.* Seattle and London: University of Washington Press.

Marr, Carolyn. 1987. *Portrait in Time: Photographs of the Makah by Samuel G. Morse, 1896–1903.* Neah Bay, Washington: Makah Cultural and Research Center; Tacoma: Washington State Historical Society.

Powell, Jay, and Vickie Jensen. 1976. *Quileute: An Introduction to the Indians of La Push.* Seattle and London: University of Washington Press.

Ruby, Robert H., and John A. Brown. 1986. *A Guide to the Indian Tribes of the Pacific Northwest.* Norman and London: University of Oklahoma Press.

———. 1976. *The Chinook Indians: Traders of the Lower Columbia River.* Norman: University of Oklahoma Press.

Smith, Marion. 1940. The Puyallup-Nisqually. *Columbia University Contributions to Anthropology* 32.

Suquamish Museum. 1985. *The Eyes of Chief Seattle.* Suquamish, Washington: The Suquamish Museum.

Suttles, Wayne. 1987. *Coast Salish Essays.* Seattle and London: University of Washington Press; Vancouver, British Columbia: Talonbooks.

Waterman, T. T. 1973. *Notes on the Ethnology of the Indians of Puget Sound.* New York: Museum of the American Indian, Heye Foundation.

Zucker, Jeff, Kay Hummel, and Bob Hogfoss. 1983. *Oregon Indians: Culture, History and Current Affairs, An Atlas and Introduction.* Portland: Western Imprints, the Press of the Oregon Historical Society.

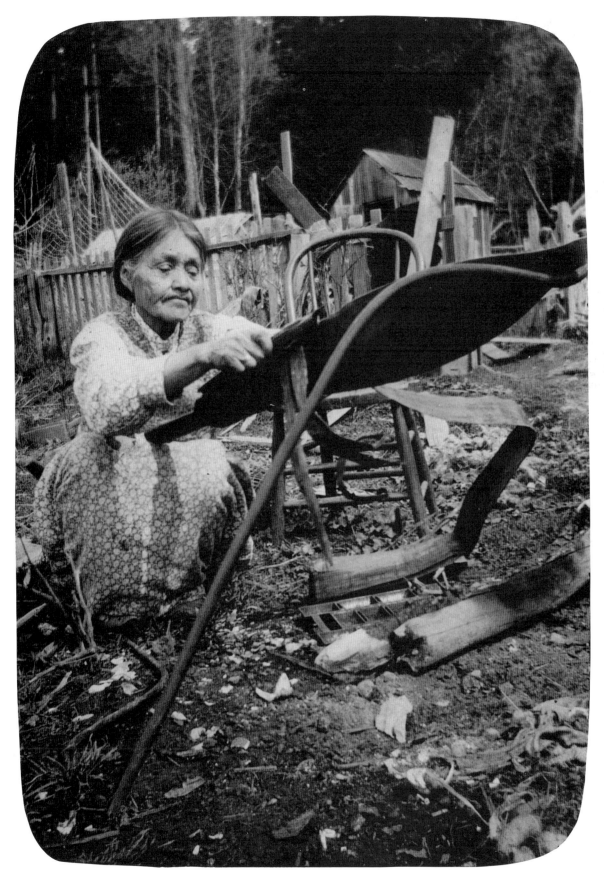

Figure 6. Mrs. Swinomish George shredding cedar bark
against the edge of a canoe paddle. Burke Museum neg.
#329.

THE SHED-ROOF HOUSE

ЮOЮOЮOЮOЮOЮOЮOЮOЮOЮOЮOЮOЮOЮOЮOЮOЮ

Wayne Suttles

INTRODUCTION

In the 1850s on Agate Pass, across Puget Sound from the site of Seattle, there stood the framework of Old Man House, said to have been built around 1815 by the brother of the chief for whom Seattle is named. In 1855 the framework of this house was measured and found to be "520 feet long, 60 feet wide, 15 feet high in front and 10 in the rear." A similar house was said to have been built at Dungeness on the Strait of Juan de Fuca by the Clallam headman King George, and a somewhat smaller one was built on Penn Cove, Whidbey Island, by the Skagit headman Sneetlum (Gibbs 1877:215).[1]

Old Man House was neither the first nor the largest such structure reported in this region. In 1808, when Simon Fraser led a party of Northwest Company fur traders down the river now named after him, he stopped at a Stalo village, "a large village" of about 200 people, a few miles upstream from New Westminster, British Columbia, about 30 miles north of the present Bellingham, Washington. He described the whole village as a single structure "640 feet long by 60 broad...under one roof" with "the front... 18 feet high, and the covering...slanting" (Lamb 1960:103).

From its "slanting" or single-pitched roof this type of house has been labelled the "shed-roof"

house. This may be a misleading term; "shed" generally refers to a small, makeshift structure, but these were hardly small, though, as we shall see, they could be easily dismantled.

Shed-roof houses were built by the Coast Salish peoples of the great inland sea that includes the Strait of Georgia, the Strait of Juan de Fuca, and Puget Sound; by the Nootkan peoples of the west coast of Vancouver Island from Barkley Sound southward; and by the the Makah and Quileute of the ocean shore of the Olympic Peninsula. There are a few sketches of this type of house—the most important made by Paul Kane at Victoria in 1847 (Harper 1971)—several accounts by observers who visited them while they were still being lived in, and a few photographs dating from the 1860s and 1870s. There are also a number of descriptions by professional anthropologists, nearly all based on the memories of informants rather than direct observation.[2] And we now have Jeffrey Mauger's (1978) work on the shed-roof house based on excavation at Ozette, the famous wet site in Makah territory.

CONSTRUCTION

From all accounts it seems that the shed-roof house was constructed according to a simple formula that could be repeated to allow expansion. The frame consisted of posts and beams. The posts were set into the ground in pairs—one taller than the other—to form two rows of unequal height. The distance between the rows determined the width of the house; the number of pairs of posts determined its length; and the difference in height of the posts determined the angle of the roof, which was usually not great. Dimensions varied from small structures, such as one

In 1951, with a dissertation on the Coast Salish of the region around the San Juan Islands, Wayne Suttles was the first to earn a Ph.D. in Anthropology at the University of Washington. Over the years he has continued research on the Native peoples of the Northwest Coast, and he has taught at the University of British Columbia (1951–1963), the University of Nevada at Reno (1963–1966), and Portland State University (1965–1985), where he is now professor emeritus.

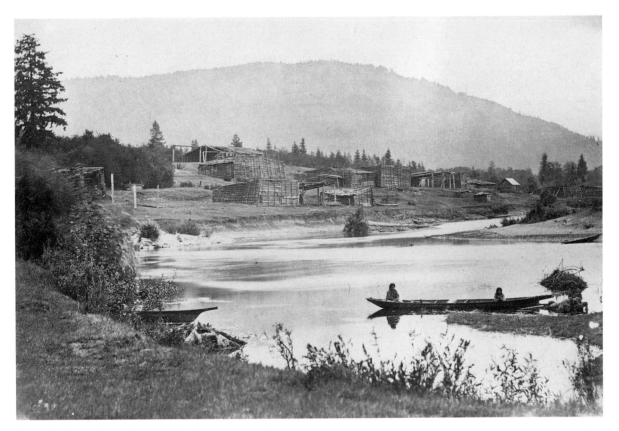

Figure 1. Quamichan village, 1866. Photograph by Frederick Dally, courtesy of the Royal British Columbia Museum, neg. #PN 1459.

Fraser saw near Hope, B.C., that was 46 feet long and 23 feet wide (Lamb 1960:99–106), to the great structure he saw farther downstream.

Like most Northwest Coast houses, shed-roof houses were usually built on a seashore or riverbank, where canoes could be pulled up, and were generally parallel to the shore, with the higher side facing the water (fig. 1). Some villages had more than one row of houses, and in some there were houses oriented in other directions. According to one tradition (Stern 1934:107–8), the Lummi once had a great house formed by putting two houses together in an L-shape. Huge structures such as the 640-foot one described by Fraser very likely consisted of several houses built end to end.

The posts were round logs, split logs, or more often, logs squared off to form heavy slabs two or three feet wide and six or more inches thick. Their tops were notched to hold the beams, which were generally round logs. The beams rested on the posts in one of two ways; in the Strait of Georgia–Puget Sound Basin from the Songhees and Lummi southward they ran crosswise (fig. 2), while in some houses to the north they ran lengthwise (fig. 1). In houses with crossbeams, the beams supported lighter stringers, which in turn supported the roof planks. In houses with longitudinal beams, the beams sup-

ported lighter rafters, which in turn supported the stringers that held the roof planks. Kane's drawing of the interior of a house in Victoria (fig. 3) shows that especially wide houses might have had additional posts in the center to support the beams.

The roof planks were an inch or more thick and a foot or more wide. They usually had lipped edges (making them bracket-shaped in cross-section), so that when laid with lips up and down alternately, they locked together. Roof planks were laid transversely, running with the slope of the roof, so that in most houses the rainwater ran off the back. The wall planks were either flat or bevelled on one edge so that they overlapped more easily. They were slung horizontally between pairs of poles (probably of Douglas fir), bound with cedar-withe ropes, and overlapped in clapboard fashion. Wall planks varied in size; the largest were as wide as three and one-half to four and one-half feet and as long as 20 to 40 feet (Gibbs 1877:215; Eells 1889:626). The tops of the walls were secured to the ends of the roof planks. In Kane's sketches (see Harper 1971: figs. 184, 186) and early photographs, the poles holding the wall planks can be seen projecting above the roofs.

Inside the house, a plank bed-platform two or three feet high and four to six feet wide extended around the walls except at the doors. In some houses

Figure 2. Lummi house frame, Lummi Point, Washington. Photograph by Harlan Smith, courtesy of the American Museum of Natural History, neg. #12129.

there was a lower bench in front of the bed-platform. The floor was earth, in some houses slightly excavated, but usually perhaps no more than needed to make it level. Smaller houses had doors at the ends only, but larger ones had doors at intervals in the front and back.

THE "PROBLEM" OF THE SHED-ROOF HOUSE

The shed-roof house occupies a position among the plank houses of the Northwest Coast that has led to speculation about its history. If we consider simply the form of the roof, which has generally been the first criterion used in classifying Northwest Coast houses, we find that most Northwest Coast peoples built houses with gable (two-pitched) roofs. The region of shed-roof houses in fact lies between two regions of gable-roof houses, one stretching from the northern end of Vancouver Island northward through southeastern Alaska, the other from southwestern Washington southward to northwestern California.

In the 1920s these facts suggested to T. T. Waterman, who taught anthropology at the University of Washington from 1918 to 1920, that gable-roof houses were once built continuously from one end of the Northwest Coast to the other until this continuous distribution was broken by the intrusion of the shed-roof house. To Waterman, shed-roof houses seemed inferior in structure to gable-roof houses, especially to those of the northern coast, and so he supposed that they were the invention of intruders with a simpler culture. Franz Boas had already argued that the Salish had recently come out of the interior, and so Waterman could argue that the shed-roof house was invented by the Salish after they emerged onto the coast and, learning something of the use of planks from earlier people on the coast,

adapted this knowledge to their own simpler needs. Later, this style—or some features of it, such as the horizontal wall planks standing apart from the frame—was borrowed by some neighbors of the Salish (Waterman and Greiner 1921:49–51; Waterman et al. 1921:25–28; Waterman 1925:473, 1973:90). Waterman's views seem to have been generally accepted and are echoed in some recent work.

But there are two problems with this reconstruction of history. First, the association of the shed-roof house with the Coast Salish is imperfect; not only did several non-Salish peoples use shed-roof houses, but many of the Coast Salish used other types. The Coast Salish of southwestern Washington built gable-roof houses only. The shed-roof house was the most common type built by all the Coast Salish of the Georgia-Puget Basin, but in both the northern and southern ends of the region, gable-roof houses were more esteemed. The shed-roof house seems to have been the preferred type in the central part of the region only.

Second, there is no longer any reason to believe that the ancestors of the Coast Salish came out of the interior recently, if ever (Suttles 1987:256–64). The Coast Salish may have been on the coast for several millennia. Therefore, rather than seeing the shed-roof house as simply the product of an imperfect mastery of the Northwest Coast architectural principles, we might better look for what qualities could have made it preferable to other types.

The Northwest Coast plank house[3] is one of the most distinctive features of a distinctive culture area. Made possible by the same well-developed woodworking technology that produced the great canoes of the region, the house in turn was a prerequisite for several basic features of the Northwest Coast culture—social, economic, ceremonial, and even esthetic. The Northwest Coast plank house was not merely a dwelling: it was a food-processing and storage plant, and it was a workshop, recreation center, temple, theater, and fortress. Let us look at the way the shed-roof house served each of these purposes for the Coast Salish people who built it.

THE HOUSE AS DWELLING

The shed-roof house provided flexible space for a multifamily household. Each family had its own supplies and fire, but the families belonging to a household frequently shared food and their members cooperated in many economic, social, and ritual activities. The household was the most important social group in Coast Salish society.

The house was divided, conceptually if not actually, into sections; a section was usually the space between house posts occupied by one family. In a smaller house a section might be the space between

Figure 3. Interior of a Klallam lodge, Vancouver Island, 1846–1847. From a watercolor by Paul Kane, courtesy of the Stark Museum of Art, Orange, Texas, #31.78/80, WWC 81.

two pairs of posts along both walls; in a larger house it was the space between adjacent posts along one wall. These arrangements in a large house can be seen in Kane's sketch (fig. 3) of the interior of a "Clallam lodge" in the Victoria area.[4] Kane states (Harper 1971:100) that houses in Victoria were 50 to 70 feet long. It appears from the height of the seated person that this house was 80 to 90 feet wide, with the house posts placed at intervals of 20 to 30 feet. Kane described the houses he visited as "divided in the interior into compartments, so as to accommodate eight or ten families…" (Harper 1971:102). The sketch shows chest-high partitions and bed-platforms extending partway out from the walls, but there is no barrier through the center. These low partitions appear to mark off the space between two house posts on one side of the house. We have an unbroken view for perhaps 80 feet through the length of the house.

Members of the family slept on soft mats on the bed-platform in their section. They stored firewood— the thick bark of old Douglas fir was preferred— under the bed-platform, placed boxes of blankets and other valuables on the bed-platform along the wall, and stored preserved foods on a shelf overhead and on racks hanging from the house frame. The walls of the house were lined with cattail or tule mats, which gave the structure a snugness that the loosely held boards alone could not have provided. In colder

weather the family could put up higher mat partitions and a mat roof, in effect building a smaller mat house within the plank house.

The placement of fires seems to have varied with the size of the house and probably also with the composition of the group sharing one fire. In a smaller house, there might be one or more fires along the midline of the house, each used by a family occupying both walls or by two closely linked families occupying opposite walls, while in a larger house the families along each wall had their own fireplaces in front of their bed-platforms (fig. 3). In any case, it was easy to relocate a fire. There were no permanent smokeholes; to let out the smoke, one could easily open the roof above the fire by using a pole to push a roof plank up and over.

The family that occupied one section of the house was usually a nuclear family—a husband, wife and minor children—perhaps augmented by one or more older or younger dependent relatives. Grown and married children would live in their own sections. A wealthy man, however, might have several wives and slaves. Co-wives had their own sections in a house, and slaves lived with their masters or mistresses.

All but the smallest houses consisted of several sections, commonly two, four, six, or more. But there was undoubtedly an upper limit to the number

of families that could constitute a functioning household. The huge structures mentioned earlier may have been essentially rows of houses end to end, each house holding a separate household.[5]

The families who constituted a household were not structured by a rigid rule of residence or principle of descent. A house might have a single owner, a man wealthy and influential enough to command the labor force required to build it. Or a house might be built cooperatively and owned jointly. In either case the men of the house might be brothers or brothers-in-law. Most marriages were arranged between families in different villages, and the bride was ceremoniously brought to the groom's village. But the couple had some choice in where they lived, and if a man's skills were valued by his wife's family, the couple might live with them. There was no disgrace in this as there was farther south, and the children would be as much at home there with their maternal grandparents as in their father's village. In fact, the choice was not limited to father's or mother's village. In the late 1940s, several older people said, "You have four grandparents, and you can go to any one of them." People prided themselves on having a choice of four alternate homes. Nor was any choice final; families could come and go. Thus as a house could stand for several decades, the ties among its occupants might become increasingly remote. (For the composition of late nineteenth-century households see Smith 1940:34–40; Collins 1974:83–86; Suttles 1951:274–86.)

The shed-roof house was well suited to this kind of variable or even fluid occupancy (Vastokas 1966:105). If more families chose to live there, the house could, provided there was room at the site, be lengthened by adding on another pair of house posts, a cross beam, stringers, and the planks for roof, walls, and bed-platform. Or, if a family moved away and took their planks with them, the house could be easily shortened by bringing in the end wall by one pair of posts.

In Northwest Coast Native society there were great differences in social standing. Some families were recognized as gentlefolk of property and good breeding, while others—perhaps a minority—were considered worthless and ill-bred. Whole households might be identified with one class or the other. Among the gentlefolk there were a few really important families with outstanding leaders. Such leaders would be acknowledged heads of their houses, and the most influential house head in a village might be acknowledged village leader, a "chief" in the eyes of Euro-American observers. However, a village leader's real authority did not extend beyond his own household and even there he could not prevent members from leaving if they chose to. Moreover, not all houses had heads, nor did all villages have "chiefs."

These house heads were wealthy men with multiple wives and slaves. Their families, of course, occupied more space in the house than other families. But, as Vastokas (1966:109) has pointed out, their greater space was simply a linear extension of the normal amount.[6] This is consistent with the absence of any formal status or constituted authority.

The house was a home base from which families went out for shorter or longer periods, generally from spring through fall, to fish, hunt, and gather shellfish, vegetable foods, and materials needed for crafts. Whether individuals stayed together on these trips depended on their particular skills. Hunters of sea mammals and hunters of land mammals were likely to go off to different sites and in smaller groups than salmon fishermen.

The loose construction of the shed-roof house was advantageous in this seasonal round. When the members of a family went off to a summer campsite, they usually loaded some of their house mats and a few poles into their canoe, so that they could build a mat house for shelter. But at sites where larger groups went for several weeks year after year, they built permanent house frames that were covered with planks for the season. In August of 1824, Dr. John Scouler visited the Lummi fishing camp at Village Point on Lummi Island, where the Lummi must have had permanent house frames. On the 27th of August "we found the Indians busily employed in removing their provisions & furniture, *even to the boards of their houses*, to their winter quarters, which were a little way into the interior" (Scouler 1905:205; emphasis mine). They were probably taking them just around Point Migley to their winter village site at Gooseberry Point or perhaps to a weir site on the Nooksack River.

Being able to dismantle one's house quickly was also useful in emergencies. Ruth Shelton, who lived in the Samish village on Samish Island in the 1860s, remembered Nuwhaha people from up the Samish River being flooded out by a freshet and arriving at the Samish village with their mats and planks to make a house there for the winter.

THE HOUSE AS FOOD-PROCESSING AND STORAGE PLANT

"From the native standpoint," Waterman and Greiner (1921:38) wrote of houses on Puget Sound, "the center and soul of the house was a great rack for drying fish." They describe a lower rack at the level of the lower eaves for fresh fish and a higher rack for curing backbones, which needed less smoke, all suspended from the roof. The house frame, as Marian Smith (1940:282) pointed out, had to be strong enough to support not only the weight of the roof but the weight of all those fish hanging from it And not only fish. Strips of meat, strings of clams, bags of camas bulbs,

baskets of roots, cakes of berries, and bags of seal oil also hung there.

It would be hard to exaggerate the importance of methods of food preservation to the Native people of the Northwest Coast. The great runs of salmon came for brief periods, when fishermen with a reef net or weir could take several thousand in a day. But unless they were carefully preserved, those fish would soon spoil. Many other foods, too, were available only for a brief season. Food preservation was primarily the work of women, and the success of a household in coping with these seasonal abundances depended heavily on the number of women's hands available.

Women processed most foods at summer camps and brought them back to be stored in the house, where they were kept dry and perhaps protected from insects in the smoke of the fires. But the fall runs of salmon, especially the late runs of chums, which dried hard and lasted long, had to be smoked indoors. Some people built separate small smoke-houses for intensive smoking, but the plank house was essential for storing food safely through the winter.

THE HOUSE AS A WORKSHOP AND RECREATION CENTER

In a climate with frequent rain, it is certainly more comfortable to work indoors, and one of the reasons why some of the old houses were so big may have been that during the winter they had to serve as workshops. Women may have worked at crafts indoors more than men. Sketches by Kane (Harper 1971:261) show women spinning and weaving indoors. Charley Edwards grew up in the big Samish house on Guemes Island and remembered women generally working inside, even when making mats. Both sexes necessarily gathered raw materials away from the house, but some men had both practical and ritual reasons for staying away. A canoe-maker, like Edwards' uncle, worked away from the village initially because that is where he found a suitable cedar tree, but he continued working there so that he could more freely use the secret ritual words that prevented the cedar wood from splitting. However, a man working with materials he could bring home might do so. Men made bentwood halibut hooks inside, Charley said, because they needed to heat rocks in the fire for steam.

Perhaps most sports were played outdoors. There boys and young men played a kind of shinny, girls a battledore and shuttlecock game, and small children many others. But the gambling of grown men and women may have been as often in the house. Paul Kane sketched a group of men gambling in the center of a house (Harper 1971:102). The game was *slahal*, played with bones or wooden disks hidden in a bun-

Figure 4. House post, Lummi Point, Washington. The carving depicts one of Lummi headman Chowitsoot's wealth powers, "the sun carrying two valises of valuable things." Photograph by Harlan Smith, courtesy of the American Museum of Natural History, neg. #12133.

dle of shredded cedar bark. Women gambled with beaver-tooth dice, probably also indoors.

THE HOUSE AS TEMPLE AND THEATER

A post from the house of the Lummi headman Chowitsoot (fig. 4) bears a simple engraved form—a large circle with a smaller one inside and two smaller ones below, at the sides, connected by lines to the larger. Julius Charles identified this as a portrayal of one of Chowitsoot's wealth powers (see also Reagan 1922:430). It was the sun "carrying two valises of expensive things."

In the past, young men and women were sent into the wilderness to fast and purify themselves in order to get help from one of the beings who might be encountered there. If a being took pity on the young person, it would appear in a vision and become that person's lifelong helper (*tamahnous* in Chinook Jargon, "guardian spirit" in the jargon of anthropology). The beings encountered might reveal themselves as animals (including some unknown to Western science) or natural phenomena, but they

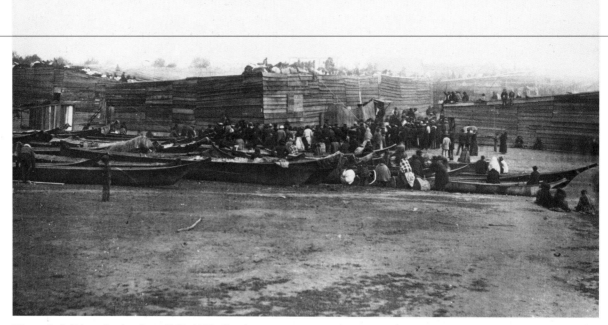

Figure 5. Salish potlatch, about 1867–1870. Songhees Reserve, Victoria, British Columbia. In this village of traditional Coast Salish cedar plank houses, people on the roofs are tossing down blankets and other gifts to the guests standing below. Photograph by Frederick Dally, courtesy of the Royal British Columbia Museum, neg. #PN6810.

might also take human form. It was dangerous, especially early in life, to reveal the identity of the helper. But later in life most people gave clues to the identity of their helpers in winter dance performances. From the Songhees and Lummi southward the most successful men portrayed guardian spirits on their houseposts.[7]

But they did not show them freely. Boas (1891:564–65) gives sketches of Songhees houseposts carved like human figures, identifying these as representations of the visions of the owners, and he adds that "the faces of these figures are always kept covered, as the owner does not like to be constantly reminded of these his superhuman friends and helpers. Only during festivals he uncovers them." Eells (1985:368–69) illustrates several Twana "tamahnous posts," one showing a human and an animal figure, another a human face. These stood in a potlatch house, where they were covered until a point during the potlatch at which they were ceremonially unveiled. The posts of Old Man House were said to have been "carved with grotesque figures of men, naked and about half size" (Gibbs 1877:215), probably also representing vision powers.

The vision power was also manifest in the winter dance, and the flexibility of the shed-roof house is seen again in the way its occupants used it for this purpose. Both men and women could become dancers, and before the Christian missionaries opposed the dancing, perhaps most people became dancers by middle age. Thus a large space was needed to invite even one's own village, and certainly a large house was required when the people of one village invited those of another. For a big dance, the host took away whatever partitions separated the sections of their house, moved the fires to make one or two in the center, shifted the roof planks to make new smoke vents as needed, and created a large open area.

At the winter dance (or "spirit dance") the dancers achieve what is described as a kind of union with an entity earlier encountered in a vision and now manifesting itself as a song, and they dance, one by one and always in a counterclockwise direction, around the central fires. Different songs require different dress and paraphernalia. One type animates a pole. In the old days, it is said, this pole moved vertically by itself, drumming against the low roof planks and making the shed-roof house a musical instrument.

The other major ceremony was the potlatch. Among the Lummi and their close neighbors, the potlatch was usually sponsored by the heads of several or all of the houses in the village. They cooperated in

inviting people from villages throughout the region within which they had friendly relations. During a period of several days the leaders of each household in turn announced their purpose: to honor the dead, transfer names to children, announce a daughter's coming-of-age; they displayed their hereditary privileges; and they presented gifts to the guests, whose presence and acceptance meant acknowledgment of the honors claimed by the hosts. Potlatch gifts might be hide garments, shell beads, and even canoes, but most often they were blankets—traditionally made of dog wool and mountain goat wool, later increasingly Hudson's Bay Company blankets obtained in trade. The guests assembled in front of the house, and the hosts used the roof as a stage from which they addressed the guests (Hill-Tout 1905:227) and upon which they piled the blankets before the final distribution (see fig. 5).[8]

Among the Clallam, Twana, and Lushootseed tribes, potlatches were hosted by men with special vision power for it, and the biggest houses are said to have been constructed especially for potlatches. Old Man House and other big houses in this region were referred to as "potlatch houses." Such houses were reportedly built for the occasion and dismantled afterwards (Gibbs 1877:215), and some or most were never used as dwellings (Eells 1985:64; Elmendorf 1960:153–54).

THE HOUSE AS FORTRESS

The Coast Salish did not glorify warfare. They preferred to deal with one another and with non-Salish people by giving daughters in marriage and linking families in a relationship that, if understood properly, led to exchanges of food and wealth and invitations to share in each other's resources. Of course there were misunderstandings and occasional conflicts. There were professional warriors, but generally no more than one or two in the larger villages and none in the smaller. While these aggressive and arrogant men wished to lead others in avenging insults or attacking people beyond the circle of intermarriage, they were also useful deterrents to potential or real enemies. The objective of such attacks was the taking of loot and of captives to be held for ransom or sold as slaves. Thus the danger of attack by some disgruntled former in-law or by a war party from some distant village was always present.

Most houses were built with precautions against sudden hostile entry. Doors were made so that they could be shut and barred at night. Some door openings were so small that a person entering had to step up and stoop simultaneously and thus be vulnerable to those within. Some had planks on either side making a narrow passage leading in toward the center of the house. This arrangement protected the people

living on either side of the door from drafts, of course, but it also meant that a visitor was immediately visible to more of the occupants. Other defenses included emergency exits, doors with spring traps, and secret trails through fields of sharpened stakes. But these, like stockades around villages, may date only from the early nineteenth century, when the Lekwiltok Kwakiutl began raiding the region.

COMPARISONS

When we compare the shed-roof house with the other major types of houses built on the Northwest Coast, we find some striking differences that seem related to differences in social organization and daily life.[9]

In the north, the usual Tlingit, Haida, or Tsimshian house was nearly square, with its gable roof facing the water, its wall planks fitted into the frame, and its floor excavated in the center so that the interior had two or more levels and a single central hearth with a permanent smokehole above it. The house could be an impressive work of art in itself, with a painted front, carved frontal pole, carved internal posts, and painted screen.

The northern household was a group formed by rules of descent and residence that brought together members of the same matrilineal kin group. Because the northern house was not as easily modified to allow for growth or reduction in numbers of occupants, presumably these rules did not allow for the fluidity of the Coast Salish household. The vertical and horizontal axes of the house expressed status differences, with the house chief on the upper level in the rear, other high-ranking members at his sides, and lower ranks on lower levels (Blackman 1981:127–31); most Coast Salish would, I believe, have rejected such explicit indication of rank. The central hearth suggests a greater unity of economy than in the multi-hearth household. Moreover, the single hearth and greater vertical dimension of the northern house must have given it different properties, which I cannot guess at, as a food-processing and storage plant. In their seasonal moves some northerners took planks with them (de Laguna 1972:304, 310–11), but probably not those fitted into the frame of the winter house; in any case, with their larger canoes and less sheltered water, they probably did not need nor could they have used catamarans like those of the Coast Salish. For potlatches the northern house was a small amphitheater. The actors performed within it rather than upon it, and so necessarily to the more limited audience that the house could hold. But at a northern potlatch, because society consisted of clearly defined opposing groups, the host ordinarily dealt with the leading persons of one or two other lineages, while at a Coast Salish potlatch the hosts had to deal with the

Figure 6. Interior of a gable roof Chinook house, Columbia River, 1846. Note the carved house post in the center and the carved wooden panel to the side. From an oil painting by Paul Kane, courtesy of the Stark Museum of Art, Orange, Texas, #31.78/210, WOP 13.

important people in every village around them. The art that decorated the northern house was symbolic of the group who lived in it—and contrasted sharply with the individualism of the decorated house posts of the Coast Salish.

On the central coast, the Kwakiutl, Northern Nootka, and some of the Coast Salish of the Strait of Georgia, when first seen by Europeans, had houses that resembled the shed-roof house in most features—axis parallel to the shore, wall planks slung between pairs of poles, no excavation, multiple hearths—but had a differently built frame and low gable roof. As we might expect, the people who built this type of house had a social organization and a ceremonial system more like that of the builders of the shed-roof house than like that of the northern coast. But by the middle of the nineteenth century, the Kwakiutl especially were shifting to a house more like the northern type, built with gable end facing the shore, and with nailed walls of milled lumber allowing for painted fronts and even frontal poles. Carved interior posts, painted fronts, and other art represented crests of the owner and his kin group.

On Puget Sound, within the region where the shed-roof house was built, some of the Lushootseed-speaking people built a unique five-pitch or gambrel-roof house; the center of the roof was nearly flat with four sides sloping away from it (Waterman and Greiner 1921:20–23). Photographs of a model that Arthur Ballard had built in 1936 and his description [10]

indicate that the gambrel-roof house consisted of a plank-covered central area—for fires and drying racks—surrounded by four lean-tos with mat roofs and plank walls, those on the sides used for living quarters, those on the ends for storage. Too little is known of this type of house for comparisons. Within the shed-roof area, some Lushootseed (Smith 1941:282–86) and Twana (Elmendorf 1960: 154–65) also built gable-roof houses that were variations of a southern type.

To the south, for the Quinault (Olson 1936:61–64) and other Coast Salish of southwestern Washington, Chinookans, and peoples of the Oregon Coast, the southern gable-roof house was the usual type. It was often parallel to the shore, with wall-planks set vertically into the ground. From the Columbia River southward, most houses were entirely excavated so that the walls were only partly visible from the outside. Smaller houses of this type had a central hearth (see fig. 6), but larger ones had several, in one or two rows. It seems that this type of house would be less flexible. A change in length would obviously require more work for an excavated than for an unexcavated house. But houses up to several hundred feet long were built by Chinookans in the Portland Basin (Hajda 1984:77–80). Households may have been less fluid on the southern coast than on the central coast; there was a much stronger tendency for men to stay all their lives in their fathers' villages. Wall planks set into the ground would be less easily removed. Near the Cascades, Lewis and Clark (Thwaites 1904–1905,4:259) saw people crossing the Columbia with dismantled houses, but these may have been from unexcavated sites. Chinook houses were decorated with what were probably representations of shamans' helpers. The Chinook had winter dances, feasts, and possibly potlatches, and so the ceremonial use of the house was possibly similar to that of people with shed-roof houses. Presumably in a multi-hearth house the fires could be moved to the center, as in a shed-roof house. Maintenance of this type of house would be more difficult. If rot occurred at the ground level, all vertical wall planks might have to be replaced, while with horizontal wall planks, it would be only the bottom one. (For the repair and maintenance of Ozette houses see Mauger 1978:190–94.)

CONCLUSIONS

This survey suggests that the shed-roof house differed from other types because it served the social, economic, and ceremonial purposes of a different cultural system. It is unlikely that this system is foreign to the Northwest Coast; probably it developed right where it existed in historic times. Thus the shed-roof house, rather than being the product of an imperfect mastery of Northwest Coast architecture by

immigrants from the Plateau, is more plausibly the product of evolution, on the coast, from some prototypical Northwest Coast plank house. It may even have developed from a prototype with gable roof and fixed wall planks, changing to its present form as the social system developed greater flexibility, the yearly round came to require greater movement of goods, and ceremonial events came to include a wider range of neighbors. Archaeological work may eventually show the course of this development, documenting architectural changes from which we might infer social, economic, and ceremonial changes.

When Waterman suggested that the shed-roof house was invented by an intrusive people, he added that, if so, the intrusive people had outdone the (supposed) earlier inhabitants in the size of their houses. True enough. Chinookan houses may have been nearly as big, but the largest Haida house known, the Monster House of Chief Weah of Masset, was only 55 by 54 feet (Blackman 1972) and could have fit into one section of that structure Simon Fraser described.

NOTES

1. Later estimates of the length of Old Man House range as high as 1,150 feet, but archaeological evidence for the placement of its posts suggests that it was about 530 feet long and varied from 40 to 60 feet in width (Mauger 1978:230–34).

2. Descriptions of Coast Salish shed-roof houses are found in Boas 1891; Curtis 1913:45–47; Waterman and Greiner 1921:14–20; Haeberlin and Gunther 1930:15–18; Gunther 1927:180–90; Stern 1934:31–32; Jenness n.d.; Barnett 1955:35–38; Suttles 1951:256–61; Duff 1952:48–49. Boas's 1891 description and illustrations of a Songhees house are especially clear and have influenced most later accounts. The Songhees were culturally very close to two Washington peoples, the Lummi and the Clallam. By the 1880s the old houses were being replaced by gable-roof houses with shake roofs and walls of milled lumber. It is possible that in the Coast Salish region no field worker following Boas ever actually saw a shed-roof house. Early in this century there were Makah shed-roof houses still standing, as seen in Curtis (1916) photographs.

3. During the last 25 years the term "longhouse" seems to have come into general use for both the aboriginal plank house and modern structures used for ceremonial purposes. It rarely appears in the earlier literature; to my knowledge only Hill-Tout (1978,3:46) and Duff (1952:48) used it. As late as the early 1960s my Coast Salish friends and acquaintances in British Columbia were still using the traditional terms "smokehouse" or "big house" for the structure where a winter dance was held; I do not believe I ever heard the term "longhouse" until the 1970s. Now it seems to have spread as far north as the Haida. The source of the term may be the Plateau, where the ceremonial house—the modern counterpart of the long mat house—has been called "the longhouse" for some decades, but its use must also be influenced by an awareness of the Iroquois longhouse, originally a long bark-covered structure.

4. After Victoria was founded a group of Clallam moved across the Strait of Juan de Fuca to stay near the fort, and this sketch may have been of their house. But at that time the term "Clallam" seems also to have meant the language or closely related pair of languages now called Straits. And so the people Kane sketched could also have been Songhees, who spoke Northern Straits.

5. Barnett (1938:127; 1955:36, 52–53) insisted that shed-roof houses around the Strait of Georgia were fully partitioned, even

where the sections were 15 or 20 feet wide. This led Smith (1941:205) to conclude that there was a northern region of "segmented" houses and a southern region, including Puget Sound, of "unsegmented" houses. But other ethnographers, as well as the Kane sketch, indicate an unbroken view through the interior of even a very large house. A misinterpretation may go back to Fraser's account of that 640-foot house he visited. He says it was divided into "apartments," but it is not clear whether these were fully separated by planks. In the Masson (1889–1890:197) edition of Fraser they were described as "separated by partitions," which led several writers to believe they were fully separated. However, in the Lamb (1960:103) edition they are "separated in portions," which could refer to some internal division of each. These apartments were square, 60 by 60 feet, except for the chief's which was 90 feet long. If Fraser's figures are right, there must have been nine of the smaller apartments. He estimated the population of the village at 200, which implies an average of 20 persons in each of the 10 apartments. It seems reasonable to suppose that each apartment housed two to four families, possibly enough to constitute a separate household, but one smaller than what is implied in Kane's sketch. The question of full partitions is still open.

6. Hill-Tout (1901:486; 1902:360; 1906:233) asserted that the chief always occupied the securest place in the center of the building, with his brothers and other nobles on either side, and commoners out beyond at the ends of the house. However, this arrangement is not reported as a regular one by any other writer, and given the nature of Coast Salish society it seems unlikely that it was.

7. Among the Coast Salish of the southern end of the Strait of Georgia and the lower Fraser River, house posts seem more often to have been decorated with representations of "cleansing devices" empowered by ritual words, and of famous ancestors (Suttles 1987:114–27). From the lower Fraser there are also reports of painted house fronts. These may have been houses that were not dismantled annually; otherwise, their owners would be faced with an annual jigsaw puzzle.

8. Because the gable-roof houses with steeper roofs that replaced the shed-roof houses could not be used as stages, scaffolds were built for the purpose. But the scaffold may have predated the change in architecture; Wilson (Stanley 1970:74) saw one in the Fraser Valley in 1858.

9. I have benefitted from Vastokas's (1966:103–12) and Woodcock's (1977:135–36) comparisons, and I am grateful for suggestions from Bill Holm and Yvonne Hajda on northern and southern houses.

10. In the National Anthropological Archives, Smithsonian Institution, Washington, D.C.

REFERENCES

Barnett, H. G. 1938. The Coast Salish of Canada. *American Anthropologist* 40:118–41.

_____. 1955. *The Coast Salish of British Columbia.* University of Oregon Monographs, Studies in Anthropology No. 4. Eugene.

Blackman, M. B. 1972. Nei:wins, the "Monster" House of Chief Wi:ha: An Exercise in Ethnohistorical, Archaeological, and Ethnological Reasoning. *Syesis* 5:211–25.

_____. 1981. *Window on the Past: The Photographic Ethnohistory of the Northern and Kaigani Haida.* National Museum of Man Mercury Series. Canadian Ethnology Service Paper No. 74. Ottawa.

Boas, F. 1891. The LkungEn. In The Sixth Report on the Northwestern Tribes of Canada. *Report of the 60th Meeting of the British Association for the Advancement of Science for 1890*, pp. 563-92. London.

Collins, J. McC. 1974. *Valley of the Spirits: The Upper Skagit Indians of Western Washington.* American Ethnological

Society Monograph 56. Seattle: University of Washington Press.

Curtis, E. S. 1913. *The North American Indian.* Vol. 9. (Reprinted 1970. New York: Johnson Reprint Co.)

————. 1916. *The North American Indian.* Vol. 11. (Reprinted 1970. New York: Johnson Reprint Co.)

de Laguna, F. 1972. *Under Mount Saint Elias: The History and Culture of the Yakutat Tlingit.* Smithsonian Contributions to Anthropology No. 7. Washington, D.C.

Duff, W. 1952. *The Upper Stalo Indians of the Fraser Valley, British Columbia.* Anthropology in British Columbia Memoir 1. Victoria.

Eells, M. 1889. The Twana, Chemakum, and Klallam Indians, of Washington Territory. *Annual Report of the Smithsonian Institution for 1887,* pp. 605–81. Washington.

————. 1985. *The Indians of Puget Sound: The Notebooks of Myron Eells.* Seattle: University of Washington Press.

Elmendorf, W. W. 1960. *The Structure of Twana Culture.* Research Studies Monographic Supplement No. 2. Pullman, Washington: Washington State University.

Gibbs, C. 1877. *Tribes of Western Washington and Northwestern Oregon.* Contributions to North American Ethnology 1:157–361.

Gunther, E. 1927. *Klallam Ethnography.* University of Washington Publications in Anthropology 1(5):171–314.

Haeberlin, H., and E. Gunther. 1930. *The Indians of Puget Sound.* University of Washington Publications in Anthropology 4(1):1–84.

Hajda, Y. P. 1984. Regional Social Organization in the Greater Lower Columbia, 1792–1830. Ph.D. diss., Department of Anthropology, University of Washington.

Harper, J. R., ed. 1971. *Paul Kane's Frontier.* Austin: University of Texas.

Hill-Tout, C. 1901. *Notes on the Sk•qō'mic of British Columbia, a Branch of the Great Salish Stock of North America.* Report of the British Association for the Advancement of Science, No. 70 (for the year 1900), pp. 472–549.

————. 1902. *Ethnological Studies of the Mainland Halkomelem, a Division of the Salish of British Columbia.* Report of the British Association for the Advancement of Science, No. 72 (for the year 1902), pp. 355–449.

————. 1906. Salish Tribes of the Coast and Lower Fraser Delta. *Annual Archaeological Report, 1905.* In Appendix to the Report of the Minister of Education, Ontario, pp. 225–35. Toronto.

————. 1978. *The Salish People: The Local Contributions of Charles Hill-Tout.* 4 vols. Edited by Ralph Maud. Vancouver: Talonbooks.

Jenness, D. n.d. The Saanich Indians of Vancouver Island. Manuscript in the Archives of the Ethnology Division, National Museum of Civilization, Ottawa.

Lamb, W. K., ed. 1960. *The Letters and Journals of Simon Fraser, 1806–1808.* Toronto: Macmillan Company of Canada.

Masson, L. R., ed. 1889–1890. *Les Bourgeois de la Compagnie du Nord-Ouest.* (Reprinted 1960. New York: Antiquarian Press.)

Mauger, J. E. 1978. Shed Roof Houses at the Ozette Archaeological Site: A Protohistoric Architectural System. Ph.D. diss., Department of Anthropology, Washington State University. (Ann Arbor, Michigan: University Microfilms International.)

Olson, R. L. 1936. *The Quinault Indians.* University of Washington Publications in Anthropology 6(1):1–190.

Reagan, A. B. 1922. Some Notes on the Lummi-Nooksack Indians, Washington. *Transactions of the Kansas Academy of Science* 30:429–37.

Rohner, R. P., ed. 1969. *The Ethnography of Franz Boas.* Chicago: University of Chicago Press.

Scouler, J. 1905. Dr. John Scouler's Journal of a Voyage to N. W. America. *Oregon Historical Quarterly* 6:54–75, 159–205, 276–87.

Smith, M. W. 1940. *The Puyallup-Nisqually.* Columbia University Contributions to Anthropology 32.

————. 1941. The Coast Salish of Puget Sound. *American Anthropologist* 43:197–211.

Stenzel, F. 1975. *James Madison Alden: Yankee Artist of the Pacific Coast, 1854–1860.* Fort Worth: Amon Carter Museum.

Stern, B. J. 1934. *The Lummi Indians of Northwestern Washington.* New York: Columbia University Press.

Suttles, W. 1951. The Economic Life of the Coast Salish of Haro and Rosario Straits. Ph.D. diss., Department of Anthropology, University of Washington.

————. 1987. *Coast Salish Essays.* Vancouver: Talonbooks; Seattle: University of Washington Press.

Thwaites, R. G., ed. 1904–1905. *Original Journals of the Lewis and Clark Expedition 1804–1806.* 8 vols. New York: Dodd, Mead and Co. (Reprinted 1969. New York: Arno Press.)

Vastokas, J. M. 1966. Architecture of the Northwest Coast Indians of America. Ph.D. diss., Department of Fine Arts, Columbia University. (Ann Arbor, Michigan: University Microfilms, Inc.)

Waterman, T. T. 1925. North American Indian Dwellings. *Annual Report of the Smithsonian Institution for 1924,* pp. 461–85. Washington.

————. 1973. *Notes on the Ethnology of the Indians of Puget Sound.* Indian Notes and Monographs Miscellaneous Series No. 59. New York: Museum of the American Indian, Heye Foundation.

Waterman, T. T., and collaborators. 1921. *Native Houses of Western North America.* Indian Notes and Monographs. New York: Museum of the American Indian, Heye Foundation.

Waterman, T. T., and R. Greiner. 1921. *Indian Houses of Puget Sound.* Indian Notes and Monographs. New York: Museum of the American Indian, Heye Foundation.

Wilson, C. 1970. *Mapping the Frontier.* Edited by George F. G. Stanley. Toronto: Macmillan.

Woodcock, G. 1977. *Peoples of the Coast: The Indians of the Pacific Northwest.* Edmonton, Alberta: Hurtig Publishers.

TRADITIONAL MUSIC IN MAKAH LIFE

⊦O⊦⟨O⟩⊦⟨O⟩⊦⟨O⟩⊦⟨O⟩⊦⟨O⟩⊦⟨O⟩⊦⟨O⟩⊦⟨O⟩⊦⟨O⟩⊦⟨O⟩⊦⟨O⟩⊦⟨O⟩⊦⟨O⟩⊦

Linda J. Goodman

When I was little, seven or eight years old [in the 1920s], we had to go from here [Neah Bay] to Tatoosh Island by canoe in order to have our Indian dances. We went out in sealing canoes; that was our only trans-portation then. Each family had its own sealing canoe and would load it up with groceries and dried fish and feather beds. Then we'd set off, and I remember being so scared. It's never calm out there, the waves are huge and smash into the rocks on Tatoosh. I used to just hang on to that canoe as we got near there; those waves were so powerful! One time when we were all lined up and trying to get ashore, I heard one of the adults say, "One canoe tipped over!" And then they had to pick them up out of the water. Someone else said, "Another canoe tipped over!" and after that I was even more afraid!

Once we got to Tatoosh we stayed for about a week of celebrations: dancing and singing. My grand-father had an old smokehouse [a lean-to for smoking fish] where we used to stay. We lived there the whole week long. The others would stay with relatives that had smokehouses there too. We'd dance all our dances outdoors on the beach, like we did here in Neah Bay.

Helma Swan Ward, Makah elder

Linda J. Goodman first met and became friends with Helma Swan Ward in 1974. At that time, Dr. Goodman was involved in research on the relationships of Makah music and culture and was living in Neah Bay, Washing-ton. Since 1979 she has been working with Mrs. Ward, compiling her life story, with an emphasis on the place of music in her life. Formerly an Assistant Professor of Music at Colorado College, Dr. Goodman presently is an ethno-historian for the Office of Archaeological Studies, a branch of the Museum of New Mexico, in Santa Fe.

Music and dance remain essential elements in the lives of the seafaring Makah people of Neah Bay, Washington. Much has changed, however, since the 1920s. At that time, Indian ceremonies had been outlawed by the United States government, and members of the tribe had to travel by canoe to storm-lashed Tatoosh Island off the northwest coast of Washington to hold their celebrations.[1] Even threats of imprisonment by government agents did not stop the Makah from secretly holding their ceremonies, and although some activities eventually faded away and others underwent various changes, traditional music has survived and remains significant in the contemporary society. Music is still performed in dif-ferent places and for several types of occasions.

In the past, Makah music functioned most importantly in ceremonies meant to uphold the power and status of the chiefs. Music was also an indispensable element in rites of passage (ceremonies connected with birth, puberty, marriage, and death), secret society activities, medicine and curing, hunt-ing and fishing, warfare, games, and recreational activities.

Most Makah songs were privately owned pieces of property; some were considered more important than others. Strict rules regulated such issues as who could own songs, how they were to be passed to descendants, who could perform them, when and where they could be performed, how they were to be taught, who could learn them, and who could buy, sell, or loan them. The politically powerful men of the village owned the most important songs, and it was these songs which were essential to the proper functioning of the socio-political system.

THE STRUCTURE OF SOCIETY AND ITS RELATIONSHIP TO MUSIC

The Makah socio-political structure of the past was organized around a hereditary, ranked system which included three main classes of people: royalty (chiefs[2] and their immediate families), commoners (distant relatives of a chief, not in the direct line of descent), and slaves (people captured in warfare and their descendants born in captivity). Each group of people had particular rights and duties in the society (Swan 1870:52; Drucker 1963:124; Sapir 1967:30).

As the highest-ranking male, a chief owned all of his family's wealth, privileges, and possessions. This included exclusive use of family-owned names, songs, dances, masks, costumes, and crests (stylized representations of supernatural beings). A powerful chief also owned big-houses, shellfish grounds, salmon- and halibut-fishing grounds, and berrying tracts, all of which he allowed his commoner kin to use (Drucker 1963:121).

The Makah ceremonial system and the music which accompanied it supported this hereditary, hierarchical socio-political system. Chiefs maintained their position primarily by hosting elaborate ceremonies: feasts, initiations, and potlatches (ceremonial displays of inherited privileges, where witnesses were paid to validate the ownership of these privileges). These occasions offered a chief frequent opportunities to perform, before a large number of guests, his most important songs and dances, to display other examples of the wealth and privileges he owned, to enhance his power and prestige, and to honor one or more members of his immediate family. Such ceremonies had little religious significance[3]; they were held largely to increase the status and prestige of the host chief and his family.

Commoners were also allowed to own songs, but these songs were fewer in number and of lesser significance than those owned by a chief. At times a chief would give a song to a commoner in payment for certain help or support rendered (Goodman 1986:380).

Most slaves were owned by chiefs, did their bidding, and had no rights or privileges in the society (Swan 187:10, 54). Slaves were not allowed to own songs, although at times they might be asked to perform a song or dance belonging to their owner.

Thus, the songs owned by a chief helped him maintain his position. It was essential that a chief own many songs and that he use them often on the proper occasions. For each ceremony he hosted, the chief had to select the relatives who would perform his songs. Members of the community knew precisely which songs belonged to a particular chief; when sung at public ceremonies, these songs renewed and strengthened the power of that chief. In the minds of the listeners, the songs evoked particular stories and also recalled the genealogical history of the family from which the chief was descended.

A chief could acquire songs by receiving them in dreams or visions, by inheriting them from his father or grandfather, or by commissioning a song-maker to compose certain songs for a particular event. Occasionally, he might also receive a song as a gift from another chief (Goodman 1978:34).

The songs, rights, and duties of a chief had to be transferred to his heir in a particular manner: the old chief hosted a lavish potlatch, during which he publicly declared his eldest son to be the new chief. Members of the audience witnessed the performance of the songs, as well as the transfer of certain rights and property, and were paid in gifts and money to remember and to teach their children. Since there was no system of writing; the line of chiefly inheritance had to be maintained through the oral tradition. Northwest Coast peoples, and the Makah in particular, chose to make these ceremonial occasions public so there would be no danger of forgetting the succession of chiefs.

Even though the hierarchical system disappeared shortly after the turn of the century, remnants of it are still apparent. Many Makah songs still stand as symbols of the power and prestige of the former chiefs, and the descendants of these chiefs continue to think of songs as valuable pieces of personal property.

THE CONTEMPORARY MAKAH POTLATCH AND ITS SONGS

The Makah still consider the potlatch ceremony and its associated songs to be the "most important." Today, the potlatch is performed to honor an important person, to display family-owned privileges, or, occasionally, to transfer hereditary rights in the appropriate manner. Privileges which may be displayed include songs, dances, masks, costumes, and curtains painted with the family crest. These same items, as well as family-owned names, may be transferred to a new owner during a potlatch. Presently called "parties"[4] by the Makah, potlatches are most often held on the occasion of a birth, marriage, birthday, girl's puberty celebration, wedding anniversary, or a memorial honoring a deceased person one year after his or her death.

Held in the Neah Bay community hall, a Makah potlatch begins with a sumptuous feast, followed by the singing and dancing of numerous family-owned songs. Transfers of names, songs, and/or other family property are made toward the end of this ceremony, which normally lasts from eight to twelve hours. Large quantities of gifts and money, given to high-ranking tribal members and other special guests, serve as payment for witnessing

Figure 1. Girls and boys performing a Feather Dance (group dance) on Makah Day, August 25, 1984. Photograph by Linda J. Goodman.

the events. Every guest receives some form of payment before the potlatch ends. The ceremony often concludes with the entire group singing social songs.

POTLATCH SONGS, DANCES, AND COSTUMES

Several types of songs are sung during the course of a contemporary potlatch: dinner songs, family-owned dance songs, group dance songs, and T'Abaa songs. Dinner songs and T'Abaa songs have no associated dances; the others include dances and appropriate costumes.

Dinner Songs

A potlatch always begins with the singing of two or more dinner songs, followed immediately by the serving of a feast. The singers who wish to participate take their hand drums and gather in the southeast corner of the hall, where they form a chorus and sing to the assembled guests. No one begins eating until the singing of the dinner songs is finished. Helma Ward explained why her people sing dinner songs:

> The reason they have these dinner songs is mostly to thank the people who are giving the potlatch, because everyone knows that it takes so much time to prepare a great big feast; it isn't easy. They realize it's hard to

get started, and you have to know how your feast is going to go over—whether you've done the right thing or the wrong thing. Dinner songs are sung in order to give thanks to the people, and of course... this is their way of also thanking the Creator for what they're preparing and what was given to them in worldly goods and food.

The song texts are filled with vocables (syllables without meaning) or with short statements relating to chiefs, power, or animals. Meaningful text words are few: "There is no tribe that can beat the chief in dancing" (Densmore 1939:160). Song texts such as this generally have little connection to the feast at which they are being sung.

When the singing of the dinner songs is completed, the host family serves the feast. This may include salmon; clam chowder; roast beef, turkey, or elk; potatoes; a variety of fruits and vegetables; salad or cole slaw; Indian and non-Indian breads, cakes, pies, and cookies; coffee and juice. Guests may take home any leftover food in the special baskets they have brought for this purpose. When the feast is finished the tables are cleared of any remaining food, the floor is cleaned, and the performance of family-owned songs begins.

Family-owned Dance Songs

The Makah consider the performance of family-owned dance songs to be one of the most important parts of the potlatch. In a particular prearranged order, each family that traces descent from a line of chiefs has an opportunity to perform several of its own songs and dances. Immediately afterward, the family pays members of the audience in goods and money for witnessing this presentation, which serves as a renewal of ownership.

Family-owned dance songs commonly seen at Makah potlatches today (and normally performed nowhere else) include Wolf dances (pl. 86), Grizzly Bear dances, Eagle dances (pl. 89), Thunderbird dances, and Hamatsa dances (Cannibal dances received from the Kwakwakʸawakʷ [Kwakiutl] tribe through marriage). Generally a pair of songs—e.g., two Wolf dance songs or two Grizzly Bear songs—are sung by each upper-class family participating in the celebration.

Ideally, family members should sing and dance only their own songs. However, since fewer people today know the songs and dances, it is not always possible for all the performers to come from the song owner's family. If members of other families are asked to sing or dance, they are publicly paid afterward and thanked for their help.

When performing family-owned dances, the dancers usually wear costumes, and either masks or "headgears" (headpieces which sit on top of the head). Normally, men are the lead dancers and have the most elaborate costumes. Each male dancer usually wears street clothes, shorts, or a dance skirt beneath an elaborate dance cape. The cape is made either of white canvas with painted crest figure designs or of black woollen cloth with red appliquéd crest designs. Appliquéd figures may be covered with white buttons, thus constituting a Makah-style button blanket. Families own the crest figures, which may not be used by non-family members.

In ancient times the Makah wore skin robes and cedar bark capes; the skin and cedar bark were sometimes painted with crest designs. When canvas became available it was substituted for cedar bark and skin. Only in more recent years have the button blankets, originally more popular in the north, come into common use in Neah Bay.

Many dances performed at potlatches require the use of a headgear—a carved wooden animal figure that sits on top of the dancer's head and is tied on under the chin. Wolves, eagles, thunderbirds, ravens, whales, and lightning serpents often appear as headgears. A particular family owns each of these headpieces, as well as full face masks (usually portraying human faces). Traditionally the men wear the headgears and the face masks. Only on rare occasions

(e.g., an especially important potlatch) are full face masks worn today (pl. 88).

Women dancers may wear either their street clothes or a specially created black, red, or white dress with appliquéd crest designs. Over the dress most women wear black dance capes, either plain or with an appliquéd red crest design. A few, however, wear white dance capes with black and/or red appliquéd designs. Frequently the women wear decorative headbands of olivella shells, red-dyed cedar bark, or glass beads.

Women perform as "side dancers," "background dancers," or "backup dancers," providing support for the men. They move into a large, open, U-shaped formation, then dance in place, simply rotating 180° while moving their arms gracefully from side to side.

The lead male dancer performs in the center of this open space. Beginning in a crouched position, he spins upward in a counterclockwise spiral, and then proceeds to perform the dance which, like all Makah dances, consists of a series of counterclockwise circuits in the central dance area. At various times the dancer bends forward, crouches, or dances fully erect, in imitation of the animal or supernatural creature he is portraying. Head, neck, shoulder, and torso movements help create the desired image. Hands are usually held at the waist, with arms bent at an angle away from the body. This arm position, which seldom changes, allows for maximum visibility of the design on the dance cape. Each dance has its own distinctive song, dance steps, body movements, costume, and mask or headgear.

In the past, each family formed its own chorus, but today, choruses often consist of all the people in the village who can sing a particular song. The song, however, is still owned by the family that retains the rights to it.

Chorus members wear street clothes, a headband, and sometimes a black, painted, or appliquéd dance cape. Each chorus member beats his or her own hand-held frame drum, which is often painted with family-owned crest figures or with non-crest designs of Northwest Coast animals or supernatural creatures.

Group Dance Songs

Group dance songs, considered entertainment songs, are still performed at potlatches; however, many more are now performed annually for Makah Day (a public event occurring each August). Not connected to power and status, these songs may be performed by anyone; most are no longer family-owned. Group dance songs offer all families, with or without hereditary rights and privileges, a chance to take an active part in the potlatch and other ceremonial activities. Occurring as a break between the more serious portions of the potlatch, these songs are often performed

between the family-owned dances, and sometimes near the end of the ceremony as well.

T'Abaa Songs

This group of entertainment songs, sung "just for fun" and usually not accompanied by dances, makes up the last category of songs sung at potlatches. A few are still family-owned. Like group dance songs, T'Abaa songs play little part in raising one's status and are not performed before the giving away of gifts. Anyone may compose and own them. T'Abaa songs serve to draw the crowd together and unite them in song one final time before the potlatch ends. The song texts generally speak of love or other common · social situations:

> I am trying to look as pretty as I can because my sweetheart is in the crowd. He is the reason for it. (Densmore 1939:167).

> What a pity I am getting old! (Densmore 1939:175).

T'Abaa Songs may also be sung when a family gathers for its own small celebration in a private home or when the participants wish to sing after a meal at the Senior Citizens' Center in Neah Bay. Such songs are cherished, especially by older people.

INITIATION CEREMONIES

In days past, initiations into Makah secret societies included the performance of special songs and dances. Best known among these ceremonies are the Klookwalli and the Hamatsa.

Klookwalli (Wolf Ceremony)

The Klookwalli, no longer performed by the Makah, was a ceremony in which children and young adults were initiated into the secret society of the same name (Swan 1870:66–69; Boas 1890:599; Ernst 1952:12; Colson 1953:178–79). Even though certain parts of the ceremony emphasized rank and status, the Klookwalli society was not limited to the elite upper class. Everyone was initiated sooner or later, and received a certain amount of prestige as a result. Even slaves could be initiated (Drucker 1951:391).

The Makah Klookwalli consisted of a five-day ceremony. New initiates were abducted by "wolves" and carried away into the woods. They were later returned to their village and placed in the Klookwalli house, where they began learning about the origins and history of individual family ancestors as well as secret and sacred family property such as songs, dances, masks, costumes, and names. Some of these items eventually became the property of the young initiate, who claimed them in a series of dances later in the ceremony (Ernst 1952:11–13, 25–27).

Much music accompanied the Klookwalli, most of it family-owned. Ts'ika (sacred, family-owned

Figure 2. Boys performing a Taming the Sea Serpent Dance (group dance) on Makah Day, August 25, 1984. Photograph by Linda J. Goodman.

chants), performed during the first four days of the Klookwalli, could be sung by either men or women and indicated that an important event was about to take place (Ernst 1952:14; Sapir and Swadesh 1955:248–49; Sapir 1913:69). No dancing accompanied these chants. Helma Ward explained Ts'ika as follows:

> A Ts'ika (chant) is a kind of prayer that things will go well and that nothing will go wrong. A chant says the same thing over and over…it doesn't have a melody. It stays mostly on one tone and sometimes slides up or down—close to Indian praying in sound….It is always done with a rattle, never a drum. Ts'ika is not the same as a song; it is a chant to help out with something; it is a prayer.

Ts'ika singers, shaking their black bird rattles, accompanied processions around the village and were present at most major Klookwalli activities.

Songs, on the other hand, were quite different. According to Mrs. Ward, "A song was always sung after a chant. A song has a drum and a beat. It has a melody and it has words." Family-owned imitative songs, which always had accompanying masked dances, were performed toward the end of the Klookwalli. At different times, both older members and novices performed some of these dances, which included Wolf, Deer, Black Snipe, Wild Man (pl. 91), Basket Woman, Raccoon, and Woodpecker dances. Periodically throughout the ceremony, wolves howled and various whistles sounded, indicating the presence of supernatural beings.

On the fifth day of the Klookwalli, after the serious portions of the ceremony were completed and all the initiates had danced, the new members lis-

tened to a series of closing speeches by their elders. The young members were informed of the proper ways to live and of the ritual practices they must observe in order to be good people (Ernst 1952:37). The entire ceremony ended with a potlatch (Swan 1870:72–73; Ernst 1952:27).

Today, no vestige of this ceremony remains. Its last recorded occurrence was in 1932 (Ernst 1952:vii), although it may have persisted a few years beyond this date. Elders now living in the village have no memory of attending a Klookwalli as children.

Much of the music for the Klookwalli has also disappeared. A few Ts'ika chants survive and are occasionally sung before family-owned dance songs at potlatches. Remaining Wolf dance songs, now performed as family-owned dances during potlatches, usually include one or two male dancers wearing plywood, painted, wolf headgears or carved, solid, wolf headpieces. Some of the imitative dances which formerly belonged to specific families and were performed on the fourth and fifth day of the Klookwalli have now become group dance songs, generally performed unmasked, for fun and entertainment on Makah Day.

Hamatsa (Cannibal Ceremony)

Portions of another initiation ceremony, the Hamatsa, which originally belonged to the Kwakwakʸawakʷ (Kwakiutl) people to the north, were acquired through marriage by some Nuu-chah-nulth (Nootka) groups on Vancouver Island and also by the Makah. Among the Kwakwakʸawakʷ, this secret initiation ceremony was, and still is, an elaborate theatrical performance known as the Cannibal dance. The new initiate, the Hamatsa dancer, must be of noble birth. He is carried off for a number of days and receives supernatural power; when he reappears, he is possessed by a cannibal spirit and has to be tamed. During a series of dances he is wild; he tries to bite other Hamatsa members, and is appeased with pieces of "corpses." At the proper time the Hamatsa dancer disappears behind a special curtain; then his monster bird associates come forth and dance. Upon completion of the monster bird dances the Hamatsa returns, having become tame for his final dance (Holm 1977:15).

The Makah seem never to have adopted the full Hamatsa. A complete version is unknown by present Makah elders. Rather, single songs and dances were received as wedding gifts by particular families and were then performed as part of the Klookwalli, at potlatches, or for Makah Day.

Today, Hamatsa dances are performed as family-owned dances at potlatches. The lead dancer, always male, wears a pair of shorts, a braided cedar bark bandolier, and a cedar bark headband. He crouches, leaps, and moves wildly in a counterclockwise cir-

cuit, all the while shouting, "Haam! Haam!" in a deep, threatening voice. His countenance is intense and scowling. His right hand is raised and trembles above his head; his left hand is lowered and trembles by his left side. Female relatives dance backup in the traditional U-shape around him, and a chorus of singers provides the music and drumming. Depending on the kinds of songs a family has inherited, a Hamatsa may next perform an upright dance with high steps. A Hamatsa performance consists of either a single dance or a pair of dances.

CURING CEREMONIES

General Curing Rituals

Music was central to curing activities of the past. Cures always involved the singing of special songs by the Indian doctor and sometimes by an assistant. Singing, beating on wooden planks, and shaking special shaman's rattles were indispensable parts of the cure. Other elements included the removal of foreign objects from the patient's body by hand or by sucking, and the application or ingestion of herbal medicines prescribed for the patient's particular ailment (Drucker 1951:202–7; Goodman 1978:45). The last known Makah medicine woman, Alice Kalappa, was active in Neah Bay in the 1940s. Curing songs have seldom been sung since that time.

Tsayak (Medicine Ceremony)

The Tsayak was a secret society whose members performed curing ceremonies for chronically ill patients who either dreamed or had a vision that this ceremony should be performed for them. Specifics of the ceremony are unknown, but in general the sick person first envisioned a certain supernatural being with long yellowish hair, who appeared in the night and promised relief if the prescribed ceremonies were performed. This vision was followed by three days of secret rites, which included continual singing and drumming. The dancers stood in a circle, and each sang his or her own song, either inherited or acquired in a dream. More women participated in this ceremony than men, although both had certain roles. After the patient was initiated into the secret rites of the ceremony, the doctor began singing over and manipulating the patient's body. As part of the ritual, new members had to be initiated at the same time the patient was being cured. Participants wore special costumes and headdresses and painted their faces red, blue, and black (Swan 1870:73–75; Densmore 1939:302).

On the fourth day, public ceremonies were held outdoors, and non-initiates could be present. The participants moved in procession down to the beach. Once there, they engaged in a shuffling circle dance around the patient and initiate, who were seated on

the ground in the center. A chorus sang, drummed, and shook rattles. Eventually the entire group returned to the lodge where the earlier secret ceremonies had occurred; dancing and singing continued there for several more days. A potlatch ended the proceedings (Swan 1870:73–75).

According to Frances Densmore (1939:302–3), an early ethnomusicologist who recorded Makah music in the 1920s and 1930s, Tsayak songs were sung in pairs: the first accompanied by very fast beating on wooden planks, and the second by a regular, steady drumbeat. A dance was performed to each song.

By 1926, the Tsayak had disappeared as a ceremony; however, some of the songs and dances were still being performed for Makah Day (Densmore 1939:302). Today the songs and dances have disappeared as well. With the adoption of Western medicine, traditional curing and the Tsayak songs are considered irrelevant by many and therefore are no longer a standard part of Makah medical procedures.

TLA'IIHL (Spirit Renewal Ceremony)

Another Makah ceremony, called Tla'iihl, was either borrowed from or performed with members of the Quileute tribe to the south. This ceremony helped renew supernatural power, given originally by a guardian spirit. Songs were an essential part of the process. Helma Ward, recalling a ceremony she attended as a child, indicated that Tla'iihl was for the purpose of "getting under power" (similar to going into a trance):

> They get under power…they just sort of start shaking and they keep on and keep on, and they can't quit singing. Each person will be singing about a half hour or forty-five minutes. They stand there and swing their hands from side to side and keep on singing. They sing one song after another until they run out of songs or until somebody makes them sit down and somebody else gets up and does the same thing. Of course they don't get under power right away, they just get up and start singing and gradually it sort of builds up and comes over them.

A Tla'iihl ceremony began with the singing of T'Abaa songs, sung "just for fun." Gradually the mood shifted and people began singing their individual Tla'iihl songs. The beat of many T'Abaa songs was the same as that of Tla'iihl songs, though the songs themselves were different. Therefore it was easy to switch from one kind of song to the other.

The Tla'iihl was considered a serious ritual, and once it began no smiling or joking was allowed. Normally, children were not allowed to attend. The songs for this ceremony were individually owned and were acquired through dreams, visions, or inheritance. Meaningful texts were short:

> I am a doctor and my individual spirit power comes from the squirrel.

This short text was enough to remind the owner of the story and the spirit power which accompanied the song. An entire recounting in words was not necessary. According to Helma Ward:

> The Tla'iihl doesn't have any healing powers. It's just that they go under power and then they are dancing, they're singing. And then sometimes when they were like that they used to get a song. Those that were really in it fully, every once in a while somebody would get a song out of it.

This ceremony no longer exists, although a few of the songs are still sung occasionally for family members.

WAR SONGS

War songs were sung at several different times and places. Before a war expedition took place, each man bathed, prayed, and sang in his own secret spot. Some war songs were sung on the beach before the group left on an expedition; others were sung just before launching the attack. Joyous songs were sung when warriors were returning in canoes after a successful battle. Victory songs were performed at a celebration in the village after the return of the successful war party (Swan 1870:50–51; Densmore 1939:182–91). Today, a few victory songs are sung occasionally at potlatches; other war songs, however, are no longer performed.

WHALING SONGS

Whales were an important food source for the Makah, and whaling was a primary hunting activity until the early 1900s. Each whaler had his own secret rituals, which he received when he went on a spirit quest. His guardian spirit bestowed whale-hunting powers on him and taught him the proper prayers, songs, and ritual bathing techniques, as well as how to hunt and harpoon a whale and tow it back to land. Once he acquired the power, a man had to continue to follow strict ritual procedures to keep himself strong and pure for whaling. Eventually he passed this knowledge on to his son and, later perhaps, to a grandson. Each individual had to seek his own guardian spirit, but was helped by his male elders.

Each whaler received from his guardian spirit at least one song, and frequently many, which gave him special whale-hunting power. Since his songs were powerful and brought him good luck, he used them every time he went hunting. He sang certain whaling songs while fasting, bathing, and praying before the hunt.

After harpooning and killing a whale, the whaler and his crew sang many towing songs as they

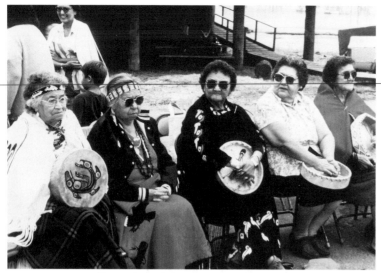

Figure 3. Makah Day singers in costume, waiting for dancers to arrive. Left to right: Helen Peterson, Ruth Claplanhoo, Helma Ward, Muzzie Claplanhoo, Meredith Parker. Neah Bay, Washington, August 25, 1984. Photograph by Linda J. Goodman.

brought the whale back to land. Each whaler had his own song, which brought him continued success, as may be seen in the following short text: "My name will be high!" (Curtis 1916:18). A whaler always gained status, prestige, and wealth by killing a big whale and bringing it home; thereafter, his "name would be high." Towing songs were sung in order "to make the dead whale's spirit feel proud to hear the crew singing happily and to make the spirit willing to let the dead body tow lightly behind the canoe" (Curtis 1916:32).

> Raven, Mountain Chief, I am going home with my whale in tow, to pour the fat of it on my fire (Curtis 1916:32).

A portion of the blubber taken from between the head and the dorsal fin of the whale, which forms a "saddle" and is considered the choicest part, was always the property of the person who first harpooned the whale. He took it home and hung it in his house, where it was carefully decorated and treated with respect. While it hung there, the oil was allowed to drip out into a trough. Songs have been recorded which concern this custom:

> My supernatural power is in the house, hanging on a staff at the head of my bed (Curtis 1916:37).

When the saddle was considered ready, it was served as a feast to invited male guests (Sproat 1868:60; Swan 1870:22).

If a whaler had killed several whales and rendered a great deal of blubber into oil, he could give an oil potlatch, where he demonstrated his wealth by pouring oil on his guests and on the fire. At one time, the Makah considered an oil potlatch to be the most important one a man could give (Densmore 1939:66–72). At this potlatch many non-sacred, family-owned whale songs and dances were performed by both men and women. Often the performers imitated whale movements and harpooning activities. The whaler's elk horn rattle provided accompaniment for certain songs; others also included the use of plank drums with wooden beaters (Densmore 1939:66–72).

By approximately 1910, whaling was no longer economically viable, and consequently the Makah ceased their whaling activities. The individual spirit quest, along with other whaling rituals, disappeared, as did most of the songs. Since the Makah now consider the few remaining whaling songs to be sacred, family-owned songs, they are carefully guarded and only occasionally performed at potlatches.

Bone Game Songs

The Bone Game, greatly loved by many Makah of both past and present, is an entertaining gambling game played by two opposing teams. Forming an integral part of the game are numerous songs used to confuse the opposing team and cause them to lose. Originally, these songs were thought to possess certain kinds of supernatural power which helped one's team to win. No dancing accompanies bone game singing, although certain dynamic hand and arm gestures are used to bring power to one's side and to confuse the opponent's side. Intense singing and drumming heighten the excitement and tension of this ever-popular game. While some of these songs were formerly family-owned, none are now (Goodman 178:124).

Makah Day Songs

The first Makah Day occurred on August 26, 1926, when members of the tribe formally celebrated their new legal status (granted in 1924) as American citizens (Hoonan 1964:23; Goodman 1977:19)

> The reason we celebrate Makah Day now is because the government in 1926 set us free,[5] and so our people decided well we're going to have Makah Day now. Now we can bone game and have our Indian dances right here on the reservation. Before that time the government didn't think it was right for us to have bone games or Indian dances. That was why the Makahs went to Tatoosh Island to do all this.
>
> In 1926 they invited whole Vancouver Island to come across and celebrate Makah Day. I remember the Canadians coming. They would come in their own boats; regular fishing boats they brought from across there. They would come in those and tow their sealing canoes behind their boats. They'd all stop in line out here. They wouldn't get off until everyone was in—all the different tribes from there—19 tribes.

BASIC ELEMENTS OF MAKAH MUSIC

Makah music is predominantly vocal, with accompaniment by drums, rattle, or hand-clapping. Most Makah songs are monophonic—they consist of one melodic line which may be sung by an entire chorus, accompanied by percussion instruments. Melody lines generally rise and fall in an undulating pattern. Repetition or prolongation of one pitch often occurs at the beginning or ending of a phrase. Repetition of phrases is common, though repeats are usually not exact. Small changes in melody or vocal ornamentation may occur.

The structure of the songs does not fall into any easily definable pattern; each is an individual creation. Most (though not all) songs have two or three phrases which repeat a varying number of times. For most occasions, two songs of the same type are sung in pairs. The same two do not always have to be paired, however.

Makah song texts consists of two parts: meaningful words and vocables. Meaningful song texts communicate information about supernatural beings, important chiefs, animals, stories, and events. Since, in the past, the Makah learned the circumstances and the story accompanying each song, the text was usually quite brief. The few words present in the old songs related key ideas, events, or characters, thus evoking an image of the complete story. A short text, serving as a reminder of the general topic, was all

that the Makah felt was necessary (Goodman 1978:138–39). James Swan noted this phenomenon when he was describing Makah music over 100 years ago (Swan 1870:49), and it still exists today.

Vocables consist of groups of syllables without any specific meaning, such as *fa la la* in English folk songs or *he ne ya* in some Navajo Indian songs. Occasionally, certain meanings do become attached to a particular group of vocables. For instance, among the Makah, *hu hu hu* can mean the end of a section or the end of a song; *hii yi hii* can stand for the cry of a supernatural wolf. Most Makah vocables have no meaning, however. Makah songs usually contain more vocables than meaningful text.

Rhythm in Makah music is sometimes simple and straightforward and at other times quite complex. Some drum patterns remain constant throughout a whole song, while in other songs the drum pattern changes once or several times, usually to emphasize certain words, to signal a change in dance steps, or to introduce a new section of a song. The basic beat patterns, mostly in groups of two or three beats, may be used alternately within a song or may be played and sung simultaneously, creating cross-rhythms. Singers, drummers, and dancers must know the song well before they can perform these rhythmic patterns correctly (Goodman 1978:137–38; 1986:381).

They would line up and tie their boats and make a straight row. Then they'd anchor and untie their sealing canoes. Then they'd all get in and they'd wait there. They wouldn't move until the Makahs were all on the beach.

This was the beginning of Makah Day when the visitors got here. Then the Makahs would start singing, beating their drums. They would be singing loud. It was beautiful because they had all those male voices like we don't have now. The Canadians with their blankets and everything would get in their sealing canoes while the Makahs were singing. When the Makahs finished, they were all ready in line out there in their sealing canoes and then they would start paddling and come ashore. Then they would take their turn singing while they were coming ashore. When they got through, the Makahs would sing again. They'd sing two songs and we'd sing two songs and by that time they would be all ashore. The Makahs would pull their sealing canoes in…

One year my father and Fred Hunter got together and made a great big thunderbird that must have been about 12 feet high for Makah Day. My dad was a carpenter so he was able to do something like that. They put it on a barge and set it out in the water. The bird's head could turn. My dad stayed in it

and kept the head turning while the Canadians came in. When the Makahs started singing, the thunderbird started making noise like a regular bird and the head would turn. That was really something. Later they pulled the bird back onto the sand again. I don't know what ever happened to that bird. (Helma Ward).

After this elaborate welcoming ceremony, there followed during the rest of the day a series of games, races, Indian dances, and a salmon feast.

Makah Day still occurs each year on a weekend near the end of August and includes essentially the same activities. Since important family-owned dances are not appropriate for this occasion (they are used only for potlatches), group dance songs are most often performed. These include the Feather, Canoe, Silent Deer, Spear, Knife, War, Snipe, Sea Serpent, Swan, and Thunderbird dances. Always well-rehearsed, dance movements are imitative of the animal or event represented. Dancers are mostly children, teenagers, and young adults. The chorus consists largely of elders. Most Makah enjoy the annual Makah Day events, which bring together and help unify the people of Neah Bay.

MUSICAL INSTRUMENTS

Makah musical instruments consist of whistles, rattles, and drums. The latter two are generally used to support singers and provide percussive accompaniment for dancers.

WHISTLES

Whistles were made of two hollowed-out pieces of wood, joined at the ends and sometimes in the middle. Some were open on the bottom; others were not. Their lengths and widths, as well as the mouth pieces and inner cavities, varied in size to produce the different kinds of sounds desired (Goodman 1978:118–19).

Whistles were not actually used as accompaniment to songs. Rather, they announced the presence of certain supernatural beings who appeared for the Klookwalli and for some other secret society ceremonies. Whistles were blown before a song began, and between its various segments.

As family-owned possessions, whistles were normally inherited by the oldest son. Made and used in pairs, they usually represented male and female or a larger and smaller animal of the same species. Whistles imitated the sounds of bear, wolf, owl, loon, eagle, thunderbird, or sandhill crane. They were used in conjunction with certain masks, costumes, and songs in specific ceremonies. Makah whistles could only be handled and blown by properly initiated men; they were not to be seen by the general population. They are seldom used today.

RATTLES

The *scallop-shell rattle* consisted of a series of scallop shells strung on a hoop. These were used by medicine men and also by lead dancers on the last day of the Klookwalli (Densmore 1939:28; Ernst 1952:30). Several other types of hoop rattles existed; these were strung with either deer hoofs or puffin beaks.

A *baleen rattle* was made from whale baleen. A pliable piece was folded in half, pebbles were placed inside, the edges were sewn, and a handle was attached. These were used by shamans (Drucker 1951:193).

An *elk horn rattle*, similar in size and shape to the baleen rattle, was made of thinned and soaked elk horn, folded and sewn after pebbles were placed inside. These were used by whalers in their secret rituals (Densmore 1939:28).

A *bird-shaped rattle* was carved and hollowed from two pieces of wood which were fitted and then sewn together after seeds or pebbles had been placed inside. The bird form, carved in smooth, flowing lines, was usually painted brown or black (see pl. 90). These rattles accompanied sacred Ts'ika songs used in the Klookwalli (Ernst 1952:14,19). Today they may be used for special occasions; the other rattles are no longer used.

DRUMS

Box drums, four to six feet high and six to eight feet long, were made of cedar boards, which were tied together with sinew or root fibers. A drum of this kind, placed in the longhouse, was used in the past for most ceremonial occasions. Two men sat on a platform above the drum and beat on it with their heels. The drum was quite sturdy and produced penetrating, powerful sounds. This type of drum is no longer made or used.

Log drums, about two and one-half feet long, were hollowed out and laid on the floor of the longhouse. Two of them were placed on the floor below the box drum, and one drummer beat on each. These drums were used in conjunction with the box drum (Ward 1988: pers. comm.).

Plank drums consisted of one or more long wooden planks which were raised slightly above the ground and struck with wooden batons about a foot long. Typically, several people beat in unison on one board. A number of these boards were normally present any time songs were to be sung. Plank drums were used for feasts, potlatches, the Klookwalli, other secret society ceremonies, and bone games. They normally accompanied voices and could be used in conjunction with the other types of drums. Plank drums are no longer used by the Makah.

Frame drums (hand drums) range in diameter from six inches to two feet and have a depth of two and one-half to three and one-half inches. The steamed and bent frame, often made of yellow or red cedar or Sitka spruce, is covered with deer or elk hide. One end of the wooden beater is covered with stuffing and a soft piece of hide. Frame drums belong to individuals and frequently have family crests or other Northwest Coast designs painted on the hides. Each person uses his or her own drum for feasts, potlatches, bone games, Makah Day, or other music-related activities. This is the only type of drum presently used by the Makah.

CONCLUSION

Although many changes have occurred with the passage of time, Makah music still retains its beauty and vitality. While no new songs are presently being created, the old ones which remain in the repertoire are diligently guarded and cared for by their owners. Each family records its own songs and carefully teaches them to the next generation. Tribally owned group dances are taught by the elders to the children in school. In part because the people strive to maintain their unique traditional music, Makah culture, with its rich ceremonial life, continues to thrive.

NOTES

1. Though the specific document ordering the banning of Indian ceremonies in the 1880s has not been found by the Bureau of Indian Affairs or other government agencies, its existence is clearly indicated. The Annual Report of the Commissioner of Indian Affairs, 1890, states:

> All heathenish and barbarous practices I have endeavored to stop and where possible prohibit altogether, such as the "Cloqually [Klookwalli] Dance"....Potlatching of all kinds...has been carried on here without stay or hindrance, and I have had a great deal of trouble in carrying out the *instructions of the Indian Department* in this matter. I have been successful in a measure, so much so, that it is practically stopped on the reservation, though they now give potlatches on an island near Cape Flattery, in the Pacific Ocean (1890:224). (Emphasis added.)

2. A chief, among the Makah, was the head of an extended family. Several chiefs could live in the same village.

3. Religious rituals relating to personal spirit power and to curing also existed, but were not directly connected to the socio-political system. These rituals, mostly performed on an individual basis, focused on the attainment and proper use of supernatural power and did not, in and of themselves, raise one's status and prestige in the society (Swan 1870:66). Today these activities and the accompanying music are carried on in private by only a few individuals.

4. Because potlatches and other ceremonies had been outlawed since the late 1880s, the Makah began having "parties," thinly disguised potlatches. A letter from Raymond H. Bitney, Superintendent for the Neah Bay Indian Agency in 1931, states:

> There is no doubt as to the harm of these Indian parties where they give away money, clothes, etc....The potlatch, which is masked as a birthday party, christening party or wedding party is going to be very difficult to stop at once. All of their old customs and practices have been revived in the past seven years and flourished up to about a year ago. The Indian Police were instructed to arrest anyone giving away money at a party or playing the bone game for money....For the past year, this office has been closing down on them more and more in an effort to stop these harmful practices (Bitney 1931).

5. The Makah were once again allowed to sing, dance, and hold their ceremonies.

REFERENCES

Bitney, Raymond H. 1931. Letter of March 3, 1931, to the Commissioner of Indian Affairs, Washington, D.C. Seattle Federal Archives and Records Center, Record Group No. 15, Taholah, Box 102, File 150: Inspections, Investigations, Reports, etc., Neah Bay Agency.

Boas, Franz. 1890. *The Nootka*. British Association for the Advancement of Science 69:582–604.

Colson, Elizabeth. 1953. *The Makah Indians*. Minneapolis: University of Minnesota Press.

Commissioner of Indian Affairs. 1890. *Annual Report of the Commissioner of Indian Affairs to the Secretary of the Interior*.

Curtis, Edward S. 1916. *The North American Indian*, vol. 11. Norwood, Massachusetts: Plimpton Press.

Densmore, Frances. 1939. *Nootka and Quileute Music*. Bureau of American Ethnology, Bulletin 124.

Drucker, Philip. 1951. *The Northern and Central Nootkan Tribes*. Bureau of American Ethnology, Bulletin 144.

————. 1963. *Indians of the Northwest Coast*. Garden City, New York: Natural History Press.

Ernst, Alice. 1952. *The Wolf Ritual of the Northwest Coast*. Eugene: University of Oregon.

Goodman, Linda J. 1977. *Music and Dance in Northwest Coast Indian Life*. Occasional Papers, vol. III, Music and Dance Series No. 3. Tsaile, Arizona: Navajo Community College Press.

————. 1978. This is My Song: The Role of Song as Symbol in Makah Life. Ph.D. diss., Dept. of Anthropology, Washington State University. Pullman, Washington.

————. 1986. Nootka Music. The New Grove Dictionary of American Music 3:380–382. London: Macmillan Press, Ltd.

Holm, Bill. 1977. Traditional and Contemporary Kwakiutl Winter Dance. *Arctic Anthropology* 14:5–24.

Hoonan, Charles E. 1964. *Neah Bay, Washington*. Seattle: Crown Zellerbach Corporation.

Mozino, Jose Mariano. 1970. *Noticias de Nutka*. I.H. Wilson ed. and trans. American Ethnological Society Monograph 50, Seattle: University of Washington Press.

Roberts, Helen H., and Morris Swadesh. 1955. Songs of the Nootka Indians of Western Vancouver Island. *Transactions of the American Philosophical Society*, 45(3):199–327.

Sapir, Edward. 1911. Some Aspects of Nootka Language and Culture. *American Anthropologist*, new series 13:15–28.

————. 1913. A Girl's Puberty Ceremony Among the Nootka. *Transactions of the Royal Society of Canada*, 3rd series, 7(2):67–80.

Sapir, Edward, and Morris Swadesh. 1955. Native Accounts of Nootka Ethnography. *International Journal of American Linguistics* 21(2):1–452.

Sproat, Gilbert M. 1868. *Scenes and Studies of Savage Life*. London: Smith, Elder, and Co.

Swan, James G. 1870. *The Indians of Cape Flattery*. Smithsonian Contributions to Knowledge, no. 220.

STORYTELLING IN THE OLD DAYS

ᚻ⧉ᚻ⧉ᚻ⧉ᚻ⧉ᚻ⧉ᚻ⧉ᚻ⧉ᚻ⧉ᚻ⧉ᚻ⧉ᚻ⧉ᚻ⧉ᚻ⧉ᚻ⧉ᚻ⧉ᚻ⧉ᚻ⧉ᚻ⧉

Helma Swan Ward

*B*orn in the village of Neah Bay, Washington, in 1918, Helma Swan Ward is a member of the Makah Indian tribe. She grew up in Neah Bay and learned about Makah culture and customs from her father, Charles Swan, and her maternal grandfather, Charlie Anderson. Both were concerned that she receive a proper Makah education and that she speak the Makah language fluently. Her grandfather had a big house on a point overlooking the Pacific Ocean, and as a child, she spent a great deal of time there and attended many storytelling events such as the one described here. At the time of this storytelling, when Helma was eight or nine years old, all stories were told completely in the Makah language.

Storytelling turns travel in a counterclockwise direction as do other ceremonial events. Dance circuits are always performed counterclockwise, and individual dancers use a counterclockwise spinning movement as they begin and end their dances. This is always the way in which these things are properly done; the symbolic significance is no longer known.

Mrs. Ward refers to "buckskin bread," which is a white flour bread, big and flat, baked on a piece of floured newspaper. When cooked, the bread has the color and texture of buckskin. Mrs. Ward also refers to several major characters who figure prominently in a number of Makah stories. Kwaati, a mischievous trickster, was involved in many adventures. Ishkus was a mean ugly old woman who stole misbehaving children. The Snot Boy (created when his mother blew her nose and the snot fell into a clam shell) saved the children stolen by Ishkus. The Changer was responsible for creating many things in the Makah world. According to the version of the Changer story presented here, people were already in existence before

the animals were created. Human beings, much to their chagrin, were turned into animals by this powerful character. Among the Makah, each family had its own version of the same story; different individuals might tell it differently.

Our thanks to Linda J. Goodman for her work in compiling this reminiscence.

Her name was Katie, Katie Anderson, and she was my step-grandmother. She was our storyteller. She was a *beautiful* storyteller! We used to love to listen to her when we were kids, because she could really put *expression* into her stories. You could sit and listen to her anytime. But she wouldn't tell stories just anytime. She used to say, "I can't tell stories unless it's dark!" We had to wait till after dark to listen to her. There were times also when there were a dozen or more couples (neighbors and relatives) and they would all come over and they'd start telling stories.

Sometimes when my grandfather, Charlie Anderson, got through doing his chores, like fixing his garden, or tilling, or after haying season, when the hay was all in the barn, he often felt like he wanted to tell stories, so then he and his wife would get ready. My step-grandmother would fix some food…she always made two or three great big buckskin breads, just big and round, like that. She'd know just about how many were coming and she'd be ready for them.

Those relatives and neighbors were scattered all around out there (in the area around Green Point and Tsooyez Beach) so my grandfather had to let them know he wanted them to come over for storytelling. Well, in order to signal the people, if it was dark, he'd use a light…because they could see his house up on top of the hill there. He'd invite them by so

many flashes—he'd cover the window, you know. My grandfather also had a big triangle-shaped iron out there which he would sound. It would all depend on which way the wind was blowing—he'd always watch. That triangle iron rang so loud they could hear it clear up the river. He'd have to use it maybe two or three times, waiting for the wind to carry. That was the way he'd carry these invitations to them and then they'd come up about an hour later.

When they arrived, my grandfather would feed them first, give them a good feed, you know, then he'd roll out a mat. They used mats made out of cattail. Some of them were four foot wide, some they made about a foot and a half wide. Every person had one of these mats. They'd take off their shoes at the door and leave them there. Then they'd roll the mats out and everybody would sit down on a mat. The short mats they'd leave rolled up for pillows. Then they'd all lay down and then they'd say, "Now, *you* tell a story!" And they'd take their turns going clear around the room counterclockwise—each one of them telling the same story, but yet it came out a little different.

My friend, Ramona, and I used to fight to be next to my grandfather. So he'd say, "Well, you get on one side and she'll get on the other side." Then my step-grandmother, Katie, would be sitting up and she'd start telling those wonderful stories. During those evenings we really enjoyed ourselves. Us kids would lay there, and just listen to the stories. We were taught to be quiet. We were taught never to run around, never to make noise during the time they were telling stories. There was really no noise at all. So everyone would just lay around there, on those mats, and listen and listen, and one would say to the next, "Now it's your turn to tell what you know about Kwaati." And each one of them would give the versions of the stories that their parents had told them. But they were still all about Kwaati or Ishkus or the Snot Boy or whales, or others. I bet the kids now would give anything to be able to understand Indian and listen to these stories, because sometimes there's hardly any meaning to it when you have to bring it out in English. It's hard; sometimes the story loses all its meaning.

One story they told was about the Changer.

One time, word got out that he was coming—that this Great Maker was coming and he was going to change the world. He was going to do what he felt like doing, and he wanted to change the world. And at that time there were no animals on this earth, just people. No animals at all. And he decided he was going to make animals, so away he went.

Then a runner from each tribe went from tribe to tribe and said, "Did you know that the Maker of Things is coming…he's going to change you into different things." "We don't want to be changed," they

Figure 1. Helma Swan Ward wearing her dance dress. A copper (symbol of a chief's wealth) is appliquéd just below the neckline; whales are appliquéd above the hemline. She carries a shawl over her left arm. A grizzly bear is painted on her drum. Photograph 1975, by Linda J. Goodman.

Figure 2. Paulette Daniels Hanson, Helma Swan Ward's niece, and Charlie Swan, Ward's father. Paulette holds whistles that perhaps are the grizzly bear whistles given to Charlie Swan by Annie Williams from Clayoquot. For this photograph Charlie wears Hamatsa gear over a painted dance cape. Today, the Hamatsa headring and neckring would be worn with shorts. Photograph by J. W. Thompson, courtesy of Lucile Muntz.

Figure 3. Paulette Daniels Hanson and Charlie Swan, about 1955, with masks from the Changing Mask Dance, owned by Charlie Swan. These masks were made by Atliyu, a carver from Clayoquot. Photograph by J. W. Thompson, courtesy of Lucile Muntz.

replied. "You better get ready," the runner said, "because he's going to come and change you if you happen to be there when he gets here. So, either hide or do whatever you're going to do."

So, they all got ready—they were going to kill him because nobody wanted to be changed into anything. So they all started making ready with their weapons—some of them made spears, some of them made hatchets to kill him with.

And there was this man—he was making a mussel shell knife…it was going to have a handle. This man was going to catch the Changer unawares…he was going to hit him…just cut him and kill him that way. So, this man was sitting there one day, really busy, just sharpening this mussel shell and getting it as sharp as he could. Well, here comes a stranger, and this man didn't know who he was. The stranger stood there and watched him sharpening his shell. Finally he said, "That mussel shell looks real sharp, what are you doing with it?" "Well," the man said. "didn't you hear? Didn't you ever hear? We got news

that there was a Changer, a New Creator coming—that he was going to change us to whatever he wanted to, and we don't want him to do it. None of us want to be turned into anything else, so we're all getting ready for him."

And this man didn't think to ask the stranger who he was or anything. So, the stranger said, "Well, that looks pretty sharp, why don't you let me handle it and look at it?" So he took the mussell shell, opened it up and put it on the man's head, and said, "Don't you know, these would make real nice ears for a deer, wouldn't they?" The man said, "Yeah, that's right, they would." The stranger said, "All right, from this day on, you're a deer." And the man turned into a deer, and he jumped. The stranger said, "You're a deer from now on; you're going to feed your people, you'll be feed for your people…that's all you'll ever be. You're going to be meat on the Indian's table…the people's table." So, the deer jumped and he took off. From then on we had deer.

So, the stranger went on and on, and he asked

different ones that he ran across like that. One time he said to a man making a paddle, "Do you know this paddle would make a real good paddle, but you're not going to use it for a paddle, except for hitting the water. Today you're going to be a beaver." So that's why they have tails like they do now.

And he went on and he saw a man sitting there making the paint for their faces. The stranger asked him what he was doing, and the man said, "Oh, we're going to have a potlatch and this is just paint for across your face." "That's very good," the stranger said, "let me see it." So he puts his hand in the black paint and he smears it across the man's face, and he says, "Now, from now on, you're a raccoon." Then he went on and on to different animals like that, and changed what he wanted to change. So this was the Changer. They didn't know him. He was a very nice looking man at that time, they said, and they trusted him. Finally the Changer left, and from that time on the Makah had animals. This is how the animals came to be.

So this was one way they would tell this story.

Sometimes if the storytelling went real late, everybody was prepared to stay there overnight. When they were through telling stories, of course, we'd eat...have something. And then they'd just lay down right where they were and go to sleep.

Sometimes they'd go on telling stories maybe two or three nights. Maybe they'd each bring something...maybe dried fish or fresh fish...whatever they had. Then the next day, they'd all get up and those that were close would go home and then come back at night. Those that had to paddle down from the river, some of them didn't go home. They'd go down the beach or visit other families or maybe they'd gather sprouts or cranberries. They didn't stay around my grandpa's house during the day. They'd bring their lunch with them and then they'd be back in the evening again, to continue with the stories.

Ah, there was some *good* stories. *Really, really* good! But then, as part of it, after I thought back about it, thought back on those years, there was always a moral to the story. More or less, they were telling us how to live our lives.

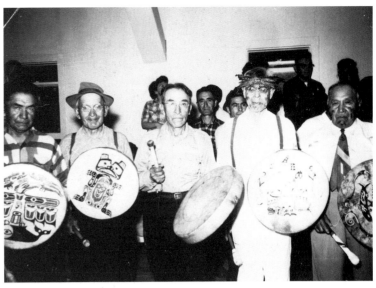

Figure 4. Makah Day singers group, from a potlatch held in the hall at Neah Bay, in the 1930s or 1940s. Left to right: Larry Irving, Jerry McCarthy, Dewey McGee, Alec Green, Sebastian LeChester. The drums held by the two men at the left were made and owned by Charlie Swan. Photograph by J. W. Thompson, courtesy of Lucile Muntz.

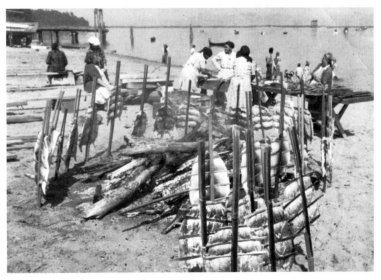

Figure 5. Makah women barbecuing salmon on the beach, 1930s or 1940s. Photograph by J. W. Thompson, courtesy of Lucile Muntz.

HISTORICAL SALISH CANOES

Bill Holm

The Salish dwellers among the bountiful rivers, tideflats, and prairies of the Puget Sound–Georgia Strait Basin had less of the dependence upon canoes that was so much a part of the livelihoods of many other Northwest Coast groups. The broad, glacial basin, with its moderate topography, was laced with trails that allowed some communication and trade between many of the resident villages. This eliminated much of the necessity for water transportation that was imposed by the fjord-divided mountains of the northern coast and the western shore of Vancouver Island (Elmendorf 1960:286–292). Even so, canoes were of primary importance to the people of Puget Sound and the adjacent inland waters, and a number of different canoe designs were developed and perfected to suit the local marine conditions.

Simplest of these was the shovel-nose canoe, a long, shallow craft whose square, smoothly raised ends were superbly adapted to travel on the many shallow rivers draining the Puget Sound Basin. It was usually propelled by poling, but was equipped with paddles for handling in deeper waters. Northwest explorer Captain George Vancouver, in his journal for May 22, 1792, described several of what seem to have been large shovel-nose canoes crossing the sound from near present-day Seattle to visit his ships

at anchor off Restoration Point on Bainbridge Island (Vancouver 1801:127).[1] But even those relatively sheltered waters were not free from heavy winds and rough sea conditions, and the usual choice for open saltwater travel was the widely used sea-going craft known variously as the Chinook, Nootka, or Westcoast canoe (pl. 85). The seaworthiness of its design, with flaring sides, delicate, upswept, and projecting prow, sharp, vertical stern, fine entry and, above all, the gunwale flare extending to both ends, was proven by Native whalers and sea voyagers in the open waters off Vancouver Island and the Olympic Peninsula.

Both the shovel-nose river canoe and the Westcoast sea canoe were widely used on the southern Northwest coast. The Salish canoe itself, with several variants, was apparently confined in manufacture and use to the Puget Sound–Georgia Strait Basin. It was seen on those waters by the first European explorers and continued in use into the twentieth century. Notably, it strongly influenced canoe design in the nineteenth century among the tribes from northern Vancouver Island to Yakutat Bay.

The *Puget Sound* canoe and its variants were the everyday transportation, hunting, fishing, and general purpose canoes around southern Vancouver Island, the Gulf and San Juan Islands, Admiralty Inlet, and Puget Sound before the advancing technology of Euro-American settlement changed the pattern of life. Only the Westcoast canoe competed with it for supremacy on the water. In its smaller forms it was light and handy for one or two persons to launch and paddle. It was fast and maneuverable for hunting. Its shallow draft and carrying capacity made it ideal for use on the clam flats. Although not the equal of the Westcoast canoe in the open sea, it was seaworthy and, used with skill and discretion, could

Bill Holm, curator emeritus of Northwest Coast Indian art at the Burke Museum and affiliate professor of art history at the University of Washington, is the author of the classic *Northwest Coast Indian Art: An Analysis of Form*, first published in 1965. Among his more recent works are *Smoky-Top: The Art and Times of Willie Seaweed* and *Spirit and Ancestor: A Century of Northwest Coast Indian Art at the Burke Museum*.

be paddled anywhere in the Coast Salish world. And when the owner finally left that world, the canoe traditionally became his sarcophagus (Elmendorf 1960:452). Ordinarily, a canoe used as a coffin was raised on a supporting frame or into the branches of a tree. In some cases the canoe was cut in two and one half inverted over the corpse. Traditionally holes were cut in the bottom to prevent water from collecting and perhaps to render the canoe useless to would-be thieves.

EARLY DEPICTIONS OF SALISH CANOES

In the drawings made on the 1792 expedition of the two Spanish ships *Mexicana* and *Sutil*, there appears what is apparently the earliest graphic record of the Coast Salish canoe. In June of that year Captains Galiano and Valdes sailed their two little schooners around the southern end of the San Juan Islands, through Guemes Channel and north past the mouth of the Fraser River. A drawing was made in those waters by the expedition's artist, José Cardero. It shows Indians in two double-ended canoes approaching the ships with Mount Baker in the background (Palau 1986:81). The canoes were depicted with more pronounced sheer than those photographed in the region a century later, but that difference is consistent with many early drawings of other known canoe types. Another drawing made later that same summer shows similar canoes in Canal de Salamanca (Loughborough Inlet) at the northern end of Salish territory (Palau 1986:75). Several drawings by members of Vancouver's expedition, which was surveying the same waters as the Spanish boat crews, illustrate canoes in the northern Georgia Strait area that are very much like later Salish craft. An engraving after a sketch by Thomas Heddington (fig. 1; Henry 1984:99) shows canoes at the mouth of Bute Inlet whose profiles resemble those of later Salish canoes, and a drawing by John Sykes (Henry 1984:114) of the village at Cape Mudge illustrates a dozen or more canoes of the Salish type drawn up on the beach. The clear silhouette of a single canoe in the water matches perfectly the form of a late nineteenth-century Salish canoe. The most detailed eighteenth-century illustrations of what seem to be canoes of this type are two drawings by Sigismund Bacstrom, who was on the Northwest Coast in 1792 and 1793 (Vaughan and Holm 1982:205). Because Bacstrom may never have come as far south as the Salish country, his sketches suggest a somewhat wider distribution of this canoe type in the early historic period than in later years. Both Spanish and English drawings made in July of 1792 in the Queen Charlotte Strait region, the country of the Kwakiutl tribes, show similar canoes (Henry 1984:97, 165, pl. 7). Those in Joseph Baker's sketch of Vancouver's flagship *Discovery* aground in

Queen Charlotte Strait are especially like the Salish craft in silhouette (Henry 1984:97).

In 1833 a collection of Northwest Coast Indian objects, including three models of Salish canoes with their crews, was given to the Literary and Antiquarian Society of Perth, Scotland, by Colin Robertson of the Hudson's Bay Company. The canoe models, now in the Perth Museum and Art Gallery, were collected on the Fraser River, very likely by one J. M. Yale, who was stationed at the Hudson's Bay Company post of Fort Langley (Idiens 1987:51). These three models are apparently the oldest of their type in existence, and illustrate very well the characteristics of this particular canoe design (pl. 84).

Many artists of the nineteenth century pictured the sleek, low Salish canoe. Drawn up in a rocky cove in the foreground of Paul Kane's dramatic, if fanciful, painting of the return of two canoe-loads of victorious warriors to the Songhees village opposite Fort Victoria is a low, graceful canoe (fig. 2; Roberts and Shackleton 1983:114).[2] It is an accurate representation of the little Salish craft that persisted throughout the nineteenth century and the first quarter of the twentieth. These canoes were frequently represented in drawings, paintings and photographs during those years. Strangely, although they were in common and widespread use in the Coast Salish country, they were not described or even mentioned in Ronald Olson's survey of Northwest Coast canoe types (Olson 1927:18–23).

In the early twentieth century, with the increased use of planked boats for sea transportation and the proliferation of roads to facilitate land travel, dugout canoes of almost all types[3] fell out of use in the Puget Sound area. An occasional exception proves the rule. In 1938 Henry Allen, a Twana traditionalist from Hood Canal and one of William Elmendorf's principal informants on Twana culture (Elmendorf 1960), made a fine, 18-foot canoe for a friend's daughter. He started another in 1955, when he was 93 years old, but Allen died before the canoe was ever finished (Graves 1955:6). The 1938 canoe may have been the last of its kind to be made by a traditionally trained Puget Sound Indian canoemaker.

FEATURES OF THE SALISH CANOE

The Puget Sound–Georgia Strait Salish canoes are recognizable by a number of features. In profile, both bow and stern project over the water, the stern in an even slope and the bow with a more or less pronounced cutwater. The gunwales rise at the ends in an evenly-curved sheer. A very uniform and conspicuous feature is a broad, protruding band extending along the gunwales from end to end. This band, markedly different from the flared gunwales of the

Westcoast canoe and the typical nineteenth-century northern canoe, is very similar to the gunwale band of the great Haida canoes of the nineteenth century. The lower edge of the band corresponds to the outwardly curled gunwale flare of the Westcoast and northern canoes and acts to throw water outward when the canoe is driven into waves. I believe that the increased buoyancy of the gunwale band itself helps lift the side of the canoe when a wave strikes broadside, or when the canoe rolls.

On most of these canoes, just under the gunwale band at the bow, a horizontal notch separates the flared gunwales from the fin-like extension of the bow. Its purpose, according to James Point, a Musqueam traditionalist, was "for looks" (Suttles 1965). The slot resembles a mouth, or "two jaws" (Elmendorf 1960:172). It reminds one of the space between the projecting gunwale "ears" and the extended bow-fin "snout" of Westcoast canoes, especially as seen in drawings and models of the very early, low-bowed type. The two features might be related, and both seem to be non-functional, "for looks."

Corresponding to the "bulge or raised strip" (Waterman and Coffin 1920:24) on the exterior of the hull is a recessed or hollowed band on the interior. This hollow band also appears on northern canoes, whether or not they exhibit the outer gunwale band. It is remarkably similar to the inner grooves under the rims of northern carved ladles and bowls (Holm and Reid 1976:72, 75-76, 100; Holm 1983:78, 79, 84). Resting on the lower lip of the inner gunwale grooves are the ends of the thwarts, typically round rods in Salish canoes. They are secured by lashings of cedar withe run through holes bored in the ends of the thwarts and the hull, or by pinning with hardwood pegs (Elmendorf 1960:182). Late examples sometimes have the thwarts fastened with nails. In canoes rigged for sailing, the forward thwart is often a flat board with a hole cut through, forming a support, or partner, for the mast.

The hollowed, interior gunwale bands on the Salish canoe converge and merge at the stern, but are separated at the bow by a V-groove that is a continuation of the intersection of the inner sides of the hull. This groove, which appears on Westcoast and northern canoes as well, is the resting place of the harpoon in a hunting canoe, or of the mast in a canoe equipped for sailing. On a hunting canoe this notch is sometimes padded with a crossbar of soft wood (Barnett 1939:239), shredded cedar bark (Barnett 1955:112; Elmendorf 1960:172), or seal skin (Suttles 1965) to quiet any rattle of the harpoon. Cardero's drawing of the canoes approaching the *Mexicana* and the *Sutil* (Palau 1986:81) and Bacstrom's sketch of the Salish-type canoe (Vaughan and Holm 1982:205) illustrate this method of carrying the harpoon.

Part of the grace of Salish canoes is in their low

profile and the gentle sweep, or sheer, of the gunwales. Interestingly, many canoes of the early historic period, even Westcoast and northern canoes, had a similar, relatively low rise to their ends. This is well illustrated by early model canoes and by the work of some of the more accurate draughtsmen of the period, such as John Webber, who accompanied Cook's expedition to the Northwest Coast in 1778 (Henry 1984:76, 77). Later Westcoast and northern canoes typically carried their ends higher; the most exaggerated version is the twentieth-century racing canoe whose prow rises almost vertically from nearly level gunwale lines (see Oliver, this volume).

Like most Northwest Coast dugout canoes (except for the puntlike shovel-nose model), Salish hulls had sharp V-sections at the ends, forming what is called a fine entrance (at the bow) and run (at the stern). Because of the extension of the fin or cutwater at the bow, the entrance was typically hollow—that is, the waterline formed a gentle S-curve, resulting in minimal disturbance of the water. On some canoes the run was also somewhat hollow. This smoothly streamlined underwater surface made for an easily driven hull that tracked, or kept its direction, well. The bow fins on some Salish hunting canoes were extended slightly lower than the line of the bottom, forming a kind of false keel that was said to reduce the slapping of waves under the bow, important for hunting wary sea mammals.[4]

TYPES OF SALISH CANOES

Although the Coast Salish canoes shared all these characteristics, there were a number of differing features that separated them into two nearly distinct classes. These classes have been equated in most published descriptions with different uses, but they may more accurately represent a geographic differentiation (Suttles 1987:4–5). The most obvious difference is in the shape of the bow fin or cutwater, which in one case is very angular and square, and in the other oblique and rounded. The model with the square, vertical cutwater has been called the "freight canoe," while the canoe with the slanting, rounded cutwater is the "trolling canoe" (Waterman and Coffin 1920:17, 18). While it is true that Waterman's "freight canoe" was typically larger than his "trolling canoe" (he described it as reaching "as much as 40 feet in length"), it appears to be more accurately described as the northern Coast Salish *upriver* canoe. It was made in many sizes and was put to most of the uses to which canoes were subject, not only for "journeys with household possessions in quiet waters." It was far more common in British Columbia than in Washington waters. The Perth models, illustrating a detailed description of sturgeon fishing on the Fraser River recorded by James Yale before 1833 (Idiens 1987:51), are all of this northern pattern.

Figure 1. "Village of the Friendly Indians at the entrance of Bute's Canal," 1792. Engraving of a drawing by Thomas Heddington (Vancouver 1801: facing p. 326). Photograph courtesy of the Special Collections Division, University of Washington Libraries, neg. #UW10542.

Figure 2. "A Sangeys Village on Esquimalt," 1846–1847. From a watercolor by Paul Kane. Photograph courtesy of the Stark Museum of Art, Orange, Texas, #31.78/66, WWC 66.

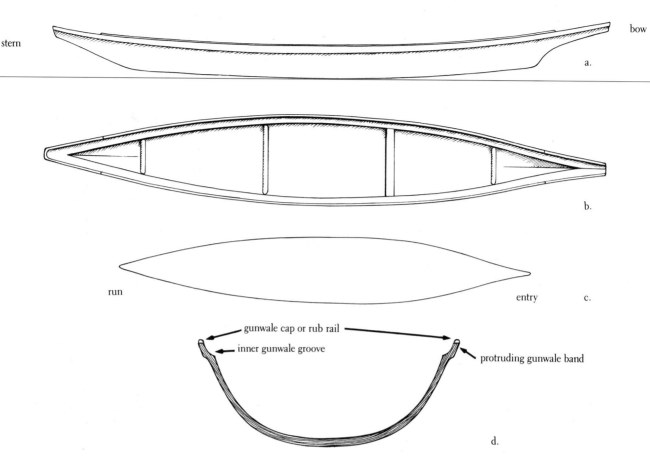

bow

stern

a.

b.

run entry c.

gunwale cap or rub rail

inner gunwale groove

protruding gunwale band

d.

Figure 3. Features of the Puget Sound–Georgia Strait Salish canoe: a. side view; b. view from above; c. waterline showing fine entry and run; d. cross section amidships. Drawings by Bill Holm, of Burke Museum canoe #1–167.

The profile of the *"Northern Gulf"* canoe, as Suttles refers to it, differs from the *"Puget Sound"* model in ways other than the square cutwater. The projecting prow is vertically compressed and parallel-sided to its juncture with the vertical fin. The sheer is ordinarily much flatter, and the sides higher in proportion to length than in the southern version. James Point (Suttles: 1965) described it as having "not much spring (sheer)" and "the same width top and bottom," features that describe a canoe that has been spread minimally (if at all) after carving. There are, however, many variants of the design, bridging the entire range of difference between the two types. A canoe at the Ferry Museum, Washington State Historical Society, in Tacoma, with the thin, projecting prow and square cutwater of the northern pattern, is broadly spread, as are other examples seen in old photographs. Point also credited the *Northern Gulf* canoe with a rounder bottom than the *Puget Sound* model. Canoes measured in the course of this study, however, show just the opposite. Many canoes from British Columbia that show the thin prow and high cutwater of the *Northern Gulf* type soften the angles of the throat and the forefoot to rounded contours. Perhaps it would be more accurate to describe the northern model as having a deep cutwater, a vertically narrow, extending prow, and minimal sheer.

Since the Salish canoe and its variations were made and used by speakers of Lushootseed, Straits, and Halkomelem languages, it is not surprising that there is some confusion about the native names in the literature. Curtis, Waterman and Coffin, Haeberlin and Gunther, Smith, Elmendorf, Collins and Hess all use a form of the word *s.dəxʷił* as the Lushootseed term for the sleek hunting canoe of the area, and *s.tiwałł* for the angular cutwater model of the northern Gulf. Duff, Barnett and Suttles all use a form of the Squamish word *snəxʷił* (a cognate of Lushootseed *s.dəxʷił*) as the name of the northern version, and *syixaʔł* for the Puget Sound canoe. Wayne Suttles (1987:4–5) has made sense out of the confusion by suggesting that the canoe type most commonly used in a given area (the slanted cutwater model in Puget Sound and the vertical cutwater model in Georgia Strait) were known in their own areas by a generic canoe term, *sdəxʷił* or its cognate *snəxʷił*. Canoes of different design, preferred by other people, were called by names referring to the direction of their place of origin.

Few watercraft match the delicate graceful shape of the *Puget Sound* canoe. It was usually small to moderate in size, ranging from 12 or 13 to perhaps 30 feet. The usual range was likely between 16 and 24 feet. Although almost all accounts describe them as very narrow, those measured ranged from 6.6 times longer than wide for the narrowest to 5.6 times longer than wide for a broad, late model, which was also unusually deep. A ratio of 1/6.6 is relatively broad for any Northwest Coast canoe. Probably the perception of narrowness was influenced by their low profile. In contrast, two *Northern Gulf* canoes (usually described as beamier than the Puget Sound canoe) measured by Wilson Duff (Duff 1952:52) were 8.5 and 9.5 times longer than wide, both narrow compared to Northwest Coast canoes generally.

The typical *Puget Sound* canoe had a bit more sheer than the *Northern Gulf* model, the gunwales sweeping gently up in an even arc, most of which resulted from the spreading process. Almost all Northwest Coast canoes were carved somewhat narrower than their final width, which was achieved by spreading the sides of the hull after softening them with steam. The procedure has been mentioned often in the literature, but misunderstandings abound. A number of interrelated changes in shape occurred in the process, and the canoe-maker needed to understand them all in order to compensate for them in the carved hull.

In addition to skill and special knowledge needed by the carver, the help of supernatural power was regarded as necessary for success. Songs and ritual words acquired from such spirit contact were employed at every step of canoe construction, from selecting the tree to the final spreading and finishing.

MAKING A CANOE

The Puget Sound canoe was usually carved from half a cedar log, with the split surface forming the upper side of the canoe. Usually this surface was carved very slightly lower so that the ends stood a little higher than the center, which was flat for most of the length of the canoe. The ends would then be tapered, leaving the center section, from one-third to one-half of the length, straight and parallel-sided. The log was turned over and the bottom carved lengthwise to a slightly concave form. This shaping prevented the development of excess rocker in the bottom when the spreading was complete, and it widened the bottom amidships. The carver had to be aware not only of what changes of form occurred during the spreading process, but what forms remained unchanged. The higher on the hull, the greater the changes in form, except for the lengthwise upward bending of the bottom.

When the outer form of the hull was complete, the canoe-maker usually drilled a series of regularly spaced holes deeply into the wood. These holes were plugged to depths equal to the finished thickness of the hull. The length of the plugs was measured in finger-widths, often one finger-width (approximately ¾ inch) for the sides and two finger-widths (approximately 1½ inches) for the bottom of small to medium-sized canoes. Larger canoes were slightly thicker, although all of them were remarkably thin.

The log, now boat-shaped but lacking the grace of the final form, was turned upright and the hollowing commenced. It was essential that the outer form be complete before any serious hollowing was done. With stone chisel and adze, fire and wedge (and later steel axes and adzes), the canoe-maker removed the interior wood until he spied the inner ends of the measuring holes. Checking the depth of each hole as he came to it, he carved down to the plug. Then he connected the rows of carved depressions, splitting off the wood remaining between the resulting grooves. Finally he smoothed the inner surface with his adze, or in more recent times with a curved drawknife (scorp or inshave), carved out the inner gunwale groove, and prepared to spread the canoe.

Among most Northwest Coast groups the spreading of a canoe was thought to be especially fraught with potential dangers, and canoe-makers took precautions to allay both physical and supernatural problems. The spreading was done in private, and special ritual actions taken. The actual spreading was a day-long activity. A fire, or even two, one on each side of the canoe, were lit to heat the rocks needed to produce the necessary steam. Water was poured into the straight-sided hull to a moderate depth. There was no need to fill the canoe. Steam is produced much more easily in a few inches of water than in a

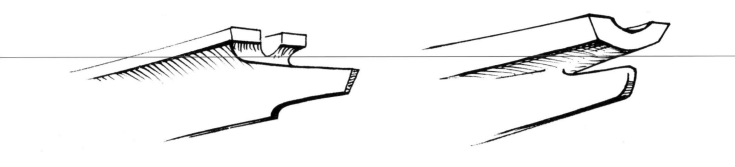

Figure 4. Canoe prows: left, early Westcoast canoe; right, Puget Sound canoe. Drawings by Bill Holm.

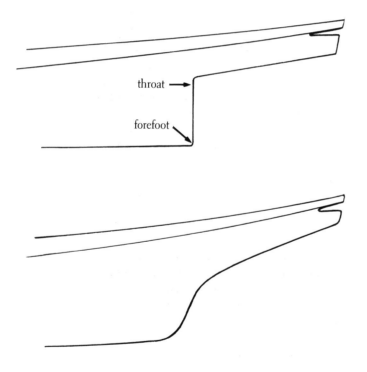

Figure 5. Canoe bows: top, Northern Gulf canoe bow with vertically compressed prow and deep, angular cutwater; bottom, Puget Sound canoe bow with slanted prow and rounded cutwater. Drawings by Bill Holm.

canoe-full, and it was the steam, confined in the hull with mats, that softened and swelled the wood fibers. Red-hot rocks were removed from the fires with tongs and lowered into the water. In a few minutes the water boiled, producing dense clouds of searing steam in the confines of the mat-draped hull. As the inner fibers expanded and the sides became flexible, the fires, and even torches, on the outer surface heated the walls of the hull, drying and shrinking the outer woodcells. Under the differential swelling and shrinking forces the sides began to roll outward. New hot rocks were added as needed. Their weight and that of the water in the canoe pushed down on the bottom, adding to the forces of change. The ends began to come up and the sheer started to develop. Cross sticks, placed diagonally between the gunwales and tapped or sprung into place, gradually pushed the sides outward. When the planned width was achieved the water was allowed to cool and then emptied. What had been a stiff, hogged and straight-side trough was transformed into an elegant canoe, with clean sheer, smoothly outcurved gunwales, flaring sides, and straight or slightly rockered bottom.

Finally, round rods were fitted as thwarts and sewed securely in place with twisted cedar withes or pegged with hardwood pins. The gunwales were protected from the wear of the paddles by pegged-on rub rails or gunwale caps of harder wood, generally Douglas fir. These never reached to the ends of the canoe, but extended over the length of the gunwales that was subject to wear. Often finished canoes were colored black on the outside by scorching the surface with torches and rubbing oil in the hot, black surface. The

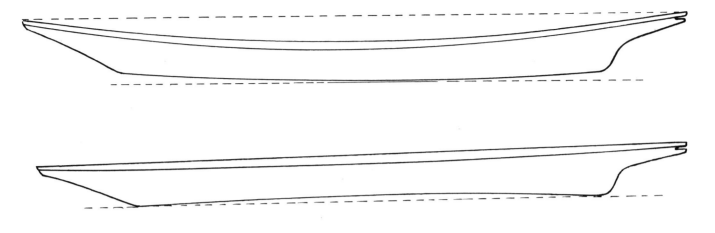

Figure 6. Canoe changes in spreading. Top: typical Puget Sound canoe after spreading, slight rocker to bottom; sheer develops during spreading. Bottom: typical Puget Sound canoe before spreading; bottom with reverse rocker or "hogged" shape to minimize rocker acquired when spread; gunwales flat before spreading. Drawings by Bill Holm.

inner surface was also often painted, sometimes with a contrasting color—white, blue, or red—in the gunwale groove.

CANOE EQUIPMENT

Canoe equipment consisted of paddles, bailer, bottom boards or cattail mats for kneeling, poles for poling, a mast and sail for medium to large canoes, and in later years oars and rowlocks. A large canoe might carry an anchor in the form of a heavy stone grooved or pierced for the anchor line, but canoes were usually drawn up on the beach rather than anchored out. It was customary all over the coast to land canoes stern first. This custom has been explained as arising from the need to present the bow to the waves when landing in surf. More likely, the slanting sterns of most Northwest canoes ran up on the beach more smoothly and with less potential damage to the canoe than the sharp bow fins. My own experience with canoes of the northern coastal type has demonstrated the practicality of stern-first landing, and it would certainly be true of both Salish models as well. Canoes were always covered with mats or brush when ashore, at least in sunny weather, to prevent cracking. Any cedar will check in the sun, and the spread canoe has built-in stresses which make it especially vulnerable. The first canoe I made was once inadvertently left uncovered on the beach all day in the sun and split the entire length of the bottom.

Canoe paddles on the Northwest Coast share certain characteristics. They have long blades in relation to their overall length. The blades are usually elliptical, widest near the center of their length. Generally they have a "*crutch*" or transverse grip. Shapes of blades and shafts differ along the coast. In Puget Sound a typical blade has a pronounced shoulder below the grip, a swelling outline near the center, and a narrowing tip with steeply angled point (Waterman 1973:pl. 27). The looms or shafts are round, flattening and widening slightly toward the transverse grip, which is usually in one piece with the loom and tapered slightly toward its ends. There are a number of variations. Although special women's paddles are frequently mentioned in the literature, the descriptions are vague. Generally they are described as smaller than men's paddles, and there is a suggestion that the blades were more diamond shaped. Big-leaf maple is the usual wood for paddles in the Puget Sound region. Some paddles from the coast of the Olympic Peninsula or Vancouver Island also were in use in the area. They were often of yew wood, and were very distinctive in shape, easily distinguishable from the local paddles.

Bailers were in the form of wooden, diamond-shaped ladles, pleated cedar bark scoops, or the West-coast prism-shaped bailer (Holm 1987b: no. 21). The flaring sides of Northwest Coast canoes make it possible for water to be thrown out rapidly with the bailer.

It seems clear that the Coast Salish canoe was in use on the Washington coast when Europeans first came to the Northwest. The same cannot be said for the canoe which came to be so famous in the nineteenth century on the coasts of northern British Columbia and Alaska. When the first explorers and fur traders arrived they found the Haida and Tlingit

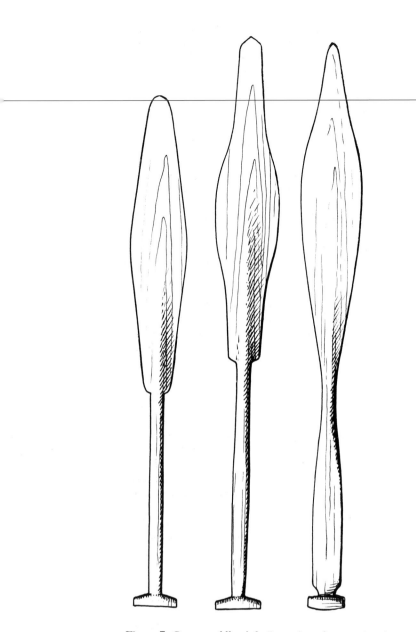

Figure 7. Canoe paddles: left, Puget Sound women's paddle; middle, Puget Sound man's paddle; right, Westcoast paddle. Drawings by Bill Holm.

using large canoes with no gunwale flare and with flat fins extending fore and aft from dory-like hulls (Holm 1987a). This unusual "head canoe," as it is called, disappeared from use in the early decades of the nineteenth century. The place of the head canoe was taken by a large vessel whose bow and stern projected over the water, the stern in an even slope and the bow with a vertical cutwater. The gunwales rose at the ends in an evenly curved sheer. A conspicuous feature was a broad, protruding band extending along the gunwales from end to end. Does the description sound familiar? These features, so uniform in the Salish for such a long time, appeared on the new canoes on the northern coast in the early years of the nineteenth century, displacing a much different—and likely less efficient—model. I believe that the principles of canoe design followed by Coast Salish carvers and their Kwakiutl neighbors to the northwest were making their way toward Alaska during the early contact period, arriving there at about the time of the beginning of the fur trade. The resemblance of the nineteenth-century northern canoe to the Coast Salish canoe has been noted, and some have suggested that the Salish model is a modified version of the northern type (Drucker 1955:64; Stewart 1984:50–52). The opposite may well be the case. The historic record of northern canoes with these design characteristics begins with drawings made in the 1820s, while the Salish form is well documented in the drawings by the first Europeans to enter Salish territory in the 1790s. There are differences between the two types, chief among them the added bow and stern blocks on the ends of the northern examples, their more pronounced sheer, particularly in the canoes of the mid- to late century, and the lack of the gunwale band on all except the large Haida vessels. But the similarities are remarkable.

Canoe making, using traditional techniques and designs, is on the rise again on the Northwest Coast. Since the 1950s, two dozen or more old-fashioned canoes of many different designs have been made on the coast, and more are being planned. With the renewed awareness of the uniqueness of Puget Sound Salish culture, interest in the graceful local canoe is rising among Native carvers. In association with the centennial celebration of Washington statehood, almost all the tribes of western Washington are making canoes. Some of these being carved in the Puget Sound area are *sdəxʷiɬ*. Sleek Salish canoes may once more grace the waters of Puget Sound.

Notes

1. Vancouver described the canoes as "cut off square at each end; and were in shape precisely like the canoes seen to the southward of Cape Orford, though of greater length, and considerably larger" (Vancouver 1801:127). Although Bill Durham (1955:36) reminds us that the canoes of that region differ from Salish shovel-nose canoes in significant details, I believe that Vancouver referred to their basic punt hull form, and not to the specific configuration of the gunwales and ends. Many early explorers and fur traders (including Vancouver, Cook, Dixon, and the Spaniards Galiano and Valdes) described Northwest Coast objects as exactly like things seen in distant places, usually Polynesia for the English and Mexico for the Spanish. In their journals, English explorers frequently used Polynesian terms for similar objects seen on the Northwest Coast.

2. Kane's painting of the two large northern canoes was based on his sketches (Roberts and Shackleton 1983: 118), which appear to be of models. Both canoe types, the "head canoe" with its broad bow fin and projecting stern (represented backward in Kane's painting) and the war canoe with massive, upswept prow, were obsolete before he visited the Northwest Coast. On the other hand, the little Salish canoe which he rendered so perfectly was a common local means of water transportation at the time.

3. In the closing years of the nineteenth century a highly specialized form of racing canoe was developed. Very long and narrow, with bow and stern pieces in the style of the Westcoast sea canoe, these racing canoes continue to be produced to the present day (see Oliver article this volume).

4. In recent years canoes of different traditional designs have been made by carvers, both Indian and non-Indian, making possible testing of their handling characteristics. In the summer of 1987 Duane Pasco made a small Salish-type canoe with a false keel. Experiments with this canoe suggest that the false keel actually decreases the tracking ability of the canoe. Experimental use of carefully made canoe replicas will perhaps answer some of our questions, and may corroborate or lay to rest theories about Native canoe characteristics and use.

References

Barnett, Homer G. 1939. Culture Element Distributions: IX, Gulf of Georgia Salish. *Anthropological Records* 1:5. Berkeley: University of California Press.

_____.1955. *The Coast Salish of British Columbia.* Eugene: University of Oregon Press.

Collins, June. 1974. *Valley of the Spirits: The Upper Skagit Indians of Western Washington.* Seattle: University of Washington Press.

Curtis, Edward S. 1913. *The North American Indian*, Vol. 9. Norwood, Connecticut: Plimpton Press. (Reprinted 1970, New York: Johnson Reprint Corporation.)

Drucker, Philip. 1955. *Indians of the Northwest Coast.* New York: McGraw-Hill.

Duff, Wilson. 1952. *The Upper Stalo Indians of the Fraser River of B.C.* Anthropology in British Columbia, Memoir No. 1. Victoria, B. C.: British Columbia Provincial Museum.

Durham, Bill. 1960. *Indian Canoes of the Northwest Coast.* Seattle: Copper Canoe Press.

Elmendorf, William W. 1960. *The Structure of Twana Culture.* Monographic Supplement No. 2. Pullman: Washington State University.

Graves, Wallace. 1955. Canoe Maker: Indian, 93, Is an Expert. *The Seattle Times*, December 18, 1955.

Haeberlin, Hermann, and Erna Gunther. 1930. *Indians of Puget Sound.* University of Washington Publications in Anthropology, 4(1). Seattle: University of Washington Press.

Henry, John F. 1984. *Early Maritime Artists of the Pacific Northwest Coast, 1741–1841.* Seattle: University of Washington Press.

Hess, Thom. 1976. *Dictionary of Puget Salish.* Seattle: University of Washington Press.

Holm, Bill. 1983. *The Box of Daylight: Northwest Coast Indian Art.* Seattle: University of Washington Press.

_____. 1987a. *The Head Canoe.* In P. L. Corey, ed., *Faces Voices and Dreams: A Celebration of the Centennial of the Sheldon Jackson Museum*, pp. 143–55. Sitka, Alaska: Division of Alaska State Museums and the Friends of the Sheldon Jackson Museum.

_____. 1987b. *Spirit and Ancestor: A Century of Northwest Coast Indian Art at the Burke Museum.* Seattle: University of Washington Press.

Holm, Bill, and Bill Reid. 1976. *Indian Art of the Northwest Coast: A Dialogue on Craftsmanship and Aesthetics.* University of Washington Press, Seattle.

Idiens, Dale. 1987. Northwest Coast Artifacts in Perth Museum: Colin Robertson's Donation. *American Indian Art Magazine* 13(1), Winter 1987.

Olson, Ronald L. 1927. *Adze, Canoe, and House Types of the Northwest Coast.* University of Washington Publications in Anthropology 2(1). Seattle: University of Washington Press.

Palau, Mercedes. 1986. The Spanish Presence on the Northwest Coast: Seagoing Expeditions (1774–1793). *To the Totem Shore.* Madrid: Ministerio de Transportes, Turismo y Communicaciones.

Roberts, Kenneth, and Philip Shackleton. 1983. *Canoe: A History of the Craft from Panama to the Arctic.* Toronto: Macmillan of Canada.

Smith, Marion W. 1940. *The Puyallup-Nisqually.* Columbia University Contributions to Anthropology, Vol. 43. New York: Columbia University Press.

Stewart, Hilary. 1984. *Cedar.* Seattle: University of Washington Press.

Suttles, Wayne. 1965. Field notes on canoes from James Point, Musqueam.

_____.1990. The Central Coast Salish. *Handbook of North American Indians.* Washington, D.C.: Smithsonian Institution.

_____.1987. Four Anthropological-Linguistic Notes and Queries. Paper read at Salish Conference, Victoria, B.C., 1987.

Vancouver, George. 1801. *A Voyage of Discovery to the North Pacific Ocean, and Round the World.* London.

Vaughan, Thomas, and Bill Holm. 1982. *Soft Gold: The Fur Trade and Cultural Exchange on the Northwest Coast of America.* Portland: Oregon Historical Society.

Waterman, Thomas T. 1973. *Notes on the Ethnology of the Indians of Puget Sound.* Indian Notes and Monographs, No. 59. New York: Museum of the American Indian, Heye Foundation.

Waterman, Thomas T., and Geraldine Coffin. 1920. *Types of Canoes on Puget Sound.* Indian Notes and Monographs, new series, Vol. 5. New York: Museum of the American Indian, Heye Foundation.

REMINISCENCES OF A CANOE PULLER

ⱵOⱵ

Emmett Oliver

*T*hough Washington has sprouted as a land of immigrants, an aboriginal people shaped rich cultures here for at least 8,000 years before Euro-Americans arrived, long before international boundaries were established. True heritage recognizes newcomers and natives alike.

There once flourished on these shores peoples and cultures highlighted by the omnipresent and hallowed dugout canoe. The canoe represents Native life at its fullest. It was used for fishing in the quiet waters of rivers and also for seagoing expeditions in quest of otter, seals, and whales. The Native canoe was an economic necessity, like a railroad or highway, and it also provided recreation, which persists to the present day in the sport of racing. For maritime people, canoe racing was an opportunity to display their prowess. When we revel at competitive canoeing, remember it was this same spirit that was a way of life to the prime founders of this land.

The Washington State Centennial has honored traditions of the past to enrich possibilities for the future. The Native American Canoe Project was conceived to perpetuate the nearly lost art of cedar canoe carving, and to generate public interest in the culture of the canoe. The Duwamish, Lummi, Makah, Muckleshoot, Nisqually, Nooksack, Port Gamble Klallam, Puyallup, Quileute, Quinault, Samish, Skokomish, Snoqualmie, Suquamish, Swinomish,

Tulalip, and Upper Skagit tribes participated in the canoe project in various ways. As part of the "Paddle to Seattle," eleven tribes built canoes. Sixteen new canoes were built; three from Quileute and Hoh River paddled north from La Push to Cape Flattery, and east through the Strait of Juan de Fuca to Suquamish—a trip of 170 miles each way. From Suquamish, the entire grand flotilla of over 20 canoes—some new, some long cherished—arrived at Golden Gardens beach in Seattle on July 21, 1989. The drama of the "Paddle" was significantly enhanced by the arrival of a group from Bella Bella, who had paddled 120 miles from Vancouver, British Columbia, to Seattle. One hundred years ago, such ocean-going journeys were common.

The following tribal statements and personal reminiscences show the deep-rooted place of the canoe in the lives of many Native people in Washington.

Thanks to Patricia Cosgrove, Project Manager for the exhibit "A Time of Gathering: Native Heritage in Washington State," for her help in compiling this article.

The advent of a dominant culture imposing economic, social, and religious changes has failed to obliterate one original aspect of Indian culture: the cedar canoe. Function has come to the rescue. We clearly witness canoe heritage in the exciting and graceful sport of canoe racing. The spirit of intertribal racing transcends the loss of so many other elements of culture. It is hoped that the Washington State Centennial observance has served to restore and perpetuate the Native canoe use as part of our cultural heritage—a heritage which has the deepest personal significance for me.

In the summer of 1934, I obtained a seat in the eleven-man Lummi racing canoe, the *Lone Eagle*.

Emmett S. Oliver, a member of the Quinault Tribe, has been an educator and a public administrator since 1936. He holds an M.A. from the University of Washington, and has served as Director of the University of California's Indian Culture Center, Supervisor of the University of Washington's Indian Program, and the Supervisor of Indian Education for Washington's Superintendent of Public Instruction. He was the Native American Canoe Project Coordinator for the Washington State Centennial Committee.

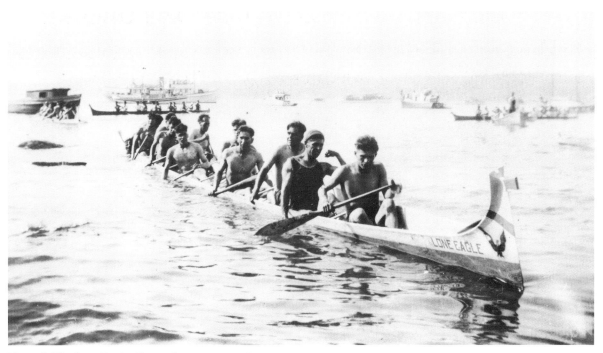

Figure 1. The *Lone Eagle*. Photo taken in Coupeville, after a race, August 11, 1934. Emmett Oliver is seated second from the stern. Photograph courtesy of Emmett Oliver.

At that time, seats were hard to come by and rarely given up, so I was honored to replace a man who had been killed in a logging accident. I assumed his position, second from the stern, which placed me directly in front of the skipper. Little did I know that that position would make me the object of particularly clear and dedicated attention. I can still hear the skipper, Bunny Washington, yelling, "Come on Emmett—PULL!"

I loved the *Eagle* so much that, when I began with the team, I painted an eagle on her bow and repainted her name in larger letters. That canoe meant a great deal to me.

Canoe racing is the kind of sport that gives spectators goose bumps. The drama of fifteen, 52-foot canoes slicing through the rough salt waters, pulled by eleven Indian men moving in perfect unison, is enough to move some to tears. When I was pulling, we practiced every evening after supper, working for four miles in preparation for the average three-mile race. The first man at the bow, known as the "stroke," set the pace; we could all see him and adjust our rate to match. There was no watching the scenery or the water, just the man in front of you. The races were grueling, with a fast cadence at the start, and then a racing pace of up to 60 strokes per minute as we settled in. When we were being challenged, or wanted to catch another canoe, the stroke would call for a "big ten" by raising his upper hand on his paddle. We'd follow by pulling deeper, grab-

bing more water for tremendous pulls. There was no real finesse or strategy, you just pulled your butt off for four miles.

In 1934, I was about to enter my junior year in college and I was preparing for football that fall, so I welcomed the opportunity to keep in shape. Pulling was augmented by roadwork as well. All in all, it was a great experience.

I have long believed that being on a pulling crew is one of the best experiences a young Indian could have. Furthermore, the revival of canoe carving and racing represents a renaissance of Indian culture. As a member of the Maritime Committee with the State Centennial Commission, I proposed a canoe project that might support this renaissance in celebration of Washington State's 100th birthday, in 1989. With the help of many individuals, I prepared a symposium on canoe carving and restoration, including arranging for the low-cost purchase and transportation of cedar logs. Many western Washington tribes built sea canoes, trained pullers, and paddled the grueling miles to Seattle. Indian canoes have become a rallying point for Indians, and represent an unprecedented opportunity to rediscover our heritage.

Immersed in the waters of their ancestors, a new generation may confront the training and discipline that are required for canoe races...

—Emmett Oliver, Quinault

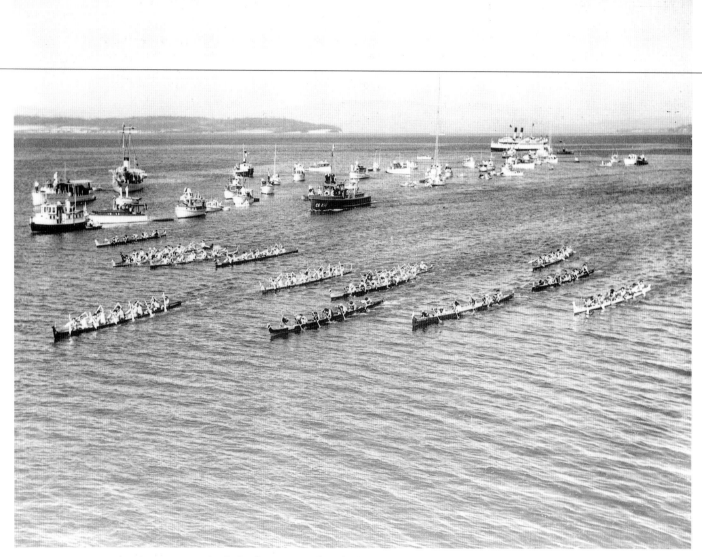

Figure 2. Canoe race, with the *Question Mark* in the lead, about 1934. The *Lone Eagle* finished a close second. Photograph courtesy of the Washington State Historical Society, neg. #16.01.001.

THE CANOE: TRIBAL PERSPECTIVES

Seventeen tribes participated in the Indian Canoe Project. Statements from representatives of eight of these tribes have been selected to present several very different perspectives. Portions of this material have been excerpted from the booklet Native American Canoes: Paddle to Seattle; *Leslie Lincoln, ed.; Washington Centennial Commission, 1989.*

AN OVERVIEW

The long canoes are returning to Quileute. After 80 years and more, ocean-going canoes will ply the waters off La Push, and paddle songs will be heard again.

Traditionally, canoes were an integral part of Quileute life; transportation and livelihood were closely tied to the ability to travel, trade, fish, and hunt from canoes. A variety of styles were used by the Quileute, and even today adaptations (for racing and accommodating outboard motors) have been made. A narrow-beam canoe was used for river transportation and fishing, and could be poled upriver through rapids and shallows. A wider-beamed smelt canoe could haul loads and allow for gillnetting, while the larger, high-bowed and wide-beamed sealing canoe could be paddled and sailed as far as 60 miles to meet the annual fur seal migration. The largest and most impressive canoe—and the most specialized—was the 56-foot traveling canoe. These highly prized vessels were carved from a single red cedar log, took 20 paddlers to crew, and could carry an entire housegroup from place to place. Designed to slip from wave crest to wave crest, the canoes could be either paddled or sailed. Long ocean journeys were undertaken in these seaworthy craft, which often covered hundreds of miles on trading or raiding expeditions. War parties travelled as far south as Hoopa in California, and as far north as Nootka Sound in British Columbia.

Today, crews gillnet for salmon and steelhead, and surround smelt schools with a net played out from a canoe designed for that purpose. Narrow, flat-bottomed, 25-foot racing canoes are outfitted with an outboard motor and are raced on a summer circuit from Aberdeen to La Push. There are approximately 15 of these specially designed craft; this particular form of racing is indigenous to the outer coast of Washington, and has a small but loyal following among tribes on the coast.

Canoes are very much a part of life on the river at Quileute, and the craft are highly prized by their owners. Thomas "Ribs" Penn still builds canoes to the specifications that his grandfather and uncles used, and though a chainsaw has replaced an axe for much of the work, a steady hand and a true eye assure a seaworthy craft.

In the 30s, 40s, everybody had a canoe, that's where me and my uncles made a lot of canoes, people wanted them. If you didn't have a canoe down there, and the fish were running so good, you'd just about die in your heart, to see all that and no canoe (Interview, October 31, 1988, Suquamish Tribe's *Waterborne* project).

Today's elders have never seen the "long canoes"—they were lost or stolen before those elders were born. There are only recollections left, and a few photographs from the 1800s. But from those recollections and photographs, the elders and the children, the carvers and the community, have built those canoes again. We have fashioned the hats and mats and boxes and baskets, the paddles and bailers and woven sails, and have trained the paddlers and sailed the canoes to Puget Sound to greet the "tall ships." We have done these things because they help us remember who we are as a Quileute people—to remember our past as we build a bridge to the future.

—Quileute: Terri Tavenner

GIFT OF THE CEDAR

The canoe was one of the gifts given to the Twana People by the ancestral Cedar Tree during the beginning of time. A canoe maker was considered valuable as a son-in-law by any Chief. Canoe making was looked on as a ceremonial gift of the Spirit; the only other way to become a canoe maker was by apprenticeship. There were also important rituals to observe in regard to the use and care of tools and implements.

To the Twana, life was unfathomable without a canoe. Even in death the wealthy were placed in a canoe for their last earthly travel across the river of life to the land of the dead.

—Skokomish Indian Tribe

THE GREAT FLOOD

My grandfather, a full-blooded Klallam, said our tribe was always here; he said that our people fled up on the highest peak here during the great flood in their canoes. My understanding was that the flood was here quite a while; they lived on whale meat. After the flood was over and started to go down, people scattered in all different directions—to Alaska, the Plains area—people just scattered all over.

—Lower Elwha Klallam: Richard Mike

WHALING CANOES

The Makah Indian Tribe is located on the most northwesterly projection of land in the continental

United States. Before the Makah Treaty of 1855, the Makah were a maritime people who hunted for whales. The Makah whaling canoe, which could carry a crew of eight as far as 30 miles from shore, was built from one cedar log, with eloquent bow and stern attachments. Masterful construction of a canoe was highly technical, especially considering the resources available. The 30-foot hull was designed with an outward flare just below the gunwale to keep waves from curling into the canoe during rough weather. Makah whaling equipment included harpoon shafts of yew wood, harpoon heads of mussel shell, barbs of elk antler tied together with whale sinew and wrapped with cherry bark, two or three fathoms of sinew line attached to the harpoon heads, 100 fathoms of cedar bough line twisted into strands to make rope, extra yew wood paddles, water bailers made of alder wood, a collection of hair-seal skin floats, and an ample supply of dried food and fresh water stored in bent-wood boxes.

—Makah: Keely M. Parker

CANOE CARVING

Frank Fowler, a Duwamish tribal member, has carved a 22-foot shovel-nose, or riverine, dugout especially for the tribe. Fowler learned carving from his father and grandfather who carved just about everything—spoons, bowls, rifle stocks. Fowler's father used to make all his own fishing tackle. Frank explained, "You got your food with the canoe most of the time."

Years ago the way I was told when they'd make a canoe, they called it "pitching a canoe"; after it was carved, there'd be rough edges and they would take a torch and go along the whole outside of the canoe and that would burn off all the excess little slivers. It hardens the wood and makes it smooth too. They used to seal it with dogfish oil, if you oil 'em they won't crack so much.

I think that with all the Indian people getting together and they're all doin' something for themselves, it'll make everybody realize that we're still here. I think we're all related, all tribes, and think we ought to all stick together. I see other members of different tribes, and I don't care which tribe it is, we're all in the same boat, or the same canoe! (Interview, November 28, 1988, Suquamish Tribe's *Waterborne* project).

—Duwamish Tribe

WORKING CANOE TO RACING CANOE

Everybody had a canoe for hunting, traveling and trawling, about 16 to 18 feet long and wide enough to pack ducks and salmon. There were no roads in my days, just wagon roads.

—Earl Jones, Lummi

Figure 3. Makah whaling canoes, about 1900. Fleet of Neah Bay whaling canoes with sealskin whaling floats and other gear. A whaling harpoon rests in its slot at the bow (see Makah whaling canoe model, pl. 85). Photograph by Wilse; courtesy of Special Collections Division, University of Washington Libraries, neg. #NA 1341.

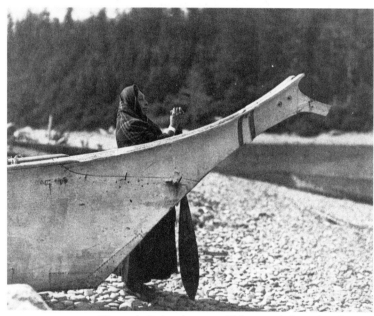

Figure 4. Quinault canoe. This canoe belonged to the Mason family. During the treaty-signing era, Chief Taxola was given the name Charles Mason, perhaps in honor of the Charles Mason who was secretary to Territorial Governor Isaac Stevens. Thereafter he was known as Captain Mason (see canoe-carving D-adze that belonged to Captain Mason, pl. 60). Photograph by E. S. Curtis; courtesy of Special Collections Division, University of Washington Libraries, neg. #NA 290.

Canoes were the most important means of travel on the waterways for the Coast Salish people, where overland travel was unusually difficult through the thick tangle of forest and understory vegetation. Canoes were used during the summer season to attend various gatherings and to reach temporary summer villages located near food sources—clams, berries, roots, and especially salmon.

By the early 1900s the eleven-man racing canoe became the focal point for Indian and non-Indian gatherings. By 1910 expert artists and craftsmen from the Swinomish Indian Reservation had carved the *Telegraph*. This craft later attained legendary status for her speed and champion crew of Swinomish pullers during the International Canoe Races held along Coupeville's waterfront from 1929 to 1941. The *Telegraph* won for 12 years in a row.

—Swinomish Tribal Community

Canoe racing is both a sport and a tradition. Canoe pulling is an art. The pullers must keep the canoe stable and learn to keep the same pace in stroking and switching the paddles. The courses range from four to six and one-half miles in length. Both men and women must endure the cold months of winter training, including sore backs, calloused hands, sore shoulders, and relearning the balance required to ride the waves in the narrow canoes. Each team may spend one and one-half to three hours per night training both in the canoe and in various exercises such as distance running.

—Emmett Oliver

Earl Jones, 76-year old Lummi Tribal Elder, began pulling canoes when he was ten years old. In his day, the 1920s, they didn't train too much because everybody used to work in the woods sawing and cutting, and since there weren't very many cars, people walked or ran. The 56-foot *Cyclone* was a fast canoe, but it was slow on the turns. Jones said they did win a couple of races in this canoe.

—Lummi: Lyn Dennis-Olsen

WATERBORNE

The dugout canoe was an integral part of Suquamish culture. The canoe was essential to the collection of subsistence resources, such as salmon and other fish, berries, roots, wild potatoes, and sea grasses. These foods were seasonal and regional and the Suquamish needed to be in particular places at specific times in order to harvest them. The canoe allowed them to travel long distances in a relatively short time, assuring quantities of food, establishment and renewal of tribal alliances, and the preservation of social and ceremonial contacts, which in turn permitted the culture to flourish beyond mere survival.

The Suquamish Tribe has documented the canoeing heritage and water-oriented Native American culture statewide in "*Waterborne*, Gift of the Indian Canoe," a multi-image slide presentation featuring an entirely Native American narrative. (This slide presentation was featured in "A Time of Gathering" at the Burke Museum).

TO A DIFFERENT CANOE:
THE LASTING LEGACY OF LUSHOOTSEED HERITAGE

Vi Hilbert

"[Our tradition]...will be transferred to a different canoe...Coming generations of young people will hear it."

—Part of a message from Susie Sampson Peter, Skagit elder, to Ruth Shelton, Tulalip elder

Lushootseed[1] is the Native American language indigenous to the Puget Sound area. It belongs to the Salishan language family whose domain extends from the Pacific eastward to western Montana, southward to Oregon, and northward to British Columbia. At the time that Euro-American settlers first came to this area, there were twenty-two languages in the Salishan family; fewer are spoken today. Lushootseed is remembered only by older members of the tribes of Puget Sound, including the Skagit, Snohomish, Snoqualmie, and Suquamish. It is the goal of Lushootseed Research, a non-profit organization headed by Vi Hilbert, to preserve as much as possible of both the language and the culture of these people.[2]

I am Vi (taqʷsəblu) Hilbert, an elder of the Upper Skagit tribe. Working to preserve the language and literature of my Lushootseed people began for me in 1967 after I met Dr. Thomas M. Hess, a linguist who encouraged and tutored me to learn the writing system—the orthography—he uses as he works on the languages of Native people in the United States and Canada. It has become my responsibility as a great-grandmother to gather, transcribe, and translate as much as I possibly can of the culture of my people for the benefit of coming generations.

Much of the material that I have published is from my own field work, elicited from relatives and friends. Dr. Hess has made all of his tape recordings and field work available to me. Some of the transcriptions are from tapes from the Leon Metcalf collection, which was donated in 1970 to the Burke Museum. My aunt, Susie Sampson Peter, was one of the historians recorded by Mr. Metcalf. In referring to Leon Metcalf's work, she said, "This conversation of ours will be there with him to his last days, then it will be transferred to a different canoe. And this is why I am happy about it: coming generations of young people will hear it." This essay is dedicated to the spirit embodied in Susie Sampson Peters' wish to share her knowledge with future generations.

The oral traditions of Native Americans have been the primary way of passing down cultural information. We are indeed fortunate that in the 1950s some of our elders were taped telling traditional stories, singing songs, and reciting history, geneologies, and other cultural information. These recordings provide at least a sample of the linguistic subtlety and rich literature of the Lushootseed people.

We can hear the rhythm and cadence in the storytelling styles of these gifted elders: Susie Sampson Peter, Upper Skagit (1865–1961); Martha Lamont, Tulalip (1880–1973); Emma Conrad, Sauk-Suiattle (1891–1965); Harry Moses, Sauk-Suiattle (taped 1950s); Ruth Shelton, Tulalip (1855–1958); Isadore (pətius) Tom, Lummi (1904–1989); Hagan Sam, Tulalip (1907–1973); Martin Sampson, Upper Skagit (1888–1980); Dewey Mitchell, Upper Skagit (taped 1950s); Charley Anderson, Upper Skagit (1876–1957); Louise Anderson, Upper Skagit (1886–1964).

My aunt, Susie Sampson Peter, was a gifted storyteller. We can hear the magic of her stories on tape.

Her detailed legends about the creation of our world take us through a journey that lets us know where we come from and how our world came to be. Aunt Susie also gives an account of the first contact with Euro-American settlers in our Skagit Valley. She voices the empathy felt by the Natives for newcomers who needed help. The newcomers were taught how to use the bounty of the land. Compassion and the normal generosity of the culture were practiced toward the settlers. Aunt Susie worked for some of them for 25¢ an hour. She learned a lot about "white ways." Her father befriended and helped a cook who had jumped ship. This man settled in the Skagit Valley and was admired for his industry. He bought tools for clearing land, built a shelter, and planted a garden. When it was harvest time, he shared his produce with Susie's family. Aunt Susie tells us how her father sent her out to become an Indian doctor, a shaman, although most shamans were men.

Ruth Shelton—Tulalip, Klallam, and Samish historian—has given us detailed accounts of first contact experiences with the Hudson's Bay traders. Her father had been sought out as a guide to help the traders in their search for furs and other saleable items. Ruth explains in Lushootseed the thoughts and feelings of our people as they became acquainted with the many new commodities brought here by the traders. Here are a few of the items she spoke about and the people's first impressions of them.

sugar: "It looks like sand, it is sweet and white."
coffee: "It is black, the white sand is put into it and stirred, and you drink it."
flour: "It is white and when you throw it onto the fire it flames up in a frightening way."
bar soap: Ruth tried to wash her hair with it at the beach and found that it made a mess.
liquor: It was brought to Tulalip from the Quinault country. Ruth explained how it affected the person who drank it. The people were amazed that anyone would drink anything that smelled so terrible and that exploded when thrown on the fire.
chickens: These also were brought from the Quinault country. Their droppings were disgusting and it was only because the rooster crowed so nicely early in the morning that their lives were saved.
hardtack: It was an amazing thing how someone had put little holes here and there in these round, hard crackers. The Suquamish thought that this was evidence of worms and they would not eat them.

Every winter, Native people gather to celebrate Treaty Day. It is not, however, the selling of our lands in 1855 at the Treaty of Point Elliott that we commemorate. Officials of the period had banned the

Figure 1. ṭaqʷsəblu, Vi Hilbert, linguist and founder of Lushootseed Research. The staff was carved by her son, Ron Hilbert Coy. Photograph 1989, courtesy of Vi Hilbert.

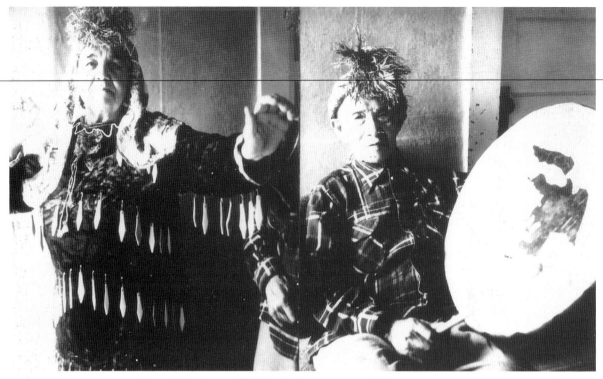

Figure 2. Louise and Charley Anderson, parents of Vi Hilbert. Shown here in ceremonial dress, they have told many legends and taped over 100 songs from their Upper Skagit ancestors and from those who were members of the longhouses. Photograph 1956, Virginia Mohling.

Figure 4. Ruth Shelton, Tulalip, Klallam, and Samish historian, who lived to be 103. Here at Tulalip, in April of 1956, she is 98. Her husband William Shelton's carved totem pole is in the background. Chief William Shelton was an important speaker for the Tulalip tribes. He also served as a policeman for his area while he worked for the Bureau of Indian Affairs under Dr. Buchanan, Indian Agent. Photograph 1956, Leon Metcalf.

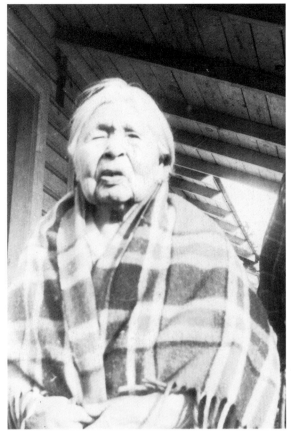

Figure 3. Susie Sampson Peter, accomplished storyteller of the Upper Skagit, lived to age 95. Here, at Swinomish in 1952, she is 86. Her father was Doctor Sampson, an Indian doctor or shaman. Photograph courtesy of Vi Hilbert.

Figure 5. Martha Williams Lamont, Tulalip elder. The cousin of Chief William Shelton, she married Levi Lamont. She lived to be 93. Photograph courtesy of Vi Hilbert.

practice of our religion. Anyone who violated the ban was jailed. My dad, Charley Anderson, Upper Skagit historian, told the following story.

Our longhouse people used to have a hard time because the priests and Government officials didn't want us to practice our religion. In 1905, Chief William Shelton, Tulalip tribes, arranged for a meeting of members of our longhouses and Dr. Charles Milton Buchanan, the Indian Agent. The people pleaded their case, asking that they be allowed the right to practice their religion as they used to, out in the open. They had been secretly trying to carry on with their traditional practices. The agent said to them, "If you can prove to me that you have anything, I will

allow it." Elzie Andrews, Upper Skagit, began singing his power song. A cougar, his spirit power guide, came walking through this building where the people were gathered. Dr. Buchanan quickly spoke up saying, "All right, now I believe you; make it go away!"

Many of our elders remember hearing this story told and retold. I heard my uncle Morris Dan and my cousin Harriet Shelton Dover discussing the correct date of this meeting. They said it was between 1903 and 1905. From that time, our people have been able to practice their old religion without fear of going to jail.

Indeed, a new canoe is carrying forward our ancient ways.

Figure 6. Annie Dan Billy, mother of Susie Sampson Peter, made blankets and other traditional handwork. Photograph about 1920, courtesy of Vi Hilbert.

NOTES

1. Pronunciation Guide to Lushootseed

a = a of father; c = ts of hats; č = ch of church; ə = a of about; i = i of machine; ł = explosive lh (place tip of tongue on roof of mouth and blow air out the sides); ƛ’ = tl of nightlight; q = k of key (gutturally); š = sh of hush; u = oo of boot; xʷ = wh of where (raspingly); x̌ = x of Mexico (as pronounced by Mexicans); ʔ = an abrupt cessation of the preceding sound, as in uh-oh; ’ = indicated letter sounded with a tightened throat; ′ = stress on a syllable.

2. Sixty-six Lushootseed legends have been published to date (see Hilbert 1980, 1985, Hilbert and Russell 1980; Hess and Hilbert 1975, 1977). Other projects in progress include the first volume of the Lushootseed canon of literature, to be published soon, and a computer up-date of the Lushootseed dictionary, which will combine Dr. Hess’ dictionary of Puget Sound Salish with all of the vocabulary collected by Vi Hilbert since 1967.

REFERENCES

Hess, Thom. 1976. *Dictionary of Puget Salish*. Seattle: University of Washington Press.

Hess, Thom, and Vi Hilbert. 1975. *Lushootseed, The Language of the Skagit, Nisqually, and Other Tribes of Puget Sound*. An Introduction (book one). Seattle: United Indians of All Tribes Foundation, Daybreak Star Press.

———. 1977. *Lushootseed, The Language of the Skagit, Nisqually, and Other Tribes of Puget Sound* (book two). Seattle: United Indians of All Tribes Foundation, Daybreak Star Press.

Hilbert, Vi. 1974. *On Transcribing the Metcalf Tapes*. Ninth International Conference on Salish Languages. Vancouver, British Columbia.

Hilbert, Vi. 1980. *Huboo*. privately printed.

Hilbert, Vi, and C. Russell. 1980. *Ways of the Lushootseed People: Ceremonies and Traditions of the Northern Puget Sound Indians*. Seattle: United Indians of All Tribes Foundation, Daybreak Star Press.

———. 1985. *Haboo: Native American Stories from Puget Sound*. Seattle and London: University of Washington Press.

WHEN CHIEF SEATTLE (SIʔAɬ) SPOKE

ᚻ᛫ᛞᚻ᛫ᛞᚻ᛫ᛞᚻ᛫ᛞᚻ᛫ᛞᚻ᛫ᛞᚻ᛫ᛞᚻ᛫ᛞᚻ᛫ᛞᚻ᛫ᛞᚻ᛫ᛞᚻ᛫ᛞᚻ᛫ᛞᚻ᛫ᛞᚻ

Vi Hilbert

The city of Seattle, Washington, is named after the Suquamish/Duwamish leader, Chief Seattle, who lived from around 1786 to 1866. Seattle is spelled Siʔaɬ in the Lushootseed language. The English spelling has resulted in various mispronunciations. A phonetic spelling that approximates the correct pronunciation is **See**-*ahth, with the accent on the first syllable. Chief Siʔaɬ is perhaps most famous for a speech that was recorded in English by Dr. Henry Smith (Smith 1887), who heard it as it was given, in the Lushootseed language, as well as translated into Chinook Jargon, a trade language composed of Native, French, and English words. We do not know whether Dr. Smith fully understood the Lushootseed, or gained his knowledge of the content of the speech from the Chinook Jargon translation. We do know that he took notes of the speech in his diary (now lost), and published a portion of the speech in English thirty-three years later, noting that it was "but a fragment of his speech, and lacks all the charm lent by the grace and earnestness of the sable old orator" (Smith 1887). Vi Hilbert has taken Dr. Smith's English version and translated it into Lushootseed, in an attempt to recreate as nearly as possible Siʔaɬ's original words. Though this Lushootseed version is admittedly only an approximation of the original speech, it gives us a sense of the phraseology that may have been used by Siʔaɬ, and certainly is the nearest we will ever come to knowing what Siʔaɬ actually said.*

Since its first publication in the Seattle Sunday Star, *Smith's English version of the speech has been quoted and misquoted, resulting in many published versions that range from faithful modernized renditions (Arrowsmith 1969) to largely fictionalized versions containing references to railroads and rotting buffalo, features which, for historical reasons, could not have been mentioned by Siʔaɬ (Kaiser 1987: 517). In addition to the many spurious versions of the speech, considerable confusion has arisen about the occasion on which this famous speech was given. Recent research supports the probability that the speech recorded by Dr. Smith was given in Seattle in December of 1854 on the occasion of the return of Governor Isaac Stevens, new Commissioner for Indian Affairs for Washington Territory, from a trip to the East (Kaiser 1987: 511). There is a record of two short speeches delivered by Siʔaɬ at Mukilteo in 1855 on the occasion of the signing of the Treaty of Point Elliott (National Archives, Washington, D.C.). Vi Hilbert presents here one of these speeches as remembered by a Suquamish elder, Amelia Sneatlum. Only two other short speeches by Siʔaɬ are known, a fragment of a speech recorded by B. F. Shaw in 1850, and a lament by Siʔaɬ in May 1858 that the Treaty of Point Elliott had not been ratified by the U.S. Senate, leaving the tribes in poverty and poor health (Kaiser 1987: 525).*

Siʔaɬ had the special gift of oratory. He was recognized as one of the most gifted orators among the Lushootseed people of Puget Sound. One of his spirit powers was that of Thunder. People possessing spirit guides may be helped in special ways. It is said that Siʔaɬ could be heard from half a mile away when he spoke (Bagley 1931). Siʔaɬ was one of the speakers when Governor Isaac Stevens was arranging treaties with our Lushootseed tribes located around these inland waters.

We don't know exactly how much information our people had about the proceedings that were to transpire at this meeting with Governor Stevens in

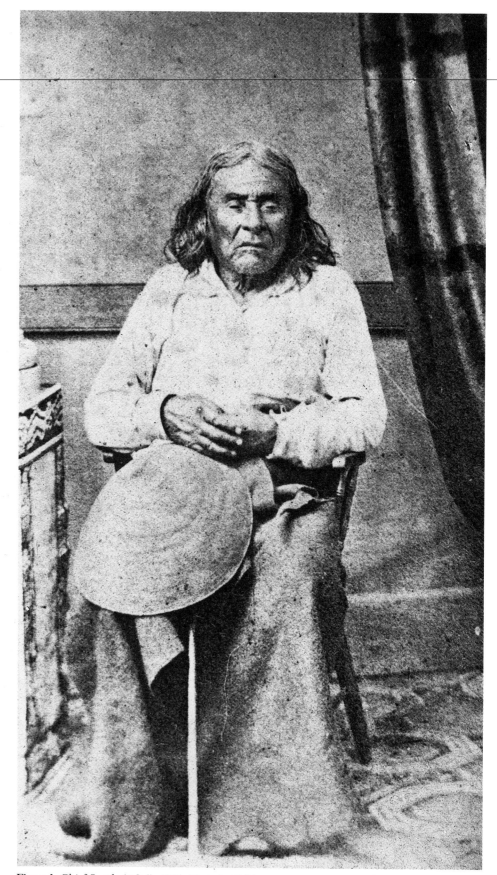

Figure 1. Chief Seattle (Siʔał), 1865. Photo by E.M.
Sammis, courtesy of the Suquamish Tribal Archives, Suq-
uamish, Washington, #1646.

1855. Some voice of authority had called the people to this meeting. People traditionally respect an invitation to a gathering. In 1855, our people spoke Lushootseed and a few used some Chinook Jargon, the trade language of this region. They knew a few English words. Siʔaɬ didn't use Chinook Jargon; he didn't like it (Bagley 1931).

Stevens addressed the tribes in English. When Governor Stevens' interpreter spoke to the assemblage, he used Chinook Jargon to explain what Stevens was saying. He read the terms of the treaty. There were many good-sounding promises. Stevens promised that the people would be taught how to build houses like those of the white settlers. They would have schools and hospitals for their people. They would be given many gifts that would make their lives easier. There had been hardship: sickness, invasion by warring tribes from the north and other restless groups, a lack of homes to protect the people from the winter cold. Many of the Native leaders were weary from their years. They were depressed by these hardships.

From the memories of Ruth Shelton, as taped by Leon Metcalf (1954), we can understand some of what took place at Mukilteo. Shelton was one of our highly respected historians, consulted by many because of her reliable memory (see Hilbert, "A Different Canoe," this volume).

Ruth Shelton tells us that a man named Xalb, one of her in-laws, was sent to invite all the tribes to come to Mukilteo to meet with Governor Stevens concerning the treaty. It was said that the tribes gathered there for fifteen days. There were some tribal representatives who immediately agreed to the terms of the treaty, but there were more who said "no" to the selling of their lands.

There was a white man named Simmons who came from near Olympia, which is called St̓ačas. He knew Chinook Jargon. He was the one who was brought to Mukilteo by Governor Stevens to interpret for him. This is the way all of the people who gathered there heard it. Governor Stevens spoke in English. Now this Simmons took the words and changed the English words into Chinook Jargon and gave these words to those who were gathered. A man named John Taylor interpreted for the Indians. He translated the Chinook Jargon spoken by Simmons into Lushootseed. John Taylor interpreted that future generations would be as white people. They would be taught to be like the white people. He repeated this several times because there were many people there. Statistics vary on the exact numbers.

There were three Indians who helped John Taylor with the interpretation. As soon as John Taylor would finish interpreting the words of Governor Stevens, then Pəx̌qidəb from Snoqualmie, Cawiʔcut from Lummi, and Sgʷəlayəʔ from Skagit would translate them from Chinook Jargon into their own Indian languages. Sdapəlq, another able speaker, also helped. The interpreters said that they thought it would be very good for the future generation to be like white people.

Governor Stevens told the people that they were to say which part of the land that used to be theirs they would want to keep forever. Cədatəlq, son of Wədəpaʔ, stood up right away and said this: "Will it be for as long as the water spills in the rivers, will it be for that long that it will be ours? And will it be for as long as the sun travels from whence it comes until it returns to the west? Shall it be that long?" Governor Stevens stood up and nodded his head (up and down in the affirmative) because there were lots of people—they couldn't hear him if he spoke. He just nodded his head "yes" and he sat down.

On tape, recorded by Dr. Warren Snyder, January 1955, Amelia Sneaχem (Sneatlum), Suquamish elder, repeated this short speech of Chief Siʔaɬ given at Mukilteo during the time of the signing of the Point Elliott Treaty (for speech, see p. 262; for pronunciation guide, see Hilbert, "To a Different Canoe," this volume).

Our spirit power songs are individual personal property and have long been respected and practiced in the privacy of our longhouses; they are never published for the general public. Amelia Sneaχem did also sing Chief Siʔaɬ's spirit power song when she related his speech. I mention it here because it was considered a responsibility for our historians to remember songs. My dad remembered and sang over one hundred songs.

Siʔaɬ possibly had more contact with white people than other Indian leaders, for he interacted with the newcomers to his Duwamish area. He and Dr. Maynard, sub–Indian Agent, had become very good friends. And it was Siʔaɬ, according to Ruth Shelton, who saved the lives of at least thirty white people by sending a messenger to warn of a raid that had been planned by Ləšcay (Leschi) from Nisqually. (Ləšcay was a war chief who was later unjustly hung, according to some accounts.) The white people listened to Siʔaɬ's messenger and escaped Ləšcay's war party.

The white people were grateful to Siʔaɬ for this and for many other favors. They respected his wisdom and appreciated his help. They showed him their respect by giving medical assistance and by sharing information about their culture. Siʔaɬ and others were impressed by this new culture. They thought it would be good to be like the people in this white culture.

Siʔaɬ also spoke in Seattle in 1854. This speech, which has become famous, was given on the occasion of a reception for Governor Stevens, the newly appointed Commissioner of Indian Affairs for Washington Territory. The reception took place in front of

Dr. Maynard's office on Main Street (Kaiser 1987). On this occasion, as well, interpreters were needed to translate from Lushootseed to Chinook Jargon and English, and vice versa.

The interpreter who listened to Siʔał's words at this time must have carefully chosen vocabulary from the limited Chinook Jargon to transmit Siʔał's philosophy. A listening white man, Dr. Henry A. Smith, sensed the beauty of Siʔał's speech (Smith 1887). He took notes of this impressive speech, and from them wrote the English version published thirty-three years later in the *Seattle Sunday Star*.

It has now been over one hundred years since the voice of Chief Siʔał moved a sensitive listener to pen the words that people from many cultures have appreciated. Although the English vocabulary was unknown to Chief Seattle, his Lushootseed vocabulary was eloquent. And Henry Smith did indeed understand the philosophy transmitted through that expressive language.

References

Arrowsmith, William. 1969. Speech of Chief Seattle, January 9th, 1855. *Arion, A Journal of Humanities and the Classics* (4): 461–64.

Bagley, Clarence B. 1931. Chief Seattle and Angeline. *Washington Historical Quarterly* 22: 243-75.

Kaiser, Rudolf. 1987. "A Fifth Gospel, Almost": Chief Seattle's Speech(es): American Origins and European Reception. In Christian F. Feest, ed., *Indians and Europe: An Interdisciplinary Collection of Essays*. Aachen: Edition Herodot, Rader Verlag.

Shelton, Ruth. 1954. The Memories of Ruth Shelton, taped by Leon Metcalf on May 20, 1954. Unpublished manuscript, comprising 37 pages of Lushootseed text, translated into English by Vi Hilbert (taqʷšǝblu) in 1981.

Smith, Dr. H. A. 1887. Early Reminiscences No. 10. Scraps from a diary—Chief Seattle—a gentleman by instinct—his native eloquence etc. etc. *Seattle Sunday Star*, October 29.

Seattle's Speech Quoted By Amelia Sneatlum, Suquamish Elder Connected Translation

1. gʷǝł ti siʔał tusux̌udx̌ud
 belonging to the specific one Seeahth (Seattle) was saying

 ʔal kʷi tuʔutreaty ʔal ti mukiltio
 on/at hypothetical-marker those-involved-in-a-treaty at the Mukilteo

 tiʔił ʔǝscut.
 that is said

 1. This is what Seeahth said

 when they were having the treaty at Mukilteo,

 what is said (here).

2. ʔǝslabǝd čǝlǝp ti dukʷibǝł
 be-looking-at you-folks the changer(s)

 ʔułǝči(l) dxʷʔal ti swatixʷtǝd.
 who-have-arrived to/toward the-specific land/earth

 2. You folks observe the changers

 who have come to this land.

3. gʷǝl ł(u)ǝslalabalčiʔǝxʷ
 and will-have-learned-what-has-been-done-by-the-hands-of-these

 kʷi łulaqbid čǝł,
 who they-will-behind we/us/our

 łuswiẁsu čǝł.
 future-children we/us/our
 (little ones)

 3. And our progeny will watch and learn from them now,

 those who will come after us,

 our children.

4. gʷǝl łuhuyil x̌ul'ab
 and they-will-become just-like

 ʔǝ ti dukʷibǝł ʔułčisǝbuł
 of the changer(s) who-have-arrived-to-us

 ʔal ti swatixʷtǝd.
 on/at the land/earth

 4. And they will become just like/just the same

 as the changers who have come here to us

 on this land.

5. haʔł kʷi sǝslabǝdlǝp.
 good hypothetical you-will-observe-them

 5. You folks observe them well.

Excerpts from a Speech of Chief Seattle (Siʔaɫ), 1854
(Transcribed into Northern Lushootseed by taqʷsəblu July 27, 1985; for pronunciation guide, see Hilbert, "To A Different Canoe," this volume)

Connected Translation

1.
tiʔəʔ adsťiwiɫ
this your-religion

1. Your religion

gʷəl t(u)asχal ʔal tiʔəʔ čʼəčʼə ƛ̓aʔ
and/now was-written on/at these rocks

was written on tablets of stone

liɫʔal tiʔəʔ χəɫ ti chickamin čʼətqsačiʔ
by-way-of this kind-of-like iron (Chinook Jargon) finger

by the iron finger

ʔə tiʔəʔ ʔəsχicil šəq siʔab
of this is-angry high Honorable-One

of an angry God

gʷaʔəxʷ čəxʷ gʷəbali.
lest you might-forget

lest you forget.

2.
tiʔəʔ ʔaciɫtalbixʷ gʷəl xʷiʔ kʷi gʷ(ə)asčal gʷəsugʷəhaytxʷs,
the Native-American and/now no could-there-be-a-way could-he-comprehend

2. The red man could never comprehend

gʷəl xʷiʔ bəgʷəsəslaχdxʷs.
and/now no could-someone-again-remember-it

nor remember it.

3.
tiʔəʔ sgʷaʔčəɫ sťiwiɫ
this our-own religion

3. Our religion

gʷəl tulʔal tiʔiɫ tuxʷdikʷ ʔə kʷi sgʷaʔčəɫ tuyəlyəlab
well, it-is-from that was-the-advice of those-who-were-our ancestors

is the tradition of our ancestors

4.
sqəlalitut ʔə tiʔəʔ sləluƛ̓tədčəɫ
dreams of these our-elders

4. the dreams of our old men,

sʔabadəbs
was-given

given to them

ʔal ti ʔəsƛ̓əbčʼ ʔə kʷi słaχil
in the silence of the night

in the solemn hours of the night

tulʔal kʷi χaʔχaʔ šušukʷli
from the sacred spirit

by the great spirit

ʔi ti sqəlalitut ʔə tiʔəʔ xʷdaʔəbčəɫ,
and the spirit-power of these our-medicine-men/Indian-doctors

and the visions of our leaders,

gʷəl ʔəsχal ʔal kʷi χəč ʔə dibəɫ ʔaciɫtalbixʷ.
and it-is-written/marked in/on the intellect of us First People

and it is written in the hearts of our people.

5.
tiʔəʔ adskayuʔ gʷəl xʷ(i)axʷ gʷəsəsχaƛtubuɫəds
this your-dead well, no-longer love you

5. Your dead cease to love you

ʔi tiʔəʔ swatixʷtəd tudəxʷgʷəcs
and this land/earth/world where-they-were-born

and the land of their nativity

ʔəsʔistəʔ ʔə tiʔiɫ ƛus ʔatəbəds
just-like of that someone-dies

as soon as they pass the portals of the tomb;

ƛuʔibʔIbəš dxʷdiʔiʔ
someone-habitually-walks toward-a-distance

they wander far away

diʔabac ʔə tiʔiɫ tʼətʼəwas
on-the-other-side of those stars

beyond the stars

ƛalal tiʔiɫ ƛusəsbalisəbs gʷəl xʷ(i)axʷ gʷəsubəlkʷs.
early/soon that they-are-forgotten and no-more does-someone-return

and are soon forgotten and never return.

263

6. ti?ə? sgʷa?čəł skayu? 6. Our dead
 these our-own dead

 gʷəl xʷi? kʷi gʷəpə(d)tab gʷəsbali?bids never forget
 and no hypothetical at-no-time would-they-forget

 ti?ə? ?adᶻalus swatixʷtəd tugʷədᶻdxʷ (h)əlgʷə?. this beautiful world that gave
 this beautiful land/earth/world gave-birth-to them them being.

7. ckʷaqaqid (h)əlgʷə? ?əsx̌aX̌ildxʷ 7. They always love
 always they are-in-the-condition-of-liking/loving it

 ti?ə? ?əspuypuy stultuləkʷs its winding rivers,
 this which-is-bent/curved rivers

 ?i ti?ə? x̌a?x̌a? sbadbadils its sacred mountains,
 and these sacred mountains

 ?i ti?ə? ?əs?alacut sbaqʷbaqʷabs, and its sequestered vales,
 and this which-is-secluded vales

 gʷəl ckʷaqaqid ?əslax̌dxʷ lił?al yədwass and they ever yearn in
 and always will-remember by-way-of someone's-heart tenderest affection over

 ti?ə? ?əsx̌ikʷəb ?al yədwass ?əshəlhəli?, the lonely-hearted living
 this is-lonely in/on someone's-heart is-living

 gʷəl X̌ubibibəlkʷ dxʷ?al kʷi gʷəsdᶻəx̌əx̌bids, and often return to visit
 and they-keep-returning to/or-toward the in-order-to-visit-someone

 gʷəsucəkʷədxʷs gʷəl gʷəsuqəbłəds (h)əlgʷə? guide and comfort them.
 keep-someone-straight/correct and could-comfort-someone they

8. łupətidgʷəsbid čəł ti?ə? adčəłx̌əčəb, 8. We will ponder your
 will-think-about-it we this your-proposition proposition,

 ?al kʷi łustəłdxʷčəł kʷi spətidgʷəsəbčəł čəła łuyəcəbtubułəd. and when we decide
 at when we-will-find-it-true our-thoughts and-we will-tell-you we will tell you.

9. tuxʷ gʷəkʷədadəxʷəłi 9. But should we accept it,
 but/however if-we-were-to-take-it

 ?əs?istə? ?ə ti?ə?əxʷ kʷi dᶻixʷ?al gʷədsxʷdigʷicid I here and now make
 this of like-this-now the would-be-the-first I-would-advise-you this the first condition

 xʷi? kʷi łusəsəqəldubčəł ?ə ti?ə? sgʷa?ič, xʷəł syabuk?ʷ, that we will not be denied
 no one is-to-stop-us of this privilege without fight/quarrel the privilege, without molestation,

 dxʷ?al kʷi gʷəsudᶻəx̌əx̌bidčəł ti kayu?ali?čəł, of visiting at will the graves,
 toward the our-visiting the graveyards-which-are-ours

 dəxʷəspədtxʷčəł kʷi yəl'yəlabčəł, where we have buried
 where-we-have-ours-buried those our-ancestors our ancestors,

 ?i kʷi bədbəda?čəł. and our friends,
 and these our-relatives/children and our children.

10. | bəkʷ čadbid | ʔə tiʔəʔ | swatixʷtəd | gʷəl | kʷiʔat | dxʷʔal | tiʔəʔ dʔiišəd. |
|---|---|---|---|---|---|---|
| every part | of this | land/earth/world | well, | sacred | to | these my-people |

10. Every part of this country is sacred to my people.

	bəkʷ	čadbid	ʔə	kʷi	sbabdil,
	every	part	of	the	little-mountain/hillside,

Every hillside,

		ʔi	kʷi	cəkʷdup,
		and	the	flatland

every valley,

ʔi	kʷi	bəkʷ	čadbid	ʔə	tiʔə	swatixʷtəd
and	the	every	where	of	this	land/earth/world

every plain and grove

gʷəl	ʔəskʷiʔatil	liʔal	tiʔił	stab	tudəxʷəshiiłčəł
well,	has-become-sacred	by-way-of	those	things	we-were-happy-about

has been hallowed by some fond memory

	xʷəłub	tiʔəʔ	stab	gʷətudəxʷəsx̌əłəłx̌əč
	even	these	things	which-made-us-sad

or some sad experience

	ʔə	tiʔił	tudsq̇ʷuʔaʔkʷbixʷ.
	of	those	who-were-my-tribespeople

of my tribe.

11. | q̇əbəł | tiʔəʔ | č'əč'əx̌'aʔ | x̌əłti | ʔəsxʷəłx̌əč |
|---|---|---|---|---|
| even | these | little-rocks | seemingly | be-without-mind/intellect |

11. Even the rocks which seem to lie dumb

	ʔal	tiʔəʔ	səsq̇ʷəlils	ʔə	tiʔəʔ	łukʷəł
	right	here	as-they-get-hot	by	this	sun

as they swelter in the sun

ʔilgʷił	ʔə	tiʔəʔ	ʔəsx̌əlbucid	x̌ʷəlč
along-the-shore	of	this	is-silent	salt-water/sound/ocean

along the silent seashore

ʔəsʔiabcut	ʔugʷəxʷisad	ʔal	tiʔił	λusəslax̌dxʷs
self-important	does-thrill	as	that	when-they-remember

in solemn grandeur thrill with memories

λ(u)tusuhuy	ʔə	ti	tushəɨhəliʔ	ʔə	ti	tudʔiišəd.
past-activities	of	the	were-living	of	the	my-relatives/people

of past events connected with the lives of my people.

12. | gʷəl | ʔal kʷi | łusxʷiʔil | ʔə | kʷi | ʔiłlaq | ʔaciłtalbixʷ |
|---|---|---|---|---|---|---|
| and | when that | it-will-be-no-more | of | the | last | Native-American |

12. And when the last red man shall have perished

	tuɨʔal	tiʔəʔ	swatixʷtəd
	from	this	land/earth/world

from the earth

gʷəl	tiʔəʔ	tusdiʔaʔs	ʔəsq̇ʷuʔ	ʔə	tiʔiʔəʔ	paspastəd
and	that	they-were-here	together	with	these	white-people

and his memory among the white men

	gʷəl	x̌ʷuɨəxʷ	łusʔəyəhub,
	well,	it-will-only-have-been	will-be-a-myth/legend

shall have become a myth

bəkʷ čad	ʔal	tiʔəʔ	ʔilgʷił	kʷi	łusʔa
every where	at/on	the	shore	hypothetical	will-exist

these shores will swarm with

	ʔə	tiʔəʔ	xʷ(i)ʔaxʷ	gʷ(ə)adsəsšuuc	skayuʔ
	of	these	not-now	that-you-can-see	dead

the invisible dead

	ʔə	tiʔəʔ	dsq̇ʷuʔaʔkʷbixʷ;
	of	these	my-tribespeople

of my tribe;

13.	gʷəl ʔal kʷi	ɫusəxʷscutəbitəbs	ʔə tiʔəʔ	adʔibʔibac	daýaý	həlgʷaʔ	13.	and when your children's children
	and when	think-about-it	of these	your-grandchildren	alone	they		shall think themselves alone

	ʔal	kʷi	bəkʷ čad	ʔal tiʔəʔ sqʷali, kʷi	xʷuyubalʔtxʷs,	suyayus,	in the fields, the store, the shop,
	in/on	every	all/every where/place	the fields	their-stores	shop/workplace	

| | ʔal tiʔiɫ | šəgʷɫ, | qəbəɫ | səsχəlb | ʔə kʷi | čʼətxʷaləp | upon the highway, or in |
|---|---|---|---|---|---|---|
| | on/at the | road/door | even | is-silent | of | trees-which-grow-close-together | the silence of the pathless woods, |

| | xʷiʔ | kʷi | ɫusdaýaýs | (h)əlgʷəʔ | they will not be alone. |
|---|---|---|---|---|
| | not | hypothetical | will-be-alone | they | |

| | ʔal tiʔəʔ | swatixʷtəd | xʷiʔ kʷi čad | gʷadsuʔəydxʷ | kʷi | gʷadsuʔalacut. | In all the earth there is no place |
|---|---|---|---|---|---|---|
| | in this | land/world | no place | could-you-find | where | you-could-be-alone | dedicated to solitude. |

14.	ʔal kʷi ɫaχ	ʔal kʷi	šišəgʷɫ ʔə	tiʔəʔ	adtawd	ʔi ʔal kʷi	ɫusəsχikʷəb	14.	At night when the streets
	in the night	on the	streets of	this	your-town(s)	and when	is-lonely		of your cities

| | ʔə | tiʔiɫ | dəxʷəstaɫlil | ʔə | tiʔiɫ | adsgʷaʔ | and villages will be silent |
|---|---|---|---|---|---|---|
| | of | this | where-there-is-living | of | those | who-are-your-own | |

| | čəxʷa | ɫulə(ə)xʷscutəbid | xʷiʔ kʷi gʷat | ʔa ʔal tiʔiɫ | and you think them deserted, |
|---|---|---|---|---|
| | and-you | will-be-thinking-about it | no one | at that-place | |

| | ɫuʔa | kʷi sqʼuʔqʼuʔ | ləbəĭbəlkʷ | ʔaciɫtalbixʷ | they will throng |
|---|---|---|---|---|
| | will-exist-there | a great-many-gathered | returning | Native-American(s) | with returning hosts |

| | tut(u)asləčəd | gʷəl | didiɫ | ʔuxʷ | that once filled and still |
|---|---|---|---|---|
| | who-filled | and | still | yet | |

| | ʔəsχaχildxʷ | tiʔəʔ | ʔadᶻalus | swatixʷtəd. | love this beautiful land. |
|---|---|---|---|---|
| | are-loving | this | beautiful | land/earth/world | |

| 15. | xʷiʔ | kʷi pə(d)tab | gʷəsdaýaý | ʔə tiʔəʔ | pastəd. | 15. | The white man will |
|---|---|---|---|---|---|---|
| | at-no | time | would-be-alone | of this | white-person | | never be alone. |

| | χub | ʔutəɫəɫcut | Let him be just |
|---|---|---|
| | it-is-good-that | being-true/honesting-self | |

| | gʷəl | haʔɫ | kʷi suʔabaɫ | sχəčs | dxʷʔal | tiʔəʔ | dʔiišəd | and deal kindly with my people |
|---|---|---|---|---|---|---|---|
| | and | good | will-give-his | thoughts | to/toward | these | my-relatives/people | |

| | yəχi | xʷiʔ | ləpʼaχaχ | tiʔəʔ | skayuʔ | for the dead are not powerless. |
|---|---|---|---|---|---|
| | because | not | unimportant | these | dead | |

| 16. | tucut | čəd | ʔu | sʔatəbəd. | 16. | Dead—did I say? |
|---|---|---|---|---|---|
| | did-say | I | question | death | | |

| | xʷiʔ | kʷi | gʷəsʔatəbəd | There is no death, |
|---|---|---|---|
| | no | hypothetical | exist-death | |

| | x̌ʷuĭ | čəɫ | ɫudᶻəlyalus. | only a change of worlds. |
|---|---|---|---|
| | only/just | we | will-change-worlds | |

Contemporary Tribes in Washington State

Confederated Tribes of the Chehalis Indian Reservation
P.O. Box 536
Oakville, WA 98568
(206) 273-5911

Location: 420 Howanut Road
Oakville, WA

Tribes forming confederation:
Lower Chehalis
Upper Chehalis
Cowlitz

Tribal membership: 485

Government structure:
5-member elected council,
Serving 2-year terms

Reservation: 4,215 acres
Established by Executive Order; October 1, 1886

Current enterprises:
Convenience store, bingo, health clinic

Planned enterprises:
Business: Fish farm and hatchery
Cultural: Drum and dance group

Events:
Chehalis Tribal Day, end of May

Chinook Indian Tribe
P.O. Box 228
Chinook, WA 98614
(206) 777-8303

Tribes forming confederation:
Cathlamet Band of Chinook
Willapa Band of Chinook
Lower Band of Chinook
Clatsop Tribe

Tribal membership: 1,350

Government structure:
7-member elected council
Serving 3-year terms

Current enterprises:
Bingo

Planned enterprises:
Seeking Federal recognition

Colville Confederated Tribes
Box 150
Nespelem, WA 99155
(509) 634-4711

Tribes forming confederation:
Chelan Nespelem
Colville Nez Perce
Entiat Okanogan
Lake Palus
Methow San Poil
Moses/Columbia Wenatchee

Tribal membership: 7,000

Government structure:
14-member elected council
Serving 2-year terms

Reservation: 1.4 million acres
Established by Executive Order; April 9, 1872

Current enterprises:
Business: Colville Indian Precision Pine Sawmill
Colville Tribal Credit Service
Three tribal grocery stores
Colville tribal logging
Inchelium Tribal Wood Treatment Plant
Lake Roosevelt Marina
C.C.T. Well-Drilling Company
Cultural: Cultural Resource Board
History/Archaeology Dept.
Archives/Records Program
Other: Paschal Sherman Indian School
Convalescent Center

Planned enterprises:
Business: Colville Tribal Gallery/Gift Shop
Moses Mountain Ski Resort
Cultural: Museum/Cultural Center

Events:
Omak Stampede Indian Encampment, second weekend in August
4th of July Celebration at Nespelem

Cowlitz Indian Tribe
1417-15th Ave. #5
Longview, WA 98632
(206) 577-8140

Tribal membership: 1,424

Government structure:
22-member elected council

Current enterprises:
Business: Community garden

Planned enterprises:
Land Claims Settlement
Museum Cultural Center

Events:
General council meetings, first Saturday of June, first Saturday of November

The Duwamish Tribe of American Indians
15614-1st Ave. South
Seattle, WA 98148
(206) 244-0606

Tribal membership: 370

Government structure:
8-member elected council
Serving life terms

Current enterprises:
Business: Non-profit Duwamish Tribal services
Cultural: Canoe Centennial Project
Annual meeting

Planned enterprises:
Cultural: Duwamish Cultural Center and Tribal Headquarters

Elwha Klallam Tribe
1666 Lower Elwha Road
Port Angeles, WA 98362
(206) 452-8471

Tribal membership: 550

Government structure:
5-member elected council, serving staggered terms

Reservation: 443 acres
Established by the Indian Reorganization Act, 1934

Current enterprises:
Business: Social-health-employment-education services
Smokeshop-variety store
Seasonal fireworks
Fishery
Cultural: Periodic language classes & storytelling
Athletic events
Museum artifact consultation by elders

Planned enterprises:
Mental health services
Recreational enterprises
Special events
Cultural Resource Library

Events:
Basketball Tournament, Port Angeles, mid-February
Alcohol Awareness Day, Port Angeles, April or May
PowWow, July or August

Hoh Indian Tribe
HC 80, Box 917
Forks, WA 98331
(206) 374-6582
SCAN 737-1216

Location: Lower Hoh River Road
Forks, WA

Tribal membership: 120

Government structure:
4-member elected council
Serving 2-year terms

Reservation: 443 acres
Established by Executive Order; September 11, 1893
Based on Treaty of Quinault; July 1, 1855

Current enterprises:
Business: Fish harvesting
Fisheries management
Cultural: Basket-weaving
Canoe-carving

Planned enterprises:
Business: Fish hatchery

Jamestown Klallam Tribe
305 Old Blyn Road
Sequim, WA 98382
(206) 683-1109

Tribal membership: 228

Government structure:
5-member elected council
Serving 2-year terms

Reservation: Trust land

Current enterprises:
Business J.K.T. Corporation
J.K.T. Computer Systems
Fireworks sales
Apartment complexes
Cultural: Summer Youth Cultural Program
Ongoing beading classes
Senior dinners

Planned enterprises:
Cultural: Ongoing cultural program: language, carving, beading

Kalispel Tribe of Indians
P.O. Box 39
Usk, WA 99180
(509) 445-1147

Location: LeClerc Road
Usk, WA

Tribal membership: 225

Government structure:
5-member elected council
Serving 3-year terms

Reservation: 4600 acres
Established by Executive Order; April 15, 1914

Current enterprises:
Business: Buffalo Enterprise
Kalispel Metal Products

Planned enterprises:
Business: Mini-mall

Events:
Annual PowWow, mid-August

Lummi Indian Business Council
2616 Kwina Road
Bellingham, WA 98226
(206) 734-8180

Tribal membership: 3,000

Government structure:
11-member elected council
Serving 3-year staggered terms

Reservation: 13,500 acres
Established by Executive Order, 1855

Current enterprises:
Business: Lummi Processing Venture
Fisherman's Cove (marine sales, restaurant, groceries)
Lummi Foreign Trade Zone
Cultural: Smoked salmon
Northwest coastal art: baskets, weaving, carving

Planned enterprises:
Business: Marina and related businesses

Events:
Lummi Stommish Water Festival, mid-June, Gooseberry Point, Lummi

Makah Indian Nation
P.O. Box 115
Neah Bay, WA 98357
(206) 645-2205

Tribal membership: 1,344

Government structure:
5-member elected council
Serving 3-year terms

Reservation: 44 square miles
Established by treaty agreement, 1855

Current enterprises:
Business: Forestry enterprise
Fishery enterprise
Construction business
Motel/restaurant business
Bingo
Cultural: Makah Cultural and Research Center

Planned enterprises:
Community College

Events:
Makah Days, late August

Marietta Band of Nooksack Indians
1827 Marine Drive
Bellingham, WA 98226
(206) 733-6039

Tribal membership: 520

Government structure:
5-member elected council
Serving 5-year terms

Current enterprises:
Business: Ceramics
Netmaking
Cultural: Arts & Crafts: basketmaking

Planned enterprises:
Business: Crabpots

Mitchell Bay Indian Tribe of San Juan Island
P.O. Box 444
Friday Harbor, WA 98250
(206) 378-4924

Tribes forming confederation:
San Juan Indian Tribe
Aboriginal Swinomish

Tribal membership: 110

Government structure:
3-member council
Serving 2-year terms

Current enterprises:
Business: Associated Fishing with Swinomish Tribal Comm.
Cultural: Researching background

Muckleshoot Indian Tribe
39015 - 172nd Ave. S.E.
Auburn, WA 98002
(206) 939-3311

Tribal membership: 800
Composed of descendents of Skopmish, Stkamish, and Smulkamish

Government structure:
9-member elected council
Serving 3-year terms

Reservation: 3,600 acres
Established by Executive Order; April 9, 1874
Based on Treaty of Point Elliott; January 22, 1855

Current enterprises:
Business: Muckleshoot Enterprise (smokeshop, liquor store)
Muckleshoot Bingo Hall

Nisqually Indian Tribe
4820 She-nah-num Dr. S.W.
Olympia, WA 98503
(206) 456-5221

Tribal membership: 382

Government structure:
5-member elected council
Serving 2-year terms

Reservation: 5,000 acres
Established by Executive Order, 1857

Current enterprises:
Business: Trading Post
Construction crew
Cultural: Various classes
Library & archives, traditional storytelling
Sports competitions

Planned enterprises:
Business: Bingo
Primary and secondary fish-processing
Cultural: Museum, Longhouse, and Sweatlodge

Nooksack Tribe
P.O. Box 157
Deming, WA 98244
(206) 592-5176

Tribal membership: 1060

Government structure:
8-member council

Reservation: 2 acres; 2000 acres held in individual trust allotments; 60 acres in tribal trust
Federal recognition received 1973
Based on Treaty of Point Elliott, January 22, 1855

Current enterprises:
Convenience store, gas station, smokeshop, trading post, dental clinic

Planned enterprises:
Bingo

Port Gamble Klallam Tribe
P.O. Box 280
Kingston, WA 98346
(206) 297-2646

Location: 31912 Little Boston Rd., N.E.
Kingston, WA

Tribal membership: 660

Government structure:
5-member elected council
Serving 1-year terms

Reservation: 1,301 acres
Established through Federal land trust, 1935

Current enterprises:
Business: Klallam Smokeshop
Ravenwood Mobilehome Park
Kazunoko Kombo (food product)
School bus financing project

Planned enterprises:
Business: Kazunoko expansion
Aquaculture products

Events:
Annual PowWow

Puyallup Tribe of Indians
2002 E. 28th St.
Tacoma, WA 98404
(206) 597-6200

Tribal membership: 1,450

Government structure:
5-member elected council
Serving 3-year terms

Reservation: 18,061.5 acres
Established by Treaty of Medicine Creek, 1855

Current enterprises:
Tribal school (K-12)
Motel

Planned enterprises:
Bingo hall

Events:
Annual PowWow, Labor Day Weekend

Quileute Nation
P.O. Box 279
La Push, WA 98350
(206) 374-6163

Tribal membership: 658

Government structure:
5-member elected council
Serving 2- or 3-year terms

Reservation: 1 square mile
Established by Executive Order

Current enterprises:
- Business: Ocean Park Resort Hotel
 Fish plant
 Commercial fishery
 Boat basin
- Cultural: Elementary/Middle school
 Language and cultural programs
 Cultural Based Alternatives to
 Substance Abuse
 Canoe projects
 Survival camp

Planned enterprises:
- Business: Restaurant
- Cultural: Living Archive Learning Center

Events:
 Elders Week, June
 Quileute Days, July

Quinault Indian Nation
P.O. Box 189
Taholah, WA 98587
(206) 276-8211

Tribal membership: 2,319

Government structure:
 11-member elected council
 Serving 3-year terms

Reservation: 196,645 acres
Established by Executive Order, 1873
Treaty of Olympia, 1855

Current enterprises:
- Business: Quinault Seafood Processing Plant
 Taholah Mercantile
 Quinault Cablevision
 Quinault Tribal Shake Mill
 Quinault Land and Timber Enterprise
 Queets Mini-Mart
 Taholah Lunch
- Cultural: Quinault Historical Foundation

Planned enterprises:
- Business: Bottomfish processing
 Ocean fishing

Events:
 Chief Taholah Days, early July

Samish Indian Nation
P.O. Box 217
Anacortes, WA 98221
(206) 293-6404

Location: 708 Commercial Ave.
 Anacortes, WA

Tribal membership: 600

Government structure:
 11-member council
 Serving 2-year terms, staggered

Current enterprises:
- Business: Samish Woolens
 Potlatch Gifts
- Cultural: Northwind Cultural Resource Services
 (Archaeological)
 Cross-cultural Education Program
 Services

Planned enterprises:
- Cultural: Cultural Interpretive Center and
 Museum
 Coast Salish cultural curriculum
 Coast Salish performing arts
 Canoe and story pole carving
 Basketweaving and fabric arts classes
 Restoration of annual canoe races at
 Anacortes

Sauk-Suiattle Indian Tribe
5318 Chief Brown Lane
Darrington, WA 98241
(206) 436-0131
(206) 435-8366

Tribal membership: 210

Government structure:
 7-member elected council
 Serving 1-year terms

Reservation: 23 acres
Established through purchase, 1982

Current enterprises:
- Cultural: Longhouse Replication Project
 Arts & crafts

Shoalwater Bay Indian Tribe
P.O. Box 130
Tokeland, WA 98590
(206) 267-6766

Tribal membership: 123

Government structure:
 5-member elected council
 Serving 2-year terms
Reservation: 1 square mile plus tidelands
Established by Executive Order, September 22,
1886

Current enterprises:
- Cultural: Shoalwater Library

Skokomish Indian Tribe
North 80 Tribal Center Road
Shelton, WA 98584
(206) 426-4232

Tribal membership: 630

Government structure:
 7-member elected council
 Serving 4-year terms

Reservation: 4,987 acres
Established by Treaty of Point-No-Point, 1855

Current enterprises:
- Business: Twin Totem Grocery & Deli
 Site fish plant
- Cultural: Twana dancers
 "Seeds of Our Ancestors," an exhibit
 of Puget Coast Salish designed and
 developed by Skokomish artists

Planned enterprises:
- Business: Fish-processing plant expansion
 Aquacultural facility development

Snohomish Tribe of Indians
1422 Rosario Road
Anacortes, WA 98221
(206) 293-7716

Tribal membership: 871

Government structure:
 17-member elected council
 Serving 2-year terms

Current enterprises:
- Business: Seeking Federal recognition
 Planning economic development
- Cultural: Archival organization
 Reprints of historic documents

Planned enterprises:
- Business: Fish product processing
 Manpower pool for bidding
- Cultural: Publications

Snoqualmie Tribe
18525 Novelty Hill Road
Redmond, WA 98052
(206) 885-7464

Tribal membership: 561

Government structure:
 9-member elected council
 Serving 2-year terms

Current enterprises:
- Business: Salmon bakes & catering
 Traditional arts & crafts
 Fry bread sales
- Cultural: Potlatches
 Language classes
 Traditional crafts
 Drumming & dancing

Planned enterprises:
- Business: Marketing traditional products
 Sales of roots and other natural
 products
- Cultural: Drumming and dancing classes

Spokane Tribe of Indians
Box 100
Wellpinit, WA 99040
(509) 258-4581

Tribal membership: 2,070

Government structure:
 5-member elected council
 Serving 3-year terms

Reservation: 155,000 acres
Established by Executive Order, 1881

Current enterprises:
- Business: Tribal bingo
 Tribal trading post
 Wood treatment enterprise
 Tribal construction
 Data processing and consulting
 services

Planned enterprises:
- Business: Possible re-opening of uranium mine
- Cultural: Publication of Spokane Language
 Dictionary and text of traditional stories

Squaxin Island Tribe
S.E. 70 Squaxin Lane
Shelton, WA 98584
(206) 426-9781

Tribal membership: 380

Government structure:
 5-member elected council
 Serving 3-year terms

Reservation: 2,175 acres
Established by Treaty of Medicine Creek, 1854

Current enterprises:
- Business: Kamilche Trading Post
 Harstine Oyster Company
 Squaxin Seafarms
- Cultural: Historical photograph project
 Tribal center and cultural exhibit
 Fisheries enhancement
 Natural resources management

Planned enterprises:
- Business: Bingo
 Expansion of current business
 enterprises
- Cultural: Establishing archives
 Historical research

Steilacoom Tribe of Indians
P.O. Box 88419
1515 Lafayette St.
Steilacoom, WA 98388
(206) 847-6448 (206) 584-6308 (Museum)

Tribal membership: 617

Government structure:
 9-member elected council
 Serving 3-year terms

Current enterprises:
 Business: Mountain Highway Boutique &
 Country Market
 Cultural: Steilacoom Tribal Cultural Center

Planned enterprises:
 Business: Museum snack bar
 Meeting room rentals with catering

Stillaguamish Tribe of Washington
3439 Stoluckquamish Lane
Arlington, WA 98223
(206) 652-7362

Tribal membership: 160

Government structure:
 6-member elected council
 Serving 3-year terms

Reservation: Actual acreage of "reserved" status
 pending; tribe owns 60 acres.

Current enterprises:
 Business: Business Center development

Planned enterprises:
 Business: Fish-processing plant
 Fireworks sales
 Recreational vehicle park
 Small business park
 Cultural: Ceremonial longhouse and historical
 area

The Suquamish Tribe
P.O. Box 498
Suquamish, WA 98392
(206) 598-3311

Location: 15860 Sandy Hook Rd., N.E.
 Suquamish, WA

Tribal membership: 660

Government structure:
 7-member elected council
 Serving 3-year terms

Reservation: 7800 acres
Established by Treaty of Point Elliott, 1855
Enlarged by Executive Order, 1864

Current enterprises:
 Business: Commercial fishing
 Port Madison Enterprises (liquor store
 & grocery)
 Cultural: The Suquamish Museum and
 Cultural Center

Planned enterprises:
 Business: Bingo and gaming enterprise
 Seafood business
 Cultural: War canoe racing teams

Events:
 Chief Seattle Days, third week in August
 Native American Art Fair, April

Swinomish Indian Tribal Community
P.O. Box 817
LaConner, WA 98257
(206) 466-3163

Location: 950 Moorage Way
 LaConner, WA

Tribes forming confederation:
 Aboriginal Swinomish
 Lower Skagit
 Kikiallus
 Samish

Tribal membership: 462

Government structure:
 11-member elected council
 Serving 1-year terms

Reservation: 10 square miles
Established by Treaty of Point Elliott, January 22,
1855

Current enterprises:
 Business: Swinomish Indian Bingo
 Swinomish Longhouse Restaurant
 Swinomish Fish-Processing Plant
 Swinomish Mini-Mart
 Cultural: Centennial Celebration Projects:
 Tribal totem pole
 Traditional carved canoe

Planned enterprises:
 Business: Swinomish Channel marina
 Archeological village site (TWIWOK)
 Cultural: Swinomish Cultural & Environmental
 Protection Agency (SCEPA)

Tulalip Tribes
6700 Totem Beach Road
Marysville, WA 98270
(206) 653-4585

Tulalip Tribes Incorporated:
 Snohomish
 Snoqualmie
 Skykomish
 Other tribes and bands signatory to Treaty of Pt.
 Elliott

Tribal membership: 2,016

Government structure:
 7-member elected board of directors
 Serving 3-year terms

Reservation: 22,000 acres
Established by Treaty of Point Elliott, 1855

Current enterprises:
 Business: Fish Hatchery and Fisheries
 Enhancement Program
 Tulalip Bingo
 Liquor store
 Logging and tree planting
 Cable vision
 Tulalip Telecommunications, Tulalip
 Bay Marina
 Cultural: Boom City, end of June through 4th of
 July, fireworks
 Canoe project
 Centennial lobby exhibit
 Canoe racing/rowing
 Tribal celebrations, including Kla-
 How-Ya Days (Labor Day weekend)
 Smokehouse ceremonies

Planned enterprises:
 Business: Solid waste incineration plant
 Industrial business park
 Fish farming
 Fish-processing plant
 Cultural: Museum

Upper Skagit Indian Tribe
2284 Community Plaza
Sedro Wooley, WA 98284
(206) 856-5501; (800) 578-3171

Tribal membership: 502

Government structure:
 7-member elected council
 Serving 1-year terms

Reservation: 130 acres
Established by Executive Order, April 1974

Current enterprises:
 Business: Wood Box Enterprises
 Timberland Services Company
 Cultural: Archives
 Canoe building

Planned enterprises:
 Business: Sawmill
 Basketry retail sales

Wahkiakum Band of the Chinook Tribe
P.O. Box 66
Skamokaway, WA 98647
(206) 795-3903; (206) 795-8603

Tribal membership: 70

Government structure:
 5-member elected council

Current enterprises:
 Business: Fishing

**Confederated Tribes and Bands
of the Yakima Indian Nation**
P.O. Box 151
Toppenish, WA 98948
(509) 865-5121; (509) 865-2800

Tribes Forming Confederation:

Kah-milt-pah Pisquonse
Klickatat See-ap-cat
Klinquit Shyiks
Kow-wassay-ee Skin-pah
Li-ay-was Wenatchapam
Oche-chotes Wish-ham
Palouse Yakama

Tribal membership: 7,500

Government structure:
 14-member elected council
 Serving 4-year terms

Reservation: 1.4 million acres
Established by Treaty of 1855, June 9, 1855

Current enterprises:
 Business: Forestry
 Furniture
 Land lease/crop share
 Agriculture
 Cultural: Yakima Nation Cultural Heritage
 Center

Events:
 Speelyi-Mi Arts & Crafts Fair, Yakima, Cultural
 Center, March
 Blacklodge PowWow, White Swan, April
 Weaseltail Memorial Day PowWow, White Swan,
 May
 Tiinowit International PowWow, White Swan, June
 Yakima National Cultural Center PowWow,
 Toppenish, June
 Toppenish PowWow & Rodeo, Toppenish, July
 Indian Encampment Toppenish Creek Longhouse
 Celebration, White Swan, July
 National Indian Days Celebration and PowWow
 Celebration and PowWow, White Swan Pavilion,
 White Swan, September
 Veteran's Day PowWow Celebration, Toppenish,
 November
 Christmas PowWow Celebration, Wapato,
 December
 New Year's PowWow Celebration, White Swan
 Pavilion, White Swan, December

Tribal Museums and
Cultural Centers in Washington State

Colville Confederated Tribes
Museum/Gift Shop
P.O. Box 223
516 Birch
Coulee Dam, WA 99116
(509) 633-1874

The Colville Confederated Tribal Museum features a gallery of photographs that depict the history of the Colville tribes. The Museum strives to develop cultural awareness of the Colville Indian heritage both within the tribes and for the general public. Complementing the permanent photo exhibit are special temporary shows put together from archival materials. In addition, various artists—tribal members or other local artists with Indian concerns—mount shows throughout the year in the museum's gallery. The museum also offers an educational video program (in conjuction with the En-awlkin Center in British Columbia), which is available for public viewing.

A gift shop offers fine crafts—jewelry, beadwork and leather goods—and art on consignment from Northwest Coast and Colville artists. Clothing and cards are also sold.

Daybreak Star Indian Cultural Center
United Indians of All Tribes Foundation
Discovery Park
P.O. Box 99100
Seattle, WA 98199
(206) 285-4425

The Daybreak Star Arts Center houses contemporary art from across the United States. Located on 20 acres in the northwest section of Discovery Park, the center was designed by Colville sculptor Lawney Reyes and architects Clifford Jackson and Yoshio Arai. Working with suggestions from many individuals and tribes, the design team created an architectural plan which, itself a work of art, esthetically complements the many shows that pass through the center's art gallery, the Sacred Circle Gallery of American Indian Art.

The construction of the Daybreak Star Arts Center reflects many of the different Native cultures represented by the All Tribes Foundation. The frame of the building complements its Pacific Northwest Coast surroundings, and the interior uses indigenous materials. Works by major Indian artists throughout the country include a wood mosaic by Chippewa artist George Morrison, a large painting by Caddo-Kiowa painter T.C. Cannon, a large oil mural by Cree artist Jimmie Carole Fife, and a six-panel totem figure by Aleut sculptor John Hoover. The Pacific Northwest Coast is represented in a carved and painted panel by Tlingit artist Nathan P. Jackson, and by two eight-by-seven-foot fir panels painted and carved by Quinault-Isleta artist Marvin Oliver.

The center has become a vivid symbol of the Indian presence and contributions to Seattle, crowning her most beautiful park. The Indian Art Market and Salmon Bake is held regularly.

Makah Cultural and Research Center
P.O. Box 95
Neah Bay, Washington 98357
(206) 645-2711

The Makah Cultural and Research Center oversees and coordinates programs which affect the culture—past and present—of the Makah people. The Makah museum is centered around two permanent collections—one archaeological, the other archival. The archaeological collection contains artifacts from Ozette and other Makah sites. The Makah Archives contains tapes, articles, books, photographs, and any other documents that are about the Makah Tribe.

There are 10,000 sq. ft. of permanent exhibition space in the Makah museum. The exhibit gallery features permanent showcased artifacts, many types of life-size replicas, and temporary exhibits. The permanent Ozette exhibit is composed of eighteen showcases which display artifacts from the Ozette archaeological collection. The showcases are arranged to take the visitor through a seasonal year of pre-Euro-American contact Makah life. Photographs and dioramas complement the artifacts (55,000 artifacts are housed in a laboratory on the reservation, of which only 1% appear in the gallery). Replicas, created by tribal members and artists, include canoes and a longhouse. The longhouse, which took two years to build, is an exact replica of the longhouses found at Ozette. Temporary exhibits include the display of several photographic collections that depict life at the turn of the century. Prints, photos, and paintings of or by American Indian people add variety to the museum's permanent collections.

The Makah Archives constitute the most comprehensive collection of Makah documents in the world. Film, slides, photos, and books detail Makah life and the retrieval of the past from the Ozette and Hoko River archaeological sites. The archives also contain hundreds of hours of spoken Makah language and recorded oral histories, along with over 35,000 pages of unpublished Makah research.

A museum shop offers many books and craft items such as baskets and cards.

Samish Cultural Center
Samish Indian Tribe
P.O. Box 217
708 Commercial Ave
Anacortes, WA 98221
(206) 293-6404

The Samish Cultural Center features an in-progress replica of a Puget Sound longhouse. Research facilities include the Northwind Cultural Preservation Services for archaeological research. Two publications relate the legends of the Samish people: *The Maiden of Deception Pass* and *The Night People: The Beaver*. A gift shop offers Coast Salish artworks such as carvings, paintings, woolen items and a handwoven Musqueam blanket.

Future plans include demonstrations and classes in traditional crafts (carving, weaving, basketry, drum making).

Snoqualmie Tribal Museum
1825 Novelty Hill Road
Redmond, WA 98052
(206) 885-7464

The Snoqualmie Tribal Museum features a free-standing twelve-panel exhibit entitled "Snoqualmie: Past and Present," upon which unfolds the history of the tribe. The museum also houses a large photo archive, oral histories, and Native language lessons on cassette tapes.

Spokane Tribal Museum
Alex Sherwood Memorial Center
P.O. Box 100
Wellpinit, WA 99040
(509) 258-4581

Located 45 miles northwest of Spokane, the Spokane Tribal Museum offers showcases displaying a wide range of Indian artifacts. Cornhusk basketry, beaded buckskin clothing, spear and arrow points, stone tools and other items testify to the Spokane Tribe's Native heritage. A small library is attached, containing related materials such as David C. Winecoop's *Children of the Sun: A History of the Spokane Tribe*.

Steilacoom Tribal Museum
1515 Lafayette Street
P.O. Box 88419
Steilacoom, WA 98388
(206) 584-6308

The Steilacoom Tribal Museum is located within the Steilacoom Cultural Center in the town of Steilacoom, a National Historic District. From Interstate 5, use Exit 119 when traveling northbound and Exit 129 when traveling southbound. After exiting, follow signs westward to Steilacoom. The Steilacoom Cultural Center is in a 1903 church building on the corner of Lafayette and Pacific streets.

The museum provides information to the general public on the traditional life and history of the Steilacoom people. The first trading post and first military fort located north of the Columbia River were each established in Steilacoom territory. The facility participates with local and visiting schools in educating students about Coast Salish culture.

Exhibits
Changing Exhibit Gallery: Features rotating exhibitions on Native American topics including contemporary art, ethnographic artifacts, and photographic histories.

Historical Gallery: Provides an interpretive display examining Steilacoom tribal life between 1792 and 1983 and includes a look at politics and canoe use.

Prehistoric Gallery: Examines society and material culture prior to 1792 as well as archaeological findings in traditional Steilacoom territory.

Collections
Artifacts: The museum has a collection of archaeological materials from traditional Steilacoom terrritory. Historic materials are also part of the permanent collection.

Library and Archives: The museum has a number of linguistic materials from the region, including the James Hoard collection on South Puget Sound Salish. There is also research information on the Steilacoom and other western Washington tribes. Open to the general public by appointment only.

Suquamish Museum
Sandy Hook Road
P.O. Box 498
Suquamish, WA 98392
(206) 598-3311

The Suquamish Museum exists to preserve the history and culture of the Suquamish Indian Tribe and to share this knowledge with its members, museum friends, scholars, and the general public. Historical photographs, artifacts, and quotes from tribal elders bring life to Suquamish Museum's premier exhibition, "The Eyes of Chief Seattle" (1983–1989). Firsthand accounts of the original inhabitants of Puget Sound move from the past to the present revealing the history of the region from the perspective of Chief Seattle and his descendants, the Suquamish people. On June 1, 1989, the Museum opened a new exhibit titled "D'suq'wub: An Exhibit About the History and Lifestyle of a Puget Sound Longhouse." Accompanying this exhibit is the twelve-minute slide/tape show entitled, "Waterborne: Gift of the Indian Canoe," which is an oral history documentary of tribal heritage. The Museum also features tours, public programming, temporary exhibits, and special events.

Exhibits
"D'suq'wub: An Exhibit About the History and Lifestyle of a Puget Sound Longhouse"

Collections
Various types of basketry, ethnographic materials relating to the Suquamish and other Puget Salish tribes of western Washington, archaeological collections, and archival collections.

A museum shop offers contemporary arts and crafts, books, posters, postcards, jewelry, clothing, and calendars.

The Tulalip Tribes
6330 33rd Ave. N.E.—Bingo Hall Exhibit
Marysville, WA 98270
(206) 653-7395

The Tulalip Tribes have an on-going exhibit, "Beneath Tall Cedar," in the lobby of the Tulalip Bingo Hall (just off Marysville exit [199] of I-5). There are photomurals and displays, including traditional baskets. A canoe, carved in conjunction with the Centennial Canoe Project, is on view across the street from the Bingo Hall.

The Tulalip Tribes are the successors in interest to the Snohomish, Snoqualmie, and Skykomish tribes, and other tribes and bands signatory to the Treaty of Point Elliott.

Yakima Nation Museum
P.O. Box 151, Toppenish, WA 98948
(509) 865-2800
Hwy 97, approximately 20 miles south of Yakima

The Yakima Nation Museum is part of the Yakima Cultural Heritage Center located on the Yakima Reservation in Toppenish, Washington. The Museum strives to preserve and present Plateau culture not only for the Yakima people, but also for the general public. The permanent exhibit is a lifesize diorama filled with local flora and fauna. The Yakima people tell their history themselves and thus promote friendship and understanding among the cultures.

Spilyay, the legendary trickster coyote, is the visitor's guide through the blend of dramatic visual experiences and explanatory poetry from a rich oral tradition. The visitor is taken from time immemorial, through the world of our ancestors, and into the present. Beautiful artifacts displayed in the permanent cases throughout the 8,000-square-foot exhibit highlight continuing traditional arts and crafts.

Exhibits
Permanent: The Challenge of Spilyay
Changing: Window cases and floor cases

Programs (call or write for a calendar)
- Traditional crafts demonstrations by local artisans during season
- Annual school classroom presentations, scheduled by appointment
- Organization/club presentations, small fee
- Annual Cultural Center anniversary celebration and Treaty Day commemoration events
- Guided tours by appointment
- Library containing special Indian section
- Giftshop: local traditional/contemporary objects

INDEX